Arts Management

*Uniting Arts and Audiences
in the 21st Century*

Arts Management

Uniting Arts and Audiences
in the 21st Century

ELLEN ROSEWALL
University of Wisconsin–Green Bay

London Oxford New York
OXFORD UNIVERSITY PRESS

Oxford University Press is a department of the University of Oxford.
It furthers the University's objective of excellence in research, scholarship,
and education by publishing worldwide.

Oxford New York
Auckland Cape Town Dar es Salaam Hong Kong Karachi
Kuala Lumpur Madrid Melbourne Mexico City Nairobi
New Delhi Shanghai Taipei Toronto

With offices in
Argentina Austria Brazil Chile Czech Republic France Greece
Guatemala Hungary Italy Japan Poland Portugal Singapore
South Korea Switzerland Thailand Turkey Ukraine Vietnam

For titles covered by Section 112 of the US Higher Education
Opportunity Act, please visit www.oup.com/us/he for the latest
information about pricing and alternate formats.

Published in the United States of America by
Oxford University Press
198 Madison Avenue, New York, NY 10016
http://www.oup.com

Library of Congress Cataloging-in-Publication Data
Rosewall, Ellen.
 Arts management: uniting arts and audiences in the 21st century / Ellen Rosewall.—1
 pages cm
 ISBN 978-0-19-997370-5 (pbk.)
 1. Arts—Management—Textbooks. I. Title.
 NX760.R67 2013
 700.68—dc23
 2013037991

Printing number: 9 8 7 6 5 4 3 2 1

Printed in the United States of America
on acid-free paper

DEDICATION

Make good art.

I'm serious. Leg crushed and then eaten by mutated boa constrictor? Make good art. IRS on your trail? Make good art. Cat exploded? Make good art. Somebody on the Internet thinks what you do is stupid or evil or it's all been done before? Make good art.

Make it on the good days too.

> *—Author Neil Gaiman, in a commencement address to graduates of the University of the Arts, Philadelphia, May 17, 2012*

This book is dedicated to those who make good art, on good days and bad days, and to those who, on good days and bad, work hard to share art with as many people as they can.

CONTENTS

PREFACE

⤳

This book began life as an online course, developed in 2006 through the University of Wisconsin System's Curricular Redesign Program of the Learning Technology Development Council. Colleagues from four schools, Megan Matthews (UW–Whitewater), Gerard McKenna and Tiffany Wilhelm (UW–Stevens Point), Debra Karp (UW–Parkside), and I (UW–Green Bay) initially proposed this project as a way to create a course that would be usable in each of our programs. We created the curriculum collaboratively, and all five of us contributed materials, case studies, exercises, and ideas to the project. Although the book you now are reading is a much different product than the original online course, it is based on the same curriculum, principles, and ideals that we all agreed on in 2006. The work we did together was groundbreaking, since the Association of Arts Administration Educators had not yet developed a set of academic standards and no standard method for teaching introductory arts management courses existed. I am proud of and grateful for the work we did together, and for the support of the University of Wisconsin System and my colleagues, especially Dr. McKenna, a pioneer in arts management education who developed one of the first undergraduate arts management programs in the United States.

Over the years, I have adapted and expanded the original online content into the format you see here, and have tested it in the crucible of my own classroom. In addition to my classes, several of my colleagues have also used the material in whole or in part; as the work continued to develop, their feedback was valuable, indeed. Many thanks to Susan Badger Booth (Eastern Michigan University), Eleonora Redaelli (University of Oregon), Doug Borwick (Salem College), Travis Newton (LeMoyne College), Sherri Helwig (University of Toronto–Scarborough), Robert Wildman (Long Island University), David Edelman (Shenandoah University), Katherine Kavanagh (Borough of Manhattan Community College), Virginia Donnell (Middle Tennessee State University), Erika Haynes (University of Hartford), Rachel Shane (University of Kentucky), and others who have read the text, used it for their classes, and helped continue its development.

Special thanks go to Alicia DeBlaey, my research assistant, who did outstanding work editing, fact checking, compiling bibliographies, and keeping me honest. Thanks to all of my students, past and present, who asked the hard questions, found typos, and pushed me toward new ways of thinking, particularly Ryan Penneau, Sandra Simpson-Kraft, and Carrie Dorski, who helped significantly at various stages with research and proofreading. I also am very grateful for the support of my wonderful colleagues at UW–Green Bay, most especially the members of the ever creative Doilie Nation knitting group, which has got to be one of the few groups anywhere that discusses academic scholarship while knitting ruffled scarves.

I am grateful to the Association of Arts Administration Educators, the professional organization for people who teach arts management in an academic setting. This wonderful organization provides resources, information, and moral support for those of us who do what we do, and shows me every day that people who teach arts management are the wisest, funniest, and most caring people on the planet. There are far more people who provided support than I can thank here, but I want to especially mention Barbara Bueche Harkins, Ximena Varela, Sherburne Laughlin, Tamasine Anne Frost, Mike Wilkerson, and Alan Salzenstein for being such wonderful colleagues and good friends.

Finally, I thank my husband Dr. Michael Rosewall, who sets the gold standard for supportive academic spouse. Whether it is the ability to read through drafts and offer suggestions without destroying my self-confidence or helping me find just the right word for the sentence, he is there.

Ellen Rosewall
January, 2013

Introduction

Even though people have been organizing, promoting, and raising support for the arts for thousands of years, the establishment of arts management as a distinct academic discipline and a recognized career field is a relatively recent development. The rapid growth in the number of arts organizations in the second half of the twentieth century along with changes in technology, access, and arts participation, created a need for increasingly sophisticated, industry-specific knowledge and training. Whereas in the 1960s there were only a few thousand arts organizations in the United States, by 2011 the National Arts Index reported total numbers of more than 113,000.[i]

Why did this growth take place? The National Arts Index and several other studies point to a number of factors. First and most important, the formation in 1965 of both the National Endowment for the Arts and the National Endowment for the Humanities is widely credited with jump-starting the proliferation of arts organizations in the United States. The federal programs accomplished this by providing direct funding to local organizations in every state for the first time in America's history. The subsequent growth of state arts councils, which were designed to duplicate the NEA's method of matching grant funds with local resources, has enabled new projects to spring up around the country. Other factors include the rise of technological advances (from television in the 1950s to the Internet toward the end of the twentieth century) that have allowed more people to be exposed to art than at any other time in history; the growth in numbers of college art, music, and theater graduates; and the increasing understanding of the role of the arts in community economic and civic growth.

Effects of this growth on the industry itself have also been dramatic. This unprecedented increase in the number and complexity of arts organizations has introduced the need for additional professional arts managers, with more advanced

[i]Kushner, Roland J., and Randy Cohen, eds. *The National Arts Index 2012: An Annual Measure on the Vitality of Arts and Culture 1998–2010.* Washington, DC: Americans for the Arts, 2012.

knowledge of financial management, marketing, resource development, and labor relations. In times of economic uncertainty, the room for error decreases, and the need for arts managers to be able to provide strategic leadership to weather the storms increases.

Since there were relatively few arts management programs in colleges and universities until close to the end of the twentieth century, it's not surprising that most arts managers during the period of rapid growth between 1960 and 1990 either came from the ranks of the artists or from other fields, such as business, management, or communication. However, as early as the 1960s, arts management programs began to emerge at the college level, and by the late 1980s, they were proliferating rapidly.

Because these programs arose in an atmosphere of need from the field and without institutional history, most were started with an entrepreneurial spirit, using existing resources and leveraging new ones to respond to each particular situation. Unlike other disciplines, which can rely on centuries of academic tradition and standards, the arts management field has just begun to discuss the overarching issues of academic arts management education. Significantly, as a sign of the field's maturity and professional development, the Association of Arts Administration Educators has recently published Graduate and Undergraduate Standards, guidelines for learning outcomes for academic programs offered by its membership.

All of this is by way of explanation for this book: the need in the field for an easy-to-read, comprehensive text that takes the student or practitioner of arts management through the theory and practice of the administration of the not-for-profit arts organization. While this book is designed for academic arts management programs, I hope it will also be useful for the board member who isn't quite sure how a not-for-profit operates, the artist who wishes to start a new business, or the staffer who could use a reference work covering basic concepts of the field.

Again, the fact that this new field exists has raised the need for a book that specifically deals with arts management as a distinct, unique industry. The arts industry has long struggled with the false dichotomy of art vs. business—as if the two were diametrically opposed. We've grown up with the stereotypes of flaky artists who are more concerned with creativity than profit, and penny-pinching, business-oriented board members who put more emphasis on a healthy bottom line than on good art.

This conversation has been distorted by the improper separation of art from business in the context of arts management. The issue is neither that art needs to act more like business, nor that business needs to help but get out of the way of the art. The issue ultimately is that the arts industry is a unique industry, which acts in different ways than other kinds of businesses and therefore needs industry-specific management techniques in order to succeed. Just as industry-specific information is needed for a career in sports management or international marketing, industry-specific information is essential to the success of any arts organization. As I often tell my students, you can't use the same principles to sell toilet paper and chamber music, although (as one irreverent student pointed out) the end result may be the same.

The charts, graphs, and appendices in this book are appropriate for use for the classroom, with or without additional information. For example, the appendix contains a complete set of financial statements for a fictional arts organization, the Child's Play Theater Company. These have been designed in a coordinated way, so that they can be used for basic classroom exercises in financial analysis. And when matched with the mission statements created for the same company in chapter 4, the documents for this imaginary organization can serve as a case study for assignments in grantwriting or program development.

The fear of every writer is that her book will be obsolete the day after it is published. With this in mind, I have tried to include current trends as well as well-tested best practices; but concepts that will stand the test of time are emphasized throughout. This is why, for example, you may see a discussion of general guidelines for successful websites but not a detailed description of formats. It is no secret that the management of the arts, like every other business, is changing rapidly in response to technological advances, the social media, changing philanthropy patterns, and even emerging business forms. For teachers, asking students to confirm the validity of information on websites is a good object lesson in navigating the wild, wild West of the Internet. That being said, I hope that you will find here some new concepts and exciting ideas. There is some amazing ground being broken by arts organizations and artists these days.

I openly acknowledge that the information in this book is, of necessity, specific to arts organizations and the arts management field in the United States. It is difficult to have a comprehensive conversation on the nature of not-for-profit corporation operation, the management of contributions, and advocacy in the legislative system without referring to specific laws and practices that create the conditions under which we do our work. The focus on American systems is deliberate, but its intent is not chauvinistic.

Likewise, my focus on the not-for-profit organization is not intended to discount the exciting work being done by all types of artists, in all types of organizational structures. Many, finding the traditional not-for-profit model too cumbersome for current conditions, are breaking new ground in developing partnerships, alternative structures, and fundraising. For example, crowdfunding websites like Kickstarter and Indie Go Go are at this writing raising millions of dollars for creative projects, without layers of bureaucracy or formal applications. The primary criteria for support on crowdfunding sites are having a good idea and being able to access a social network. Lack of an established board of directors or a strategic plan is not disqualifying. For now, the not-for-profit model is the system we have to organize and manage the mission-based arts organization, but people are poking at its limits every day. Tomorrow—who knows?

The bottom line is that this book is intended to provide practical information and relevant help to people who believe in the arts and are working to bring arts to audiences. Ultimately, the single most significant difference between the arts and other industries is the role of mission in planning, managing, and marketing the arts. Regardless of whether in twenty years we are still operating within for-profit and not-for-profit structures or in some other system, it is a certainty that the overriding goal will continue to be sharing art with audiences.

This focus on mission in a not-for-profit arts organization is often misunderstood by those whose primary orientation is profit. Too often, a concentration on mission is misinterpreted as setting aside business sense in favor of artistic whim, or worse, a deliberate rejection of profit because of an animosity toward capitalism. Even those in the arts industry fall into the trap of assuming that a profit-making orientation is the norm, but it's one that artists have chosen to reject. In other words, many both inside and outside the arts industry assume that the priorities of money and art cannot peacefully coexist in the artistic soul.

The idea that mission and money are incompatible leads to some detrimental conclusions, many of which are, unfortunately, very much a part of the thinking in many arts organizations today. Most misleading is the false belief that a truly mission-based program will attract only a small audience and therefore, in order to make money, the organization must lower its artistic standards to appeal to a broader spectrum of the public. This attitude is toxic in a couple of ways. First, it may be threatening to the organization's mission and thereby to the organization itself. At the very least, it may be perceived as patronizing and elitist, implying that although members of the general public are incapable of fully appreciating good art, we need their money to do what we want to do, so we will give them something we think they will be capable of enjoying.

Like the other aspects of the arts industry listed earlier, which act differently than comparable facets of other industries, the role of mission in the management of the arts is an essential concept for arts managers to understand. To develop a healthy attitude toward mission, arts organizations must think of it not simply as a philosophical concept, but as a legal issue and a management challenge. In order to make good management decisions in a mission context, arts managers need a strong grounding in the philosophy that marries high artistic standards with a vigorous pursuit of the resources to make the art happen. This means balancing earned and contributed income opportunities, human and other resources, available artistic products, and community input, as well as simply trying to sell tickets.

Not so long ago, I asked a question in class and it was clear that no one was going to attempt an answer. After an uncomfortable silence, a student asked tentatively, "Mission?" When I looked at her quizzically, she said, "Well, you always say that mission is the answer to everything!"

Mission may not be the answer to everything, but it certainly an essential core concept, one that is vital for effective arts management education. We have our challenges cut out for us: responding to an unsteady economy and a shifting cultural job market, working to incorporate and keep pace with rapidly changing technology, and always advocating for the needs of art in the short term and long term alike. The best way to respond to all of these challenges is to make sure that we have a thorough grounding in the unique management needs of the arts industry that will allow the artists to do what they do best: make good art.

CHAPTER 1

⌘

What Is Arts Management?

"Go into the arts. I'm not kidding. The arts are not a way to
make a living. They are a very human way of making life more
bearable. Practicing an art, no matter how well or badly, is a
way to make your soul grow, for heaven's sake. Sing in the
shower. Dance to the radio. Tell stories. Write a poem to a
friend, even a lousy poem. Do it as well as you possibly can.
You will get an enormous reward. You will have created
something."

—KURT VONNEGUT, *A MAN WITHOUT A COUNTRY*, 2007

With all due respect to Mr. Vonnegut, this book is dedicated to the idea that
the arts are a wonderful way to make both a life *and* a living. Many others
think so too; in fact, the amount of arts activity in the United States has exploded
over the past forty years. According to the National Arts Index, there are over
113,000 not-for-profit arts organizations and 800,000 arts businesses in the United
States. The arts industry supports 2.2 million artists and generates $150 billion in
consumer spending.[1] This does not include arts activity that is facilitated by non-
arts groups such as government agencies, economic development organizations,
and educational institutions.

The arts are an important part of our lives—nearly everyone we meet in a day will
come into contact with the arts. People may choose to listen to music while working
out, attend a gallery opening after work, take their children to music lessons, or choose
a print for their home at an art fair. They may attend concerts, plays, museums, or
festivals. They may describe themselves as "into" the arts, or they may not identify
themselves as arts participants. But participate they do . . . in record numbers.

All of this arts activity needs to be organized, which is where arts managers
come in. With the growth in arts activity, there has come a need for specialized
information on how to manage the arts industry.

After finishing this chapter, you should be able to:

- Describe the role of the arts in individual and community life
- Discuss the way the arts have been managed throughout history and how
 that affects arts management today
- Understand the need for management techniques that are specific to the
 arts industry

1

DEFINING THE ARTS

The arts are generally defined as a set of activities involving human creativity, divided into various disciplines including visual arts, music, literature, and dance. When people talk about "the arts," they are most often talking about what we might define as the "fine" or "high" arts: symphonic music, serious drama, concert dance, and museum-worthy visual art, as opposed to mass-produced and widely distributed products such as movies, recorded music, and television, which are more often classified as entertainment. The line between arts and entertainment has traditionally looked something like the chart below.

ARTS	ENTERTAINMENT
Produced individually or on small scale	Mass-produced and widely distributed
Produced by artists trained in a traditional manner, primarily in university arts programs	Produced by artists and artisans from a variety of backgrounds, including self-taught and apprenticed
Seen live in traditional venues such as concert halls and museums	Live participation can include more casual venues such as bars, nightclubs, outdoor festivals, and movie houses
Artistic merit has priority over popularity	Popularity has priority over artistic merit
Organized as not-for-profit organizations	Organized as for-profit businesses

Today, however, the traditional lines between fine arts and entertainment have blurred to the point that they are barely recognizable. Many factors, from technology to changing socioeconomic patterns, have contributed to this; we'll discuss many of them throughout this book. For now, it's important to note that researchers are defining the arts more broadly than they might have even a decade ago, and that has significant implications for how we discuss the management of the arts.

To illustrate, here is a quiz. What percentage of people in America today do you think would say they participated in the arts during the past twelve months?

1. 34%
2. 75%
3. 96%

The answer? It depends on how you define the arts.

The "granddaddy" of arts participation research, the **National Endowment for the Arts,** has measured seven benchmark fine arts activities every five years since 1982. These results are published in the NEA's Survey of Public Participation in the Arts (SPPA).[2] During this period, arts participation has stayed fairly consistent,

hovering around 37% of the population claiming to have attended at least one activity during the preceding year in several activities most often associated with the traditional definition of the arts, including classical music, jazz, opera, musical and non-musical plays, ballet, and art museums. While the 2008 survey found a slight decline, to 34%, other indicators lead researchers to believe that arts participation is not declining, but changing.

In 2011 the NEA took a fresh look at the 2008 SPPA data, in light of changing patterns of arts participation. The resulting report, *Beyond Attendance,* acknowledged that art forms are changing to reflect the use of technology, infusion of diverse cultural traditions, and a less rigid division among artistic disciplines. In addition, arts participation has moved out of arts-specific venues like concert halls and museums and into bookstores, community centers, homes, and city streets. According to the report, "Arts participation can be understood as occurring in multiple modes, sometimes overlapping; arts attendance, personal creation and perform and participation in the arts through electronic media."[3] When the criteria for participation were expanded beyond attendance to include creating art and accessing the arts via the Internet or electronic media, the data already collected for the 2008 study showed that 75% of Americans participate.

Other studies have found similar results. When arts are defined broadly to include such activities as singing in a church choir, purchasing CDs, reading literature, visiting historic sites and monuments, listening to music in a club, and attending ethnic or cultural events, participation rates can rise as high as 96%.[4] Indeed, using these criteria, it is hard to imagine that there are any Americans who do not participate in the arts in some way.

In this book, we are going to use the concept of "the arts" in its broadest possible sense. As the *Beyond Attendance* study noted, technology and particularly the Internet has democratized the arts to the point of effectively eliminating the division between the fine arts and entertainment. This does not mean, however, that anyone is advocating for a lower standard of quality in the arts. Instead, the conversation needs to be shifted a bit. Instead of centering the discussion on the difference between arts and entertainment, we can now concentrate on defining and promoting artistic quality—wherever it may be found.

DEFINING CULTURE

The word *culture* comes from the Latin *cultura,* meaning cultivation.[5] The term is used in two basic ways: first, to define the habits, norms, and accumulated knowledge of a group of people and second, to imply the growth or improvement of something. Both these concepts are used in conjunction with the arts.

The concept of culture as the growth of individuals and society has its roots in the scientific usage of the concept of culture as cultivation, as in horticulture (the growth of plant life) or agriculture (cultivation of animals and crops). As plants, animals, and bacteria can be cultivated and improved, so can the human brain. Education is related to this concept of culture, and so are the arts. Since the nineteenth century, the arts have been considered to be such an important part of

the development of a "cultured" human being that the words "arts" and "culture" are sometimes used interchangeably.

The other concept of culture also has important meaning for the arts. The norms of a group of people are communicated and passed down to succeeding generations through creative expression, and so we can also refer to the collection of songs, dances, writing, and visual art that is unique to a group of people as part of their culture. In this sense, though, culture has a somewhat broader meaning than simply artistic expression. Culture may also include costume, habits, traditions, history, and even food, all of which also inform and affect creative expression.

Many in the arts industry include both meanings of "culture" within the circle of the arts, and we increasingly hear the term "arts and culture" when people refer to creative activity. This trend not only acknowledges the cultivation aspect of culture and the idea that the arts are an important part of what makes us human, it also reflect an awareness that we live in a world with a rich diversity of different cultures and traditions whose creative expression is worthy of communication. Some in the industry, however, are wary of the use of *culture* in the sense of improvement of a human being, as it implies that some people are "cultured" and some are not, and that "culture" is a privilege reserved for people who are educated enough to understand it (or wealthy enough to access it). In its common usage now, the word is understood to include not only high culture, but popular culture, ethnic cultures, community traditions, and the cultures of socioeconomic, social, gender, and interest-based groups (gaming culture, urban cultures).

DEFINING ARTS MANAGEMENT

We use **arts management** in this book to mean the management and organization of arts and cultural organizations of all kinds. The terms "arts administration" and "cultural management" are also commonly used to mean essentially the same thing. Arts management can apply to both the not-for-profit and for-profit arts, although it is more commonly used within the not-for-profit arts.

Within the field, several important subcategories are developing, including the following:

- **Cultural policy**: the study and practice of legal, legislative, and public policy issues related to the arts and culture
- Arts **advocacy**: the attempt to change public and political conditions surrounding arts and culture
- Arts **entrepreneurship**: the encouragement of the growth of arts small businesses, the careers of individual artists, and innovation in existing businesses
- Artist management: the management of careers and promotion of individual performing, visual, and literary artists
- Cultural planning: the practice of working within communities to coordinate the growth and maintenance of arts and culture
- Public art: the management and maintenance of art in the public realm, including (but not limited to) art supported by tax dollars

Case 1-1

Case Study: New Orleans

The city of New Orleans, Louisiana, wonderfully exemplifies how community and culture are intertwined. The culture of New Orleans has always been diverse and unique, given its location at the mouth of the Mississippi River. with its strategic port that has served everything from the slave trade to the fur trade to commercial fishing and oil tankers. The interaction of Europeans, African slaves, Acadian ("Cajun") settlers, and native tribes over the years led to a rich mixture of traditions, including the birth of jazz and blues, several distinct culinary styles, and of course the world-famous Mardi Gras festival.

When Hurricane Katrina hit New Orleans and the Gulf Coast in 2005, a big part of the discussion of restoring New Orleans had to do with its culture. How do you restore a culture that has grown up in a community? Do you replace what is lost, or do you allow new traditions to emerge? And what about the practicalities of cultural activity? Restoring the jazz scene in the French Quarter, to use just one example, meant not only cleaning and restoring bars and nightclubs but trying to find musicians who were scattered by the storm, replacing lost or damaged instruments and sound equipment, and even persuading residents who had relocated to come back.

One of the most successful examples of the restoration and preservation of New Orleans culture following Katrina can be found in the New Orleans Musicians' Village, part of the New Orleans Area Habitat for Humanity. The brainchild of New Orleans residents Harry Connick Jr. and Ellis Marsalis, Musicians' Village has as its twin goals the establishment of a community for musicians dislocated by the storm (many of whom had inadequate housing prior to Katrina) and the provision of resources to preserve and encourage the unique musical traditions of the area. Musicians' Village offers low-cost housing, a toddler park, and elder-friendly units. The Ellis Marsalis Center for Music, which opened in 2010, makes available lessons, rehearsal space, and performance space for students and professional musicians.

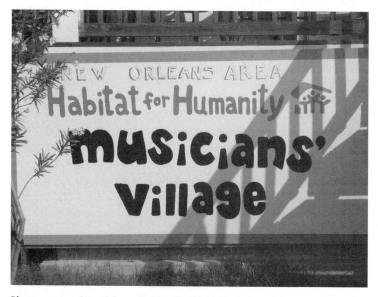

Photo courtesy New Orleans Habitat for Humanity

- Entertainment/media management: the concentration on for-profit arts activities such as music and film promotion and distribution, touring productions, broadcast media (radio and television), and new media
- Community arts: the practice of engaging communities in culturally democratic, community-specific, and socially active arts and culture
- Discipline-specific management: including museum management, performing arts management, and festival management

Management of arts and cultural organizations generally includes such functions as marketing, fundraising, budgeting and financial management, board relations, management of staff and volunteers, program planning and evaluation, and education—all of which are discussed in this book. In a small not-for-profit organization, one arts manager may be expected to work directly in several of these areas; in larger organizations, it is more likely to see these areas split into separate departments with specialized staff.

ORGANIZING THE ARTS THROUGH HISTORY

Where there are humans, there is art. This has always been so; indeed, some scholars feel as though the urge to create art is one of the things that defines us as human. Because art and culture have functioned differently in different societies, however, the role of the arts manager has changed. The modern field of arts management, encompassing the variety of tasks listed earlier and charged with bringing arts and audiences together, has arisen relatively recently. Although the modern field of arts management looks very different from related practices in ancient Greece or medieval Europe, there are remnants of many different systems in arts management today.

Arts and cultural management are affected significantly by political and economic systems, which is why it's also important to note that the American system for supporting arts and culture is different from other systems around the world. This system is affected by our tax structure, which defines the different types of businesses that deliver the arts, as well as incentives for arts support.

From the beginning of human history, the arts have held a place of importance in society. In many tribal societies, **artisans** are the keepers of tradition and tribal customs and thus hold an exalted position within the tribe. Sometimes, as we shall see, the impetus for creating art and presenting it to the public begins with an artist, in the attempt to gain visibility for works of art. Other times, art is facilitated by a community in the attempt to provide communal experiences, beautify the community, or create a better quality of life for citizens.

The arts have been organized by a variety of institutions and organizations throughout history, including governments, religious institutions, wealthy individuals, artists themselves, and art institutions.

The Government

Since the days of ancient Greece, the governments of cities, regions, states, and nations have been involved in organizing arts activities. The city-states of Greece

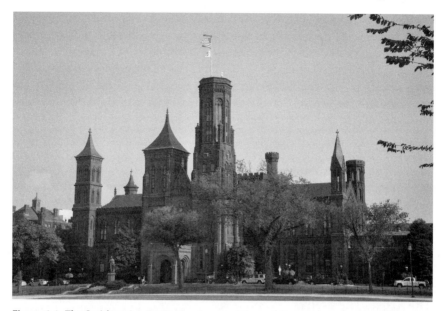

Figure 1.1 The Smithsonian Institution is one of the public museums supported by the Federal government.

organized play festivals, administered by city magistrates and supported by the citizens of the community. City magistrates in Rome were also responsible for organizing the Roman play festivals, and for displaying treasures brought home from military campaigns.

Although the arts continued to flourish in the courts of rulers and the nobility throughout the Renaissance, the concept of state sponsorship of arts institutions began in 1767, with the creation of a German state theater.[6] Government-run museums, theaters, opera companies, and symphonies have been commonplace in Europe since the nineteenth century. In America, this concept has continued, both at the federal level with the Smithsonian Institution, and at the state and local level with county museums, state historical societies, and city-owned performing arts facilities.

Religious Institutions

The role of religious institutions in collecting, preserving, displaying, and commissioning art is vast and multilayered. Artistic objects have always enhanced worship and the spiritual experience in most of the world's religions and cultural traditions.

Because the arts use symbolism and creation to express what sometimes seems unexpressible, the link between spirituality and the arts has been a part of human existence for many thousands of years. Artifacts from religious rituals have been preserved from nearly every culture and time period. These range from iconic images to sculpture to items used in religious ceremonies, as well as sacred texts.

Religious institutions also been influential in the development of architecture, music and theater. For example, in the Middle Ages in Europe, Catholic churches (and eventually cathedrals in Romanesque and Gothic style) were built in gradually growing towns and urban areas. Morality plays and allegories were organized by the church during the Middle Ages for the education of the populace. Well into the nineteenth century, the Catholic Church was one of the most influential commissioners of choral and instrumental music.

Wealthy Citizens

The need to seek patronage for the arts is not unique to today's culture. Throughout history, we see the artistic activity made possible by wealthy citizens and nobility—some just amassing private collections and others using wealth to improve their communities. Examples abound, from the Medici family in Renaissance Italy to Emperor Joseph II of Austria, who was Mozart's patron, to Andrew Carnegie in nineteenth-century America, who used wealth from the steel industry to establish a series of free libraries across the country.

The Artists Themselves

The concept of the artist who has a creative idea and works to compile whatever forces are necessary to present his or her art to the public is as old as ancient Greece and as contemporary as the modern-day jazz musician who puts together a band and seeks a place to perform. Until the nineteenth century, however, there was no such thing as a market-driven artist.

Prior to the Romantic period, most artists, musicians, and playwrights were under the patronage of nobility, the state, or the church. Our stereotype of the "starving artist" had its roots in the Romantic period, when it began to be much more common for artists to create art first and seek venues later.

The advent in twentieth-century America of the not-for-profit system and incentives for creation of new businesses has led to a proliferation of self-employed artists (and musicians and theatrical professionals), touring performers, and arts organizations.

Arts Institutions

The first independent symphony orchestra in America was the New York Philharmonic, established with the support of wealthy patrons in 1842.[7] The Metropolitan Opera Company was founded in 1883, and other growing American cities began to establish their own independent museums, symphonies, opera companies, and theaters late in the nineteenth century and through the twentieth.

When the income tax system was initiated in America in 1913, Congress also established a system to allow some businesses that provide services for the common good to remain exempt from paying federal income tax. Allowance for a deduction for contributions to charitable organizations was established in 1917.[8] Arts organizations in America have traditionally been granted not-for-profit charitable status, which has allowed such organizations to flourish without being beholden to government or religious sponsors.

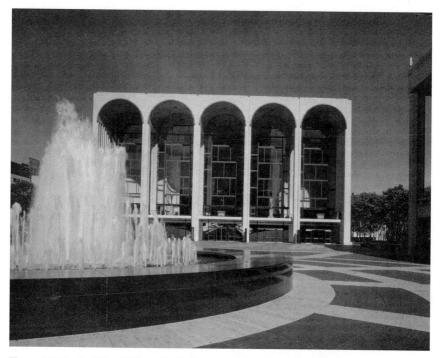

Figure 1.2 Avery Fisher Hall at Lincoln Center, New York, home of the New York Philharmonic, one of America's first independent arts institutions.

THE ARTS IN AMERICA

"I must study politics and war that my sons may have liberty to study mathematics and philosophy. My sons ought to study mathematics and philosophy, geography, natural history, naval architecture, navigation, commerce and agriculture in order to give their children a right to study painting, poetry, music, architecture, statuary, tapestry and porcelain."

—President John Adams, in a letter to his wife

America has always had a love-hate relationship with the arts. In the early days of the United States, many (including Thomas Jefferson and John Adams) felt as though establishing the arts as a priority would provide a powerful legitimacy for the new country. Others condemned the arts as being representative of the wealthy, decadent societies they had come to America to avoid; they feared that governmental control of the arts would inhibit individual creativity and innovation and perhaps even lead to censorship and state control of artists.

Because of this duality, there has never been an overarching agency in the United States dealing with arts and culture. As support systems for the arts developed, they have been designed according to American practices of distrust of government interference, support for the individual, and desire for local control. Through policies at the federal, state, and local level, direct government involvement in the arts has been minimal. Instead, the government has preferred

to provide incentives for the creation of new business, and federal funds are often passed to local and state governments to be distributed.

As early as 1827, a formal system of federal support for the arts was proposed by John Trumbull (to President John Adams).[9] It wasn't until 1965, however, that the National Endowment for the Arts was formed to provide direct funding for arts organizations around the country.[10]

Today, the arts in America rely on support from a variety of sources, including the government, wealthy and not-so-wealthy patrons, and partnerships with other community organizations, religious institutions, and schools. As we shall see, they are sometimes managed by trained professional staff, sometimes with volunteers, and many times with a combination of the two. Not-for-profit organizations are governed by volunteer boards of directors in a checks-and-balances system that provides not only support but protection for the artistic mission of the organization.

THE ARTS IN CONTEMPORARY SOCIETY

"Despite the extraordinary growth of arts activity, their popular involvement and domestic and international esteem, it appears that most Americans view the arts as marginal activities. As a consequence, educators and lawmakers often fail to recognize the embeddedness of the arts in American life—their economic value and symbolic importance, and benefits for individual communities and personal well-being."
—Joni M. Cherbo, in *The Public Life of the Arts in America*,
Cherbo and Wyszomirski, eds., 2000

For at least twenty years, the arts industry has been battered by round after round of cuts to governmental arts funding and arts education programs in schools. The rationale often given is that limited funds must be directed to "more important" programs, like math or science, or that cuts won't matter because fewer people are affected by the arts than other activities in society.

In a society that often judges the worth of things by their monetary value, the arts sometimes have an uphill battle. Those whose lives have been deeply affected by the arts often have difficulty explaining their feelings to legislators or school board members who are charged with using limited resources in the way they feel will help the most citizens. It is possible to value the arts in both tangible and intangible ways. In recent years, the arts industry has developed statistics that prove the worth of the arts to the economy, tourism, health, and the mitigation of social problems as well as the value of arts to individual lives. We'll discuss these benefits throughout the book. It's important for every arts manager to understand how arts and culture are viewed, and to be able to develop persuasive arguments for support.

We are living in a time of great transition for arts and culture. Shifting patterns of governmental support, reductions in funding for arts education in schools, and the marginalization of the arts as described in the quotation that begins this section combine with a great democratization of arts and culture

brought about by the massive increase in numbers of arts organizations and distribution of arts and culture via film, television, recordings, and the Internet. Audience participation in the arts today is very different from the practices of fifty years ago. Today's arts managers not only need to learn the traditional skills of grant writing and program management, they need to understand how diverse audiences are accessing the arts and how to negotiate new technologies for both delivery of the arts and marketing.

What will the twenty-first century bring for arts and culture? The only thing certain is change.

IN CONCLUSION

The twenty-first-century world of arts and culture is a world of both challenge and opportunity. We are challenged to shape society and encourage the growth of high-quality art in an environment of competing entertainment enterprises, an often indifferent public, and budget cuts to government programs and school arts activities. We have an opportunity to take the enormous cultural forces and technologies that are reshaping the world as we know it, and to use them to share art with the world.

DISCUSSION QUESTIONS

1. How would you respond to these views:
 • "In times of economic hardship, there are more important things to worry about than the arts."
 • "We need to cut back on the arts in schools and concentrate on math and science so our children will be competitive in the world."
 • "It's more important to spend money on feeding the hungry and housing the homeless than it is to support the arts."
 • "The arts shouldn't be propped up with tax dollars, they should succeed or fail in the marketplace like any other business."

 After you have finished this book, come back and try these questions again!

2. John Adams' quote implies that he considered the presence of the arts a sign that America had reached the status of a civilized country. What is your assessment?

3. How would you define "art" and "culture"? What characteristics do they share? Where do they differ?

4. How many of the forms of support for the arts that have been present throughout history still exist today?

CHAPTER 2

⚜

Management in the Arts Organization

"What if, in the end, the arts organization is not a problem to
be managed, but an instrument to be played?"
—ANDREW TAYLOR, "THE ARTFUL MANAGER," *ARTSJOURNAL*

Although the word "management" has been in use since at least 1598, the
many attempts throughout history to devise the perfect management system
have for the most part been unsuccessful. At its heart, management is as much an
art as a science.

The most skilled managers are able to understand the needs of the organiza-
tion, develop plans to achieve these needs, and direct people in the duties that will
accomplish organizational goals in the most efficient and productive way possible.

For some, the idea of management is not separate from the idea of leadership.
In fact, as we shall see, leadership is considered to be one of the four functions of
management. A good manager cannot simply be an efficient worker; he or she
must also understand how to inspire and direct others to work for the good of the
organization as a whole.

In this chapter, we will talk about the functions of management and leadership,
as well as some of the different management theories that have guided management
practice throughout history. Then, we will take a look at the unique environment
of the arts organization and examine the management needs of arts and cultural
businesses.

Finally, we will discuss the development of an individual management or
leadership style. Part of learning what it means to be a manager or a leader consists
of understanding what styles, preferences, and communications skills you bring to
the workplace and how you prefer to interact with others.

After finishing this chapter, you should be able to:

- Describe the concept of management and its historical applications
- Explain how an arts management culture may be the same or different than
 a corporate culture
- Analyze what management styles and techniques work within an arts orga-
 nization
- Discuss the difference between management and leadership
- Begin to develop your own management and leadership style

MANAGEMENT TODAY

Management is often defined as the process of organizing and directing the various resources (human, financial, and material) of a business or organization. Sometimes the definition of management focuses on the act of supervising other people: managers coordinate the interactions of people carrying out designated tasks, assign duties, and evaluate performance. Both definitions imply that through management, the goals of the organization or business are achieved. Therefore, good management is often seen as a key component of an organization's ability to accomplish its goals.

Historically, management theory has often concentrated on efficiency: how to get the most productivity from the fewest resources. This traditional view of management, however, is based on assumptions that may or may not apply to all businesses in the twenty-first century. For many businesses, efficiency alone may not be enough to cope with an increasingly complex competitive environment, which may include global forces, online shopping, and businesses crossing traditional

Case 2-1

Case Study: Innovation and Change in the Book Industry

Borders, founded in 1971, was originally an innovator in the book industry, combining large inventories with a sophisticated computer tracking system, and eventually adding music products and coffee shops to the stores. The firm went bankrupt in 2011, at which time much of the blame was placed on management's inability to recognize and adapt to customers' preference for online sales. Barnes & Noble, while maintaining "bricks and mortar" stores, also built an online presence, and has gotten into the e-book revolution with its development of the Nook e-reader. While by 2012 Barnes & Noble's market share still lagged behind the industry giant Amazon.com, industry analysts generally agree that it has weathered the storm—for now.[i]

Ironically, independent booksellers may be among the biggest winners in the changing book industry. Independent booksellers have been innovating since the 1970s in the face of increasing competition from chain stores, including (at the time) B. Dalton and Waldenbooks. While the early chains were gobbled up by larger interests, smaller independents moved under the radar and worked to survive by reaching out into their communities, emphasizing personal service, and scheduling author events. With the advent of online sales, every independent bookstore can have easy access to the same inventory as any other bookstore, and organizations like the American Booksellers Association[ii] provide joint marketing tools. For example, the ABA has taken advantage of economic trends toward supporting local businesses by branding independent bookstores as "indies": local, contemporary and responsive.

[i] "As Its Final Stores Close, We Ask: What Happened to Borders?" Huffington Post, September 16, 2011. http://www.huffingtonpost.com/2011/09/15/what-happened-to-borders_n_965235.html.
[ii] http://bookweb.org/index.html.

boundaries that previously had separated them (e.g., grocery products now found in discount stores). Management experts also concede that in some businesses, especially not-for-profit organizations, the ultimate goal may not be the maximization of profit; therefore, merely accomplishing efficiencies may not be sufficient.[1]

Increasingly, the discussion of management theory has turned from efficiency to innovation. Rapid changes in technology, social values, and the workplace have created a turbulent and unpredictable environment in which the most important managerial skill is the ability to effectively manage change and stay ahead of the curve. Some of the most successful businesses today are those that manage change by creating a new path.

Another aspect of contemporary management is the realization that, while some management theory can apply to all businesses, differences in industries require specialized management techniques. This has led to the subdivision of management into specialty areas including sports management, hospitality management—and arts management.

THE FOUR FUNCTIONS OF MANAGEMENT

Even though management theory is evolving, there are many aspects that remain constant. One way we might look at management is to see it as creative problem solving. In order to solve the problem of carrying out the business of the organization, four basic activities, or functions, are necessary.

The four functions of management are **planning**, **organizing**, **leading**, and **controlling**. For goals to be achieved, all four functions must operate smoothly and must be integrated with the other functions.

Planning
Planning is the ongoing process of developing the mission and objectives of a business and determining how these will be accomplished. Planning includes both the broadest view of the organization (its mission) and the narrowest (a specific tactic for achieving a specific objective).

In many ways, planning is the hardest function of management. Anticipating and responding to changes requires constant attention, as well as input from multiple people, from leaders of the organization to individual workers, on both the administrative and artistic sides of the aisle. Most arts organizations are continually updating a variety of plans that serve the organization, including long-range and strategic plans, program plans, marketing plans, and budgets.

As noted earlier, innovation is often one of the most important aspects of planning. To accomplish the planning function, managers must be able see the "big picture" and put together the various aspects of the situation at hand, including the opinions and input of various employees, volunteers, and board members. After analyzing a situation, an effective manager will be able to understand how

different actions might cause different results. Part of managerial training is learning about **best practices** in other organizations that can help with development of options. Another aspect is the development of creative thinking skills, which can help the manager generate ideas, obtain inspiration from diverse sources, and adapt plans to current environments.

Organizing

Organizing is the process of converting plans into action. Organizing can include creating a list of duties, developing deadlines and timetables for work, assigning tasks, determining and assembling the necessary resources, and carrying out the plan. It is the organizing function that most people think about when they think of management. The organizing function is also the locus of the process of supervising others and assigning authority.

In an arts organization, the organizing function might include such activities as hiring staff, recruiting volunteers, marketing, soliciting contributions, writing grants, and facilitating events. A good manager can develop a structure for the tasks that need to be done, assign appropriate people to those tasks, and determine a timetable for work.

Leading

Leading is the act of directing the behavior of all personnel to accomplish the organization's mission and goals. In order for the goals to be achieved, a shared vision and a clear understanding of everyone's role in the process must be developed. The person or persons in charge of the organization's mission or individual goals and objectives are functioning as leaders when they diplomatically inspire all personnel involved in the task to work together for the best result.

Managers are often called upon to be leaders, in the sense that all of the workers involved in a situation need to be encouraged to do their best toward the achievement of the goal. We will talk more about leadership later.

Controlling

Controlling is an aspect of management that is frequently underestimated. Like planning, it is a continual process; like organizing, it involves translation (although this time, from actions into evaluations) and like leading, it involves diplomacy. Controlling is the function of monitoring work to check progress against goals, and taking corrective action when required. Once a plan has been put into place, the manager must continue to monitor the situation, communicate between those doing the work, and be prepared to change course if necessary.

Controlling may include such activities as providing updated financial reports to the board of directors, studying attendance figures from the last season, evaluating employees and volunteers, and distributing a satisfaction survey following a program.

HISTORICAL DEVELOPMENT
OF MANAGEMENT: 1776–1920

If the most important aspect of contemporary management is change and innovation, why is the historical development of management important? And, if the arts are not managed like other industries, why is it necessary to learn about how factories were managed a century ago?

Organizational management has been a part of business since ancient times. The practice of management can be traced to government organizations developed by the Sumerians and Egyptians.[2] Some management practices have changed as conditions in the workplace changed, but many have remained constant. A short examination of the historical development of management will help us determine which management practices are appropriate for today's arts organization.

The discovery and development of new political and social theories from the **Reformation** until the **Enlightenment** led to theories about management from such philosophers as Hobbes, Locke, and Machiavelli. Following the political revolutions in France and America in the late eighteenth century, economists including Adam Smith initiated the idea of the marketplace as an entity independent of government and the mercantile system. Smith's 1776 book, *An Inquiry into the Nature and Causes of the Wealth of Nations,* laid out the philosophy that has guided economic theory ever since.[3] According to Smith's concept of the **invisible hand of the marketplace,** each individual strives to become wealthy intending only personal gain; but to this end, the individual must exchange with others who sufficiently value what he has to offer. Because of this, Smith theorized, the forces that guide the marketplace, though unseen, will ensure that a free market will ultimately serve the public interest.

The extensive study of management became more prevalent after the start of the **Industrial Revolution** in the late nineteenth century, when the presence of more workers working on a single task or for a single company necessitated the development of systems of labor management. The Industrial Revolution was also significant because of the mechanization of human labor, which meant that the worker was no longer viewed as an individual, but as an extension of a machine. The creation of the factory line led to the creation of a labor class and also to the creation of managerial jobs supervising workers on the line.

The prevalent management theory in the early twentieth century was **scientific management**. In the 1880s, Frederick Winslow Taylor, known as the father of scientific management, proposed that human beings could be thought of as extensions of machines and, therefore, could be made more efficient through the use of carefully applied scientific principles of motion and thought. Perhaps the most well-known proponents of scientific management to the general public were Frank and Lillian Gilbreth, whose practice the techniques of testing time and motion studies on their twelve children was described by two of their children, Frank Jr. and Ernestine, in their popular book *Cheaper By the Dozen.*[4]

In 1917 Henri Fayol proposed the theory of **administrative management**. This theory was based on the principle that workers had different skills that could

be matched with the various needs of the organization. Work specializations, designed in a **hierarchical** system, could result in efficiencies in both management and production. In order to make administrative management work, workers needed to acknowledge the authority of supervisors; they were also required to subordinate individual interests to the interests of the business and to work within a system of rules and discipline. In return, they could expect appropriate compensation for the work they did, a chance to move "up the ladder" to a job higher in the company structure, and a workplace atmosphere of fairness and justice.

Administrative management was a groundbreaking theory in 1917, and many aspects of this theory remain today. Some of these are given below.

PRINCIPLES OF FAYOL'S ADMINISTRATIVE MANAGEMENT COMMONLY PRACTICED TODAY

1. *Division of work*: when workers are specialized, efficiency is increased as each specialist grows more skilled.
2. *Authority*: managers have authority to make decisions, but the responsibility to make them with knowledge.
3. *Unity of direction*: each team should be working under the direction of one manager, using the same plan as every other manager.
4. *Subordination of individual interests to the common interest.*
5. *Scalar chain*: each employee should understand his or her role within the hierarchy of the organization.

When you look at the list of Fayol's principles, you can see some of the management characteristics that are a part of modern arts organizations, just as in businesses of other types. Division of labor, for example, is obvious in arts organizations when we look at the work done by artistic and administrative staff. The scene designer in a theater is (usually) not responsible for entering names into the database or printing the financial reports. The marketing director is (usually) not responsible for hanging an exhibit in a gallery. The use of a strict hierarchy, however, is not always a comfortable system for arts organizations. In contrast to a "typical" corporate hierarchy, the division between administrative and artistic decision making is more layered. Arts organizations also have different types of workers than are found in businesses of other types. William Byrnes, in his book *Management and the Arts*, describes a common situation for an arts organization: a volunteer in an arts organization is not required to be there; if she is ordered to work beyond what she believes she agreed to do, she can simply not return.[5] It is clear that the management of arts organizations calls for innovative approaches.

HISTORICAL DEVELOPMENT
OF MANAGEMENT: 1920–2000

By the 1920s, management theory had evolved because of the need to consider the human factor. Adherents of the scientific management and the administrative

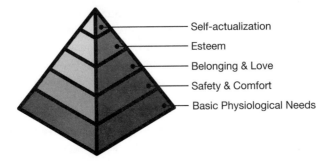

Figure 2.1 Maslow's Hierarchy of Needs

management theories were sometimes confounded by the stubborn inability of workers to react strictly as predicted. Scientific management also uncovered the pesky truth that humans treated like machines were subject to injury and abuse.

The **humanistic perspective** of management emphasized the importance of understanding human behaviors, social interaction, and group processes. In 1924 a groundbreaking study at the Hawthorne Wire Works examined the effect of lighting on productivity. Workers were tested under a variety of lighting conditions and monitored for every possible change. The scientists were astonished to discover that it didn't matter what conditions were in effect, productivity in the test group kept increasing. Their conclusion was that it was the attention paid to the workers, not the specific conditions, that led to the desirable results.[6]

The idea that humans have basic needs that must be met before their jobs can be accomplished was advanced by Abraham Maslow in his 1943 paper, "A Theory of Human Motivation."[7] The author proposed what is now referred to as **Maslow's hierarchy of needs.** In it, Maslow suggested that the most basic human needs, such as shelter and food, must be satisfied before people can concentrate on other, "higher" functions like **self-actualization.**

Maslow's hierarchy is sometimes used as an argument against funding the arts, viewing art as relating more to the higher functions like self-actualization than lower functions like safety and security. We'll discuss this in more detail later.

As the midpoint of the twentieth century arrived, management study began to diverge, presenting a number of theories that attempted to deal with the many work situations facing the American economy. Some of the theories that have application to the arts are as follows:

- **Theory X and Theory Y**
 Douglas MacGregor in 1957 proposed **Theory X**, which assumes that workers generally dislike work and must be coerced into performing well; and **Theory Y**, which assumes that workers are predisposed to be creative and cooperative, and should be encouraged rather than threatened.
- **Total Quality Management (TQM)**
 Toward the end of the twentieth century, management scholars looked to Japanese management systems and experimented with **Total Quality**

Management, a system that embraces both the commitment to continual product/service improvement and the role of the individual "associate" in facilitating that improvement.

- **Systems thinking**

 Systems thinking assumes that the business is a complex organism with many seemingly unrelated parts and activities. Understanding the way the system works is key to understanding how to manage it. In many ways, systems thinking is a reaction to administrative management, which broke each business down into several parts arranged in a hierarchy. Systems thinking recognizes that the organization of a business may not be as simple as a set hierarchy and that influences and inputs can come from many sources.

- **Contingency**

 A **contingency** approach to management is based on the idea that different organizations under different conditions may need to be managed in different ways. One of the important contingencies, as we've noted, is the nature of the industry. General Motors, which sells products made on factory assembly lines, may differ greatly from Google, which is engaged in marketing both an online search engine and the opportunity to advertise to those who search.

 Contingency management also assumes that some industries and types of businesses share common characteristics. This view is useful to us in arts management, as we study how the management of arts and cultural organizations differ from managing retail businesses, or how the **for-profit** arts industry shares characteristics with the **not-for-profit** arts industry.

MANAGEMENT AND THE ARTS ORGANIZATION

Arts managers, board members, staff, and volunteers often instinctively realize that what works in a non-arts business doesn't always work when it comes to the arts. Yet often the differences are chalked up to the inefficiencies or inexperience of the people working within the organization. Many well-meaning supporters of the arts have encouraged arts organizations to adopt a more "businesslike" attitude, tightening up management practices, and producing results that could be quantitatively analyzed. If we understand the rules of contingency management, however, we know that what works in one industry can't necessarily be successfully transferred into another. Here are some of the unique aspects of the arts industry that must be taken into consideration when developing management plans.

- **Arts organizations have both artistic and administrative workers.**
 While other businesses may have different departments working together to support a single goal, the arts business has a unique construction comprising both artistic functions and administrative functions. It is not uncommon in an arts organization to have an artistic director and an administrative director with equal authority in the enterprise. In an arts organization, the artistic

function must work cooperatively with the administrative function. Neither function will be successful without the other.

- **Arts organizations have many types of employees.**

 Unlike a typical corporation or small business, arts organizations typically have a diversity of employees working together toward a common goal. In addition to artistic and administrative employees, paid staff may work side by side with volunteers, permanent employees may team with contracted and seasonal workers, and members of the board of directors that governs the organization at times will be found working as volunteers on individual organizational functions.

- **Arts organizations often have untrained workers.**

 When a person is hired to work in a business environment, his or her employment is usually the result of some kind of qualification or training. In an arts organization, as in other nonprofits, well-meaning volunteers are often assigned to tasks for which they have had no formal training. Members of a board of directors who come from for-profit situations may have had little experience with arts organizations. Paul DiMaggio[8] also describes a generation of arts managers who came to the field via training in a specific artistic discipline, such as music or theater. While acknowledging that their energy and enthusiasm for the field was one of the driving factors in the expansion of the arts in the second half of the twentieth century, many arts managers also are working to train the next generation of arts leaders in the practices that will allow them to avoid having to "learn on the job" as many of their predecessors did.

- **Arts organizations often work in isolation, reinventing the wheel and not taking advantage of best practices.**

 Because in a single community there often is only one symphony orchestra or one arts council, arts organizations tend to have access to fewer support services directly applicable to their needs. Many Chambers of Commerce and other business groups neglect the needs of not-for-profit arts organizations in favor of programs for the more traditional businesses (e.g., retail, leisure, manufacturing). And, while arts councils and service organizations are increasing in number, geographical and time restrictions often limit the ability of arts organizations to take advantage of those resources. This is especially true of smaller organizations.

- **Arts organizations often have an informal operating structure.**

 Many arts organizations operate in a more informal corporate culture than traditional businesses. This is partly because of the variety of types of workers that inhabit an arts organization (including volunteers coming from other jobs or from home); hours that spill over into evenings and weekends, and the diversity of tasks that need to be performed. Some organizations believe that an informal, cooperative atmosphere is more conducive to attracting and retaining volunteers; others believe that a hierarchical structure or a rigid adherence to policy works against the cooperative nature of creating art.

- **Arts organizations often operate in a not-for-profit environment but have similarities with for-profit companies.**

 Management guru Peter Drucker sums up the difference between a for-profit environment and a not-for-profit environment this way: "The product [of the not-for-profit] is neither a pair of shoes nor an effective regulation. Its product is a changed human being."[9] In not-for-profit organizations, the mission of the organization is the bottom line, not profit... but because many arts organizations sell tickets and market to the public (unlike many other not-for-profits, which serve specific populations, like hospitals or human service organizations), and because some arts organizations (like the film and recording industries) are for-profits, this distinction is often difficult for the public to discern.

So what management practices should arts organizations adopt? That is the focus of the rest of this book. Because of the unique atmosphere and needs of the arts, many arts organizations have deliberately scorned traditional management theories in favor of a much looser structure. While this practice may preserve a creative atmosphere, it may be less than ideal from a management perspective. Without structure, consistency is lost and the organization can change drastically from project to project and from administration to administration. Without knowledge of best practices developed by the industry over the years, each organization can waste valuable time figuring out policies and procedures, perhaps burning out employees and volunteers as it searches for the best solution to the organization's needs.

In order to have the best opportunity to accomplish the mission and goals of the business, an arts organization needs a management structure that allows the organization to absorb the knowledge of the industry, communicate among the different functions of the organization, carry institutional memory from season to season, and change with the times.

While arts organizations do not advocate a single system of management, most are beginning to understand the value of working on their internal systems to develop management structures that work for them. The most successful arts organizations adopt policies that allow them to transition seamlessly from season to season and through changes in administration, artistic staff, or boards.

Case 2-2

Case Study: The Learning Organization

In the book *The Fifth Discipline: The Art and Practice of the Learning Organization*,[i] management expert Peter M. Senge presents a management theory that is geared toward the specific needs of contemporary society. Senge says that if the only thing we can count on is change, then the most important function of management is to manage change.

The goal of the Fifth Discipline is to create an organization that is capable of learning and growing, dealing with the changes that are inevitable. What Senge calls the learning organization has some of the following characteristics.

(continued)

Shared vision
- A learning organization has a common sense of purpose and commitment to developing shared images of a desired future. This necessitates communicating this vision to all members of the organization: employees, staff, board, and donors, as well as audiences. In order for a change to be successful, it must be communicated to all.

Systems thinking
- The organization is a complex system with many variables. To be successful, more people shopuld be able to see the business as a whole, not just its parts.

High-leverage interventions
- With any problem, there are many solutions. The best one is the one that will create the most change with the smallest amount of effort.

Testing assumptions
- Before the age of exploration, all scientists KNEW the world was flat. Now is the time to test our assumptions and make sure what we "know" is actually true.

 Unfortunately, many organizations have "learning disabilities," which prevent them from growing and changing. Some of these are as follows:

 I am my position
 - Most people will say what they are, not how they function within the whole. They then feel little responsibility for what happens: when things go wrong, it is someone else's fault.

 The enemy is out there
 - It's always easy to blame an external agent. It's the economy, or that theater built down the road, or the media that never run stories about us.

 Fixation on events
 - We usually are fixated on finding the one event that is the cause of the problem. Unfortunately, most serious problems are caused by gradual accumulation of many problems, which we often don't notice until they get too big to ignore. Instead of focusing on fixing one problem, we should be trying to understand the bigger picture.

 I will work harder
 - The illusion of working harder is simple: if we don't know what caused the problem in the first place, simply working harder at the same thing isn't going to solve the problem.

 Dividing the elephant
 - Here's an old Sufi proverb: Dividing an elephant in half does not create two small elephants. We are so used to administrative management, we are not trained to look at anything other than our part of the elephant.

An arts management situation
Is the theory of the learning organization applicable to arts management situations? Read about the following situation and answer the questions at the end to see for yourself.

For ten years, an arts organization has held a silent auction to raise money. The first eight years, the event raised over $10,000. In the ninth year, it raised $8,000, and the tenth year, $7,000. The auction committee got together to decide what to

do about the decline in funds. The first assumption they made was that the auction was still a good way to raise funds— they just needed to improve the event so that it would once again raise $10,000. They came up with the following possible reasons for the drop in income:

1. The local hospital had just started a silent auction, so now the arts group had competition.
2. Too much money was being spent on advertising, cutting into profits.
3. There weren't enough volunteers soliciting auction donations.

The committee proposed the following solutions:

1. Change the date of the auction so that it won't compete with the hospital auction.
2. Reduce the budget for advertising and ask the marketing committee to come up with a plan to get more free publicity.
3. Increase the number of volunteers.
4. Increase the number of items on the auction table.

This is what happened:

1. The date was changed.
2. More volunteers were recruited and more auction items were secured.
3. The marketing committee was able to get some advertising donated, but not as much as they had hoped. However, the members were told not to spend money so they did not.
4. The attendance stayed about the same.
5. The income stayed about the same, spread out among more auction items.
6. The net proceeds were slightly higher because of the decrease in advertising costs.

Questions

1. What "learning disabilities" did the organization use to try to solve these problems?
2. Using the principles of the learning organization, how might the decisions have been improved?
3. What would you recommend for the future? Why?

[i]Senge, Peter. *The Fifth Discipline: The Art and Practice of the Learning Organization*. New York: Current, 1994.

Case 2-3

Case Study: What Kind of Manager Are You?

What management skills do you possess? Are you the type of person who will shape the vision of an organization or carry it out? When you have the opportunity to supervise others, organize a project, or plan for the future, what work habits, personality traits, and interaction styles do you bring to the situation?

(continued)

Part of developing your skills as an arts manager consists of understanding your personal work style and character so that you will understand what their effects as you interact with others. One of the tools that can be used to determine how your personality type affects your work is a personality inventory. The Myers-Briggs Type Indicator®, developed by Katharine Briggs and her daughter Isabel Briggs Myers during World War II,[i] is one of the earliest and most widely used personality tests. In the Myers-Briggs, a series of questions prompts the respondent to choose which of two situations feels more comfortable (e.g., having a predetermined outcome or leaving things up in the air). The answers determine whether the respondent is extroverted or introverted, sensitive or intuitive, thinking or feeling, and judging or perceiving. Other psychologists and social scientists have developed personality tests that either attempt to simplify Myers-Briggs or use other systems.

Personality tests were developed for use with individuals, but they can also be used in group situations. Often, comparing the results of coworkers' personality tests can lead to new understandings about how the members of the group can work as a team.

[i]www.myersbriggs.com

LEADERSHIP VS. MANAGEMENT

"I used to think that leadership was like conducting a symphony orchestra. But it's more like jazz. There's more improvisation."
—Warren Bennis, "Organizational Consultant and Leadership Expert,"
On Becoming a Leader, 1989

One of the four functions of management is leadership, an activity so important that it is often considered by itself. Like management, leadership has also been described as having four functions: vision, communication, motivation, and innovation.

Vision
A leader must clearly be able to envision the future of the organization. Whether leaders have developed their own vision or are working with another's vision, they must articulate that vision clearly and believe it thoroughly. Contrast this with management, which is primarily focused on carrying out a vision.

John Kotter puts it this way:

Leadership is the development of visions and strategies . . . [while] management involves keeping the current system operating through planning, budgeting, organizing, staffing, controlling and problem solving.[10]

Communication
It's not enough to possess a vision; a leader must be able to communicate that vision to others in a way that will induce people not only to buy into the vision but

to work together to achieve it. This is in contrast to an organizing function of management, where the emphasis lies more heavily on assigning tasks and facilitating plans.

Motivation

Leaders must be able to encourage and motivate all members of the organization to buy into a shared vision and work together to achieve it. Motivation is especially key in times of stress or challenge, and at times of change.

Innovation

As John Kotter says, "The fundamental purpose of management is to keep the current system functioning. The fundamental purpose of leadership is to produce useful change."[11] Innovation, coping with change, and guiding the organization into the future are functions of leadership.

While the arts industry is constantly searching for skilled managers, the industry as a whole is equally concerned with encouraging the development of the next generation of leaders. As diMaggio has observed, many of the current leaders of the arts industry came to power in the arts boom period of the 1970s and 1980s; these men and women will be retiring within the next ten to twenty years. The leaders who take over from them will face a world that is dramatically different; arts participation and delivery have undergone massive changes owing to technological advances, competition, and changing political and economic conditions.

A recent study, *Involving Youth in Nonprofit Arts Organizations: A Call for Action*,[12] describes the need for new leadership this way: "The issue of generational succession in the arts industry looms ever larger as the exodus of baby boomers begins. All of us will need to marshal our best ideas if we are to compete successfully for the next generation of leaders and patrons in an increasingly competitive marketplace." In other words, to provide leadership in this changing world,

Case 2-4

Case Study: Characteristics of Leadership

Who do you consider a leader? What characteristics make people leaders? Listed below are several characteristics often cited as important for leaders. Which ones do you share?.

Sense of mission – leaders are able to formulate a vision and communicate it to others.

Mentorship – leaders mentor and train others, rather than taking credit for themselves.

Courage – leaders are willing to justify their vision even in the face of opposition or even danger.

Competency – leaders are seen as knowledgeable about their field of expertise than one problem at a time. Leaders change course when the situation warrants it.

Integrity – a leader does what is morally and ethically right, and does not abuse a position of power by belitting the opinions or work of others.

arts leaders of the future must be able to embrace change; moreover, they must be comfortable with both traditional and innovative arts participation and be able to maintain artistic standards while experimenting with new forms of programming. It's up to you!

IN CONCLUSION

In any arts organization, the **four functions of management** and the **four functions of leadership** play a part in helping accomplish the mission of the organization. A successful organization will be able to develop a management philosophy that is appropriate to the organization, its personnel, and its mission. A successful arts manager understands his or her personality traits, work habits, and leadership/management skills and sees how they can be useful within the arts organization.

DISCUSSION QUESTIONS

1. Think of a company you feel is innovative. What is the nature of their innovation? Do you think this innovation will allow the organization to survive new competition? Why or why not?
2. What are some ways that arts organizations fail to take advantage of innovative management? Why do you think this might be so?
3. Which aspects of scientific management, humanistic management, or other twentieth-century management theories do you see in arts organizations today? Are these being effectively used, or are they outdated?
4. Have you ever taken a personality test? What did it reveal about your work style? There are several places online where you can take a simplified version of Myers Briggs or another personality test. If you have never taken a test like this, try searching online and see what this process may be able to teach you about the way you work, learn, and interact with others.
5. Think of a person you consider to be a leader. What characteristics led you to think this? What leadership characteristics do you possess?

CHAPTER 3

⌁

Organizational Structure

"If you want to change a culture, you will have to start by changing the organization."

—British scientist Mary Douglas,
Measuring Culture: A Paradigm for the Analysis of Social Organization, 1985

The last time you attended a play, did you think about whether the theater was a commercial business or not-for-profit organization? When you perused an exhibit at an art gallery, was it clear whether the gallery was operated by a single owner or governed by a board of directors? Like most people who attend arts events, your primary concern probably was the art itself, not the organization . . . but the structure of the organization had everything to do with the final product that you saw. What goes on behind the scenes of an arts activity is an essential part of the success of the art, even though it's important to keep remembering that organization isn't an end in itself!

The arts are a unique industry in that they can be organized as for-profits, not-for-profits, or government agencies; as small businesses with single owners or as large corporations. This diversity of structure is less common in other industries. It would be hard, for example, to imagine a car dealership structured in any other way than as a for-profit business. To understand why arts businesses choose various structures, it is necessary to understand the business structures that are present in our current economic system and the characteristics of each one.

After finishing this chapter, you should be able to:

- Distinguish between not-for-profit, for-profit and governmental organizations and identify their unique characteristics
- Describe the Internal Revenue Service criteria for tax exemption and how it applies to arts organizations
- Explain what factors contribute to decisions about organizational structure
- Analyze the pros and cons of various structures for arts organizations and the unique structural challenges facing arts businesses

PHILOSOPHY OF ORGANIZATIONAL STRUCTURE

Imagine that you had the opportunity to start from scratch and form a society. How would you do it? You would have to consider the various needs of the individuals in the society and the society as a whole and devise systems to meet those needs.

For example, you would want to figure out how the citizens of the society could obtain the materials and staples they would need to survive. Thus you might design a system of trade so that the people who grew crops could exchange their produce for other supplies owned or made by someone else.

If your citizens needed to be educated or trained in particular skills, you would have to figure out how they would receive that training. You would need to find ways to provide services required by everyone, including protection, and health care, and to establish and maintain a suitable **infrastructure**. And, you would also need to develop systematic means of providing for those who are unable, for one reason or another, to provide for themselves.

Throughout history, civilizations have developed many different ways to deal with the needs of society. Within the current American economic system, there are three basic legal structures: for-profit businesses, not-for-profit businesses, and governmental agencies. There are some types of businesses that straddle the line between these basic structural types, or do not fall into any of the structures, and there are some emerging structures that cross boundaries. We will discuss some of those a bit later. All business structure types operate differently, and each has advantages and disadvantages for both the businesses and the public. But with them, most of the vital functions of society can be accomplished.

Arts and cultural organizations can be part of any of the three sectors. Each organization will choose the structure that best allows it to accomplish its goals, given the resources to hand or reasonably anticipated. Most of the "high" art forms, such as classical music, fine art, and ballet, have traditionally been organized within the not-for-profit sector. Industries such as the film industry and the music recording industry are usually for-profits because of their ability and desire to mass-market their products to a broad audience. But there are other artistic and cultural activities that more properly fall under the umbrella of government, **collaborative** structures, or alternative structures.

The chart that follows shows how many of the common types of arts organizations are likely to be structured. Note that some types appear in more than one category: you can see theater produced by a not-for-profit company or a for-profit Broadway producer, for example. A performing arts center can be an independent not-for-profit or housed in a building on a state university campus.

Before we discuss more how arts organizations function within the different types of businesses, or sectors, we must take a closer look at the characteristics of each sector.

ARTS ORGANIZATION STRUCTURE CHART

	Not-for-Profit Corporations	For-Profit Businesses	Government Agencies
PRODUCERS	Theater company Symphony orchestra Community chorus Summer theater Dance company	Private galleries Recording studios Individual artists/bands Broadway theater Touring companies Film industry	School music, drama, art programs Jobs programs with art focus
PRESENTERS	Performing arts centers Arts festivals Arts and lecture series	Arenas and stadiums Movie theaters Theme parks Rock/country festivals	Performing arts centers located at state universities or at high schools
CURATORS	Museums Historical sites Public galleries Botanical gardens	Some touring art exhibits Private collections Private galleries	City/county museums College art galleries Zoos Libraries The Smithsonian Institution
SERVICE	Local arts councils State arts service orgs Discipline-specific organizations Some arts-resource websites	Some arts-resource websites Some industry-specific groups Booking agents	NEA State arts boards/ councils City/county arts agencies

FOR-PROFIT BUSINESS (AKA "THE PRIVATE SECTOR")

The basic function of a for-profit business is implied in its name: to create profit. The other name for this sector, the **private sector**, means that all of the businesses in the for-profit sector are owned privately; that is, not by the government.

The primary goal of any for-profit business is to create **profit** for its owner or owners, whether a single person in a small business or shareholders in a large corporation. A system of for-profit businesses assumes that individual members of society will make money by creating and selling products and services that others want, and that the incentive of creating profit for those individuals (rather than for a king, feudal lord, or government) will lead to competition, better products, and more choices. For-profits are the most common form of business; approximately 90% of employed Americans are working in for-profit businesses.[1]

For-profit businesses may be either **unincorporated** or **incorporated**. Within these two basic forms there are several kinds of structures, each with advantages and disadvantages.

Corporations

A **corporation** is a legal entity that is separate from any single owner but has many of the legal rights of an individual. A corporation may be privately or publicly held. A privately or closely held corporation is owned by a small group of individuals, each having control in proportion to the number of shares of stock owned. A publicly traded corporation sells shares of stock in the corporation to the public. Profits are then split proportionally between all shareholders; the payments are called **dividends**. The operations of a corporation are governed by a **board of directors**, but these people are not considered owners of the business unless they also own stock.[2]

The advantage of incorporating a business is that it protects individuals from the **liabilities** (debts and financial responsibilities) of the business. Incorporating also allows the business to continue after the death of the original owner.

Unincorporated Businesses

Most small for-profit businesses are unincorporated. An unincorporated business can operate either as a **sole proprietorship** or a **partnership**. Sole proprietorships are businesses that have a single (sole) owner (proprietor), while partnerships have two or more owners. In a sole proprietorship, the government essentially considers the company and its owner to be one and the same entity. Sole proprietors (everything from private physicians to family farmers to retail store owners) file their business tax statements along with their personal income tax, and they are liable and responsible for every part of the business. Partners are liable for only the percentage of their partnerships.

The advantage of sole proprietorships and partnerships is that the owner(s) have total control over business decisions and can keep all of the profits. There is no limit to the amount of profit that can be made, and those who have the skills and ambition to work independently can do very well. The disadvantage is that if the business does not do well, the owner's personal assets are in jeopardy.

Limited Liability Corporation

The **limited liability corporation (LLC)** is a relatively new form of business structure that combines some of the advantages of a corporation (minimal personal liability) with the advantages of a sole proprietorship or partnership (the ability to make management decisions and keep profits). More and more businesses are choosing this option. As with any business decision, however, it is always wise to seek the counsel of experts before deciding on a business structure.

For-profit businesses have the same advantages for the arts as they do for other types of businesses. Organizing as a for-profit business works well for independent artists as well as businesses that provide the kinds of goods and services that can be mass-marketed. As many artists have found, however, sometimes the act of making art and the act of making a profit can come into conflict. If you've ever read an interview with an actress who made several million dollars on one film but then accepted a much smaller fee for appearing in a movie that more closely reflected her personal beliefs, you know what this means. Inherent in the for-profit concept is the idea that to consistently make a profit, you need to sell the kinds of products that people will buy. For some, this means that making art purely "for art's sake" isn't always an option. On the other hand, there are many musicians, actors, filmmakers, directors, and other kinds of artists who have made a very good living by creating works that conform to their deepest artistic beliefs.

On a small scale, then, any individual artist making a living selling work or performing is operating a sole proprietorship. Individual painters, sculptors, graphic designers, actors, stagehands, and musicians are all considered sole proprietors of arts small businesses.

Other arts small businesses include music stores, booking agents, art galleries (particularly galleries selling the work of one or a small group of artists), architecture firms, graphic design companies, and bookstores.

For-profit arts corporations are generally the kinds of businesses that market their products nationally and internationally. The category includes record production companies, film producers and distributors, theme parks, and some Broadway and touring theatrical companies. Media companies, like the owners of radio and television stations, are sometimes involved in the distribution of products like music, films, touring theatrical productions, and even blockbuster art shows.

Case 3-1

Case Study: Disney

One of the world's largest and most successful arts and entertainment corporations is the Walt Disney Company (www.disney.com). Founded in 1923 as an animation studio for Disney's cartoon characters, the business gradually expanded to include a theme park and some feature-length movies; its shares have been publicly traded since 1957. Today, the Disney empire includes one of the biggest Hollywood studios,

(continued)

eleven theme parks, and dozens of television stations, including ABC, ESPN, the Disney Channel, Lifetime, and A&E. Disney is also involved in live theatrical events, having produced several successful Broadway and touring productions of its most popular movies, including *Beauty and the Beast* and *The Lion King*. The success of the company from the very beginning has been attributed to the founder's aggressive-ness, independence, and innovations. Even critics of Disney's aggressive business practices acknowledge that the company has insisted on high artistic standards throughout its history, bringing many innovations to its ventures, including the first feature-length animated film and the first feature-length film to use digital animation.[i]

One example of a Disney venture that has been commercially successful as well as artistically praised is the theatrical production of *The Lion King*, which opened on Broadway in 1997. To stage this animated story, whose characters were all animals, Disney hired Julie Taymor, a director who had made her name in avant-garde theater. Taymor envisioned the characters as stylized puppets, with the human actors visible under elaborate headdresses or wire cages. Even she was surprised at the amount of artistic freedom she received during the preparation of the show: "The Lion King is a very commercial work, but what they've let me do is very experimental. I was totally delighted and surprised."[ii]

We often think of commercial art as incompatible with artistic freedom. Cer-tainly if an artist or corporation desires to mass-market an artistic product, decisions about content and format need to be made with as much attention to the bottom line as to artistic potential. However, we can all think of many examples, from paint-ings that sell for millions at auction to commercially successful Broadway shows like *The Lion King*, that represent the successful coexistence of art and commerce.

Discussion Questions

1. Can you think of examples of art or artists that have been both commercially successful and artistically innovative? How do you think these artists were able to straddle the line between art and profit?
2. What is your definition of the difference between art and entertainment? If one work of art can, like *The Lion King*, be both, why is it necessary to maintain a not-for-profit sector for the arts?

[i]Watts, Steven. *The Magic Kingdom: Walt Disney and the American Way of Life*. Boston: Houghton Mifflin, 1998.
[ii]Quoted in "The Lion King, A Different Breed of Cats," *Time*, July 28, 1997.

GOVERNMENT (AKA "THE PUBLIC SECTOR")

Even though our modern American system places a great deal of faith in the mar-ketplace to create products and services that provide citizens what they need to survive, there are some functions of society that cannot be performed by individ-ual citizens or businesses. These include making and enforcing rules and laws, providing defense and security for citizens, and operating services needed and used by all citizens equally. Governments are entities that provide these services and fund them through the collection of taxes and fees. Governmental agencies are also referred to as the **public sector**—paid for with public (taxpayer) funds.

The arts have been operating within the public sector for thousands of years. Governments have traditionally understood that the organization of artistic activities,

support of artists, and maintenance of collections of artwork and historical artifacts important to the state is an essential function of government, and citizens have throughout history supported having their tax dollars subsidize such activities.

In many European countries, government operates or provides significant subsidies to state museums, galleries, symphony orchestras, theater companies, opera companies, and radio and television stations. In America, the federal government operates venues including the Smithsonian Institution, historical parks and monuments, and agencies dealing with specific artistic and cultural activities such as the National Trust for Historic Preservation, as well as providing direct support via the National Endowment for the Arts. At a local level, many communities have museums, monuments, and historic landmarks that are operated by city or county governments.

NOT-FOR-PROFIT BUSINESS (AKA "THE PHILANTHROPIC SECTOR")

"Suppose you asked someone, 'What is an elephant?' and the person answered, 'An elephant is a nonhorse.' You would probably find the answer unsatisfactory. The term nonprofit . . . suggests a business enterprise not organized to make a profit. But it tells us very little about the essential characteristics of this type of entity."

—Thomas Wolf, *Managing a Nonprofit Organization in the Twenty-First Century*, 1999

The not-for-profit sector is the collective name used to describe institutions and organizations in American society that are neither government nor for-profit business. Although the term "nonprofit" is commonly used, as the preceding quotation suggests, it can be misleading. We're going to use "not-for-profit" because many believe that the expression more accurately and positively describes this kind of business.

The concept of a not-for-profit the way we understand it today is actually a relatively modern one. When the income tax system was instituted in 1913, the U.S. government also included a program to **exempt** some organizations from paying income tax. The determining factor in receiving a **tax-exempt status** was what the organization did. If it was performing a service that was for the public good, defined primarily as services the government did not or could not perform on behalf of citizens, exemption was granted. From the founding of our country, American preference for individual **entrepreneurship** over governmental control has led to the belief that many aspects of society would function more efficiently if they were organized as private businesses but given incentives by the government to perform services that would benefit society as a whole.

In his book *Managing a Nonprofit Organization in the Twenty-First Century*, Thomas Wolf describes a day in the life of a typical American family. It starts with a parent dropping one kid off at day care and reminding the other children about

field trips to the YMCA, history museum, and symphony; it also includes visiting a relative at a nursing home and receiving a pledge call from the local public radio affiliate.[3] There are over a million not-for-profit organizations in the United States, and we encounter them every day; yet many of us are not aware of how they operate or the importance they play in our lives.

Not-for-profit status is an Internal Revenue Service designation. The specific section of the Internal Revenue Code defining not-for-profits is **501(c)(3)**, which is why you'll hear this designation sometimes used to describe not-for-profits. A 501(c)(3) charitable status carries with it the implication that the organization is in business to further its public service mission, not to create a profit for owners. Therefore, all decisions made in a not-for-profit are made with the mission in mind, not profit.

A common misconception that an organization of this type is not allowed to make a profit. The definition of a not-for-profit has nothing to do with how much money the organization does (or does not) make. The essential difference between a not-for-profit and a for-profit business is that any profits (often called surplus funds in not-for-profits to avoid the impression that profit is a motive or goal) must return to the organization to support the organization's public service mission, as opposed to being paid out to owners or shareholders. Thus it isn't true that a not-for-profit can only break even or lose money.

Figure 3.1 Art Fair
Many people are not aware that some of their favorite community activities are, in fact, not-for-profits. Artstreet, Green Bay WI. Photo courtesy Mosaic Arts, Inc.

Characteristics of Not-for-Profit Businesses

We're going to spend a little more time discussing specifics of not-for-profit businesses; partly because this type of business is often misunderstood, and partly because so many arts organizations are organized as not-for-profits.

Listed next are some common misconceptions about not-for-profits. It's not uncommon to hear these thoughts even from those who volunteer for or work for not-for-profits. It's important, however, that all of those involved with not-for-profit organizations learn about the unique nature of this type of business so that they will be able to make appropriate decisions on behalf of the organization.

- **A not-for-profit is so named because it is not capable of making a profit.**
 This idea assumes that profit is or should be the primary aim of any business. A not-for-profit has just as much chance of turning a profit as any other business. The difference is the purpose of the funds in a for-profit, there is incentive to make decisions that create more profit for the owners, and in a not-for-profit, the incentive is to create resources which will allow the organization to serve the mission.
- **Not-for-profits use volunteers because they can't afford to hire employees.**
 Not exactly. Not-for-profits use **volunteers** so that more resources can be directed toward the charitable mission. Take, for example, a theater whose mission is to keep ticket prices low enough that children can afford to attend. This theater would likely use volunteer ushers so more children could be served. At the same time, using volunteers helps a not-for-profit involve the community in its mission.
- **Not-for-profits are just businesses that are managed poorly or provide products nobody wants. If a business is any good, it will survive in the marketplace.**
 Successful not-for-profit businesses are surviving in the marketplace . . . but it's a marketplace whose sources of income are different from those of a for-profit business. A not-for-profit business has to be just as well managed to attract contributions and grants as it does to attract paying audiences. Poorly managed not-for-profits will struggle just like poorly managed for-profits.

Requirements for Not-for-Profit Status

As noted earlier, part of the definition of a not-for-profit business is its mission: the organization is in business to serve the mission, not to create profit for owners. Another part of the definition is the not-for-profit's status with the federal government. Businesses that wish to be not-for-profits can apply for **charitable** status according to section 501(c)(3) of the Internal Revenue Code. According the IRS, the following criteria must be met in order for a business to be granted charitable status:[4]

- **They must be organized and operated exclusively for one of the purposes set forth in section 501(c)(3).**
 The exempt purposes set forth in the IRS code include charitable, religious, educational, scientific, literary, testing for public safety, amateur sports competition, and the prevention of cruelty to children or animals. The term "charitable" is used in its generally accepted sense and includes "relief of the

poor, erection of public buildings, monuments or works, lessening of neighborhood tensions, elimination of prejudice and discrimination, defense of human and civil rights, and combating community deterioration and juvenile delinquency."

- **The business must not be organized or operated for the benefit of private interests, and none of the earnings of the organization may benefit any private shareholder or individual.**
 This aspect of the code does not mean that a not-for-profit cannot pay employees. **Earnings** in this context means that any funds left over when expenses have been paid, what we generally call "profit." If a charitable organization has money left over at the end of the year, that money stays with the organization to continue to support the organization's charitable purpose. Surplus funds can be invested, used to purchase buildings or capital equipment, or simply carried over into the next year's budget, whichever is most appropriate for the organization. Such funds cannot be paid to members of the board of directors or distributed to members of the organization as dividends. In keeping with the spirit of this rule, most charitable organizations even refrain from paying bonuses to employees.

- **The organization must not attempt to influence legislation as a substantial part of its activities or participate in political campaigns for or against political candidates.**
 This rule is a sticky one. Most arts organizations today acknowledge the need to inform elected officials about the needs of our industry, and to inform our **constituents** about upcoming legislation and elections that may affect the organization. One of the keys to understanding how this rule affects not-for-profits is the phrase "as a substantial part of its activities." We'll discuss the particulars of what does and does not constitute improper political activity later. In general, however, an organization that sticks to general voter education (such as informing constituents about issues without taking a side, or telling constituents to vote without endorsing a candidate) is safe on this part of the code.

- **It must not engage in illegal activities.**
 It may seem obvious that businesses that receive government benefits may not engage in illegal activities. Yet we seem to hear every day of fraudulent and illegal activities on the part of even the largest corporations. The key here is that illegal activities that occur in the context of operating a not-for-profit may cause the organization to lose its charitable status and to incur other penalties if found guilty.

Not-for-Profit Privileges

In return for following the rules just listed, the IRS grants the following privileges to charitable organizations:

- **Not-for-profit organizations are exempt from paying federal income tax.**
 Not-for-profit is a federal statute and applies only to federal income tax. Most states also honor the exemption from income and property tax, but

other taxes may be applicable, including payroll tax, sales tax and worker's compensation.

Even though not-for-profit businesses are exempt from paying income tax, the IRS has reporting requirements for exempt organizations to help ensure that the exempt organization is complying with regulations and properly disclosing financial and donor information. The IRS document called **Form 990** requires basic information from smaller charitable businesses and increasingly complex information for those with larger budgets. In addition, there are a number of mandatory supplemental schedules, including conflict of interest policies and whistleblower policies, which were added to guard against corporate malfeasance. Even though no income taxes are due from not-for-profits, reporting on Form 990 is nothing to mess around with. Organizations should consult with an accountant or tax attorney to make sure they are keeping up with the latest regulations.[5]

- **Not-for-profit organizations may accept contributions and offer a tax deduction in return.**

 Tax-exempt organizations may accept charitable contributions from donors, and those donors may receive a **deduction** from their own income taxes for those contributions. These deductions are subject to some limitations; for example, a donor must exclude the value of any goods or services received from the charity in exchange for the contribution.

 Informally, for-profits can receive contributions. For example, a retail store that is going out of business might choose to donate its supplies and equipment to another business. The difference is that a person donating anything to a for-profit business cannot receive a tax deduction for his or her contribution.

- **Not-for-profit organizations may receive other financial benefits granted by federal, state and local governments and businesses.**

 Not-for-profits are eligible for lower postage rates, and in many states they do not have to pay sales tax either on their own revenue or when they purchase goods and supplies. Many businesses provide discounts or free services to schools and not-for-profit organizations, sometimes as a part of a donation or sponsorship and some as a matter of policy.

The foregoing privileges constitute a substantial financial and organizational benefit to not-for-profit businesses. Not having to pay income taxes allows more resources to be funneled directly to the organization's mission. The ability to accept contributions means that the organization can rely on sources of income in addition to sales of products. Once again (and it can't be said often enough), contributions must be part of the revenue stream of a not-for-profit organization. This is not because the business would otherwise fail; it's because contributions help diversify the income of the business, providing insurance against the possibility that a bad year of ticket sales will endanger the enterprise. Contributions allow those who believe in the mission of the organization to support it beyond personal participation. This source of revenue also helps ensure that the organization serves

others. And, contributions help the people the organization wishes to serve by increasing the affordability of the not-for-profit's products and services (whether they be museum exhibits or theatrical productions).

Distinctive Features of Not-for-Profit Businesses

Because of the way not-for-profits are set up, and the benefits they provide to society, they differ in significant ways from the structure of for-profit businesses.

Here are some of the unique characteristics of not-for-profit businesses:

- **Mission is the bottom line.**
 A for-profit is in business to create profit for owners or shareholders. A not-for-profit's business is to accomplish the charitable purpose for which it has been granted tax-exempt status. Therefore, the decision-making process in a not-for-profit is very different from that in a for-profit: the only financial requirement is that the organization make enough money to continue serving the mission. If a for-profit is deciding what programs to offer or merchandise to sell, management is likely to choose based on what product will be the most appealing to the most people, whereas a not-for-profit would likely choose on the program would best serve the constituents of the organization, even if it probably wouldn't make as much money as another program.

 Because mission is so important to a not-for-profit, a charitable organization will also measure success in ways that go beyond reporting how much money was made or how many customers were brought in. A not-for-profit also has to devise ways to measure the quality of its product, to determine how the mission was served, to ascertain whether the right constituents were reached, and to assess the degree to which changes (improved health or well-being, social or economic status perhaps) were observed in those constituents.

- **All not-for-profits are corporations.**
 There is no such thing as a not-for-profit unincorporated business, similar to a sole proprietorship or partnership in the for-profit sector. This is because the organization provides a charitable service for the common good and therefore must be safeguarded from the self-interest of individual owners. As a legal entity separate from any individual owner, the mission of the organization is protected, and the organization can continue even after the original founders are gone.

- **The not-for-profit is governed by a board of directors and managed by staff.**
 Like any corporation, the structure of a not-for-profit separates the functions of governance and management. This means that a board of directors decides on the mission, policies, and plans of the organization and directs staff (whether they be volunteer or paid) to carry out those plans. In a not-for-profit business, separating these two functions provides a form of checks and balances. We'll discuss governance and management more thoroughly in Chapter 5.

- **The not-for-profit staff may contain both paid and unpaid workers.**
 The presence of volunteers is unique to the not-for-profit sector. Using vol-
 unteers supports the mission of a not-for-profit by allowing the organiza-
 tion to channel more resources into serving the mission rather than paying
 employees. However, the presence of both paid and unpaid workers in an
 organization presents special challenges. Volunteers may work for limited
 terms, come and go unexpectedly, or come to the organization with fewer
 skills than career workers. In addition, personnel can sometimes serve
 more than one function within the organization, as when a board member
 also serves on a committee. We'll discuss volunteers and other personnel
 further in Chapter 6.
- **The not-for-profit may have both earned and contributed income.**
 Because a not-for-profit can accept contributions as a result of its tax-
 exempt status, most not-for-profits operate with a combination of **earned
 income** and **contributed income**. Financial policies and budgets, which are
 constructed to balance financial risk with protecting the mission, must take
 into consideration the amount the organization charges for services and
 goods, balanced against the need to share the mission with the public.

One of the misconceptions about not-for-profits alluded to in this section is
that the organizations must ask for contributions because they have failed some-
how to earn enough money for their survival. This, as we have noted, is not true:
to protect its mission and to make its product accessible to the public, a not-for-
profit must arrive at a dynamic combination of earned and contributed income.
And of course, an organization that has an inferior product or is poorly organized
will find it just as difficult to secure donations as earned income.

ALTERNATIVE STRUCTURES

Although most of the businesses and enterprises in the United States are organized
in one of the three sectors listed earlier in the chapter, many are also experiment-
ing with new kinds of partnerships, collaborations, and structures that allow an
organization to adopt the best features of all three sectors.

Some new business structures are emerging that attempt to bridge the gap
between private enterprise and public good. One such structure is called an L3C,
a type of "low profit" limited liability corporation that allows for-profit organiza-
tions to emphasize mission and even be eligible for certain types of grants but has
more flexibility than a formal not-for-profit corporation. This kind of flexibility
appeals to entrepreneurs who have a narrow charitable focus and want hands-on
control of the business.

The most common form of alternative structure is a **public/private partner-
ship**. In this form of collaboration, an entity such as a museum or performing arts
center that's owned by a city, county, or state government forms an independent
501(c)(3) not-for-profit to facilitate the programming within the building or to
operate as a foundation to raise funds for the programming. This arrangement

allows the not-for-profit to be protected from the expense that comes with owning and maintaining a building; the benefit to the governmental entity is avoidance of the risk and expense associated with putting on programming. Having a separate not-for-profit in place also allows the organization to accept the kinds of contributions that a government entity cannot receive.

Another frequently used method of combining different structures is creating a for-profit business that exists to support a not-for-profit. The federal government has special rules for this kind of activity, and the organization may be liable for income tax on the for-profit portion of the earnings if these earnings meet the test for **Unrelated Business Income Tax (UBIT)**.[6] To qualify as a for-profit business liable for tax, the business must be substantially unrelated to the organization's charitable mission. Thus, a museum gift shop selling art books and items related to exhibits normally is considered to be a part of the museum's mission-related programs. But, if the museum decided to operate a coffee shop within or outside the museum, the proceeds of sales of coffee and bakery items might be taxable.

Many times, however, arts and cultural activities are organized informally by groups of people who don't wish to go through the complications of starting a business. Examples include clubs, such as Painters' Guilds, which exist primarily for the benefit of the close-knit membership; or they can be glorified committees that come into existence to organize a single event and have no need for ongoing structure. An informal structure is not possible for organizations that want to hire employees or to offer their donors a tax deduction for contributions. However, some informal groups choose to stay unstructured and partner with a not-for-profit so that they can receive donations.

Case 3-2

Case Study: John F. Kennedy Center for the Performing Arts

In 1958 President Dwight D. Eisenhower signed bipartisan legislation creating a national cultural center. The National Cultural Center Act included four basic components: it authorized the center's construction, spelled out an artistic mandate to present a wide variety of both classical and contemporary performances, specified an educational mission for the center, and stated that the center was to be an independent facility, self-sustaining and privately funded. As a result of the last stipulation, a mammoth fundraising campaign began as soon as the act became law.

It wasn't until 1971 that Eisenhower's dreams for a cultural facility became reality. The John F. Kennedy Center for the Performing Arts, commonly known as the Kennedy Center, opened in September 1971; it is located in Washington, D.C., on the banks of the Potomac, near the Lincoln Memorial.

From its very beginnings, the Kennedy Center has represented a unique public/private partnership. As the nation's living memorial to President Kennedy, the center receives federal funding each year to pay for maintenance and operation of the building, a federal facility. However, the artistic programs and education initiatives are paid for almost entirely through ticket sales and gifts from individuals, corporations, and private foundations, and the building itself was built with $23 million in federal funds and an additional $68 million in private contributions.

(continued)

Today, the Kennedy Center (www.kennedycenter.org) is a leader in the presentation of the performing arts, not only hosting a wide variety of programs by some of the greatest performing artists from around the world, but also commissioning new works, offering hundreds of free performances every year, and maintaining an extensive arts education program including activities for students of all ages, teachers and other adults, and families. The Kennedy Center's Arts Management program provides resources for emerging and professional arts managers, including a website (www.artsmanager.org), fellowships, internships, and helpful information for the field.

Figure 3.2 The John F. Kennedy Center for the Performing Arts, Washington, D.C.

CHOOSING A STRUCTURE

If an arts organization can be structured as a for-profit, not-for-profit, or governmental entity (or even organized informally with no specific business structure, such as a club or artists' guild), what factors go into making that choice? Let's look at an example that outlines some of the relevant factors.

Case 3-3

Case Study: Choosing a Structure

Two actors become friends in college and develop original theatrical material that they wish to continue performing after graduation. They are young, enthusiastic, and talented, but certainly not wealthy.

(continued)

If they decided to form a for-profit partnership . . .

- They would be able to make as much money as their skills and marketing allowed.
- They would be entirely responsible for the operation of company: artistic product, administration, and overall decision making.
- They could not seek grants or donations, but they could receive corporate sponsorships in exchange for advertising.

If they were to consider not-for-profit status . . .

- They would need to formulate a public service mission that fit within the IRS guidelines for a 501(c)(3) organization.
- They could solicit contributions and grants, which would take pressure off ticket sales.
- They could use volunteers to help with their operations.
- They would have a board of directors governing the organization.
- They would also lose some control over the artistic product because they would, by definition, be employees of the corporation, not its owners.

They could seek a partner, like a library, school, or another theater company, in which case . . .

- They would have the advantage of the security provided by the established organization.
- They might have the benefits associated with employee status of their partner.
- They would need to conform to the mission of the partner.
- They might find themselves lower on the priority list than other, more established programs within the organization.
- If funds to the host institution are cut, their new theater company might be in jeopardy.

They could always operate without formally starting a business, but . . .

- They could not pay themselves or any employees.
- They would have to use their own bank accounts for operations.
- They could not seek donations, and options for sponsorship would be limited.
- The more visible they became, the more likely the IRS would be to force them to choose a structure.

If you were one of these two actors, which structure would you choose, and why?

FORMING AN ARTS NOT-FOR-PROFIT

The arts not-for-profit, like any not-for-profit organization, must go through a number of steps to achieve not-for-profit status. Applying to the Internal Revenue Service for not-for-profit status is not complicated, but because it is a legal process, most arts organizations retain legal counsel to help them. During the application process, the organization must develop and adopt organizational documents that outline the organization's reason for existence and thus become its legal governing documents.

There is a great deal of help for those who wish to start new not-for-profit corporations. See Appendix 3 for a list of resources for not-for-profit start-ups.

Resources for Forming Not-for-Profit Corporations

In addition, those wishing to form not-for-profit corporations should check on laws that govern their state. In most communities, the Chamber of Commerce or SCORE (Service Corps of Retired Executives) can help with the necessary steps and recommend legal and financial professional who can also provide assistance.

In the formation of a not-for-profit, however, it is essential to seek assistance from those who are familiar with not-for-profit rules and regulations. It is unwise, for example, to work with an accountant who has no experience with contributed income. Even professionals are many times unaware that the legal needs of not-for-profits are quite different from those that apply to for-profit businesses. Every legal document, from a budget to a business plan, must reflect consideration of these unique needs.

First Steps

A group of people that wishes to start a new not-for-profit organization should first draft a **mission statement** for the organization to make sure that everyone is clear from the beginning what the business is all about. Next, a board of directors should be assembled, consisting of people who agree with the organizational mission and are willing to work to set the project in motion.

Before formally starting a new not-for-profit business, especially if that business will require a great deal of start-up capital or the construction or purchase of a building, most organizations undertake a **feasibility study**. This work can be done informally, or it can be an extended process involving a consultant, community studies, interviews with potential funders, and even environmental studies (if property is involved). Although some are tempted to skip the feasibility study on the premise that they are going to start the business no matter what, it is valuable to go through the process in order to gauge potential reaction to the organization and to gain support. Most who have completed feasibility studies have also learned a great deal about potential community reaction, and some have even uncovered previously unknown funders.

The next step is to incorporate the business. This is done by drafting and approving **articles of incorporation**, the official document which outlines the primary rules governing the management of the corporation. Once developed, the articles of incorporation are filed with a state or other regulatory agency when the business is incorporated. The document spells out the purpose of the organization and gives the name(s) of the organizer(s), the names of the corporation's initial board of directors, the location of the organization, and the general rules which govern the corporation.

The Three Bs

Other documents are also necessary at the founding stage to provide a road map for the organization in its early years. These are the "three B's" of the organization: budget, business plan and by laws.

An organization's **bylaws** define the governance policies for an organization in more detail than the articles of incorporation. Bylaws include such definitions as the required number of board members, how they are elected, officers of the corporation, terms of office, rights and responsibilities of members, and how meetings are run. Bylaws are also filed with the state but, unlike articles of incorporation, they can be amended or changed by an organization's board of directors to reflect changes in the organization. Bylaws are most useful when they are regularly reviewed and changed to reflect current conditions.

A **business plan** is a management document that outlines the basics of the organization's programmatic, financial, and marketing plans. Business plans are often used in the for-profit world to seek loans or venture capital to start or expand a business. In the not-for-profit world, a business plan provides guidance to the board of directors and also forms the basis of a case for support by potential contributors.

A **budget** is a document that projects income and expenses over a certain financial period. As a part of a business plan, some organizations project finances out five years, as much to check feasibility as to set goals. Once the business is up and running, a budget will be constructed annually.

Application for Not-for-Profit Tax Exemption

Once the organization has assembled a board of directors, created and approved organizational documents, and incorporated, it is time to apply for tax-exempt status.

As noted earlier, it is advisable to consult with a knowledgeable lawyer during the application process. Many lawyers offer pro bono services to charitable organizations. Volunteer Lawyers for the Arts (http://www.vlany.org/) is one organization that works to match lawyers with arts organizations.

The application and instructions for applying for tax-exempt status can be found on the Internal Revenue Service website (www.irs.gov). The organization is asked to supply as attachments such materials as its bylaws, a history of the entity, and a description of its mission and programs. With the application, a new organization will be asked to answer a number of questions that help the IRS determine whether the criteria for tax exemption are satisfied.

When the Internal Revenue Service grants tax-exempt status to a not-for-profit corporation, it sends an official letter known as the **Letter of Determination** (as in "determination of exempt status"). An organization's Letter of Determination, which constitutes legal proof of exempt status, is often included with grant applications or presented to banks, retail institutions, or other entities to receive not-for-profit rates or exemption from sales taxes.

IN CONCLUSION

Although arts organizations can structure themselves in a variety of ways, many choose the not-for-profit structure because of the tax advantages and ability to receive contributions from supporters. In choosing a structure, an

arts organization must understand the legal, financial, and policy ramifications of the form selected.

DISCUSSION QUESTIONS

1. Think of examples of arts and cultural organizations in your own community or that you have experienced. What are the differences between them? Why do you think these organizations chose the types of structures they did?
2. Arts and culture are one of the few activities that are commonly organized as businesses under a variety of legal structures. Can you think of others?
3. A misconception about not-for-profits that is specifically related to arts organizations is that symphonies, museums, community theaters and the like are organized as not-for-profits because they produce the kinds of art that fewer people want to see—and therefore, by implication, would not survive as for-profits because of the lack of sales potential. Given our discussion to this point about the purpose of a not-for-profit, how would you answer someone who expressed this belief?
4. Although the U.S. government gives less direct funding to arts organizations than is true of other countries, supporters of this system say that the indirect subsidies of exemption from taxes more than make up the difference. What do you think?
5. The arts are not specifically listed as one of the types of organizations eligible for charitable status. Given the definition of the term "charitable" in the IRS description, why do you think that arts organizations qualify? What kinds of arts organizations might be denied tax-exempt status based on the IRS definition?

CHAPTER 4

✦

Planning for Organizational Success

"Successful organizations, whether community arts
organizations or multinational corporations, typically possess
one thing in common—a compelling, articulate vision."
—CRAIG DREESZEN, *FUNDAMENTALS OF
ARTS MANAGEMENT*, 2003

"Successful organizations, whether community arts
organizations or multinational corporations, typically possess
two things in common—a compelling, articulate vision and a
plan for how to get there."
—ANONYMOUS ARTS MANAGER

Not so long ago, an arts organization called in a consultant to help figure out
how to solve the organization's financial problems. In trying to uncover the
source of the problems, the consultant asked several board and staff members, volun-
teers, and members of the community about the organization's vision for the future.
Not surprisingly, each person the consultant spoke with had a different idea of the
organization's vision. Again, not surprisingly, members of the community, including
funders and potential audience members, were unsure of what the organization was
trying to accomplish and thus had little motivation to participate.

The problem with this organization wasn't failure to write enough grant pro-
posals or to hire enough ticket office workers. The problem was that no one had
formed that compelling, articulate vision, nor had anyone taken the time to create
a plan that would allow that vision to be communicated through the organization's
artistic programs, marketing materials, and fundraising activities.

Most people who work in the arts want to share arts and culture with the
world. In this respect, arts managers are no different from the artists themselves.
Many arts organizations are guided by the artistic vision of an artistic director;
others operate on a vision shaped by community voices or tradition. But all orga-
nizations share the need to work together to create a unified conception of the
direction they wish to take into the future.

When you finish this chapter, you should be able to:

- Describe what mission and vision statements are and how they fit into an arts organization's overall planning
- Analyze and construct mission, vision, and values statements
- Explain the philosophy of strategic planning and how it fits into an arts organization's activities
- Evaluate an organization prior to planning with a situation analysis
- Use standard planning practices to create a strategic plan for an arts organization

WHY PLAN?

Planning is one of the four functions of management, introduced in chapter 2. In many respects, planning is one of the most exhilarating tasks an arts organization undertakes. Planning allows an organization's members to remember why they're in business and to translate their dreams into action.

The need to formulate a shared vision and plan for the future, however, is more than a nice goal for a not-for-profit arts organization. A not-for-profit organization is granted tax-exempt status with the understanding that it will perform service in the public good. The charitable **mission** of the organization, therefore, becomes the reason for the existence of a not-for-profit; it is the not-for-profit's "bottom line."

Organizations rely on the planning process for multiple reasons.

- Planning helps the organization establish realistic goals and expectations, using the (often limited) financial and human resources of the organization most efficiently.
- Planning decreases duplication of effort and helps prioritize activities.
- Planning often may result in increased funding or larger audiences, as a message is developed that can be more clearly communicated to funders and to the community at large.
- Planning helps all members of the organization align around a shared vision and common goals.

Because the work of an arts organization is carried out with the input of the board of directors, staff, and volunteers, it's easy to have different factions of the organization working without knowledge of what another group is doing. If everyone from the ushers to the finance committee knows what the organization ultimately wishes to accomplish, all decisions the organization makes and all actions each individual takes will serve the organization and will not detract from its success.

Imagine an organization whose members make up everything as they go along, becoming mired in politics and territoriality, or changing course every time a new board or staff member joins the organization. Now imagine the potential for success for an organization that has access to the creative input of all of its members

toward goals that are understood by all, clearly communicated to the community, and enthusiastically embraced by board, staff, and volunteers.

WHY NOT PLAN?

Planning makes sense for arts organizations; it may even be an essential part of a not-for-profit's ability to retain tax-exempt status. But many organizations resist the planning process.

Some arts organizations claim that there is little time left to plan after so much energy has been used in the execution of the programs already agreed on. "And when do you plan," they ask, "while programs are constantly going on?"

The answer to the question about finding time to plan has been noted implicitly: an organization that is adept at planning will use its resources wisely and won't waste time working inefficiently by doing over tasks that were poorly done, reinventing the wheel at every turn, or burning out volunteers. An organization that takes the time to plan will learn that there is more time to plan!

Most organizations also discover that planning is both an annual and an ongoing process. Incorporating regular planning activities into the organization's budgetary cycle, for example, allows the organization to prepare for the upcoming year, while regular monitoring of programs will allow evaluation and adaptation at every stage of the process.

Some organizations resist planning because of the belief that it's focused on administrative, not artistic, needs. Strategic planning in the for-profit sector often is geared toward the creation of more profits. It is easy, argue some, to come up with plans to increase the number of computers or to have a volunteer orientation, but not so easy to plan for artistic quality. Organizations that plan, however, discover that taking care of the computers and the volunteers does serve the art by reducing the time that must be spent on these matters.

Another common reason organizations give for not planning is that since conditions change so quickly, spending a lot of institutional time creating a plan that may soon be obsolete seems wasteful. Not too long ago, it was customary for planning experts to recommend a ten-year planning cycle: an organization would prepare a ten-year plan, spend the next ten years carrying it out, and begin the planning process again in the ninth year for the subsequent decade. Then, the recommended cycle became seven years, then five. Now, a "long-range" plan usually consists of a three- to five-year cycle, with annual updates to accommodate changing conditions.

No one knows what will happen next year, next month, or next week, but that doesn't mean we can't plan. If an organization thinks of a plan as a step-by-step instruction manual that must be followed to assure predictable results, the plan that emerges probably will gather dust in a file drawer. But if the people think of the planning process as a set of guidelines that provide a compass for decision making, planning will evolve into a valuable tool for achieving organizational success.

It is helpful to think of planning as a dynamic process that allows the organization to look ahead, imagine the future, and yet mount a flexible response if

changes occur. For successful organizations, planning is both **linear** (looking into the future) and **concurrent** (adjusting as events unfold). Some organizations, mindful of the uncertainty of the future, plan for a number of different scenarios, each of which can be followed depending on a variety of factors. If we reach our fundraising goal, for example, we will operate one way; if we fall short of our goal, we will do things another way. **Scenario planning** allows an organization to be prepared for a variety of eventualities.

TYPES OF PLANS

One of the factors that makes planning seem difficult is that there are many types of plans. What are these kinds of plans, and which ones are necessary for arts organizations?

Long-Range Plan

A **long-range plan** is simply a projection into the future of the organization's goals. As noted earlier, the time period of a long-range plan these days is usually three to five years, although in some situations it may be useful for an organization to plan further into the future. For example, an organization may decide that a planning horizon of more than five years will be necessary if it is to position itself for a major fundraising drive or for building a new facility.

Strategic Plan

A **strategic plan** is a long-range plan with the addition of strategies for achieving the desired goals. Most comprehensive plans are strategic plans; it is difficult for an organization to list goals without attempting to figure out how they will be achieved. In fact, many organizations use the term "long-range plan" when they actually mean "strategic plan."

Once an organization has constructed a long-range or strategic plan, several other kinds of plans flow from the primary plan:

- **Program or project plan**
 A **program plan** deals with a single aspect of the organization's operations, such as an education program or a special event. An organization usually has several program plans in place at once. A program plan can be as simple as an outline of the goals and strategies of the program, or it may include budgets, manuals, and evaluation procedures. Another example of a program plan is a marketing plan or fundraising plan.
- **Budget**
 The **budget**, which is the financial plan for the organization, is usually prepared annually for the organization as a whole and for individual programs. A budget should reflect the priorities of the organization's strategic plan.
- **Annual work plan (Operating plan)**
 When a strategic plan is updated annually, it forms the basis for the organization's **annual work plan**. Work plans, which may include lists of tasks,

deadlines, and performance goals, can also be prepared for individual staff members. Once again, however, it is important to note that work plans flow from the organization's broader goals as expressed in the strategic plan.

MISSION, VISION, AND VALUES

The first step in planning is the creation of the organization's mission statement, which forms the basis for the rest of the process.

The Mission Statement: A Statement of Purpose

A **mission statement** is generally regarded as the guiding statement of purpose of the organization, that which defines its charitable mission. Ideally, a mission statement is concise and easy to remember, a clear articulation of the organization's purpose.

A mission statement is developed when the organization is founded and should be examined frequently to make sure it continues to be current and relevant. A mission statement is used as a guiding purpose when planning, developing programs, and budgeting and often appears on marketing materials, an organization's website, and in grant applications. Funders often ask to see the organization's mission statement in order to help evaluate whether a program they are being asked to support is consistent with the organization's purpose. The Internal Revenue Service examines an organization's mission statement to determine whether the funds the organization collects are being used properly.

Successful arts organizations think of a mission statement as a living statement that can unite all of the members of the organization under a common purpose. Many say that everyone in the organization, from board members to volunteers, should be able to recite the mission statement. A well-written mission statement that is a central part of all organizational communications helps the organization make decisions and rally people around the cause.

Although there are no hard and fast rules for writing mission statements, successful ones share many characteristics. They accurately reflect the current priorities and activities of the organization, and they are specific enough to allow the development of clear guidelines for planning purposes. Successful missions statements are free of "insider jargon," which might not be understood by funders or the community at large, and they should be brief enough to be remembered and communicated easily. They should contain compelling images, which engage the imagination and enthusiasm of many.

A good mission statement answers two questions: "What do we do?" and "For whom do we do it?" For example:

> The mission of the Child's Play Theater Company is to provide opportunities for children and youth from the Curd County area to participate in the development and production of original plays.

Notice that the mission statement also provides for limitations on the activities of the Child's Play Theater Company. For the organization to accept participation

by children in other communities, or to mount a production of a play that was not developed by constituents of Child's Play, the board would have to discuss the proposed program to ensure that it was appropriate.

In the construction of a mission statement, each organization must incorporate consideration of the following factors.

- **Artistic quality**
 While no arts organization would deliberately plan to produce work of low artistic quality, the definition of "quality" varies from organization to organization and has implications for everyone involved. A symphony that aspires to be a "world-class" orchestra, for example, is committing to hiring internationally known musicians and conductors (not simply community members who are the best players), programming music that is on par with the best orchestras in the world, and producing printed and online materials that are equal to those of the orchestras they wish to emulate. A community theater, by contrast, may choose to emphasize involving a wide variety of community members, regardless of previous training.
- **Product(s) and service(s)**
 What products and services will the organization offer? This is a deceptively difficult question. While the primary "product" for a museum may be art exhibits, most organizations will be engaged in a variety of activities including recordings, educational activities, and special events. A good mission statement will make reference to the products and services that are essential to the organization. Failure to limit products in the mission statement makes it difficult to narrow down the range of choices later.
- **Scope**
 Is the organization in business to serve the immediate community, or will it have a wider geographic scope? Is the purpose of the organization to provide programs for community residents or to serve the broader industry? What audiences are expected and desired? While it might be tempting to dream of an organization serving the broadest possible audience, in practicality more closely defining the scope of the organization is helpful in the making of funding and resource allocation decisions.

Michael Kaiser, executive director of the Kennedy Center for the Performing Arts, states that despite differences in substance or style, all mission statements should be clear, concise, complete, and coherent.[1] A mission statement that accomplishes those objectives will provide a strong road map both for participants in the organization and for potential funders and supporters.

The Vision Statement: Dreams for the Future

A mission statement speaks of what the organization does right now. Another useful statement for an arts organization is a **vision statement**, which expresses the organization's aspirations and hopes. A vision statement is often described as a statement that outlines a picture of the organization's desired future. If a mission

statement answers the questions of what we do and for whom, the vision statement answers the question "How will the world be different because we exist?"

A vision statement is often paired with a mission statement for planning purposes, but this brief summary is not required for funding or organizational purposes. Here is an example:

> Child's Play Theater Company seeks to improve the lives of children and youth by giving them the tools for creative self-expression, discipline, and teamwork, as well as the positive rewards of achieving a goal. We envision a world in which our graduates, who have become strong, creative, and healthy adults, take their place as leaders of their communities.

Vision statements can be very creative. Sometimes, vision statements are written by using exercises of imagination, such as having board members draw pictures of what the organization will look like in five years, or putting together a poem. The dynamic process of constructing a vision statement can be useful to organizational planning and can generate excitement about the future.

Case 4-1

Case Study: Mission and Vision Statements

Here are some mission and vision statements from actual organizations—only the names have been changed. Analyze them according to the principles just discussed. Are they mission or vision statements? Which are effective and which less so?

- **Cream City Children's Choir**
 The Cream City Children's Choir is a multiracial, multicultural choral music education organization, shaping the future by making a difference in the lives of children and youth through musical excellence.

- **Buckminster Center for the Arts**
 Buckminster Center for the Arts strives to be the best comprehensive community resource for education and performance experiences in the musical arts for people of all ages, abilities, and economic circumstances. We fulfill our mission through a variety of fantastic music lessons, performance experiences, master classes, and many other opportunities for the entire family.

- **Curd County Public Museum**
 The CCPM is a general museum of art, history, and science. It is dedicated to the collection and preservation of significant objects relevant to Curd County, and, secondarily, the entire state. It is the Museum's mission to interpret its collections and provide educational insight through exhibits, informational programming, and publications.

- **Greentown Community Symphony Orchestra**
 - **GCSO Mission:**
 The mission of the GCSO is to promote orchestras and performances of the highest quality for the enjoyment of ever-widening audiences and pursue educational experiences for youth and adults through musical collaborations.
 - **GCSO Vision:**
 Exceptional music experiences for the people of Greentown.

Taglines and Slogans

To communicate both its mission and its vision to the community, an organization often adopts a **tagline** or slogan that can be used on marketing materials. A tagline, paired with the organization's name in a logo or written materials, can be a strong way to convey concisely the essence of mission and vision:

> Child's Play Theater Company:
> Shining a Spotlight on the Leaders of Tomorrow

Values Statements

Many organizations also find it useful to develop **values statements**. A statement of values helps an organization understand the principles by which it operates, the priorities it recognizes, and its expectations for members' behavior. A values statement, when communicated to a volunteer, might help him or her understand that it is more important to allow all children to participate than to encourage some to become stars or for adults to do the work for the young performers and crew:

> The Child's Play Theater Company believes in the inherent creativity of every child. We are focused on the development of this creativity. We support the rights of all children to express themselves freely and to participate in our activities in a safe, nonjudgmental atmosphere.

ASSESSING THE ORGANIZATION: THE SITUATIONAL ANALYSIS

An important part of the planning process is assessing the organization's current situation. To be realistic and achievable, a plan for the future must be based on an accurate appraisal of the current realities of the organization. Prior to creating a plan, successful organizations undergo a process called **situational (or environmental) analysis**. A situational analysis is a structured way to examine internal strengths and weaknesses and external conditions that will affect the organization's ability to carry out a plan.

For example, let's say an arts organization wishes to expand the season from three events to four. If people begin to plan without taking a look at external factors, they might miss the fact that a new competing organization is proposing similar activities for the upcoming year. If they plan without considering internal factors, they might concentrate on their artistic goals even though they don't have enough volunteers to ensure successful staffing of the additional event.

Internal assessment is an analysis of the organization's strengths and weaknesses. Internal assessment includes a variety of factors that the organization itself can control, such as available financial and human resources; skills and talents available through staff, board, and volunteers; and past successful programs. Accurate records can be very useful in helping an organization assess its current situation and set goals and objectives for the future. Financial statements, attendance reports, evaluations of previous programs, and audience surveys are some of the

kinds of internal information that should be gathered and studied prior to planning. The most complete picture of an organization's situation will contain hard facts, as well as opinions from a variety of people.

External assessment examines conditions and events that may affect an organization's future as much as its own internal situation. The ability of the arts organization to carry out its plans can be affected by the economy, the actions of other local arts and entertainment organizations, political situations, and even issues that affect the entire community, such as an employer moving out of town or the revitalization of a downtown area. Studying external conditions, either informally or systematically through focus groups and interviews, should be an integral part of the planning process.

There are many different models for conducting a situational analysis. A quick Internet search will lead you to a number of websites with different processes and activities. It is important for each organization to analyze its situation objectively and with as much input from board, staff, volunteers, audiences, and donors as possible. Market research can also be an important part of the situational analysis process to ensure that the organization is not making decisions without accurate knowledge.

Assessment Using the SWOT Process

One method of collecting useful information on both internal and external situations is to conduct a **SWOT analysis**. SWOT, an acronym for "strengths, weaknesses, opportunities, and threats," is a framework for brainstorming with regard to factors that may affect the organization. Although the SWOT process does not replace research in assessing a situation, it does provide an opportunity to get input from many sources without fear that ideas will be disparaged or ignored.

The first step in a SWOT, whether it is being done with a small or large group, is to brainstorm as many items as the group can think of in the following categories:

SWOT ANALYSIS CHART

Internal factors	External factors
Strengths What do we do well? What internal factors are operating in our favor?	Opportunities What external opportunities exist that can help us meet our goals?
Weaknesses Where do we fall short of meeting our patrons' needs? Where do we need help?	Threats What external situations have potential to harm us?

- **Strengths**

 Consider internal factors like programs, facilities, resources, staff, and volunteers——not external factors like "a good economy" or "being in a city that supports the arts." Strengths might include "free parking" or "more than two hundred volunteers."

- **Weaknesses**

 Like Strengths, this category refers to internal factors, not external conditions. Examples could include a diminishing subscriber base or too few volunteers.

- **Opportunities**

 What current community or global factors might provide opportunities for us? In this category, consider external factors as described earlier under "external assessment." Examples could include a new insurance company slated to come to town or downtown redevelopment.

- **Threats (sometimes called Challenges)**

 What current community or global factors pose threats to us? Examples could include such conditions as a symphony orchestra's plans to raise prices or a bad farming year that threatens the local economy.

EXAMPLE OF SWOT PROCESS

Internal factors	External factors
Strengths	Opportunities
No mortgage on the building	New tourism campaign in our city
Strong executive director	Insurance company relocating across
High renewal rate on memberships	the street
State arts council grant	New community foundation grant program
Weaknesses	Threats
Outdated marketing materials	Cuts to city arts budget
Lack of innovation in programming	Senior worker program ending
No staff comfortable with using social media	First Bank now supporting youth programs only

During a SWOT brainstorming session, each participant can list as many factors as he or she can think of, regardless of whether another person disagrees. Discussion of the various factors is not allowed; the preference should be for listing as many factors as possible. One way to conduct a SWOT is to have all participants just shout out suggestions to the whole group. Other ways include breaking the group into smaller units and having each one complete its own SWOT; or each individual could write down his or her suggestions and present them to the group.

After the brainstorming, the participants narrow the list to prioritize the issues most crucial to the organization. This can be done following discussion or by voting. One approach is to give each member of the group the opportunity to select the four or five issues he or she considers to be most important to the organization, whether those be strengths, weaknesses, opportunities, or threats. Individuals can vote with stickers or with handwritten symbols such as stars or dots. The results of the voting make it easier to spot trends by noticing similar items that are considered to be important. For example, if topics like "lack of fundraising staff" and "not enough donated income" receive several votes, it is fair to assume that fundraising will be or should be a key issue for the organization.

When key issues are identified for the organization, these can form the basis for construction of the rest of the plan. If the organization identifies fundraising as a key issue, for example, a reasonable next step would be to consider setting a long-term goal to improve fundraising capability or to increase donated income.

CREATING THE PLAN: GOALS, OBJECTIVES, AND STRATEGIES

Once an organization has defined or refined its mission, vision, and values, and conducted a situational analysis, it is time to create the plan itself. We have previously defined a long-range plan as a plan that outlines goals and a strategic plan as one that includes the strategies for achieving the goals.

Planning terminology is often confusing, and the terminology charted at the end of this section is used by many people in different ways. To ensure successful planning, it is important that all members of the organization be on the same page when they use planning terms like "goal" and "objective."

A strategic plan moves from the broad to the specific. Once the key issues facing the organization have been identified by means of situational analysis, the organization creates broad goals that members wish to accomplish by means of the strategic plan. Within broader goals, interim objectives are developed, and strategies help accomplish the objectives. Successful plans then assign timetables and personnel to each strategy and monitor completion according to the timeline.

The chart below depicts the relationship of objectives and strategies to a single goal. In the next subsection, we will define these terms more thoroughly.

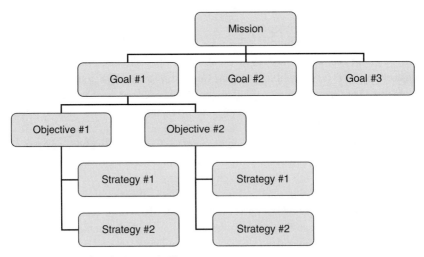

Figure 4.1 Hierarchy of a Strategic Plan

Goals

Goals are desired results or conditions that will be accomplished by the conclusion of the plan. In a not-for-profit arts organization, they are consistent with the mission of the organization. Goals are often confused with strategies; it is useful to think of a goal in terms of an actuality, not an action.

Using this definition, a goal might be: Create an education program by next June. The phrase "Do market research to determine the whether an education program is feasible by next June" would more accurately be described as a strategy for reaching the goal.

Objectives

An **objective** is a specific short-term result consistent with a goal. Think of objectives as "mini-goals," interim steps that must be achieved in order to realize a goal.

Objectives are most successful when they are specific, measurable, and realistic. For example, "Institute two Saturday morning workshops by 2015" would be a better objective consistent with the stated goal than "Start Saturday classes."

Strategies

Strategies are methods by which objectives and goals are achieved. In the hierarchy of planning, goals are broken down into objectives, and strategies are created for each objective. An example of a strategy consistent with the goal and objective above might be, "Hire an instructor to teach the Saturday morning classes."

Action Steps (tasks)

Action steps, sometimes called tasks, are specific jobs necessary to complete strategies. At the action-step level, duties are assigned to specific people: "The marketing director will prepare a brochure listing the new classes, to be ready for mailing by the end of March."

Timeline

To coordinate all aspects of the plan and chart progress, the organization must have a timeline. This document lists key tasks, or action steps, designates the person to whom they've been assigned, and gives the deadline for completion. Sometimes, a timeline will also include benchmarks, or interim deadlines and monitoring points.

Here is one way an organization could chart goals, objectives, strategies, and timelines. This chart also includes assignments for who will be assigned the task and allows the organization to update the plan when tasks are completed. Without assignments and timelines, the plan may end up sitting in a drawer or gathering dust on the shelf. It is important for an organization to think of a plan as a blueprint for action by all involved with the organization. See Appendix 13 for a sample strategic plan table template.

We could also insert goals, objectives, and strategies into the chart below.

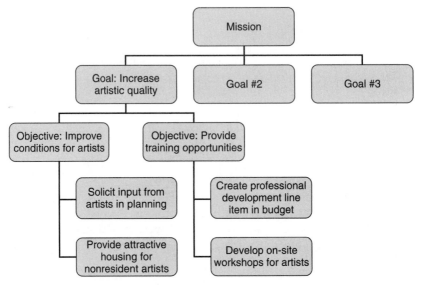

Figure 4.2 Goals, Objectives, and Strategy Hierarchy

The case study that follows provides an opportunity to practice the construction of organizational charts.

Case 4-2

Case Study: Goals, Objectives, and Strategies

Now that you've seen some examples of goals, objectives, and strategies, can you identify them? Here are a few examples for practice. In each one, the three items listed are related—one is the goal, one is the objective, and one is the strategy. Here's a hint: to identify the goal, look for the broadest statement, then get more specific as you move to objectives and strategies. You should see a clear progression from a goal down to a strategy.

Example #1:
- Increase our organization's financial security.
- Approach the Arts Council for a grant.
- Increase grants 25% by the end of the next fiscal year.

Example #2:
- Create a new logo and unveil it with a press conference.
- Increase number of volunteers by 50%.
- Increase our visibility in the community.

Example #3:
- Attract and retain professional staff.
- Increase efficiency of our administrative operations.
- Create job description for the executive director.

Answers: Example #1: G, S, O; Example #2: S, O, G; Example #3: O, G, S

MANAGING THE PLANNING PROCESS

As we have seen, planning is an ongoing activity for arts organizations. Sometimes, organizations find it helpful to schedule a specific planning activity, such as a board retreat led by an outside facilitator. Such a step can be especially useful when the organization has not had formal plans thus far or when major changes are necessary. Retaining the services of a facilitator is also useful when territoriality or strong opinions threaten to derail the process. Your local arts council or state arts agency can usually point the way to a facilitator skilled in working with arts organizations.

Other organizations maintain planning committees, and sometimes the work is done by various committees dealing with specific issues; for example, the finance committee would prepare the budget, or the marketing committee would submit a marketing plan. Structures and processes can vary from organization to organization—the most important thing about managing the planning process is to do it.

The plan may be complete, but the planning process is not. As we have seen, among the most important activities in the planning process are creating timelines and assignments for completion of the strategies (and objectives and goals!) and monitoring the progress of each segment of the organization as each task is completed.

IN CONCLUSION

Planning is one of the most important governance functions of the arts organizations. For help in identifying the most efficient ways to accomplish its mission, the organization can use the planning process, which includes situational analysis; creation of mission, vision, and other pertinent statements; and adoption of goals, objectives, and strategies. Planning also helps an organization ensure alignment around its mission and goals, make the best use of human and financial resources, and show its responsibility to supporters.

DISCUSSION QUESTIONS

1. Analyze the mission statement for the Child's Play Theater Company using Michael Kaiser's criteria. Is the statement clear, complete, and coherent? If any of these factors are missing from the Child's Play mission statement, how would you change it?
2. Find examples of mission, vision, and values statements on arts organization websites and analyze them according to the criteria discussed in this chapter.
3. Conduct an informal SWOT analysis for an organization with which you are familiar. Are you able to delineate key issues? What might you choose as goals in relation to those key issues?
4. Planning is both an internal process and an external opportunity. What portions of a strategic plan might be shared with potential funders or partners? Are there parts that should be kept confidential? Why or why not?

CHAPTER 5

✒

Governance and the Board of Directors

"Good governance in the performing arts needs to be grounded in an astute and creative understanding not only of the art but also of the artists who make it."

—Nancy Roche and Jaan Whitehead, in *The Art of Governance*, Roche and Whitehead, eds., 2005

In addition to management, there is another important aspect of the operation of any business, and that is the function of **governance**. To govern means to steer, guide, or provide direction. With any business, there is a need to steer the organization toward its goals, to decide on overriding principles the organization will follow, and to put in place the resources that will ensure the success of the organization. With a not-for-profit business, governance is especially important because responsibility for oversight of the organization's adherence to its charitable function and exempt status lies with the governance function.

In this chapter, we will examine the role of governance within the arts organization, as well as the functions of the board of directors, which is the governing body of the organization.

After finishing this chapter, you should be able to:

- Explain the difference between governance and management
- Understand the role of the board of directors in the governance of a not-for-profit organization
- Describe the responsibilities of the board of directors and how they differ from staff responsibilities
- Understand how not-for-profit arts organizations recruit, train, and evaluate board members

GOVERNANCE VS. MANAGEMENT

The difference between governance and management is significant to an arts organization, as it is to any business. While both functions are essential, they are separate and, in a not-for-profit corporation, performed by different entities.

To help get a picture of the difference between governance and management, let's use an analogy of sailing a boat. If someone decides to use a boat to get from one place to another, the actual sailing is only part of what needs to happen. Before getting into the boat, someone must decide what kind of boat is to be used, what kind of crew and supplies are needed, the direction the boat will take at the outset, and the destination. In this example, making these decisions listed and monitoring their execution comprise the governance function.

If governance is providing direction to an organization, management is carrying out that direction. With our sailboat analogy, someone (perhaps the captain, perhaps someone else) has planned the journey, but it's up to the captain to sail the boat. Sailing the boat involves carrying out the general instructions of the plan, but doing so will require the making of many decisions, according to the needs of the journey. Sailing the boat and making the hourly and daily decisions that enable the vessel to reach its destination is management.

In a for-profit small business, the owner may provide governance for the organization while simultaneously performing management functions or hiring other people to manage the business. In a corporation, governance and management functions are separate from each other. This is because the corporation itself is a legal entity ultimately accountable to its owners (stockholders in a for-profit, the public in a not-for-profit). In a not-for-profit, separation of governance and management is a form of checks and balances to help protect the charitable mission of the organization.

If the functions of governance and management are separate, who does each one? In a for-profit corporation, the answer is simple: a board of directors provides governance, and the corporation's staff provides management. This is sometimes stated as "The board makes policy, the staff carries it out." In the not-for-profit organization, however, the lines are not so clearly drawn. Even though the board of directors is the governing body of the organization, a not-for-profit may operate with minimal or even no staff, so that the members of the board of directors sometimes act as volunteers carrying out the policies they have approved. Because in a not-for-profit it is more common to see the same people performing both management and governance duties, it is important for members of a not-for-profit to avoid confusion and conflicts of interest by coming to a clear understanding of which duties are which.

Some of the duties that a board of directors must undertake to fulfill the governance function are creating plans and policies for the organization; developing and enacting the organization's official documents, including the bylaws and articles of incorporation; ensuring compliance with rules and regulations; and imparting financial stability to the organization. Some typical management duties are preparation of grant applications, handling of money, facilitating programs, and maintaining the organization's database and other records.

The chart on page 62, which outlines some of the differences between governance and management activities, is followed by an illustrative case study.

COMPARISON OF THE FUNCTIONS OF GOVERNMENT AND MANAGEMENT

Governance	Management
Initiates and facilitates planning	Advises board of directors and provides data for planning
Advises on daily operations	Manages daily operations
Concerned with outcomes	Concerned with the means to reach outcomes
Accountable to public and to the law	Accountable to the board
Determines organizational mission	Determines strategies to achieve mission
Oversees the chief staff member	Oversees other staff
Approves budgets	Manages finances

Case 5-1

Case Study: Governance vs. Management

Do you think you understand the difference between governance and management? Test your knowledge on some examples of duties and tasks often performed in arts organizations. Which of these belongs to the governance function, and which to management?

Example 1: Approving the organization's budget for the upcoming fiscal year
Answer: This is a governance duty. The key word here is "approving." Although many different entities might be involved at different points in the research and preparation of a budget, the board of directors ultimately must approve any official plans and policies for the organization.

Example 2: Creating the mission statement for the organization
Answer: This also belongs to governance. The mission is the driving force behind all other decisions within the organization.

Example 3: Preparing financial reports for the board meeting
Answer: This belongs to management. Although the board must approve financial reports, the actual preparation of these documents is a management function.

Example 4: Composing a fundraising letter and sending it out
Answer: This is also a management duty, as would be any activity initiated to help achieve an organizational goal.

Example 5: Nominating new members to the board
Answer: As with any duty that has to do with the business of the board, nomination of new members belongs to governance.

THE NOT-FOR-PROFIT BOARD OF DIRECTORS

All corporations are legally required to have a governing body, most often called a board of directors. In a for-profit corporation, the board may receive compensation; but in a not-for-profit, the board is an all-volunteer body.[1] The size and makeup of the board is determined by the organization's bylaws, and most boards are headed by officers, which include a president (or chair), vice president, treasurer, and secretary. The board of directors may oversee a number of committees, which carry out the functions of and report to the board. We'll discuss these more later. The board of an arts not-for-profit functions just like other not-for-profit boards, with the difference that the governance process must address both artistic and administrative functions.

A board of directors sees that an organization maintains its not-for-profit exempt status by ensuring that the organization follows its charitable mission. The board creates the vision and values that help frame the plans and set the direction of the organization. It also ensures that the organization has the necessary resources to effectively deliver its programs and services, thus fulfilling its mission. In addition, the board must do all of the work necessary to maintain and perpetuate itself, including nominating new members to the board and ensuring that all board members are properly trained.

You will hear people who serve on boards referred to as board members, trustees, or directors. They should not be confused, however, with staff members whose title includes the word "director," such as the executive director, marketing director, or development director. For clarity in this text, we will designate those who serve on governing boards as "board members."

TYPES OF BOARDS

A 501(c)(3) not-for-profit corporation is required to have a governing entity, but there is no consistently used name for this body. The most common term for a governing board is a **board of directors**. Another term often used is board of trustees. Legally, a board of trustees is the same as a board of directors, but today the former term is less common than it used to be. The word **trustee** refers to that officeholder's responsibility to guard the organization's mission and ensure that donated funds are held in trust to accomplish the mission of the organization and in accordance with donor wishes. As the responsibilities of the governing board expanded throughout the twentieth century to include oversight of all functions of the organization, more boards in recent years have become known as boards of directors.

Governing boards can have a number of structures or ways of operating. Some boards, particularly those in not-for-profits, which often have little or no staff, are "working boards," whose members perform management as well as governance functions. Others are "policy-making boards," whose members perform only governance duties and are hands-off when it comes to day-to-day operations. Many

believe that boards can and should progress throughout the life cycle of the organization from working to policy-making boards, but this does not always happen.[2]

A not-for-profit may have other "boards," which assist with the governing function but do not have primary responsibility for guarding the mission. We shall discuss advisory boards, auxiliary boards, honorary boards, and ex officio (board) members.

Advisory Board

An advisory board is a group of professionals who volunteer time and expertise to counsel the staff or board of directors. They do not make corporate decisions or have voting privileges; rather, they offer advice, generally meeting less frequently than the governing board. Some advisory boards never meet as a group but agree to be called upon as individuals because of specific skills or expertise. Arts organizations often have advisory boards composed of artistic professionals in the organization's area of specialty.

Another use for an advisory board is to provide community input and oversight for an organization that is not a 501(c)(3) corporation. Arts organizations operated by governmental entities and schools are not legally required to have governing boards, but many do commission advisory boards, which can provide specific expertise or even act very much like a governing board. Many times, organizations like these that start as advisory boards end up creating separate 501(c)(3) corporations so that they can accept donations and perform other functions more freely.

Auxiliary Board

An auxiliary board is essentially a committee charged with a significant task within the organization. Many auxiliary boards are traditionally fundraising boards, sometimes with "Guilds" or "Friends" in the organization name; they raise funds by organizing special events and donating the proceeds to the sponsoring organization.

Honorary Board

An honorary board is a group of individuals who may never meet as a group. The members, however, often contribute financially, open doors to other resources, and are willing to lend their names to endorse the organization's mission. An honorary board usually comprises people who bring instant name recognition, prestige, or resources, or who have contributed significant time or resources to the organization in the past. Often, past executive directors or presidents of the organization continue to serve on an honorary board. Occasionally, an organization will honor significant people in the organization's history by bestowing upon them **emeritus** status, which is a permanent but nonvoting place on the organization's governing or honorary board.

Ex Officio Board Members

Ex officio is a term meaning "by virtue of office or position." Boards often include provisions for certain persons to sit on the board because of the office they hold.

For example, a performing arts center owned by a school district might invite the school district superintendent to sit ex officio on the board so that the board can be continually informed about matters affecting the district. Often, a not-for-profit will ask the executive director or CEO to sit ex officio on the board. Depending on the official and his or her reason for being there, the bylaws may state that ex officio members will not have a vote.

FIDUCIARY DUTY

It is a great honor to be asked to serve on a board of directors, but with that honor comes great responsibility. Every person who serves on a board must be prepared to work with others in that select group to ensure that the board's responsibilities are fulfilled.

The role of the board of directors is important but often misunderstood. Many board members accept the invitation to join because they support the mission of the organization and want to see it succeed. Some board members have been volunteers with the organization and feel that board service is a reward for their previous contributions. Others assume that they are joining the board to help manage the organization or simply to offer their advice to the staff. Since board members of not-for-profit organizations serve voluntarily, many also assume that being on the board is just a higher level of volunteerism. While board service may be all of these things, it also entails a significant legal responsibility, which the board as a whole, as well as each member, must understand.

The governing board of a not-for-profit corporation and each member of that board has a **fiduciary duty** to that organization. Fiduciary is a word which comes from the Latin *fiducia*, meaning "trust." Fiduciary responsibility is the highest standard of care imposed by law. It means that the board and its members must put the interests of the organization above any personal interests and must care for the mission of the organization at the very highest level of ethical standard.

The Three Duties
In legal terms, a board member's fiduciary obligation is often described in terms of **the Three Duties.**[3] These are the **duty of care**, the **duty of loyalty**, and the **duty of obedience**. We shall discuss them in turn.

Duty of Care
Board members are expected to use their best judgment and to operate in good faith when they make decisions on behalf of the organization. In practical terms, this means doing their best to attend all board and assigned committee meetings; study minutes, financial statements, and other documents in advance of board meetings; use best judgment to retain professional help such as legal or financial assistance when necessary; and make sure that the organization and its officers are adequately protected with appropriate insurance.

Duty of Loyalty

Board members are expected to put the interests of the organization ahead of their own personal or professional interests. This can be facilitated by developing and signing conflict-of-interest policies and by asking individual board members to keep the board informed about potential conflicts of interest that may arise during their service.

Conflict of interest is generally described as a situation in which an individual's personal interest is at odds with his obligation to the organization he or she serves. Conflict of interest also exists when an individual stands to gain personally from a corporate decision or other actions that might elicit reasonable questions from an independent observer. In the case of board service, for example, a board member who owns an accounting firm would refrain from bidding on the organization's accounting contract because of the obvious conflict. To avoid conflict of interest, organizations normally refrain from such questionable activities as hiring relatives of staff or board members, using the businesses of board members as vendors, or having board members vote on matters that affect their private finances or businesses. It is generally not appropriate for staff members to serve as voting members of not-for-profit boards, because at some point the votes regarding salary and other employee issues constitutes a conflict of interest.

In addition to avoiding conflict of interest, the board member who is conscientious about the duty of loyalty will maintain appropriate confidentiality regarding the organization's business. Once the board has reached a decision, for example, it is inappropriate for any board member to air or discuss an opposing view in public.

Duty of Obedience

Directors are expected to make decisions with the organization's mission in mind, and with knowledge of applicable federal, state, and local laws and statutes. Thus a good director will seek to become knowledgeable about applicable laws and reporting requirements and will take pains to ensure that legal obligations, such as collecting payroll tax and filing financial reports, are handled properly; it will also be necessary to ensure that donated funds are used for the purpose for which they have been designated. Finally, a good board member will always consider mission first when voting on plans, budgets, or personnel.

The fiduciary responsibility of the board is a legal, not just an ethical, concept. This means that the members of the board of directors are legally responsible for the decisions they make on behalf of the organization. However, according to the legal principle called the "business judgment rule," board members cannot be held liable for the consequences of their decisions (even bad decisions), provided those decisions were made in good faith and with the best interests of the corporation in mind.[4] While individuals must be aware of the legal responsibilities inherent in board service, they do not need to fear that by serving on a board, they are putting themselves at risk of legal action. However, the knowledge that board service is a significant responsibility makes it even more important for all board members and potential board members to have a thorough comprehension of the meaning of their service.

Case 5-2

Case Study: The Three Duties in Action

Example #1

Community member: I really disagree with the museum's decision to raise prices.
Board member: I do, too. I voted against it, but they never listen to me.

In our first example, the board member is violating the duty of loyalty by expressing, outside the board room, an opinion contrary to a board vote. A better exchange might go like this:

Community member: I really disagree with the museum's decision to raise prices.
Board member: It was a difficult decision, but there are many reasons we had to make it. I hope you will still support the museum, and I'd be happy to take your thoughts back to the board.

Example #2

Board president: Any discussion on the proposed budget before we vote?
Board member: I didn't print out my copy, do you have any extras?

This board member violated the duty of care by neglecting to prepare for the meeting. Decisions made on behalf of the organization require the best possible input and preparation from all board members. This is better:

Board president: Any discussion on the proposed budget before we vote?
Board member: After carefully reading this proposal, I have some questions about the numbers in the earned income section.

Example #3

Board president: This audit is going to cost us more with the new financial regulations.
Board member: Why do we have to have an audit, anyway? We're a poor nonprofit!

Okay, your turn. Which of the duties is the board member violating? What would be a more appropriate response?

GOVERNING RESPONSIBILITIES OF THE BOARD OF DIRECTORS

"A productive board must conduct its business in an honorable, effective and courageous manner."

—David Jenkins, *501(c) Blues: Staying Sane in the Nonprofit Game*, 2003

Within the governance function, six areas are generally accepted as encompassing the governing responsibilities of not-for-profit boards. Deciding how these responsibilities will be carried out in each organization is part of the function of the board, often defined in the organization's bylaws or in published policies.

These areas of responsibility are governing and leading the organization, fulfilling the law, being accountable, overseeing the chief executive, representing the community, and ensuring the financial well-being of the organization; in addition,

individual directors have responsibilities corresponding to each member's role on the board.

Governing and Leading the Organization

The primary responsibility of the board of directors is setting the overall direction of the organization. This includes overseeing the mission and setting in place the long-range and short-term plans that will guide the organization.

The mission of the organization, adopted when the organization is founded, defines the core purpose of the organization. Thus although it is the founding board that adopts the mission, the mission also has to be reviewed regularly to be sure it continues to accurately reflect the purpose of the organization. The board of directors can choose to affirm the organizational mission or make any warranted changes to it.

The board is also responsible for initiating and conducting the strategic planning process and for approving all plans once they are in place. This includes both long-range plans and the annual plans necessary for operation of the organization, such as budgets, marketing plans, fundraising plans, and work plans. The mission provides direction for all planning, which is another reason for the board to review the mission statement regularly.

A good board of directors will understand all of the organization's programs and will regularly assess them against the organization's mission, the needs of the constituencies represented by board members, and other measures of success determined by the organization. The board of directors (as a whole and as individuals) should be familiar with all of the organization's programs and should understand how each one fits within the mission.

Another important part of the governance function is monitoring the performance of the board, which also covers the activities that ensure that the board keeps operating and serving the organization well. Such activities, which sometimes are called **board operations**, include adopting and following a recruiting and nominating process to find qualified board members, training board members, assessing the performance of the board as a whole and that of individual board members, and creating opportunities for board development.

Fulfilling the Law

It is essential that the organization be governed in a way that fulfills the charitable mission under which has been granted tax-exempt status—but it is also essential that the organization fulfill other aspects of the law that are applicable to not-for-profits and arts businesses. Because of these conditions, many boards wisely either recruit as board members persons with experience in not-for-profit law or seek an ongoing relationship with a lawyer who can act as an adviser.

The first responsibility of a board is to adopt its own legal documents, such as the articles of incorporation and the bylaws. Throughout the life of the organization, the board crafts and approves other necessary organizational documents: conflict-of-interest policies, personnel manuals, financial management policies, and other policies and procedures appropriate to the organization.

In addition to their own internal rules, not-for-profits are bound by all governmental regulations that apply to their respective businesses. This means that the board of directors is responsible for filing appropriate governmental reports, seeing that payroll taxes are paid for employees, and treating employees and volunteers in accordance with local, state, and federal regulations.

As a corporation, the organization will enter into legal contracts ranging from employee contracts to contracts for services to agreements with other organizations or businesses. It is the responsibility of the board to ensure that these contracts are legal and that they are fulfilled.

Being Accountable

Any business is accountable to several entities: the government that chartered it, the shareholders who own it, and the community that supports it. For a not-for-profit business, this means operating within the limits of the law as noted earlier, but it also means behaving ethically and within the parameters of the organization's mission and obligation to provide certain services or products to the community in accord with its charitable status.

A not-for-profit that accepts contributions is also accountable to the donors who gave those contributions and is legally and ethnically obligated to see that those funds are used for the purpose the donor intended.

Ensuring the Financial Well-Being of the Organization

If an essential function of the board of directors is to protect the mission of the organization, part of that function is to ensure that the organization has the resources to accomplish that mission, both now and into the future. Although the organization's staff might do much of the work of bringing in financial resources, it is the responsibility of the board to set in motion the policies and practices that ensure that the organization is on sound financial footing.

As a part of the planning process, the board creates the annual budget and approves it before the beginning of the organization's **fiscal year**. During the year, the board monitors progress against the budget by reviewing financial statements giving information on the organization's financial performance and position. It is the responsibility of every board member as well as the board as a whole to understand the organization's finances and monitor them in the best interest of the organization. Because the financial structure and reporting methods of not-for-profit businesses differ from those applying to for-profit businesses, it is necessary for board members to understand what criteria they should use to monitor financial success. It's not necessary that every board member be an accountant, but all board members who lack a solid grounding in financial statements should be trained to understand the statements of the organization.

If a part of the board's governance responsibility is ensuring the financial well-being of the organization, most agree that a part of that responsibility is ensuring that the organization has enough resources to carry out the plans approved by the board. This means actively working to attract resources for the organization. The content of this responsibility will differ across organizations, and the matter is

sometimes controversial, as many board members believe that engaging in fundraising activities falls under the responsibility of management, not governance. We'll discuss this more later. But for most boards, the responsibility of seeing to it that funds are available to execute plans the members have approved can include making personal contributions, using connections to attract contributions, or sitting on a committee to plan a fundraising event.

Overseeing the Chief Executive

The board is responsible for determining what is needed to carry out the management function of the organization. This means that the overall organizational structure of the organization, including development of the organizational chart, is a responsibility of the board of directors.

In many organizations, there is a paid chief executive, or head of the management team. This person may be called the executive director, administrative director, CEO, or general manager. The board provides oversight for the position, usually held by one person who reports directly to the board. In an arts organization, however, there may be two chief executives reporting to the board: the heads of the artistic staff and the administrative staff.

The board is responsible for creating a job description, hiring the chief executive, reviewing his or her performance, and setting terms of employment. The oversight of the rest of the staff, however, then becomes a management function and is overseen by the chief executive, often with active input from the board or a personnel committee, depending on the needs of the organization.

Representing the Community

> "Many nonprofit organizations are the best kept secret in town. Others go about their business without the benefit of any input from those they are supposed to be serving. In both cases, the fault lies partly with trustees who do not understand that part of their responsibility is to promote their organization's activities widely and to seek opinions about the organization from a variety of people."
>
> —Thomas Wolf, *Managing a Nonprofit Organization in the Twenty-First Century*, 1999

A not-for-profit organization is not a closed group serving the interests of an owner or **shareholders**; it is an organization with an obligation to serve the public good. Decisions should be made with an understanding of how they affect the public, both the direct recipients of the organization's programs and the community as a whole. The board of directors, therefore, has a duty both to represent the public's interest and to represent the organization to the public. This means that the organization will make sure that the makeup of the board reflects, as much as possible, the opinions and ideas of those whom the organization serves. It also means that members of the board will be ambassadors for the organization, spreading the word about the organization, its programs, and its policies.

The concept of including representatives from the organization's constituencies means different things for different organizations. For an organization that serves an entire state, for example, it might be important to make sure that all geographic areas of the state are represented on the board. An organization providing artistic programs to a community should have a board that accurately represents the recipients of those programs. For some boards, that means recruiting a combination of people with business or financial connections, artists, users or potential users of the organization's services, and a diverse segment of community members, including people of various ethnic and cultural backgrounds.

We mentioned before the characterization of boards as either "working" or "policy making." The stereotype of a working board is a board filled with artists and hands-on volunteers, eager to see the organization succeed because of their efforts but lacking the political or financial clout to make a significant difference to the organization's funding. In contrast, boards with large budgets often seek wealthy and influential members who can bring financial resources into the organization, but in doing so they sometimes lose the connection with artists and the people they serve. A wise organization will find a way to include in its governing process the opinions and resources of a variety of people.

Responsibilities of the Individual Board Members

We've noted that it is both an honor and a responsibility to serve on a board of directors. In addition to the collective responsibilities of the board, certain responsibilities are incumbent upon individuals.

Each board must decide what it expects from individual board members, although there are many duties that are common to all boards. Many boards adopt commitment forms (see Appendix 5), which are signed by board members annually to provide a formal reminder of what they personally have agreed to do during the upcoming year.

Board members are expected to participate both materially and financially in the activities of the organization. Primary among material responsibilities is attendance and active involvement in board activities, committees, and organizational events. Obviously, no board member should agree to serve if he or she cannot commit to attending board meetings regularly. Boards commonly assign each member to sit on or even chair a committee and to be active in its work; this is known as **material participation**. Board members should also plan on attending as many of the organization's programs and events as possible, especially fundraising events. Many board members are encouraged to bring guests to programs whenever they can, to introduce new people to the organization.

Another aspect of material participation has to do with some of the governing responsibilities listed earlier. As a part of the duty of care, every board member should take the time to learn about all of the organization's programs and issues. Board members should then be willing and able to share this information with community members. Nothing is more damaging to an arts organization than the

revelation that a board member was unable to answer questions about upcoming programs.

It is absolutely essential that every board member participate financially in the organization to the best of his or her ability. Financial participation often consists of making an annual donation to the organization. It might also include being a current member of the organization, purchasing season tickets, or donating goods or services to everything from the organization's offices to the fundraising silent auction.

Some board members and potential board members, under the mistaken impression that only wealthy people can contribute at a level that will make a substantial difference to the organization, balk at entering into a financial commitment. Some board members have been overheard to say things like, "I can't afford to give any money, but I'll give a lot in time and effort." A gift from every single board member is essential to the organization, however. This is because financial participation by individual board members is an important gauge of the commitment to the organization's success of those in governing positions. An organization that is not willing to require every board member to give a financial gift undercuts its case when members approach outside funders for donations.

A common maxim in the not-for-profit world is that board members should be prepared to "give, get, or get off." This means that board members who are not willing to be passionate enough about the organization to support it with their own financial resources and to share the organization with potential new donors and audience members should be prepared to step aside and let others take the lead. As one board member put it, "First of all, flat out, [all board members] should have to donate to the project. No exceptions. If they can't be bothered to give to the project then how can they ask anyone else to cough it up? If they don't have sufficient belief, how can they inspire that belief in others?"[5]

THE ROLE OF THE BOARD IN FUNDRAISING

The role of the board in the organization's fundraising process is crucial but often misunderstood. We can say without in any way downgrading the significance of the responsibilities already discussed that the board's fundraising responsibilities are important enough to deserve additional discussion.

We've discussed the board's responsibility to "ensure the financial well-being of the organization." To fulfill that responsibility, the board will prepare budgets and monitor financial reports. Individual board members should also participate financially in the organization as described in the preceding section. But board members also must recognize that they have a significant role in attracting contributions to the organization. This aspect of board responsibility is often controversial. Many board members feel that fundraising should be a management activity, conducted by experienced staff who understand the process and are trained in it. In addition, the thought of asking for money makes many people nervous. Some board members who are told about the board's involvement in

fundraising imagine that they'll have to ask their friends for gifts to the organization, and many are not comfortable doing that.

The function of fundraising on behalf of the organization is so important that it must be regarded as an "all hands on deck" activity, where every single person in the organization has a responsibility. Fundraising in most organizations is complex and encompasses many functions, from writing fundraising letters to facilitating fundraising events to writing grants to asking individuals for donations. Within these functions, there are varying tasks that must be accomplished by everyone: volunteers, staff, and board members.

Those who are not willing to assume responsibility for seeking donations for the organization should consider whether it's appropriate for them to accept the invitation to join the board. However, it is also important to note that agreeing to participate in fundraising activities does not mean doing things that make a person uncomfortable. There are many ways that board members can use their abilities to help with the fundraising effort.

In organizations with paid staff, the most efficient way to facilitate fundraising is to have the staff involved in the middle of the process, with board members taking part at either end. The board initiates fundraising annually by passing a budget and creating plans for funding it. The staff then does a great deal of the management work, including keeping records, doing research, preparing letters and other printed materials, and writing grants. At the other end of the process, individual board members can participate by adding signatures to fundraising letters, serving on committees to plan events, writing personal thank-you notes, and adding letters of support to grant applications or other solicitations.

Many board members are quite capable of participating actively in the **solicitation** process by identifying prospects and making calls on potential donors. One rationale for board involvement in solicitations is that the organization is best served by creating long-term relationships with donors that go beyond the donor's relationship to a particular staff member.

A board member who says, "I'll join the board, but I won't do fundraising," is exhibiting a fundamental lack of knowledge of the process. Helping board members understand not only their responsibility, but the nature of fundraising, is an important part of board development.

COMMITTEES OF THE BOARD

It is common for boards to **commission** a number of committees to accomplish the work of the board. Not every board has committees, but larger organizations find that they cannot accomplish the board's duties without dividing the responsibility into a number of work areas.

When a board is functioning effectively, committee chairs give reports at board meetings and make recommendations for the full board's consideration. Board meetings should not be used to do committee work. For example, a committee could meet and prepare a plan to redesign the organization's membership program, whereupon the board would review the plan, perhaps offer suggestions

for revision to the committee, and approve a final plan. The full board should not be asked at a regular board meeting to develop the membership program.

Committees do not have to be composed of board members only. In fact, committee work is a good way to bring new people into the organization and to use the expertise and enthusiasm of those who cannot, for one reason or another, be board members. Bringing community members into the committee structure is another way to help ensure that board members don't burn out.

Every organization is different, and so each one will need different committees, but the committees identified next are common.

Standing (or permanent) committees are committees that are part of the board's operations at all times, no matter what programs or services the organization is providing or how many members are on the board. They are often mandated in the bylaws of the organization, and their members accomplish the work that is necessary to fulfill the legal responsibilities of the board.

Standing committees are governance committees. They perform the ongoing work of the board necessary to fulfill the governance function and to handle board operations. They may meet on regularly year-round, or they may be **ad hoc** committees, coming into existence when they are needed (e.g., to conduct a search for a new executive director or to create a budget) and becoming inactive when the work is finished. Some of the common standing committees are described next.

Executive Committee

The executive committee is normally made up of the officers of the board (president, vice president, secretary, treasurer, and sometimes past president). In some circumstances, committee chairs or other appropriate leaders sit on the executive committee, which is usually empowered by the bylaws to make decisions on behalf of the board when necessary. The members can meet regularly or as needed between board meetings to discuss issues that will have to be presented to the full board.

Finance Committee (sometimes called Budget Committee)

The finance committee oversees the financial operations of the organization, including preparing and presenting a budget to the board for its approval, monitoring the financial activity of the organization, preparing (with staff) financial reports for board approval, and making recommendations to the board with respect to unusual activity (such as large purchases or approval of financial policies), The treasurer normally chairs the finance committee.

Governance Committee (sometimes called Nominating, Leadership, Board Operations, or Board Development Committee)

The governance committee is responsible for the overall development of the board of directors, including identifying and recruiting board candidates, writing job descriptions for board members and committees, assessing the overall effectiveness of the board, and recommending board policies. Some boards have committees that perform only the nomination function, with the board tending

to board operations and development as a whole. However, more and more boards are realizing that attention to board development is an ongoing process calling for care and attention that the group as a whole may not have time to provide.

Human Resources Committee (sometimes called Personnel Committee)

The human resources committee is responsible for hiring and evaluating the chief executive and assisting with overall personnel policies of the organization. The committee may be a standing committee (this is more common in larger organizations), or it may be convened when a search or employee review is necessary.

Fund Development Committee (sometimes called Fundraising Committee)

The fund development committee is responsible for overseeing the fundraising effort. The exact duties of this committee depend on the needs of the organization; if there is no paid staff, the committee will do everything, including preparation of fundraising materials, mailings, and grant applications. Sometimes there are committees dealing with specific fundraising activities, such as membership or an annual fund drive. The fund development committee presents an excellent opportunity to include members of the community who have particular fundraising expertise but lack the time or perhaps the ability to serve on the board.

Planning Committee

The planning committee is responsible for creating the plans that govern the organization's mission, goals, and annual priorities. Assigning the bulk of planning work to the planning committee, while allowing for board and community input, is one way of ensuring an ongoing planning function while continuing to accomplish the programs of the organization.

Program Committees

Program committees are committees that convene to assist with the management needs of the organization. When there is little or no paid staff, committees contribute significantly to the management work of the organization. When there are staff members working on these tasks, program committees can either advise the staff, provide volunteer services to the operation, or take a significant role in supplementing the work of staff. With program committees, it is important to avoid misunderstandings by clearly delineating the respective roles of board and staff. The appropriate staff person usually sits ex officio on the committee to provide management assistance and to make sure roles are clear. For example, a committee that researches and proposes a performing arts or exhibit season, an education committee, a scholarship committee, or a festival planning committee probably could use an ex officio member.

Marketing Committee

The marketing committee works on the creation of the overall image of the organization and various promotional strategies. It may create a marketing plan,

recruit community members with marketing expertise to generate marketing ideas, and work with staff to execute the plans. Because this entire operation has become so complex, some organizations have subcommittees for marketing operations including website oversight and social media.

Proper organization and instructions are necessary to help any committee do its work properly. Creating a job description is an example of one way an organization can ensure the committee members understand the group's responsibilities. We will discuss more about job descriptions in chapter 6.

THE RELATIONSHIP OF BOARD AND STAFF

"Après moi, le board."

—George Balanchine

The board of directors of a not-for-profit organization is authorized by the state and by the organization's supporters to guide the organization. It is, therefore, accountable to the public trust. The chief executive is hired by the board and entrusted with providing leadership to the staff and overseeing day-to-day operations/programs. Although accountable to the board, the chief executive often is seen as the leader and public face of the organization. Indeed, the chief executive may be the founder of the organization. The preceding quotation from the famous choreographer George Balanchine, founder of the New York City Ballet, refers to the board's role in providing continuity for the organization even as executive directors or artistic directors come and go. Mr. Balanchine's tongue-in-cheek comment indicates that he may not have particularly liked this arrangement, but, like all staff members, he lived within the boundaries of the not-for-profit system.

A strong relationship between the board and the chief executive is crucial to an organization's success. This requires regular and open communication between board chair and chief executive, clarification of the roles of both board and staff, and ongoing evaluation and assessment of both board and staff.

Why is it necessary to talk about maintaining a good relationship? Shouldn't that be obvious? The fact is that the division of responsibilities between governance and management in a not-for-profit organization differs from the normal operating procedure in for-profit businesses, especially when board members are also volunteering their time to do staff duties. This can sometimes lead to misunderstandings about where responsibilities begin and end and the nature of the authority in decision making. For example, a board member might question a staff spending decision, feeling that in doing so she is exercising her duty to ensure the financial well-being of the organization. Or, a staff person and a board member working together on a project might not be sure which of them has the final authority if there is a difference of opinion.

Case 5-3

Case Study: Community Arts Festival

A community-based arts center has an annual outdoor festival, with artists selling their work in booths, food sales, and live music. The event has become popular, with over 50,000 people attending annually. The Art Fair Committee is one of the busiest and largest committees of the art center, and several board members belong to it, although there is also a staff member whose full-time job it is to manage the festival.

Each year, the board of directors approves a budget for the festival, based on what has happened in past years. As the staff member is managing the festival, she stays within the spending guidelines set by the board.

One day, the chair of the Art Fair Committee who is also a member of the board, asks the staff member to order from the rental company tents of a particular type for the food booths. The staff member questions the request, saying that the tents the board member wants would be outside the budget parameters set by the board. "But I'm on the board," responds the committee chair, "and I'm ordering you to do what I tell you to do."

The staff member orders the more expensive tents and is criticized by the board as a whole for going over budget.

Questions

Why did the board criticize the staff member for following an order from a board member?

What should have been the proper relationship between the board member/committee chair and the staff member?

General Rules of Communication

Although each organization will need to develop its own procedures and lines of communication, there are a few general practices that make this communication easier:

- Individual board members do not supervise the chief executive; it is only the board as a whole that performs this role.
- The board may designate the president or the entire executive committee to act as the chief executive's supervisor on an ongoing basis.
- Board members likewise do not supervise other employees and may not order them to perform tasks in disagreement with the employee's staff supervisor or the chief executive.
- Organizational charts are helpful in establishing lines of communication.
- Job descriptions are helpful for all employees, volunteers, and committees.

RECRUITING BOARD MEMBERS

One of the ongoing tasks of the board of directors is ensuring that the board perpetuates itself. Recruiting board members who are capable of and prepared for the responsibilities of board work, and who fit into the needs of the organization, is a continual process. A healthy board is regularly infused with new people, bringing fresh perspectives and a variety of contacts for resource development and partnerships.

The board often empowers a committee, such as the governing or nominating committee described earlier, to carry out recruitment. All board members, however, should always be looking out for people to bring onto the board and finding ways to integrate new colleagues into the organization.

The first step in preparing to recruit new board members is to analyze the needs of the organization that can be addressed by persons who sit on the board. Boards often consider such candidates as attorneys, accountants, business and community leaders, artists in the organization's discipline area, human resource specialists, marketing or fundraising experts, and people who are well connected with funders or others who could be useful to the organization. At each nominating period (usually annually), the board or nominating committee assesses the makeup of the board and identifies current needs. Then, the committee researches prospects to fill those positions.

The most useful board members are those who are already active and familiar with the organization. Thus, the next step is to invite prospects to programs, introduce them to key staff and board members, and involve them in committees. Sometimes, a prospective board member is identified two or more years before nomination becomes feasible. Patience is a virtue, however; board members who are not fully committed to the organization when they join the board are likely to be less productive and may fall by the wayside quickly.

At some point in the process, the committee decides that a particular person is indeed a good candidate for board membership. At this point, the committee formally nominates the individual, thus signaling that he or she can be formally invited to join the board. Once a candidate has agreed, the board as a whole will vote on the nomination.

Although every board has a different nomination and approval process, normally potential candidates are well screened prior to nomination and are asked informally if they would consent to serve if elected. Once a candidate has been approved by the board, a formal offer of membership can be extended. At this time, the new board member must accept the terms of office, which usually means agreeing to the meeting schedule, length of the term, committee assignment, and any other requirements of board membership.

A new board member should be provided with appropriate information and documents about the organization so that he or she will be able to perform assigned duties properly. Often these materials take the form of a board manual or notebook that contains documents and information pertaining to the organization, as indicated by the list that follows.

Items commonly found in a board manual

- Mission and vision statements
- Articles of incorporation
- Organizational bylaws
- Organizational history
- Letter of Determination [of tax status]
- Strategic plan
- Annual calendar
- Current and recent past budget and financial statements
- Policies and resolutions pertaining to the board
- Organizational brochures and print materials
- Annual report
- Current list of funders
- List of board members, with contact information and dates of terms
- Board member job description
- Committee list giving names of members and job descriptions
- Staff list with contact information
- Organizational chart
- Recent board meeting minutes

In addition to providing information, many boards schedule some kind of **orientation** for new board members, to introduce them to their new colleagues

Case 5-4

Case Study: Term Limits for Board Members

How long should a board member serve? Although there are no legal require-ments or guidelines, many organizations adopt policies that limit the length of time that individuals can remain on the board. Doing so helps ensure that fresh opinions are constantly brought to the table and that unproductive or disruptive board members can be replaced. But, as the article below from BoardSource points out, there are advantages and disadvantages of term limits. Every organization must decide for itself what is appropriate.

Should Your Board Have Term Limits?
A BoardSource survey revealed that nearly three-quarters of respondents have three-year board terms and those that limited terms had, on average, a maximum of two terms. Rotation can be a healthy and natural way to help a board grow with the organization and provide ongoing opportunities for renewal and revitalization. Here are some things to keep in mind as you ponder term limits.

Advantages of term limits
- Larger circle of involved volunteer leaders
- Balance of continuity and turnover
- Infusion of new ideas and perspectives
- Built-in rotation of ineffective board members

(continued)

Disadvantages of term limits
- Loss of institutional memory
- Increased time for recruitment and orientation
- Need for continuous education and team building

Advantages of not having term limits
- Retention of passionate, active board members
- Deep understanding of organization
- Know personalities and group dynamics

Disadvantages of not having term limits
- High risk of organizational stagnation
- Fatigue, boredom, and loss of commitment
- Difficult to integrate the occasional new member
- Disconnect over time as environment changes

Reprinted with permission from the July/August 2006 edition of Board Member, Volume 15, Number 4, a publication of BoardSource. BoardSource is a 501(c)(3) organization located in Washington, DC. For more information, call 800-883-6262 or visit www.boardsource.org. BoardSource © 2012. Content may not be reproduced or used for any purpose other than that which is specifically requested without written permission from BoardSource.

and to train them to assume their duties. The orientation may take the form of a workshop or social event, or **mentoring** by someone already a board member. Most boards have found that orienting new board members to their duties helps them discharge the responsibilities they have accepted better and more productively.

IN CONCLUSION

The governance function of a not-for-profit is a function that is important but sometimes misunderstood. It is essential for the success of an arts organization to make sure board members know and fulfill their responsibilities, and for potential board members to understand their roles prior to agreeing to serve.

DISCUSSION QUESTIONS

1. If you were putting together an advisory board for a small, community-based arts organization, what kinds of people and/or skills might you consider? What might be some reasons people will have for agreeing to serve on an advisory board but not the organization's governing board?
2. Directors' and officers' liability insurance is a specialized form of insurance that protects board members from being sued for actions they perform on behalf of the organization. Some organizations don't purchase this insurance because of the expense. Based on what you have just read about the legal

responsibilities of boards, do you believe this insurance is a wise investment by a not-for-profit organization?

3. Spending board time preparing and adopting manuals of policies and procedures strikes some board members as busy work, assigned when they'd rather get on to making the art happen. Yet adopting policies and keeping them up to date might serve and even protect the mission of the organization. What are some of the reasons for this?

4. Traditional fine arts genres like classical music and ballet have often been criticized for being elitist, both in their programming and in their governance. "Music by dead white men for wealthy white donors" is how one community member disparagingly described the product of a symphony orchestra. If a board wishes to diversify its membership in order to better represent its community, how might the introduction of heterogeneity affect the organization's programming? And, if an organization's constituency is overwhelmingly representative of one ethnic or cultural group, is it always desirable to diversify the board?

5. A common complaint by not-for-profit staff members is that board members don't work hard enough, don't understand their roles, and therefore make poor decisions on behalf of the organization. But in today's busy world, the best board members for any organization are likely to be those who have other responsibilities as well. How much time, energy, and effort should be expected from board members? Given the group and individual responsibilities listed in this chapter, are not-for-profits expecting too much from volunteer board members? What can be done to make board members' service more productive?

CHAPTER 6

⚬

Human Resources
in the Arts Organization

"People decisions are the ultimate—perhaps the
only—control of an organization. No organization can do
better than the people it has."
—PETER DRUCKER, *MANAGING THE NON-PROFIT*
ORGANIZATION, 1990

Imagine a community theater preparing for an upcoming production. In one
space, the actors are working with the director to stage their scenes. In another,
musicians are rehearsing the score with the music director The costume and scene
shops are full of people sewing, painting, fitting, and hammering. Few people out-
side the arts would think of this as a workplace, but in fact, it is. The employees
in this case include artistic personnel, technicians, and administrative workers. It
is likely that many, if not all of them, are volunteers. The actors and musicians,
along with others who are building the sets or making the costumes, might well be
involved with this production without knowing anything about the structure and
mission of the organization that is putting on the production. Some may be
involved who will never meet the actors or musicians—people who do marketing
or fundraising for the production, for example. They all might be together for a
few weeks, or some might have stayed with the organization for several years,
having been involved in earlier productions, as well. Most of the employees prob-
ably haven't filled out income tax forms or received employee handbooks, nor will
most know in advance how many hours they are going to work. They will all have
different levels of training and experience. Some workers may never have per-
formed similar tasks before.

You might say that it's ridiculous to compare a community theater production
to a workplace—the people in the arts organization are just having fun, aren't they?
Yet, just as in any business situation,the people sewing, painting, fitting, and ham-
mering must work together on behalf of the organization to accomplish its goals.
And even though this particular situation is clearly more casual than what's typical
of many workplaces, it is important for every arts organization to approach the
"people decisions," as Drucker calls them in the opening quotation, with the same
efficiency and professionalism required in every other aspect of the organization.

In this way, not only will the mission be accomplished, but everyone involved will have a better time.

When you finish this chapter, you should be able to:

- Describe the unique environment of the arts organization with salaried staff, contract workers, and volunteers
- Explain the role of the volunteer in the not-for-profit arts organization
- Evaluate methods for recruiting, training, and managing volunteers
- Understand the basics of hiring (writing a job description, seeking staff, contracts) and evaluation of employees and volunteers

THE NOT-FOR-PROFIT WORKFORCE

Just like any business, arts organizations require human resources. In the arts organization, these resources come in many types, sizes, and forms. Most arts organizations operate with four kinds of workers: regular paid staff, contracted staff, outsourced workers, and volunteers.

Regular Paid Staff

A paid staff worker, whether salaried or paid by the hour, is generally assumed to be a long-term employee of the organization. Paid staff may be **artistic** or **administrative**. Regular paid staff positions range from executive director to office assistant. Some arts organizations have no permanent paid staff, relying primarily on other types of workers as listed in the subsections that follow. Many operate with a combination of paid and other types of employees. With regular paid staff, it is important to understand the laws of the state in which the people are hired as well as Internal Revenue Service regulations regarding such employees.

Contracted Staff

The artistic and administrative nature of arts organizations requires that some workers be employed on a short-term, project basis. For example, a contracted staff member might be a stage manager or a costume designer hired for one show only, or box office personnel hired only while the theater is in season. **Contracted staff** are important for their specific skills and expertise, but whether they will ever work for the organization again is uncertain. Their needs as employees and their loyalty to the organization differ, therefore, from those of regular paid staff. Their classification according to the Internal Revenue Service and other government entities differs, as well. Often, contracted staff are union workers, which means that the arts organization that hires them must understand the applicable laws and regulations for the contracts involved.

Outsourced Staff

Occasionally, arts organizations have a need for temporary, specialized services that do not require the hiring of a permanent employee. Such services are often

outsourced to other businesses; the workers are never employed by the arts organization. An example of an outsourced staff member might be a consultant hired to facilitate the creation of a long-range plan. Outsourcing on a larger scale might consist of the hiring of a firm to conduct telephone sales or do market research or accounting. The arts organization does not have to assume legal responsibility for these workers, since they remain the employees of their original businesses (or, as in the case of consultants, remain self-employed). There are, however, reporting requirements that must be fulfilled.

Volunteers

Most not-for-profit arts organizations use a number of workers who are not paid at all. Volunteers donate their time to the organization for a variety of reasons, as discussed later. The presence of volunteers allows the arts organization, like any not-for-profit, to devote more scarce resources to programs that accomplish the mission of the organization. Since volunteers are not receiving pay (beyond reimbursements for expenses they incur on behalf of the organization), the organization is not required to register their presence with the Internal Revenue Service or any other governmental agency. This does not mean, however, that the organization has no responsibilities toward volunteers. Volunteers should be regarded as seriously as any paid employee when it comes to such matters as creating a safe work environment or providing the proper equipment.

In fact, there is a growing trend toward paying volunteers—perhaps not as much as a regular employee, but enough to honor the work of the volunteer and help ensure continued participation. Many volunteers are people with significant work experience and skills, and some cannot consider an extended commitment to a not-for-profit organization without some compensation. According to the *New York Times*,[1] this trend also benefits organizations, allowing them to expect more loyalty from volunteers.

WHICH TYPES OF STAFF SHOULD BE HIRED?

Each organization will need to determine which kinds of staff will be most effective and efficient for the particular situation. Many organizations, mindful of the limited resources of a not-for-profit, are tempted to consider unpaid and contracted workers before hiring salaried staff. These groups assume that hiring salaried staff will be more expensive than engaging unpaid and contracted workers. Sometimes, however, the disadvantages associated with volunteers outweigh the benefits of the lower initial cost to the organization.

The chart on page 85 outlines some of the advantages and disadvantages of each kind of employee. Organizations should weigh these factors carefully in making hiring decisions.

ADVANTAGES AND DISADVANTAGES TO AN ARTS ORGANIZATION
OF HIRING WORKERS FROM VARIOUS SOURCES

	Advantages	Disadvantages
Paid employees	Stable workforce Loyalty to the organization Can develop long-term relationships	Cost of salary/wages Cost of benefits, taxes
Contracted employees	Can hire for special skills Can hire for limited periods No need to pay benefits or taxes	Per-hour cost may be higher Less loyalty to the organization Constant need to train new workers
Outsourcing	Can hire for special skills Don't have to manage employees Can build community relationships	Per-hour cost may be higher Little or no loyalty to organization Company policies may differ
Volunteers	No cost to organization Can seek special skills Can build community relationships	Constant need to retrain Organizational instability Potential lack of skills/experience

Another factor in hiring decisions should be the Internal Revenue Service classifications of employees. The IRS has very strict rules about which employees can be considered to be independent contractors and which can be considered to be regular employees. A business that falsely identifies an ongoing employee as a subcontractor (contracted employee) to avoid paying benefits or payroll taxes risks fines or penalties that could cripple the business. Any business that hires an employee should realize that the cost of employing workers is not limited to the salary or wages paid; the advantages, however, may easily justify the added cost.

An organization hiring volunteers should also be aware that many of the expenses a person may incur while volunteering are deductible. Although individuals may not deduct the value of time spent volunteering (even if they are skilled professionals who normally would charge for the same services), other items such as parking, transportation, and unreimbursed out-of-pocket expenses may be deductible.[2]

One of the best ways to operate an arts organization with efficiency is to adopt personnel policies that are professional and consistent. Such policies also should reflect consideration of the laws in the state where the organization is incorporated. State laws can impact, for example, contracts with different kinds of employees and the extent to which the organization is **liable** for injury or other

misfortune to employees, volunteers, and contracted workers, as well as unemployment issues and **grievance** procedures.

THE ORGANIZATIONAL CHART

One of the main functions of the management of any organization is creating an organizational and structural system that will serve the organization's needs and mission. You can see from the complexity of functions that must operate smoothly and the number of people involved in the planning and execution of the artistic product that organization is essential for the arts not-for-profit.

According to William Byrnes, four benefits can be derived from a good organizational system:

1. Making clear who is supposed to do what
2. Establishing who is in charge of whom
3. Defining the channels of communication
4. Applying resources to defined objectives[3]

Sometimes people wrongly assume that a not-for-profit, because of the presence of volunteers and the need to concentrate on mission more than profit, can operate in a more casual manner than a for-profit business. Even though the atmosphere in an arts not-for-profit may be more informal than the environment found in a typical corporate structure, and even though volunteers must be treated differently in many ways than paid staff, organization remains essential for the arts not-for-profit. Not only will the job be accomplished more efficiently, but everyone, including volunteers, will be more satisfied with the work experience when the lines of communication are clear and the job is completed efficiently.

One of the ways an organization can structure working relationships is with an **organizational chart**. The organizational chart lists all of the working functions of the organization, both governance and management, and shows the relationship of each function to other functions as well as the type of work performed within

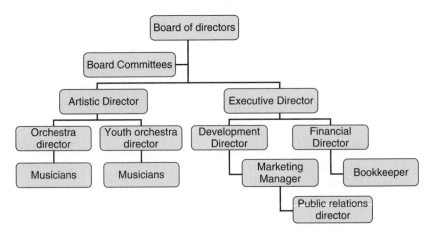

Figure 6.1 Sample Organizational Chart

each function. It should be clear from reference to an organizational chart who supervises whom and who is responsible for what within the total work structure.

The chart for an arts organization will have a special need to categorize the relationship of board functions and volunteer activities to the activities of paid staff, and the relationship of the artistic and administrative functions to each other and to the board of directors.

The example on page 86 is a simple example of an organizational chart for a musical organization. Obviously, since it is wise to include all four types of workers on the chart, most organizations will have a chart that is more complex.

PERSONNEL MANAGEMENT

"Some people say that the arts need to operate more like a business. I say that most businesses need to operate more like the arts."

—Paul Meinke, small-business owner,
Green Bay, Wisconsin

Many of those who have worked in arts organizations have heard is said that the arts "need to operate more like a business." This phrase, sometimes spoken by corporate executives being approached by arts organizations for funding, reflects a bit of frustration at the informality of many arts organizations and even, perhaps, a basic misunderstanding of the nature of the arts not-for-profit, which is always to operate with volunteers, a high degree of turnover, and workers with more enthusiasm than training.

This does not mean, however, that arts organizations must be unprofessional or inefficient, or casual in treatment of staff. All staff, whether they are salaried, unpaid, or contracted, should be treated in a businesslike way. The work of the organization, as with any business, will be accomplished most efficiently if the organization meets the following criteria:

- Understands its legal responsibilities with regard to all types of employees
- Creates clear job descriptions and terms of employment
- Adopts personnel policies that protect both workers and the organization

Not-for-profit corporations are operating in the public service, not to benefit private individuals. This is one reason that personnel policies need to be as transparent as possible, even when this is not a specific legal requirement. Creating and publishing personnel policy manuals, posting employment notices in public places, and conducting employee reviews with opportunity for input from a variety of people are some ways of achieving transparency.

Lines of Communication

The organizational chart shows lines of communication among staff members, departments, and the board. An organizational chart makes it clear who reports to whom and clarifies job responsibilities within the system. All types of personnel,

including contracted workers, volunteers, and board committees, should be included on the organizational chart.

Staffing

As noted earlier, each organization determines the kinds and numbers of staff that will be necessary to perform the work of the organization. Staffing structure and personnel policies are up to the board of directors. Naturally, the board will want to accomplish the work of the organization while using its financial resources as efficiently as possible, but a good board will understand the difference between simply saving money and getting the job done properly. Before artists are hired, the board must decide what criteria will be used to judge artistic quality.

Once the board has approved policy and budgetary decisions regarding employees, the members will hire the chief executive, who is then responsible for hiring the rest of the staff (including most volunteers other than board members and committees). Sometimes, however, the artistic director, too, reports directly to the board and is hired and overseen by the board, not the executive director. The larger the organization, the less the involvement of the board in hiring and maintenance of most of the staff. In a small organization, on the other hand, the board president or a personnel committee may be involved in approving job descriptions, salaries. and personnel policies. The board may also be called upon during a grievance process or employee disciplinary situation.

Job Descriptions

Once a staffing structure and positions have been designed, job descriptions can be constructed that outline the areas of responsibility, specific tasks and duties, and measures of evaluation. A job description usually also outlines the **chain of command** and may list terms of employment.

It is important for every worker, even volunteers and contracted workers, to have a job description. A well-constructed job description can serve as a basis for evaluation, eliminate misunderstandings about responsibilities, and provide a guideline for supervisors. It's also a good idea to create job descriptions for functional areas such as committees. The board is usually involved in creating or approving job descriptions for the chief executive and for volunteer committees that report directly to the board. The chief executive, department supervisors, or committee chairs create job descriptions for their areas of supervision. **Accountability** at all levels is important to ensure that the mission of the organization is safeguarded.

See Appendix 14 for an example of a volunteer job description.

Hiring

When a vacancy occurs in the organizational chart, the organization must decide how to advertise the position and screen for the best candidate. In a traditional situation, a position is advertised, applications are accepted, and applicants are screened and interviewed. As noted earlier, the board is the primary actor in hiring the chief executive, who then hires the rest of the staff. In smaller organizations,

Case 6-1

Case Study: Writing a Job Description

Writing job descriptions is one of the most important tasks any organization undertakes. A good job description is creative, accurate, and thorough; it can attract the best people to the position, give them strong direction and eliminate misunderstandings. Job descriptions should be considered dynamic documents and should be examined and revised whenever new personnel are added and annually, in the case of returning workers.

Although specifics of job descriptions can vary, all job descriptions should include the following:

- Hours and time commitment (including beginning and ending dates, if applicable)
- Overall job description and specific duties
- Chain of command
- Qualifications for the job
- Benefits (or perks) that the worker will receive
- How to apply (if used during the hiring process).

For more information on writing a job description, take a look at the following:

- Free Management Library (www.managementhelp.org) – click on "Employee Performance" and then "Employee Job Description"
- TechSoup (www.techsoup.com) – search for "Write a Volunteer Job Description"

though, a personnel committee is sometimes involved in the process, with duties clearly defined for all parties. This arrangement can help protect the chief executive and ensure the fairness of the hiring process.

Prior to initiating the hiring process, the organization must decide on the application procedure that is most conducive to hiring the most qualified candidate. Many arts organizations hire performing artists on the basis of auditions, and so criteria for selection must be developed, as well as a process that is fair and defendable. Sometimes, auditions (particularly those involving union artists) need to be conducted under conditions set forth by representative organizations such as the Actors' Equity Association or the American Federation of Musicians.

Employment Terms and Contracts
Once a candidate for a position has been selected, an offer is made. A formal offer of employment, signed by the president or CEO of the organization, should include the terms under which the employee has been hired, salary (if paid), and benefits offered. Employment contracts are subject to state law. It helps to have a lawyer regularly review employment contracts and letters of agreement to make sure they are in compliance with applicable laws.

Because all arts organizations are different, the terms under which employees are hired can vary widely from organization to organization. Many not-for-profits, especially smaller ones, have traditionally offered fewer "standard" **fringe benefits** such as health insurance or life insurance, because the costs of covering fewer than

five employees can be difficult to absorb. Many smaller organizations prefer to channel the most resources possible into their mission, rather than pay for benefits. There is increasing awareness, however, of the need to treat arts workers as professionals and not to undervalue their service by assuming that the flexibility and informal nature of an arts job will be enough to attract desired candidates. Most organizations also understand that not offering benefits automatically limits the applicant pool to those who don't need them. So, arts organizations are beginning to think creatively about how benefits can be offered while respecting the limited amount of funds available to pay for them. Some organizations pay the employee a direct **pretax** sum, which he or she can apply to the health care or retirement plan selected. Others offer a menu of benefits, such as **flex time**, reimbursement for expenses such as parking and work-related travel, professional development opportunities, or child care credit.

Evaluation

At some point, it is necessary to determine whether a worker has performed the job to the satisfaction of his or her supervisor and the board. Regular evaluation of employees (including volunteers and board directors) and a clear, written evaluation policy protects both employees and the organization. Employees who are told during the hiring process when and how they will be reviewed, and whose reviews take place in a fair environment with standard procedures and open input, will have no cause to fear the occasion. It is especially important in small organizations, where the process can be more intimate, to create conditions that ensure that personal feelings (either for or against the employee) have less opportunity to sway the evaluation. The review or evaluation process can be an important opportunity for employees and supervisors alike to set goals for the upcoming year, both for job performance and for the professional/personal development of the individual.

VOLUNTEERS IN THE ARTS ORGANIZATION

The presence of volunteers in the arts not-for-profit provides the organization with a dynamic influx of enthusiasm, energy, and skill. People volunteer because they feel strongly about working to make the world a better place. They believe in the organizations they volunteer for, and are passionate about the work they do. At the same time, the organization is dependent on that passion to accomplish its work. It is important for arts organizations to recruit the best volunteers they can find and to treat them well.

Volunteerism Today

Americans have always been generous with their time and have understood the need to volunteer. The nature of volunteerism, however, is changing. A generation ago, there was a ready-made corps of volunteers made up of retired citizens and homemakers. Now, more people are joining the workforce and staying there longer.

Case 6-2

Case Study: Interesting Facts About Volunteerism in America

America has always relied on volunteers to do much of the important work of the not-for-profit sector.

- In 2011 volunteers contributed over 8.1 billion hours to not-for-profit organizations.
- This translates to a value of over $173 million if those workers were paid.
- Millennials, Gen Xers, baby boomers, and older adults all volunteer at similar rates.
- If volunteers were added to the paid workforce, some estimate it would be the largest employment sector in America.

Source: The Corporation for Volunteer Service: http://www.volunteeringinamerica.gov/Infographic.cfm

At the same time, new people are entering the volunteer workforce. They are represented by the following categories:

- Students required to accumulate community service or internship hours
- Professionals developing credentials for promotion or leadership opportunities
- Employees of firms who make a commitment to support local not-for-profits as their contribution to the community

While these changes have created a greater diversity in the volunteer pool, they have also led to a change in the expectations of volunteers. Many new volunteers today have busy lifestyles and multiple priorities, hence less time to devote to a single organization or task. In response to this reality, many organizations are redesigning their volunteer duties, creating single-task, ad hoc committees, designing unique tasks that can be done with little training and in a limited amount of time, and considering paid coordinators (also volunteers) to manage the larger numbers of volunteers flowing through the organization.

It's important to note that not-for-profits don't use volunteers simply because these entities aren't "real" businesses and can't afford to pay employees. The use of volunteers allows the use of the maximum financial resources in support of the organizational mission. Volunteerism also gives the not-for-profit organization access to the input, talents, and skills of a wide variety of the public. The practice spreads the word about the organization through the community, creates a greater sense of ownership of the not-for-profit by community members, and helps ensure that the programs of the organization are valid and useful.

Why Do People Volunteer?

Why do people volunteer? There are many reasons. Thomas Wolf lists some of them in *Managing the NonProfit Organization in the Twenty-First Century*:[4]

- Sense of self-satisfaction: to feel needed, to earn respect or just to have fun
- Altruism: to help others

- Companionship: meeting people and spending time doing something worthwhile with them
- Learning: collecting experience to increase job opportunities or just to learn something new
- Devotion to an organization: belief in what the organization does
- Creating professional contacts: meeting community leaders and networking
- Prestige: interacting with prestigious organizations and people
- Fulfilling requirements: students wishing to acquire community service credits or to complete class tasks
- Perks: special benefits such as behind-the-scenes access, invitations to parties with artists, free tickets, or T-shirts and other merchandise can provide incentive to some volunteers

One of the best ways for an arts organization to be able to recruit and keep high-quality volunteers is to understand the motivations of people who are likely to volunteer. An organization that assumes that people volunteer just because they love the organization and want to support it (or support the arts) may miss out on excellent volunteers who wish to be associated for different reasons. An organization that is aware that people may volunteer for many different reasons will also be on the lookout for ways to increase and emphasize desired benefits. For example, organizations that work with students or interns who are anxious to learn job skills and build up résumés will want to provide training in specific skills or let students know that they will receive a letter of recommendation at the conclusion of their volunteer time.

The great generosity of Americans notwithstanding, there are also several barriers that keep people from volunteering. Any organization wishing to use volunteers must consider these factors during recruiting:

- Lack of time: many people believe that they have relatively little leisure time. Demands on time, from work to school to family responsibilities, leave many feeling that they have no time left to give to the community.
- Fear of commitment: people who perceive volunteerism as an ongoing commitment may be reluctant to get involved in something they can't easily get out of.
- Societal expectations: a generation ago, people who did not work for pay were expected to do a certain amount of volunteer work in the community, most often for their house of worship or their child's school. Now, there is less expectation—and fewer people available who are not working.
- Social fears: a potential volunteer who doesn't know anyone in the organization may find it difficult to make a commitment.

Arts organizations that are successful in recruiting volunteers are able to dispel fears as well as appeal to needs.

Preparing for Volunteers

Just as it is necessary to prepare for paid employees by planning job descriptions and making sure that each worker has the resources to succeed, it is necessary to prepare

and plan for volunteers. The organization considering volunteers should carefully spell out job descriptions and lines of communication and authority and should ensure that everyone has adequate work space and access to essential materials and supplies. Many organizations have paid or unpaid volunteer coordinators, who have primary responsibility for implementing and monitoring the volunteer program.

Organizations that use volunteers should also secure and maintain proper insurance coverage and publish policies regarding volunteer responsibilities, rights, and procedures.

Before recruiting volunteers, organizations are well advised to determine what skills and types of people are being sought. If special skills, training, or particular ages or backgrounds are important to the organization's needs, such factors will be part of determining where the search will be carried out.

Where does an organization find volunteers? If it has an established volunteer program or high visibility in the community, it may be able to fill volunteer ranks simply through word of mouth. But for most organizations, recruiting good volunteers requires time and care. Recruitment should focus on the volunteer, not the organization. The goal is to attempt to find the most qualified candidates while ensuring that people who sign on do so with a full understanding of their responsibilities and a commitment to the organization.

Recruiting Volunteers

Organizations looking for volunteers usually employ a variety of techniques to find them. We mention several approaches to recruitment next.

Case 6-3

What do Volunteers need to Know?

Before agreeing to serve an organization, there are basic questions a volunteer may ask. Below is one assessment by a leading arts management expert as to what organizations should be able to answer when recruiting volunteers. How can an organization provide this information?

Potential volunteers will want to know:

- Who is your organization?
- Why do you need volunteers?
- What will a volunteer get out of working with you?

You should be able to demonstrate to a potential volunteer that:

- Your organization is a worthy, credible one;
- Your organization can provide a meaningful, fulfilling and challenging experience while being flexible given the volunteer's time limitations and need for appropriate training;
- You have specific opportunities in the form of job descriptions;
- Others with similar experiences have been involved in a productive way in the organization.

Advertising and Publicity

An organization may wish to send out a news release or consider paid advertising in, for example, local newspapers, company newsletters, or chamber of commerce publications. Specialized media, such as a Spanish-language newspaper or a Christian radio station, offer access to specific segments of the population.

Community Partnerships

Ongoing relationships with local chambers of commerce (and other economic development groups and committees), government agencies, senior centers, houses of worship, and other community not-for-profits can provide links to volunteers. Key people associated with these partners can recruit personally, or the organization can place information about opportunities in newsletters or bulletin boards.

Educational Institutions

Many high schools today require students to perform community service hours as a prerequisite for graduation. Many organizations maintain specific tasks that can easily be done by students with little previous connection to the organization. Arts organizations have also found success working with music, theater, and art programs, and with student organizations devoted to artistic causes. At the college and university level, many students seek internships, which allow them to develop job skills in a controlled setting. Many organizations work with local educators and college faculty members as a way to keep the organization's needs in mind when the schools are placing students.

Businesses and Corporations

Businesses and corporations often find it advantageous to encourage volunteerism in their employees. Having employees out in the community promotes the business as a good corporate citizen and offers it a way to support organizations its employees care about. Many businesses even provide paid time off to volunteers, or match employee volunteer hours with financial gifts to the organizations.

Volunteer Agencies

In many communities, volunteer placement agencies act as clearinghouses for volunteer placement in several local not-for-profit organizations. The volunteers register with an agency, indicating the types of jobs and organizations they are willing to serve. Organizations that contact the agency then receive lists of potential volunteers. Several national organizations, such as the Service Corps of Retired Executives (SCORE), Retired Senior Volunteer Program (RSVP), and Business Volunteers for the Arts (BVA) provide specialized volunteers. The local arts council or chamber of commerce is likely to know what volunteer agencies exist in each community.

The chart on the next page lists some of the places where volunteers can be found.

SOURCES OF VOLUNTEERS

Volunteer Agencies	Community and Professional Organizations	Youth/Students
Volunteer Center	Civic organizations	Schools (community service coordinators)
Volunteer Action Center	Church groups	Schools (students)
City Cares of America	Trade associations	Clubs (scouts, arts-related clubs)
Business Volunteers for the Arts	Fraternal organizations	Church youth groups and music programs
Volunteer Lawyers for the Arts	Labor union	College and universities (student organizations)
Americorps		Colleges and universities (interns)
VISTA volunteers		
Seniors	**Specialized Needs**	**Other Sources**
Senior centers	U.S. Army Corps of Engineers	Job Corps/career counselors
Retirement communities	Telephone Pioneers (retired telephone workers)	Urban League
Churches		Ethnic organizations
Councils on Aging	Service Corps of Retired Executives (SCORE)	Political/advocacy organizations
Retired Senior Volunteer Program (RSVP)	Volunteer Lawyers for the Arts	Neighborhood associations
Service Corps of Retired Executives (SCORE)	Prisoners/individuals with community service sentences	VSA Arts
AARP		Associations for Retarded Citizens
Learning in Retirement programs		

Care and Feeding of Volunteers

Finding the right volunteers is only one part of a successful volunteer program. Keeping the volunteers you have is another. Successful organizations will work hard to make sure volunteers stay successful and happy.

Selection

In some circumstances, it's appropriate for an organization to accept any volunteer who applies. In other cases, it is most valuable to both the organization and the volunteer to make sure that appropriate candidates are selected through an open, fair, and informative selection process. Volunteers who are accepted should receive a memo of expectation outlining duties, hours, responsibilities, and goals.

The rejection of some would-be volunteers doesn't have to mean hard feelings or bad public relations for the organization. Instead, it can provide an opportunity to share information about the organization; in addition, it is easy enough to ask a

rejected volunteer for permission to contact him or her if an appropriate opening becomes available.

Orientation

Once volunteers have been selected, it is important to orient them to the organization, the tasks to be performed, and the individuals' responsibilities. **Orientation** helps volunteers by ensuring that they understand their duties and can be enthusiastic advocates for the organization; the process helps the organization by ensuring that work is performed successfully in a positive atmosphere. Orientation should include information not only about the tasks to be performed, but also about the organization and its goals, as well as talking points for responding to questions that may be asked by the public. Even a volunteer who seems to know a great deal about the organization will benefit from orientation.

Recognition

We have discussed some of the benefits volunteers hope to receive from the experience. Since the organization is not paying them, it is important that they receive recognition and reward for the important work they do for us. In designing recognition programs, successful organizations tailor rewards to the needs of the specific volunteers—for example, providing a letter of recommendation to a student or organizing social activities for singles.

Two of the most important aspects of recognition are making volunteers feel needed and making them feel like an integral part of the organization. Creating meaningful work, promoting good workers to positions of increased responsibility, sharing "insider" information, and allowing volunteers to meet and interact with staff and board members are some ways to achieve these goals. Many organizations schedule regular volunteer recognition banquets or comparable events. Others provide free or discounted tickets (the opportunity to see performances is a prime motivator for performing arts volunteers), T-shirts or other free merchandise, or special name tags; some allow volunteers to use the organization's facilities for birthday parties or other events.

Other ways to honor volunteers include promoting their service with news releases, feature articles in the newspaper, thank-you notes, letters to the editor, "Volunteer of the Year" awards, and features on the website.

Figure 6.2 Many organizations use bumper stickers or window clings, which can honor volunteers at the same time they promote the organization.

The Artistic Volunteer

Many volunteers seek out the arts because they have artistic aspirations them-selves. They may be interested in volunteering for an arts organization because they believe they can promote their own art or be involved in artistic decision making. It is important for the arts organization to be clear about the use of volunteers in artistic situations. Artistic decisions should have clear expectations so that decisions do not become personal or a reflection of artistic quality.

Other people volunteer for the arts because they like to be around artistic people. While they may not desire to be in the limelight, they are attracted by the magic of making art and happily work behind the scenes painting sets, lining up props, and setting up music stands. If the motivation for volunteering is to help the arts to happen, a volunteer will quickly become frustrated with stuffing envelopes and entering names into a database. A wise organization will make sure all that volunteers touch the arts in whatever ways are appropriate.

IN CONCLUSION

While managing personnel in the arts organization may indeed be, as some have suggested, "the management of egos," it is important for the organization to adopt policies and practices that allow the organization to achieve its goals through efficient use of personnel. Paid, unpaid, contracted, and outsourced workers all have important roles in the not-for-profit arts organization.

DISCUSSION QUESTIONS

1. Can you tell from the organizational chart on page 86 which of these functions are performed by paid staff and which by volunteers or contracted workers? How? Is the employment status of staff useful information on an organizational chart?
2. If an arts not-for-profit is not able to offer health care or retirement benefits to its employees because it is too small to get competitive rates, what options are there for hiring employees who need these benefits?
3. Think about occasions in your life when you've volunteered for a school, church, or community organization. What was the nature of your volunteer commitment?
4. What were your reasons for volunteering?

Program Planning and Evaluation

"The spirit of Creative America has spurred us to say and write
and draw what we think, feel and dream . . . to celebrate in
dance, in songs, in paint and on paper, the story of America; of
who we are, where we have been, and what we hope to be."
—HILLARY RODHAM CLINTON, QUOTED IN
GARY O. LARSEN, *AMERICAN CANVAS: AN ARTS
LEGACY FOR OUR COMMUNITIES*, 1996

In the planning of programs and activities, arts organizations face a number of
variables. Thus it is important to ensure that programs are consistent with the
organizational mission, that they are feasible given internal and external resources,
and that adequate information is available to measure success and improve the
program. The organizations that stand the best chance of accomplishing their
goals are those that determine measures of success for their programs, study feasi-
bility when adding new programs, and systematically evaluate the results.

The first facet of this process is deciding what programs the organization will
undertake. All of the governance and management activities of an arts organization—
developing a strong board of directors, establishing an organizational system, cre-
ating a mission, adopting financial procedures and budgets, raising funds—are
ultimately in place to support the arts' primary business: bringing arts to audi-
ences. But what arts, when, and how often? Out of a world of choices, how does
each arts organization decide what to do? This chapter describes some of the vari-
ables in that process.

Another important part of the process is evaluating programs once they are
up and running. A strong evaluation process helps protect the mission of the orga-
nization by ensuring that programs are accomplishing their stated goals in the best
way possible.

Program planning is related to stewardship: making sure that money given to
accomplish the organization's mission is used responsibly. It is also about making
efficient use of the organization's human and financial resources, and serving
community needs. We'll deal with all of these issues here.

When you finish this chapter, you should be able to:

- Explain the meaning of "mission-based programming" and describe how
 arts organizations base program planning on their missions

- Evaluate the feasibility of a program based on financial resources, human resources, and community factors
- Consider how community relationships, working with artists, and artistic controversy affect program choice
- Develop measures of success for a program and evaluate its success based on those measures

MISSION-BASED PROGRAM PLANNING

Any organization's general guidelines for program development start with the organization's **mission**. Because the Internal Revenue Service grants a not-for-profit **tax-exempt status** based on a particular mission, a **501(c)(3)** charitable organization is above all legally obligated to use its resources in support of this mission. For example, an organization that is granted 501(c)(3) status based on a mission to provide arts education for teenagers will quickly find its exempt status in question if it's found that the bulk of its activities involve exhibiting visual art produced by adults.

Mission-based programming is more than a legal issue. Not-for-profit organizations are supported by donors who have contributed because they support the mission of the organization. The organization therefore bears responsibility for making sure the funds are used appropriately and that the programs planned advance the cause for which the contributions were given.

The first question, therefore, that an organization must ask is, "What programs or activities can we do that will best help us to accomplish our mission?" This may also involve considering what programs or activities might be prohibited by the mission. An organization that receives tax dollars from a particular city, county, or state might be restricted in offering services outside that area unless it is clear that the primary constituents are adequately served. An organization dedicated to exhibiting the art of contemporary American artists will need to discuss how a proposed exhibit of Impressionist masters can be said to advance that mission.

FUNCTIONS OF ARTS ORGANIZATIONS

A basic component of defining programming has to do with the overall function of the organization. An organization may be a **presenter**, a **producer**, a broadcaster, a museum, or a service organization. Although some organizations limit their activities to a single function, most do not, even if the primary function is well defined. A performing arts center whose primary mission is to present touring productions of musical and theatrical acts may also find itself scheduling educational programs or working with a local public radio station to broadcast a concert. An exhibiting organization may have a gift shop that sells work of local artists. Many organizations are diversifying their activities because of competition and need; some have begun sharing programming with other organizations to maximize resources.

FUNCTIONS THAT ARTS ORGANIZATIONS PERFORM

Function	Definition	Examples
Presenting	Hosting touring performances produced by others	Performing arts center; lively arts series; speaker series
Producing	Creating performing arts productions	Community theater company, choral ensemble, dance troupe
Curating and exhibiting	Selecting and presenting exhibits of visual art or historical artifacts	Art museums, history museums, galleries
Educating	Presenting educational programs to children, youth, or adults	Art, music or theater classes, pre-concert discussions, meet-the-artist events
Preserving	Ensuring the preservation of works of art, historical artifacts, monuments, folk traditions, or languages	Museum collection, recording folk music, documenting ethnic traditions
Teaching	Scheduling classes, workshops, or other educational activities	Music, dance or art schools, senior centers, public schools
Serving	Providing services to other arts organizations or the community	Arts council, economic development organization, government agency
Communicating	Broadcasting or disseminating the arts via recordings or multimedia	Public radio and television, independent radio stations, websites, recorded music
Selling	Selling artistic creations or related merchandise	Outdoor art fair, museum gift shop, art gallery, music store

ARTISTIC CONSIDERATIONS IN PLANNING

When a manufacturer goes into business, it must decide not only what products it will make but who will buy them. The answers to those questions impact a variety of other financial and management decisions, from whether to make products that will transport well to the quality of product the desired customer will be able to afford. An arts organization is no different, but issues of quality and artistic "product" are often subjective and difficult to define. To avoid disagreements and disappointments among visionary artists, passionate board members, and practical staff members, the leaders of a wise organization will discuss artistic issues and choose an artistic direction with the same thoroughness they used to develop and adopt a budget or create a marketing plan.

Artistic Quality

No arts organization wants to deliberately create or present bad art. But each organization will define its measures of artistic quality according to many criteria. A community theater, for example, may find it more important to cast a variety of community members than to keep starring the same actress, even though she is the best in town. On the other hand, that same community theater may decide to hire a professional technical crew to ensure that its volunteer actors can concentrate on acting and not hanging lights or painting sets in between calls.

Artistic quality is very subjective. Two people who are present when the same work of art is performed or exhibited can have very different experiences. An arts organization can avoid endless nonproductive discussion about whether the recent exhibit or concert was "good" by being strategic in developing measures of success and general artistic principles, and then making sure that each person in the equation knows his or her responsibilities.

Artistic Direction

Many arts organizations have an artistic director, head **curator**, or other person in charge of artistic direction. Others choose to operate without a single artistic director but have people in charge of different artistic functions, like a different stage director for each play or separate curators of art, history, and education. In some organizations, the executive director or the CEO performs both artistic and administrative functions.

Many organizations develop an artistic **niche**, concentrating on a well-defined, specialized area such as Impressionist paintings or contemporary American plays. Decisions to specialize often arise from the artistic passions of the founders of the organization and can result in a very successful strategy, especially when the particular specialty is unique to the community. However, organizations that elect to specialize must also consider the practical ramifications of such a decision. Are there enough lovers of Gilbert and Sullivan operettas in the community to support such programming? If not, how can the organization market to a broader geographic area, increase knowledge of the art form, or perhaps use technology to increase needed support?

The format the organization chooses is based on its mission, resources, and management structure. In every case, however, the board is ultimately responsible for the artistic direction of the organization, as it is responsible for all policies that govern the organization's mission. Adhering to this responsibility is especially delicate when the artistic direction is centered on the vision of a founding director or a charismatic personality. The founding director may have been the driving force for the creation of the organization; the charismatic personality may have enabled it to attract a wide following. A 501(c)(3), however, is bound by legal requirements (and it can't be said often enough!) to ensure the ongoing success of the organization, not individual personalities.

Working with Artists

An organization that has determined its standards of artistic quality and a process for making artistic decisions is well on its way to developing a program for working

with artists. Artists, of course, are the key to successful arts programs, but that doesn't mean that organizations will automatically be organized and professional in dealing with these professionals.

It is important to include artists in all phases of the planning process. Working side by side with appropriate board and staff members, artists can help design programs that are sensitive to both artists' needs and audience tastes. Many arts organizations ask artists to serve on boards and committees, and seek out specialized help when new programs are being developed or ongoing programs evaluated. Artists can also serve on selection committees and juries, design audition criteria, and help formulate procedures manuals. When the National Endowment for the Arts and many state arts agencies evaluate grant applications, they look for a strong artistic direction and clear evidence of artist involvement.

Organizations that have developed artistic policies will be wise to communicate them to all involved in the organization, including staff, contracted workers, and volunteers. It is important, for example, for a guest curator to learn that public forums and lectures are a part of her job, or for a guest conductor to know that the organization expects that auditions will be advertised throughout the state. Similarly, when artistic policies are communicated to docents and ushers, these volunteers will be able to answer questions from the public in a way that advances the organization's goals.

It is also necessary to develop policies that treat artists professionally and with respect in the work environment. In addition to paying artists fairly, an arts organization should be especially sensitive to the way artists are sometimes treated by those who don't understand their needs. Arts organizations should, for example, structure schedules in consultation with artists to allow adequate time for rehearsal, warm-up, or other preparation, just as they should provide a deposit against future payment if the artists will be incurring out-of-pocket expenses for, say, materials.

One "pet peeve" frequently cited by artists consists of requests by businesses and organizations to donate work, on the premise that the market exposure the artist receives will be adequate compensation. (If this seems like a logical request, imagine asking a retail store to donate products to a charity auction "for the exposure.") For example, one performing arts center recently sent out e-mails asking local musicians to perform in the lobby prior to a scheduled production. "We don't have any money to pay you," the arts center said, "but we will be happy to promote your appearance in all of our advertising for the evening's event." Some musicians grumbled that the arts center was attempting to boost their patrons' audience experience (and therefore future ticket sales) by using local performers without any consideration of how valuable those musicians were to furthering this goal. Others agreed (some even negotiated free tickets), but were burned when the "marketing exposure" turned out to be a line in the ad that read "Come early for free jazz music in the lobby!" An arts organization, more than any other business, should be expected to understand the value of what artists do.

Cultural Sensitivity
Whether it be a desire to bring new audience members into the circle of the organization, a need to share culturally specific work with current audiences, or an

opportunity to reflect the changes occurring in a given community by bringing together partners representing a variety of ethnic and socioeconomic groups, many arts organizations today offer wide diversity in their programming. As Grams and Farrell state in *Entering Cultural Communities*, "Today's changing cultural environment presents not only challenges but also an important opportunity for the arts to contribute to the livelihood and liveliness of their local communities."[1]

Diversification requires a great deal of cultural sensitivity. If, for example, programming is scheduled without including the affected community in decision making, an organization runs the risk not only of looking elitist but of ignoring important cultural issues. Thus it's important to prepare performers to show flexibility when some audience members clap at the "wrong" time; similarly, consultation with representatives of a community that honors its pre-Columbian heritage can prevent the organization from committing the major faux pas of presenting sacred objects in a disrespectful way. Careful planning and a respect for the art to be presented is essential.

Figure 7.1 Cultural Sensitivity

Art and Controversy

It has been said that where there is art, there is controversy. In recent years, we've heard about controversies ranging from boycotts and withdrawal of funds from museums showing works by controversial artists to outrage expressed by citizens at public art exhibits or other works deemed to be insensitive, offensive, or even blasphemous by certain groups of people. But controversy over art is not unique to our time. By its very nature, art is emotional and can cause strong feelings either for or against an individual work. All arts organizations that produce good art should be prepared for the likely need, at some time, to deal with controversy.

It's important to remember that controversy is not the same as **censorship**. Censorship involves removal or withholding from the public of something (whether it be a work of art, a piece of literature, or another form of artistic expression) by a controlling agency, perhaps a government, a religious authority, or, on a smaller scale, a governing organization. Often, parties who are the subject of controversy cry censorship when in fact no censorship has taken place. In a democratic society, this is a delicate issue. In general, our laws support freedom of expression, but the debate continues as to whether there are circumstances under which censorship of art or expression is acceptable.

Controversy is especially prevalent in the growing field of public art. While many communities are increasing **public funding** for art that has been paid for with tax dollars and is viewable by the general public, the art may become the center of a controversy if taxpayers don't like or don't understand it.

How does an arts organization handle controversy? Not necessarily by attempting to avoid it—many a museum or city council has found itself in the midst of an emotional situation despite having taken every precaution to plan uncontroversial programs. Controversy can arise from objection to subject matter, but it can also arise when artists feel slighted by a selection process, when citizen groups feel underrepresented, and even when governmental officials want to have a say in artistic selection.

Some of the common kinds of controversy entail subject matter; issues specific to time, place, or site; and the use of public funds.

Controversy over Subject Matter

Controversy most commonly arises over subject matter. Works of art that portray or present material that is perceived as offensive, including (but not limited to) nudity, sexual, religious, or cultural images, have been the subject of controversy throughout history. In 1863 Édouard Manet's painting *Déjeuner sur l'herbe (Luncheon on the Grass)* was scandalous for its portrayal of casual nudity in contemporary subjects. More recently, in 1999, an exhibit entitled *Sensations: Young Artists from the Saatchi Collection* was the subject of controversy at the Brooklyn Museum for including, among other things, a painting entitled *The Holy Virgin Mary*, in which the artist had emphasized his African heritage by including elephant dung in depicting Mary. "*Sensations*" was a part of a national debate about whether taxpayer dollars should fund controversial art.

Controversy Specific to Time, Place or Site

Sometimes a work of art that would attract little attention in one time or place can become controversial later, or because of the specific circumstances surrounding the work. *Blue Shirt*, a sculpture by Dennis Oppenheim scheduled to be installed at the General Mitchell Airport in Milwaukee, Wisconsin, was eventually scrapped because some citizens objected to what they perceived as an outdated portrayal of Milwaukee as a blue-collar community. Eric Fischl's *Tumbling Woman* was removed from the lobby of Rockefeller Center in New York City in 2002 for an entirely different reason. Although the sculpture was intended to honor the people who died falling from the Twin Towers of the World Trade Center on September 11, 2001, many saw the realistic nude as an inappropriate and distressing reminder of those deaths.

Controversy over Use of Public Funds

When taxpayer dollars are used to fund art, there are often those who complain about the way those dollars are being spent. Their objections have ranged from questions of cost ("Why are we funding this when our dollars are needed else-where?") to content ("I don't want my tax dollars funding projects with which I disagree."). In recent years, several controversies have sprung up with regard to art in prisons. Some argue that people who are being punished by incarceration should not have access to arts programs. Others argue that works of public art in prisons are not accessible to the general public and therefore should not be paid for with public funds.

Case 7-1

Case Study: Controversy from Members of the Public

A local arts council engaged in a public art project that placed temporary exhibits and installations in empty storefronts in a downtown area. Called "phantom art galleries," these exhibits were intended to encourage downtown revitalization by making the recipient neighborhoods seem less empty. A community member complained about the exhibit that happened to be located in a storefront directly across the street from her office window, stating that a nude image it contained offended her. Since she had no choice but to look at the exhibit during her work hours, she lodged a complaint of harassment against both the arts council and the city. She cited her belief that she had the right, while in her workplace, not to be exposed to something against her values.

As it turned out, the issue resolved itself naturally. By the time the harassment claim had worked its way through the system, it was time to change the exhibit.

Questions

1. Do you feel that the citizen was within her rights to claim harassment in this issue? Does it make a difference that the exhibit was partially supported by tax dollars?
2. If the exhibit had been permanent instead of temporary, and you were on the arts council board, what steps might you have taken?
3. What steps might the arts council take to anticipate or to deal with future similar incidents?

While arts organizations cannot always plan for controversy, they can prepare for it by maintaining access to legal counsel, adopting and publishing procedures for damage control, and making planning and selection processes as transparent as possible. Each organization also must decide as part of the planning process how much risk, programmatic or financial, the board is willing to undertake. If part of an organization's mission is to expose the public to new art, the possibility of the need to handle controversy somewhat frequently will be understood.

AUDIENCE AND COMMUNITY CONSIDERATIONS

In the "bringing arts to audiences" equation, the "audience" side deserves as much consideration as the "arts" side. Each arts organization must think about the environment in which it operates, the needs of its audiences, and the needs of the community at large. As with art, these issues are only partly defined in the mission statement. There are many other decisions for the arts organization to make.

Audiences and Stakeholders

For whom do we create art? The answer, of course, is everyone . . . but only some people will experience our programs directly. When arts organizations plan programs, part of the process involves deciding which audiences might be likely to attend or participate in those programs and how the organization will market to them.

But there are others in the community who will also be affected by what the arts organization does. Many entities and individuals have a stake in what the organization decides: the tourism bureau marketing the community to visitors, schools looking for classroom resources, companies trying to entice new employees to the area . . . even the printer who supplies the arts organization's brochures and posters. All of these, and many more local citizens, businesses, and groups, can be considered to be **stakeholders** in an arts organization's decisions. Therefore, their concerns should be aired and respected during planning.

Understanding that the arts organization is a vital part of the civic environment that nurtures it enables arts organizations to plan with a broader focus in mind. This doesn't mean changing the mission to develop programs just because the Visitor and Convention Bureau thinks tourists will like them, but it may mean consulting with a variety of stakeholders during the planning process, keeping stakeholders informed of new initiatives and changes, and seeking collaborations and partnerships with businesses and civic leaders beyond those we normally think of as audiences.

Quality of Experience

An operagoer recently complained about discomforts experienced while attending an outdoor concert version of an opera that was presented as part of a summer

festival. Despite world-class singers and a first-rate orchestra, the operagoer was frustrated by mosquitoes, an increasingly chilly evening, and occasional traffic noises from the nearby highway. "I'll never go back," he ended up thinking. "If I want to watch *Carmen*, I can rent a DVD and do so in the comfort of my own home."

An audience member's experience with art begins when he or she encounters information about the performance or exhibit and continues long after the last note has been played or the last painting viewed. Although the arts organization can't control whether the audience member has had a bad day at work or had trouble finding a parking spot, it can ensure that the ticket holder will find clean bathrooms, pleasant volunteers, and comfortable seats or agreeable viewing conditions.

Discussion about the quality of the experience should be at least as important as discussion of the art itself. As with artistic considerations, the organization should be able to adopt policies that create standards for as many aspects of the audience member's experience as are practical to control.

Community Input in Planning

A not-for-profit arts organization should continually seek ways to involve the community it serves in the planning process. While it may be easier to simply plan programs that the artistic director wants to do, or that the marketing committee feels might be good audience-pleasers, seeking both formal and informal community input makes sense for a variety of reasons. The more the community is involved in planning programs, the more closely the programs will match both the organization's mission and the community's needs. In addition, community members who have participated will have more stake in the outcome of the program and will be more likely to recommend the program and the organization to friends and associates.

There may be special need for input from representatives of certain groups in the community when the organization is planning culturally specific programming (i.e., programming involving the culture or heritage of a particular cultural or ethnic population). Including members of the particular cultural group in the planning process ensures that the programming will be authentic and respectful, affording a positive experience to all audience members.

Obtaining community input, however, requires careful planning and should be conducted with a clear understanding by all parties of the pitfalls of a poorly thought-out input process. One presenter, for example, asked for input via an audience survey: "What would you like to see presented in this series next season?" The audience members listed popular performers, big Broadway shows, and other options that the small presenter in a small town couldn't possibly pursue. This planners learned that much better information would be forthcoming if they asked such specific questions as "Is it important to you to have events appropriate for the family to attend together?"

GAINING COMMUNITY BUY-IN

Most organizations that have tried collecting community input prior to making artistic decisions have found it to be a valuable process that ultimately leads to more involvement by community members. A community member who has expressed an opinion is more likely to attend a program and share information about it with friends and associates. Allowing audiences to respond after curators and artistic directors have narrowed down prices, touring dates, and suitability keeps the artistic control in the hands of the people who know the most about the artists and avoids setting up unrealistic expectations.

Some of the methods organizations are trying include the following:

- Special events where community members can view clips of potential performers to book and vote on their favorites
- Facebook contests
- Audience feedback on performances via websites or social media
- Encouraging participation on tourist and attraction sites such as Yelp and TripAdvisor
- Looping video of upcoming events at libraries or other community gathering spaces
- Offering previews at festivals followed by brief surveys

DEFINING SUCCESS

Because mission is a not-for-profit's bottom line, it follows that not-for-profit arts organizations will have different ways of defining success than for-profit businesses, whose primary concern is creating profit. Each organization will need to define its own criteria for success, not only for the organization as a whole but for each program.

Financial Success

It is always tempting to assume that a program is successful if it makes money, but financial success is only one possible criterion for the overall success of a program. With a mission-based programming philosophy, the creation of profit is not a primary goal. In fact, it may not be a goal at all. An organization may seek to simply break even on a new program, or it may adopt a goal of bringing in a certain amount of income from ticket sales and a certain amount from corporate sponsorships or grant funds. Arts organizations can also adopt different goals for different programs on the premise that some may create **surplus** revenue that can support programs that are expected to bring in less money.

Artistic Quality

Although there will usually be at least one board member who will point out, reasonably, that artistic quality won't pay the bills, defining artistic goals is an important part of determining a successful outcome for each program. Once again, because

definitions of artistic quality must be to a greater or lesser extent subjective, an arts organization that creates criteria for judging artistic quality is less likely to become mired in personal (but less useful) evaluations when the program concludes.

Size and Makeup of Audience

Audience size or numbers of participants in a particular program may be a criterion for success, regardless of whether the number chosen translates directly into revenue for the organization. It's also important to note, however, that audience numbers, like financial numbers, can be misleading. For some programs, a smaller audience of more deeply involved participants is preferable. For others, broad access is desirable. In many cases, it is also important to measure the levels of participation by desired groups, particularly if the organization's mission is to serve certain community segments or if the aim is to increase diversity among the supporters of the organization. Defining audience size goals helps board, staff, and volunteers in the task of putting numbers into the proper context once the program has ended.

Quality of the Experience

While definitions of financial and artistic success can vary, every organization wishes to create conditions under which each participant can enjoy the arts experience, as opposed to inadvertently creating barriers that discourage future attendance. As noted earlier, each organization must determine the standards used to evaluate the quality of the experience based on the needs and expectations of its own audience.

Carryover

One possible goal for a program might be to create audiences for other programs. Many organizations that plan popular events or "blockbuster" shows hope that the audiences that have experienced what the arts organization has to offer will come back for other programs. Many of the same organizations have discovered over the years that just getting people in the door does not necessarily secure ongoing loyalty. An organization that wants to create carryover from one program to another must actively cross-promote both programs. An organization can offer, for example, a discount on a season subscription to people who attend the annual holiday performance, or send letters to newcomers informing them of upcoming events.

DETERMINING FEASIBILITY

After an organization has developed an idea for a new program, tested the program against the mission of the organization, and determined measures for success, the next step is to determine whether the resources necessary to achieve that success are at hand.

It is tempting to move ahead with a program just because a majority of board and staff members think it's a good idea, or because someone is particularly passionate about the idea. A wise arts organization, however, will develop new programs carefully, compiling a great deal of knowledge before beginning. In this

section we discuss some of the factors that should be considered before deciding to begin a new program.

Finally, the organization will need to evaluate the psychic cost of adding programs. A program that seems like a splendid idea when people are sitting around the board table may seem less attractive when it becomes clear that to make it happen, the board will have to commit to resources that would stretch the organization beyond its comfort zone. The board needs to be particularly sensitive to the effect a new program will have on staff. It's valuable to remember that a good idea may well still be a good idea a year or two down the road, when adequate resources are in place.

Ideally, the organization will have enough time to conduct research to determine such factors as whether audiences or participants will respond to a new program, whether sponsors or donors will wish to contribute, or whether other programs in the area will offer competition. If a new program involves significant change or requires significant resources, many organizations will choose to undertake a **feasibility study**, involving extended research and testing of the new idea. Feasibility studies are usually conducted when organizations are contemplating building projects, formation of new not-for-profits, or embarking on major fundraising campaigns, since undertaking projects like these without adequate information can be very costly. A formal feasibility study often involves hiring an outside consultant who can be objective, as well as interviewing community members and prospective donors and collecting the data needed to make an informed decision.

Many programs do not require full feasibility studies, but that does not mean that an organization should simply proceed with a program because someone thinks it's a good idea. The more thought and research expended in the development of a new program prior to implementation, the more successful the program is likely to be.

EVALUATING FEASIBILITY: FACTORS TO CONSIDER

- **Internal factors**
 - What will the program cost?
 - Will existing staff be able to incorporate the program into current workloads, or will additional staff be needed?
 - What additional space and supplies will be needed?
 - What technology will be required?
 - What will be the effect of this program on existing programs?
- **External factors**
 - Is there a need for this program?
 - Will our intended audience support it?
 - Are there competing programs? If so, how will our program provide something unique?
 - Will we be able to obtain needed sponsorships, grants, and volunteers?

EVALUATING PROGRAMS

Evaluating programs is an important part of the development and assessment process. Obviously, evaluation helps the organization understand what worked and what didn't. But evaluation is not just something an organization does to improve programs; it is often required by outside funders as a condition of funding. Nowadays, government agencies, foundations, and even private funders require an evaluation report at the conclusion of the funding cycle. Evaluation, therefore, becomes one more important way that the not-for-profit accomplishes the mission of the organization and helps ensure future funding.

Programs should be evaluated by measuring the outcomes against the previously defined measures of success. If we were attempting to attract new audiences, did that happen? Did we achieve our artistic goals? Did the program break even, create surplus revenue, or attract the proper mix of earned and contributed income? Answering these questions calls for building methods of evaluation into the planning process from the very beginning. What will be the best way to find out what we need to know?

It's also important for an organization to understand what kind of reports the funders have in mind when they request evaluation data. For some, a simple, informal report will suffice. Because many government agencies are accountable to taxpayers, however, these bodies will expect the arts organization to employ more specific and measurable evaluation methods.

Outcomes vs. Outputs

In the evaluation of programs, organizations must be careful not to assume that completion of a program means that its goals were accomplished. An organization that sends a report to a grantor outlining when the program took place and what happened is actually stating *outputs*, not *outcomes*.

In a mission-based organization, no program is an end in itself but, rather, a means to an end. An organization that merely evaluates outputs ("We did the program, therefore it was a success.") is assuming that the goals were accomplished, regardless of whether they actually were. If, for example, the goal was to present a world premiere of a work by a local composer, then simply doing the program would constitute both an output and an outcome. But if one of the goals was to encourage young composers, the evaluation won't be complete until it's been determined whether the output (the concert, or other activities such as lectures or classroom visits) led to the desired outcome.

Many evaluators use a logic model to evaluate outcomes. The logic model assumes that there is a logical path from goal to outcome and that this path can be evaluated. There is no one right way to construct a logic model, but one way looks like this:

LOGIC MODEL FOR PROGRAM EVALUATION

Goal (intended outcome)	Activities (outputs)	Resources (inputs)	Evaluation Methods	Actual Outcomes
Increased participation by families with children aged 3–8	New 10 a.m., hour-long performance	Marketing postcard	Name capture of new families	
	Run-out performance at YMCA	Partnership with YMCA staff	Survey families	YMCA collaboration not successful due to staff changes
	Snacks after family performances	Budget for food	Ticket sales records	Families requested that they be allowed to bring healthier snacks
		Additional staff time on this project		Additional staff time did not interfere with other projects
				Participation by families increased 20% during season

Types of Evaluation

"When the cook tastes the soup, that's formative evaluation. When the guest tastes the soup, that's summative evaluation."

—Robert Stack
—Cited in Scriven 1991: 196

The most effective evaluation is able to measure outcomes from a variety of different directions. When designing such assessment programs, organizations should consider ways to include evaluations of four types: formative, summative, quantitative, and qualitative.

- **Formative evaluation**
 Formative evaluation takes place as the program is being offered (i.e., while it is still forming). During this time, some factors (e.g., participant satisfaction) can be measured that are more difficult to measure after the program is over. Formative evaluations are often more informal than other types.

- **Summative evaluation**
 Summative evaluation takes place once the program has been completed. Unlike formative evaluation, summative evaluation is postponed until complete results are known, at which time the organization can form conclusions that can be carried into future programs.
- **Quantitative evaluation**
 Quantitative evaluations involve numbers (quantities) and hard data. Examples of quantitative data are number of participants, number of tickets sold, and number of volunteers needed.
- **Qualitative evaluation**
 Qualitative evaluation has to do with more intangible measures (quality). Qualitative data can be collected systematically but is as important as qualitative data in painting a complete picture of the results of the program.

Individual reactions to art may vary widely and are often difficult to measure—yet collectively, they are our most important criterion for success. It is far easier to measure success by audience numbers or financial gain; yet a full house is no guarantee of artistic quality. Statements like "We'll know we succeeded if we get a standing ovation" or "We failed at this program because we didn't break even" do not speak to the measurement of artistic goals. But how can we measure artistic success? Many organizations build questions about artistic response into audience surveys or interviews with artists and participants after an event. Others can gauge artistic success by monitoring student progress or carryover into other kinds of programs.

Methods of Evaluation

There are several commonly used and generally accepted methods of evaluation. The methods chosen depend on the goals of the program and the organization's reporting requirements.

Evaluation methods should be developed in the formative stages of program planning and should be directly tied to success. Many funders, particularly those who disperse public funds, require the organization to list goals for the program in the form of desired **measurable outcomes**. When the program is completed, the same funders will also evaluate the success of the program according to the organization's stated goals. Measuring success will also help with strategic planning, indicating to the organization how best to allocate resources and time in the future.

As noted earlier, it is not useful, from either the organization's or the funder's point of view, to state goals too vaguely or simplistically. It may be difficult to determine measurable outcomes, especially artistic ones, but the exercise is well worth it. Careful evaluation of programs is responsible stewardship, which can help ensure not only continued success for the programs themselves but also funding for future initiatives.

Among the commonly accepted evaluation methods are counting and reporting, observation, documentation, participant response, and pre- and post-testing. We consider each of these briefly.

- **Counting and reporting**

 Sometimes the simplest evaluation methods are the best. It's important to determining how many tickets were sold, how much money was made, how many people came to more than one concert—but it's also important for the organization to determine exactly what needs to be counted. In the formative stages, the systems for data collection should be set up to enable the accumulation of accurate data. We've shown that judging the success of a program exclusively on financial or attendance data may be insufficient and does not tell how well the program performed in advancing the organization's mission.

- **Observation**

 Observation during the formative stages of a program can provide a great deal of information. However, observations recorded in a formal evaluative sense are a lot different from mere hearsay. A board member who comments, "Everyone I talked to loved the program," or "I heard somebody say that the box office line was busy for two days straight," is not providing adequate information for accurate evaluation. To be valid for evaluation purposes, observation should be carefully planned and monitored. For example, an organization might plant volunteers outside the information booth during busy hours to time how long it takes visitors to a museum to get answers to questions. Another way to collect observed data is to determine desired responses (e.g., showing completed artwork to others) and observe how many participants display the desired behavior.

- **Documentation**

 Documentation, or the creation of a record of the events that took place, can include photographs or films of activities, written reports of the planning and facilitation of the event, or collection of evidence including artwork, artists' statements, newspaper articles, and other artifacts.

- **Participant response**

 Audience and participant response to a program can be collected in a number of ways. Audience surveys and response forms can be inserted in programs, handed out as participants leave the program, or sent to selected participants after the program has ended. Interviews and focus groups give the opportunity to obtain more in-depth information and to hear discussion of responses. The particular form of audience response, as with any evaluation form, should be planned in conjunction with goals.

- **Pre- and post-testing**

 In scientific and educational research, one way to evaluate a change in behavior or amount of learning is to test participants prior to and after the event. This method can be used in arts organizations in a variety of ways. For example, an organization may randomly sample community members to find out how much they know about upcoming programs, and then sample again after a marketing campaign or introduction of a new program.

IN CONCLUSION

Bringing arts to audiences is the central focus of any arts organization. But all organizations face a number of issues when deciding which programs or activities to undertake, planning those programs, and evaluating them. The best way to ensure success for any organization is to match programs to the organizational mission, plan carefully, and evaluate responsibly.

DISCUSSION QUESTIONS

1. Visit the website of an arts organization in your community. Analyze its programs based on what its mission statement says it will do. Are the programs currently being facilitated consistent with the mission statement? Are there any areas of the mission that are not being served? Do any programs seem to be inconsistent with the mission?

2. If you are an artist, performer, director, or stage technician, what are some of the issues you wish would be addressed by organizations with which you are working?

3. Many artists would say that there are few, if any, circumstances in which the censorship of art is acceptable. What do you think? Are there situations in which you would approve censorship of art? What is the difference between censorship and being sensitive to the beliefs and feelings of ethnic, religious, or minority groups?

4. Artist Richard Serra once said, "I don't think it is the function of art to be pleasing. Art is not democratic. It is not for the people." Do you agree or disagree with this statement? Why or why not?

5. How do you define artistic quality? Are there ways to measure artistic quality other than by personal preference?

6. Nello McDaniel and George Thorn, authors of *The Quiet Crisis in the Arts*, state that "most organizations operate at least 30%–50% above their capacity."[2] What might they mean by this statement? Why would arts organizations choose to do more programming than they are capable of handling easily with existing resources?

CHAPTER 8

✦

Financial Management in the Arts Organization

"A nonprofit business is an organization driven by its community objectives and organized to obtain and manage the financial resources necessary to accomplish those objectives. If we think of this as a balancing act with mission and money on either side, a nonprofit business has achieved the critical balance between the two."

—Jeanne Bell Peters and Elizabeth Schaffer,
Financial Leadership for Nonprofit Executives

Do you think of yourself as an "arts person" or a "business person"? Or are you both?

The concept of financial management for not-for-profit organizations has undergone significant changes in the last several years. Many of those involved in the not-for-profit world have grown up with passion for the cause and a feeling that "money" is a bit of a dirty word. But recently, there has been a change of attitude toward financial management in not-for-profits. This new outlook has been ascribed to basic changes to the economy, the need to compete with all of those other organizations for funds, publicity surrounding some fundraising scandals in national organizations, and a growing interest on the part of donors in measuring effectiveness of their investments.

Financial management is not about putting money first. It's about managing money effectively to ensure the success of the organization and to ensure that the funds entrusted to the mission of the organization are used appropriately. It's about balancing mission and money.

More than one arts manager has grumbled, "I didn't get into this field because I wanted to do math." Yet financial management is much more than a tedious task that must be performed before you can get on with the fun stuff. Financial management is one of the things we do to enable the art to happen. Good financial management is one of the best ways to ensure that arts organizations survive, thrive, and bring art to the communities they serve. As Christine Burdett puts it, "Financial management is such a fundamental aspect of organizational sustainability that every board member and staff person should know the basics. The good

news is that the principles of financial management are easy to understand and well within the grasp of every key member of the organization."[1]

FINANCIAL DISTINCTIONS
OF NOT-FOR-PROFIT BUSINESSES

As we learned in chapter 3, there are significant legal and structural differences between for-profit and not-for-profit businesses. These differences also affect the way for-profits and not-for-profits organize and report their finances. The purpose of a for-profit business is to create profit for the business's owner(s) or shareholders. The purpose of a not-for-profit is to accomplish the charitable mission for which the organization was granted tax-exempt status. The essential difference in purpose has implications for how income and expenses are recorded and categorized, what information is shown on financial statements, and what kind of financial reporting is necessary.

FUN WITH ACRONYMS

Here are a few of the acronyms commonly used in accounting.

FASB stands for Financial Accounting Standards Board. The FASB is an independent (nongovernmental) body responsible for establishing standards of accounting and financial reporting in the United States.

GASB stands for Governmental Accounting Standards Board, the federal agency that regulates accounting standards.

GAAP stands for Generally Accepted Accounting Principles, a set of accounting and financial reporting standards administered by the FASB.

It's important to note that even though not all of the agencies that issue statements on accounting standards are government regulatory agencies, the effect is the same. Any business that fails to follow GAAP or to comply with standards established for its industry will soon find itself in trouble with the IRS—another good reason that a qualified accountant should be a part of any not-for-profit's management system.

The primary difference between for-profit and not-for-profit financial management is the concept of **stewardship**, the act of taking care of resources that have been entrusted to people or organizations. You might hear, for example, talk about how people should be good stewards of the environment.

In a not-for-profit, stewardship means two things. First, an organization has been entrusted with accomplishing a mission that will serve the greater good. All of the organization's decisions, therefore, including financial ones, must be made in the context of serving the mission rather than creating profit, as would be required in a for-profit business.

Stewardship also has to do with the fact that not-for-profits have been given **contributions** by individuals, foundations, corporations, and the government in

service of the organization's mission. The organization has a legal and ethical obligation to care for the money in the way the donor intended. This means its bookkeeping must be structured in a way that allows board members and others to keep track of donated funds so that they can be sure the money is spent for the intended purpose.

Keeping track of donated funds and managing them with integrity is not just a wise practice, it is also expected as a part the Generally Accepted Accounting Principles (GAAP) for not-for-profit accounting. Statements 116 and 117 of the Financial Accounting Standards Board (FASB) are two of the principles that set out the rules for accounting for contributions.[2] These rules encourage not-for-profits to account for contributions according to the wishes of the donor. This practice is called **fund accounting**.

Fund accounting is unknown in for-profit accounting; since all income in a for-profit is earned income, there is no need to segregate specific types of contributions. In a not-for-profit, however, fund accounting allows not-for-profits to create tracking mechanisms for contributed income according to restrictions on use of the funds. Contributed income can be **restricted**, meaning that a donor has indicated that the donation must go for a specific program or purpose, or **unrestricted**, meaning that the donor has placed no restrictions on the use of the funds. We'll discuss more about this concept in the next section.

Because of changing economic conditions, reporting requirements from the Internal Revenue Service, and the increasing scrutiny of not-for-profits by both regulators and the public, an annual **audit** by an accounting firm qualified and knowledgeable in not-for-profit accounting practices is a wise investment, even if a professional audit is not required by the organization's funders or by the agencies to which it must report. Some small not-for-profits, hoping to save money, count on the services of a volunteer treasurer or staff expertise to "take care of the accounting." Unless that person has specific knowledge of not-for-profit regulations and accounting, however, this plan could end up costing the organization much more than would an audit.

FINANCIAL MANAGEMENT TERMS AND CONCEPTS

Before going further, it is necessary to learn a few basic terms commonly used in financial management. When doing so, it is helpful to think of Newton's Third Law: "For every action, there is an equal and opposite reaction." When bookkeeping meant literally writing down all transactions in a set of books, bookkeepers were careful to keep the ledger balanced by ensuring that every transaction that took place on one side of the ledger was reflected on the other side as well. **Double-entry bookkeeping** is a common accounting method that acknowledges that each financial transaction affects two different areas of the financial statement. For example, when the organization pays a bill for printing newsletters, the amount of cash is decreased, but the line item totaling how much was paid for printing throughout the year is increased. The concept can be confusing to most of us who

are not accountants, because we are used to a single-entry system, as in our check-books, where it is desirable to maintain a positive balance.

Nowadays, computer software programs perform most double-entry book-keeping actions behind the scenes, but it is useful to understand the concept in order to set up bookkeeping systems accurately. Because ultimately the two sides of the ledger should balance, the double-entry system allows the organization to quickly check for accuracy. A brief description of how this accounting method works follows.

In double-entry bookkeeping, we create a system for classifying each type of transaction with other similar transactions. We do this by creating a list of **accounts**, or line items, for the types of transactions likely to occur. For example, we may want to create accounts for individual donations, corporate sponsorships, and government grants so we can track how much the organization is receiving during the year in each category.

Separating financial transactions into accounts is useful to the not-for-profit organization in many ways. It allows the organization to monitor progress throughout the fiscal year so that corrective action can be taken if necessary. In addition, it allows the organization to make informed decisions when it comes time to create a new budget. And, most important with regard to stewardship, it allows the organization to track how contributions are being used and to use that information in preparing reports for funders.

The subsections that follow discuss a few important financial "actions and reactions" that are important to know.

Income and Expenses

All businesses have **income** (sometimes called revenue): money that comes in to the organization. They also have **expenses**, or outflows of money. Examples of income accounts include ticket sales, gift shop sales, government grants, and annual fund contributions. Typical expense categories are office rent, payments to artists, art supplies, and scenery construction. Income and expenses reflect ongoing activity that has taken place during the time period being tracked—usually since the beginning of the last report or the beginning of the fiscal year.

Earned and Contributed Income

As we've learned, one of the fundmental differences between not-for-profit organizations and for-profit businesses is that not-for-profits have two basic types of income: **earned** (exchanged with a buyer for goods or services as in ticket sales, merchandise sales, admissions) and **contributed** (gifted in support of the mission). Contributed income is an integral part of the financial operations of any not-for-profit. Many arts organizations rely on a greater percentage of earned income than, for example, a health care charity or social service organization, because they sell something: tickets to performances, merchandise, or admissions to museums, for example. This means that they need to understand how to attract and to manage both kinds of income.

Restricted and Unrestricted Income

Contributed income can be either unrestricted or restricted in its use. A **restricted** donation means that the donor intends for the money to be used for only one particular purpose, and it cannot be used for anything else. Thus a contribution received to support building a new wing on an art museum cannot be used to pay ongoing staff salaries. **Unrestricted** donations are given with no expectation that the funds will be used for a specific purpose. If you send a check for $25 at the time of an organization's annual fund drive, you do so in general support of the organization and the funds are unrestricted; the organization can apply them wherever they are most needed.

It's important to note that restricted and unrestricted income are related only to donor intent, not to organizational intent. If the board decides to set aside some funds to be used only to commission new works of art, for example, that is their business and the IRS doesn't need to know whether those funds are still segregated next year. The government is primarily concerned with ethical use of contributed funds, not internal decisions.

Administrative and Artistic Expenses

Arts organizations have both **administrative expenses** (rent, office staff, marketing, utilities) and **artistic expenses** (sets, costumes, royalties, compensation to guest artists). One of the challenges for arts not-for-profits is working out the balance between the two. How much administration is necessary to support the artistic programs? The answer usually entails a trade-off. If, for example, an organization is all-volunteer, hence has no paid office or administrative staff, administrative expenses will be low; but the lack of staff might hurt the organization's ability to adequately market programs or raise funds. Each organization must come to a balance that works for them, but there are guidelines for healthy organizations that we'll discuss further below.

Assets and Liabilities

Knowing how much money has come in since the last financial report and how much has been spent is important. The information, however, shows only part of the picture of the financial health of an organization. As an example, let's imagine that you have just received your paycheck. If you didn't know that you had a drawer full of bills, that paycheck would suggest a healthy financial situation. In order to know where you really stand financially, you need to look at what you owe other people as well as what you own. A not-for-profit business is no different. **Assets** are things the business owns that have cash (material) value. These may include buildings, furniture, an art collection, costumes, and even the cash in a checking account. **Liabilities** are what the organization owes to others: payroll taxes, outstanding loans, and other debts. By subtracting the liabilities from the assets, you will have the organization's **net worth**.

Cash and In-Kind Donations

Not-for-profits can receive cash **contributions** (donations in monetary form, whether they are literally cash or check, credit card, or electronic transfer) or

Case 8-1

Case Study: Budgeting for In-Kind Donations

A youth orchestra has put on successful gala fundraising events for several years. Each year's affair has been larger and more successful than the last. One of the reasons for this success is the large number of in-kind donations from local merchants, including printing for the invitations, flowers to decorate the dinner tables, and raffle items from area restaurants and shops. Since the orchestra doesn't have a lot of cash expenses, nearly all of the money that comes in can be considered to be "profit."

One year, a new committee chair is selected. She asks to see the budget for the past year's event so she will be able to construct a budget for the upcoming gala. "There is no budget," the committee members tell her, "We traditionally spend no money because everything is donated, and we cover what little cash we do spend by soliciting cash donations. That way we can keep everything off of the books."

So, the committee chair bravely proceeds, soliciting in-kind gifts and donations as a part of the organization of the event. However, since many of those gifts had been given because of personal relationships with the former chair, the newcomer is unable to cover expenses. The committee critizes her for not bringing in as much as her predecessor and, after the gala, she is fired from her volunteer position.

Questions
1. How might the organization have prevented this outcome?
2. Why might it have been wise to operate the event with a budget reflecting the "expenses" for the event as well as the in-kind donations received?

in-kind gifts (gifts of goods or services, like donated artwork, **pro bono** legal services, or a discount on printing). Again, this concept is unique to not-for-profits, since for-profit businesses cannot officially receive contributions. Although it can be challenging to properly classify and quantify in-kind gifts, most financial professionals recommend that these items be reflected on the financial statements somehow. If they are not, the true financial activity and net worth of the organization will not be recorded, and that can cause problems when the organization is reporting or creating future budgets.

Cash and Accrual Accounting

An organization may choose to organize its accounting on a cash or accrual basis. **Cash accounting** simply means that transactions are entered into the accounting system at the time of completion. Your checkbook is a simple cash system: you enter income when you receive it and expenses when you write a check or make a debit card transaction. In an **accrual accounting** system, transactions are entered at the time they are initiated. Income is posted when it is earned, and expenses when they are owed. For example, if the organization receives notice of pending receipt of a grant, that income can be realized immediately as a receivable in an accrual system. In a cash system, the income isn't realized until the check arrives. Expenses in an accrual system are recorded as they are owed (e.g., when supplies are ordered, when the printer finishes your brochure), instead of when the bills are paid.

Not-for-profits can manage their finances by using the cash system or the accrual system, but to comply with generally accepted accounting principles, they must use the accrual method in preparing financial reports. Most not-for-profits, especially those that need to track cash flow, have expenses and income crossing fiscal years, or have a large number of outstanding bills or unpaid pledges, find that accrual accounting presents a more accurate financial picture than cash accounting.

Receivables and Payables

In an accrual system, businesses can have receivables and payables as well as income and expenses. A **receivable** is an income item that has been promised but not yet received. A **payable** is an expense that has been initiated but not yet paid.

In for-profit business, receivables and payables are as real to the organization as income that has been received and expenses that have already been paid. A customer who purchases an item and arranges to pay for it in installments has created a legally binding agreement with the seller. If that customer fails to pay, the business can sue to get the money, can repossess the product, or can deduct the loss on the next income tax statement. Legally, most pledges for contributions to a not-for-profit business are not considered to be receivables, even though the organization may have booked the income as such. A contribution that is pledged but not received cannot be counted as a loss for the not-for-profit organization, since the donor has not received any goods and services in return for the promised contribution. For this reason, many not-for-profits record only certain types of pledges as receivable. These may include a government or foundation grant, where a contract for the funds is signed by both organizations, or a major donor gift or corporate sponsorship, where the donor has received naming rights or other benefits in consideration for the gift.

FINANCIAL MANAGEMENT SYSTEMS

Efficient financial management is an integral part of accomplishing the mission of the arts organization. Financial management helps the board and staff make well-informed decisions by providing objective information about past financial performance. Accurate statements and budgets help the organization assess its current situation and plan confidently and realistically.

Sound financial management is also a necessary part of showing accountability to funders, governmental agencies, and the public at large. Funders may require financial statements to evaluate the organization's suitability and may also require statements at the end of the funded project to ensure that the money they gave was spent as they'd intended. Even though not-for-profit businesses don't pay income taxes, they still must report their finances to several governmental agencies, including the Internal Revenue Service.

As we noted earlier, financial statements of charitable organizations are available online to anyone who wishes to access them. The IRS makes public the **Form 990** returns of 501(c)(3) organizations, and these documents are easily available

via a number of websites. Thus, a funder that doesn't ask for financial statements from your organization can still learn about your financial situation with a simple search, and of course potential funders and other members of the public can do the same. Good financial management is not just good practice, it also has profound implications for the future of the organization.

ACCESSING FINANCIAL INFORMATION AND FORMS 990

According to IRS disclosure regulations, exempt organizations must make available for public inspection their three most recently filed annual 990 or 990-PF returns and all related supporting documents. Form 990 returns from charitable organizations (including public foundations) are available on many websites. You may have to be persistent to find the organization you're looking for—not all websites have comprehensive or up-to-date information. If you can't find an organization's Form 990 online, you can receive a report by contacting the organization directly or by asking the IRS to share this information.

Here are a few of the websites commonly used to research 990s. Give them a try—research a not-for-profit on several different sites and compare the information you find.

Guidestar: www.guidestar.com (some information only available with subscription)
Foundation Center: http://foundationcenter.org/findfunders/990finder/ (foundations only)
Charity Watch: http://www.charitywatch.org/
Charity Navigator: http://www.charitynavigator.org

Case 8-2

Case Study: Operating without a Budget

Once upon a time, there was an arts council in a small town that was formed by a number of enthusiastic arts supporters, eager to bring arts activities into their community. They received a small amount of money from the city council to present their first program, and it was very successful. After that, they planned more programs, but they never prepared a budget. They said that since they didn't know how much money they were going to make, a budget wasn't necessary. They adopted a practice of paying for up-front expenses with personal checks from board members, who were reimbursed with receipts from the programs . . . that is, when there was enough money from ticket sales or admissions to cover the costs. Not surprisingly, the organization quickly began to fall apart and is no longer in business.

Discussion Questions
1. How is this example related to internal controls?
2. Is simply adopting a budget a good control practice?
3. What practices might the arts enthusiasts have adopted to have had more success with their organization?

Of course, the best reason to have an effective financial management system is that it allows the art to happen. Even though not-for-profit arts businesses place mission before money, it is a fact that without at least enough income to cover expenses, the arts business won't be around very long.

The concept of stewardship guides all financial management decisions in a not-for-profit corporation. As we shall see, the people designing a financial management system for an organization must be able to easily find the information that tells them whether that organization is adequately serving both the mission and donor requirements.

A financial management system includes several different types of activities. "Accounting" is the term used to collectively describe these activities. Within accounting are some half-dozen functions, which we introduce next.

Design of Financial Systems and Policies

Every organization must design financial systems and policies that are appropriate to its particular situation. Systems should be designed so that information is recorded in a way that that facilitates correct analysis of the data and gives the organization a good basis for budgeting for the future. For example, the organization will want to figure out how to classify expenses in a way that makes it easy to obtain information on how grant money was spent once the project is over.

Budgeting

Every organization needs to develop a system for projecting income and expenses for the upcoming fiscal year. We will discuss the budgeting process further in the next chapter.

Bookkeeping

Although sometimes confused with accounting, bookkeeping is only one of the activities under the broader heading of accounting. Bookkeeping is the act of recording financial activity. Within bookkeeping fall the functions of documenting (keeping proof of transactions), recording (entering transactions into a ledger or register), and summarizing (creating reports based on recorded information).

An essential part of setting up financial systems is developing policies for each of the three bookkeeping functions. The organization will need to decide, for example, how transactions are to be documented. This is especially important in a not-for-profit, since the organization will need to record not only how much donated money was received and when, but what the funds are to be used for and what benefits (if any) were promised to the donor. The details of these policies vary from organization to organization, but many not-for-profits keep both computer records and hard-copy files as a standard **internal control**.

Data Analysis

For any business, financial records mean nothing if they cannot be analyzed. The financial statements and reports that are created in the bookkeeping function, if

they are set up properly, can be analyzed to give the organization information about current conditions and future expectations.

USING ACCOUNTING SOFTWARE

Accounting software for small and large not-for-profits is readily available and can greatly streamline accounting procedures. However, it is still necessary to have a thorough understanding of the accounting process so that the correct software can be purchased and configured to meet your organization's requirements. Although it's tempting to save money by putting together simple spreadsheets or purchasing a basic small-business software package, most times these systems do not accommodate the specific needs of not-for-profits, including separating restricted funds, allocating expenses to grant income, or even separating earned from contributed income. Organizations considering the purchase of software packages should also be aware of the latest regulations from the IRS regarding financial reporting, so that information can be properly recorded.

Several low-cost options exist for not-for-profits. Tech Soup (www.tech soup.com) offers software to not-for-profits for little or no cost. Several sites, including Shareware.com, have shareware, freeware, and evaluation software. With shareware or freeware, the obvious caveat is that you get what you pay for. Organizations should seek impartial evaluations of shareware and freeware, making sure not only that the software meets their needs but that the software is not supported by adware or spyware.

Setting Up a Financial Management System

Organizations setting up accounting systems will need to ask themselves a number of questions in order to make some basic decisions. For example, they'll have to determine who will be responsible for various aspects of the accounting operation and what information will be needed. An organization that must provide final reports to granting agencies will have to make sure the necessary information is easily accessible. To track individual programs (e.g., to find information necessary for next year's budgeting), management will want to be sure the organization's system provides the necessary detail and that income and expenses from each program can be easily compared. Ultimately, the decisions made by the organization are only as good as the information on which they were based. The subsections that follow define a few of the decision areas.

Fiscal Year

Early on, each organization must decide when to begin and end its fiscal (financial) year. Although most individuals operate on a fiscal year that corresponds with the calendar year, a business can set its fiscal year according to the needs of the enterprise or of the industry. One of the primary considerations in setting fiscal year is to keep expenses and income associated with one season or activity within the same fiscal year. Thus, many arts organizations whose seasons follow a school year (September–May) calendar start their fiscal years on July 1.

Cash or Accrual?

Having established its fiscal year, the organization will need to decide whether to use cash or accrual accounting. Although cash accounting is simpler, it may not be adequate for not-for-profits. Because accrual accounting records transactions when they are initiated, this method may give a more complete picture of the actual financial position of the organization than cash accounting. Moreover, by offering a broader picture of the organization's finances, accrual accounting may allow officers to be more responsible in all the group's management activities.

Let's look at an example of cash vs. accrual accounting. Your own checkbook is a cash accounting system—you enter the amount of your paycheck when you receive it and record expenses when you write a check or use an ATM. On one day, you may have $1,000 in your checking account, which would sound like a nice balance if you didn't know that your rent was due next week. In accrual accounting, that rent bill would already have been entered in your system as a payable expense, and you would know more accurately that you didn't really have the full thousand dollars at your disposal. Although as an individual it may be easier for you to keep in mind when your bills are due without using accrual accounting, the task becomes much harder when several people are involved in different aspects of the accounting process.

Accrual accounting is required for governmental reporting, including the Form 990, so deciding to use accrual accounting is also part of designing an accounting system with your reporting needs in mind. Many smaller organizations that don't receive government grants sometimes use cash accounting because it is simpler and may not require accounting software. Also in this camp are organizations whose income is low enough to exempt them from the duty to file a Form 990 with the IRS. However, most financial experts suggest that even the smallest businesses use accrual accounting because with this method they can better see the big picture and make accurate decisions.

Financial Principles and Policies

Organizations also need to discuss financial principles and policies that will guide their financial management practices. An organization may decide, for example, that it wants to build up a cash reserve to give it the ability to weather a slow economic period or to compensate for a poorly attended program. This policy decision may affect several aspects of financial management, from budgeting to deciding when to use volunteers and when to use paid staff. Making these kinds of decisions during the planning process helps ensure that all members of the organization are on the same page when it comes to managing individual aspects of the organization.

CHART OF ACCOUNTS

The next step in developing a usable financial management system is designing a **chart of accounts**. A chart of accounts is a list of all of the individual line items, or accounts, used in the accounting system. Each organization sets up a chart of

accounts according to the different types of income, expenses, assets, and liabilities that currently exist or can be anticipated for in the future. A chart of accounts is also a way for the organization to make good financial decisions by ensuring that different categories are organized in ways that can easily be captured and summarized.

Each account in a chart of accounts is normally assigned an account number, which allows different categories and subcategories to be totaled easily on a spreadsheet. Although with accounting software, most of the calculations are done behind the scenes, the organization must still set up the chart of accounts.

Charts of accounts may be as simple or as complicated as the organization's needs. However, certain commonly used systems and categories apply to many similar organizations. Here's an example of one common four-digit numbering system:

> 4000 Income
> > 4100 Earned income
> > > 4110 Ticket sales
> > > > 4111 Holiday concert

In this example, each column represents another division of a larger category [for simplicity, our first example doesn't include subitems in the columns]. All accounts beginning with 4000 will be income, but within "income," the columns headed by the other three digits subdivide the category further. The second column is earned income, so if we add up all of the line items with a "1" in the second column, we will obtain a total for all earned income produced by the organization. The third column will contain all income that comes from ticket sales (a subcategory of earned income), and so forth. Categorizing accounts in this way allows the organization to collect information at several levels. Thus the board and financial staff members can find specific information like the amount of income generated by ticket sales for the holiday concert, or they can get a total for all of their ticket sales.

Let's take this system a little further to see how it would be expanded to include other kinds of income:

> 4000 Income
> > 4100 Earned income
> > > 4110 Ticket Sales
> > > > 4111 Holiday concert
> > > > 4112 Spring concert
> > > 4120 Gift shop sales
> > > > 4121 CD Sales
> > 4200 Contributed income
> > > 4210 Grants
> > > 4220 Donations

Although income and expenses are reported separately from assets and liabilities (see previous chapter), the chart of accounts is a single set of consecutive

numbers. Thus, if assets and liabilities are classified as 1000 and 2000, then income and expenses would not repeat these numbers; they would begin at 3000, as in the example below:[3]

1000	Assets
2000	Liabilities
3000	Fund balances
4000	Income
5000	Expenses

A sample chart of accounts for an arts organization can be found in Appendix 7.

Case 8-3

Case Study: What's Wrong with this Picture?

Here is an example of a chart of accounts that does not use the system described above. What is different about this system? Can you think of some of the ways that this system might not be as useful for the organization as the one recommended above? How would you improve it?

1000	Ticket sales
1001	Donations
1002	Gift shop sales
1003	Grants
1004	CD Sales
1005	Sponsorships

TYPES OF FINANCIAL STATEMENTS

Because it is necessary for the board and staff to responsibly plan and to monitor the financial health of the organization, they require reports that show various aspects of the organization's financial activity.

Financial statements are generally prepared by staff in cooperation with the organization's treasurer (and may be prepared directly by the treasurer when there is no paid staff) and presented to board members at regular intervals for their knowledge and approval.

In addition, financial statements may be viewed by people outside the organization under several circumstances—for example, when the organization submits a grant application or applies for a loan. Some funders request final financial reports when a grant project is completed. In addition, all not-for-profits with annual income exceeding $50,000 are required to file an annual **Form 990** with the IRS. The content of these forms is public information and may be obtained by any entity, including donors, requiring information about a not-for-profit organization.[4]

The organization's bookkeeping and accounting procedures should therefore be prepared to facilitate access so that board and staff members can easily find the information they need for all of these situations as well as for purposes of internal

monitoring. During the setup phase, it is helpful to consult with someone who has specific knowledge of not-for-profit accounting practices. Accountants who work with not-for-profits should be well versed in the concept of fund accounting and reporting requirements for not-for-profit corporations.

The subsections that follow discuss the types of statements used by not-for-profits and other kinds of businesses. Each report deals with a specific aspect of operations, and all are needed in order to paint a complete picture of an organization's finances. The complete set of financial statements for the fictional Child's Play Theater Company found in Appendix 1 can be used to illustrate the concepts.

Statement of Activities (also called Activities Statement, Operating Statement, Revenue Statement)

A **statement of activities** is often referred to in for-profit accounting as a profit and loss statement, or P&L. In not-for-profit accounting, many prefer the term statement of activities. A statement of activities lists the income the organization has received and the expenditures that have been made during a particular financial reporting period. Often, these statements have columns comparing current financial activity to a previous month or year or to the organization's budget. This format allows the board to check progress against goals or compare recent performance with historical information. The statement of activities is organized into accounts that itemize the various types of income and expense. Most businesses list income at the top of the statement, so that expenses in each column can be subtracted. The last line in the "current activity" column represents the total profit or loss sustained during the financial period. In a not-for-profit, this line is more often labeled "net income, surplus," or "net of expenses." Although it is not improper for a not-for-profit to use the word "profit" to describe income remaining after expenses have been paid, many not-for-profits prefer to avoid it.

Statement of Position (also called Balance Sheet)

In contrast to an activities statement, which shows income and expenses, the statement of position shows assets and liabilities. Rather than showing activity during a particular period of time, the statement of position is a "snapshot" of the organization's financial status at a particular period in time. It is used to assess the organization's financial health.

The top section of any position statement lists the assets of the organization. These can be separated into **current assets**, which can be readily converted into cash for use during the current fiscal year (e.g., a checking account or money market account) and **fixed assets**, longer term assets that are not easily converted into cash (e.g., a building, art collection, or restricted endowment account).

The middle section of the position statement lists the organization's liabilities. These too are separated into current and long-term liabilities. Current liabilities are those that are due within the current fiscal year, including bills to be paid, payroll taxes, and short-term loans. Long-term liabilities might include mortgages, leases, and other obligations that will take longer than a year to repay.

The bottom section of the statement of position is called **net assets** in for-profit accounting. In not-for-profit accounting this section is often labeled **fund balances**. No matter which term is used, the final section gives the difference between assets and liabilities. The term "fund balances" is used in not-for-profit accounting because any restricted and unrestricted funds the organization may have are listed here.

One of the reasons this statement is often called a balance sheet is that the top two sections (Assets and Liabilities) will always equal the amount in the bottom section (Net Assets or Fund Balances). The fact that these two sections balance has nothing to do with whether the organization is or is not healthy—we'll talk about assessing financial health in the next chapter. A simple formula for remembering how a balance sheet works is:

$$assets - liabilities = fund\ balance\ (net\ assets)$$

Annual Budget

An annual **budget** is a document that outlines financial plans for the organization for the upcoming fiscal year. An annual budget (which must be approved by the board) sets out realistic estimates of goals in various income and expense categories. A budget guides spending and management decision and provides an objective standard for evaluation of programs and administration. It also allows the board to accurately monitor the progress of the organization and to control financial activity. Many organizations, for example, require staff to seek approval from the board to spend more than the allotted budget for any item.

Budgets are organized in the same way as activities statements: income and expense accounts are listed with the amount that is expected to be earned and spent in each account during the fiscal year. More information about building a budget is provided in the next subsection.

Other Financial Statements and Reports

While the basic three reports present a fairly complete picture of an organization's financial status and activity, reports of other types are sometimes needed to supply specialized information. These may include the following:

- **Program reports** detail financial activity related to specific programs (e.g., income and expenses for a single exhibit or show). Sometimes program reports must be sent to a funder at the end of a grant period. Program reports are also useful to break down larger figures in the statement of activities. Suppose, for example, that the statement of activities shows a loss in education programs for the year. A program report, however, might reveal that the losses were concentrated in one program that was canceled because of bad weather. This information would be important for building the budget for the following year.
- Program or department budgets present a financial plan for a program or one part of the organization (e.g., a marketing budget). These budgets also

may be annual (year-long) plans or plans for a shorter period of time (such as the duration of a program). Often, departments or committees present budgets for their areas to the executive director, finance committee, or other person or group tasked with preparing the overall budget at an early stage in the process.

- **Cost center** reports are activities statements for distinct sections of the business whose expenses and income need to be tracked separately. For example, if a ballet school had facilities in two cities, it would be useful to monitor income and expenses for each facility (cost center).
- Status/Progress reports show detailed activity against goals for specific initiatives, such as a subscription drive or fundraising campaign. Status reports may be related to the budget, but more often they are related to goals set for the specific initiatives. An organization, for example, may budget conservatively for the annual fund but set an internal goal that is higher than the official budget number. A status report for the annual fund would show progress toward the ultimate goal, not necessarily the budget.
- **Cash flow** projections allow the organization to predict when income will come in and when expenses will incur. This allows an organization to plan to have adequate funds on hand for necessary expenses at any given time. For example, a symphony orchestra may know ahead of time that there will be large expenses about a month before the season begins and that ticket sales income will not peak until closer to the first concert. Knowing this, the orchestra can compensate by moving other expenses to nonpeak times or scheduling income activities such as fundraising events or membership drives before the time that funds are needed.

IN CONCLUSION

Financial management, including the proper recording of financial transactions, adopting and monitoring budgets, and instituting appropriate internal controls, is the responsibility of every not-for-profit business. Efficient, safe systems not only protect board members and employees, they help ensure that the mission of the organization is accomplished.

DISCUSSION QUESTIONS

1. Why do the terms *restricted* and *unrestricted* not apply to earned income?
2. Organizations whose seasons follow the school year (roughly September–May) often adopt a fiscal year of July 1–June 30. Why doesn't the financial year for these organizations start on September 1?
3. Why is it necessary for all members of the organization to understand basic principles of financial management? How can an organization convey this information to board members, staff, and volunteers?

CHAPTER 9

⤴

Planning for Financial Management

"We believe that the financial management process exists to support the management process . . . accordingly, it is assumed that financial management should assist the governing board, the director and the staff in carrying out their fiduciary responsibilities in order to achieve organization mission, goals, and objectives."
—Robert P. Gallo and Frederick J. Turk, *Financial Management Strategies for Arts Organizations*

In the previous chapter, we learned about some basics of financial management and how effective financial management is a tool for accomplishing the mission of the organization. In this chapter, we'll take these concepts further.

As Gallo and Turk note in our opening quotation, good financial management is one of the best ways for the organization to accomplish mission, goals, and objectives. In this chapter, which is the second part of our examination of financial management, we'll go deeper into the principles that guide the setting up of a financial management system, as well as planning for both contributed and earned income.

Like other topics we've studied in this book, financial management in the arts has some unique aspects. Some aspects mirror what we find in other types of not-for-profit organizations, while others, such as ticket sales, more closely resemble those of a for-profit system. Understanding these unique aspects and balancing all of the financial aspects of the organization is key to organizational success.

When you finish this chapter, you should be able to:

- Understand the factors that go into setting up an accounting system for a not-for-profit arts organization
- Understand the factors that go into planning for earned and contributed income for an arts organization
- Describe ways that organizations can protect the organization's assets through asset management

INDICATORS OF FINANCIAL HEALTH

There are many ways to analyze the finances of a not-for-profit organization to try and form an opinion as to whether the organization is financially healthy. The amount of cash in the bank is only one indicator. It is also necessary to examine more than just income and expenses.

One of the ways to determine financial health is to create and regularly analyze a variety of types of financial statements. As we do so, we try and discover answers to the questions that follow.

- **Can the organization meet current needs and commitments?**
 If you have $1,000 in your checking account, at first glance it would seem as though it's time for a night on the town. But if you have bills in your drawer totaling $1,500, then the picture is different. The same is true for an arts organization. In order to be healthy, an organization should have enough funds at any one time to meet the current obligations of the organization, and the means to take care of upcoming commitments.

- **Does the organization have more assets than liabilities?**
 It is a generally accepted rule in business that an organization is healthy if it has at assets valued at twice as much, at least, as liabilities. This means not only that you should have adequate resources to meet not only current needs but also needs that will continue into the future such as rent payments and salaries. The total should include adequate **liquid assets**—those that can be converted to cash easily. Liquid assets include money market accounts, short-term investments, and certificates of deposit.

 Nonliquid assets are assets that cannot be converted into cash easily. In many cases these are also assets the organization doesn't wish to convert to cash—things like a permanent art collection, costume and scenery in storage, or a building. If an organization has too many nonliquid assets, however, the balance sheet might look healthy but it runs the risk of being "building rich but cash poor," and just as unable to pay bills as if it had no assets at all.

- **Does the organization have a diversity of income sources?**
 The diversity of income sources available to not-for-profits not only presents a variety of opportunities for income development but is a necessary part of ensuring financial success. An organization dependent on only one source of income, such as ticket sales, a big annual event, or a regular gift from one major donor, places the organization at risk, should that source of income be reduced. What will happen to the organization if it rains throughout the festival, or if the major donor moves to a different community? Spreading income between a number of sources is not only practical, it protects the mission by allowing programs and the organization a chance to succeed even when one source is endangered.

- **Does the organization have an appropriate mix of artistic and administrative expenses?**
 An arts organization must balance the percentage of funds expended on artistic programs and with that spent on program administration. What is appropriate is different for each organization. A producing organization like a theater or opera company, for example, will have far more artistic expenses than an arts council whose primary job is administrative. A volunteer organization will have more artistic than administrative expenses. But within the general characteristics of the type of organization and its

situation, it's important to know that the organization is allotting as much priority to managing the organization as it is to making the art. Making a decision to spend most of your money on purchasing new costumes, for example, is risky if you have to raise more funds to support the purchase and you don't have enough administrative staff to send out fundraising letters or keep track of donations. The rule of thumb is that an organization that veers too far from a 50/50 balance of artistic to administrative expenses should be able to justify that decision and understand the risks it entails.

- **Is cash flow a challenge?**
 Even though an organization may anticipate enough cash to cover expenses by the end of the year, there may be times when expenses are anticipated but cash is not available. For example, some government agencies don't reimburse organizations until a given program is complete. Under these conditions, would your organization be able to find enough resources to cover the expenses while the program is being conducted? Anticipating **cash flow** means scheduling anticipated revenue and expenses at times during the year that will not leave the organization unable to pay its bills, and it may also mean working with a surplus or **endowment** fund so that rent and salaries can be covered during slow periods.

- **Do financial actuals match budget projections?**
 A single year with a mismatch between budget and actual income and expenses is to be expected—there are plenty of variables between the time the budget is prepared and the programs are facilitated. But if an organization routinely underestimates expenses or overestimates income, something is wrong.

- **Can we find adequate evidence that the mission is being protected?**
 In the past several years, there have been a number of scandals exposing charities that raised funds for various causes and spent a relatively small amount of the money raised on the actual cause. Instead, funds donors hoped would be used to research cures for cancer or to provide aid for disaster victims went to support more mailings to collect more money or to unreasonably high administrative salaries. While paying salaries or sending mailings is certainly not bad (in fact, they are a necessary part of doing business for a not-for-profit), the measure is in the percentage of funds used for various purposes. Evidence that the mission is being protected might include an appropriate percentage of artistic expenditures, evidence of programs which are high quality and are regularly evaluated, and evidence that the board of directors is regularly monitoring financial systems.

The financial statements for our hypothetical Child's Play Theater found in Appendix 7 can be used to study these concepts.

INTERNAL CONTROLS

Another way to ensure that an organization remains financially healthy and that the mission is protected is to institute adequate **internal controls**. The board and staff have an obligation to ensure that organizational resources are not diverted

from their proper purpose because of error, loss, theft, or unethical procedures. The measures that are used to safeguard assets are called internal controls.

Good internal controls safeguard the organization's assets, contribute to efficient operations, and promote compliance with governmental and other regulations. Controls also establish an image of responsibility and stewardship, and show the public that they can trust the organization to use contributed funds responsibly and with the highest standards of accountability.

Some organizations shy away from instituting internal controls because they feel the practice makes management appear to be distrustful of employees or volunteers. Some staff are resentful of controls that make it seem that the board doesn't trust them to do the right thing. On the contrary, however, internal controls can benefit employees, board, and volunteers because mistakes or discrepancies can easily be traced and proven, or prevented from happening in the first place.

Some smaller organizations feel that instituting internal controls is less important for them than for a large corporation, or fear that such a system be too difficult to monitor with an all-volunteer staff. Because of the nature of the organization of not-for-profit corporations, however, even a small organization has a board of directors, hence can institute internal controls.

Following are a few basic rules for establishing internal controls:

- **Institute segregation of duties.**
 Segregation of duties simply means that no one person or entity within the organization is responsible for all parts of any decision or transaction. This means, for example, that the person who receives cash should not reconcile the bank statement. The presence of a board of directors ensures that some decisions, such as adopting the budget, cannot be approved by just one person.
- **Adopt and publish policies.**
 It is wise for not-for-profit organizations to develop and publish policies for a variety of activities, including employee, administrative, and financial actions. Examples of areas in which policies are often adopted are the payment of bills, recordkeeping, and the acknowledgment of donations. Policies for employee matters, including personnel reviews and grievance procedures, protect employees.
- **Document transactions.**
 Creating a paper trail for every transaction, from a bank deposit to a promise for donor recognition, should be a daily practice for the arts organization. Organizations should consider policies that create both hard-copy and electronic records. A daily computer backup (especially of financial and database programs), and offsite storage for important corporate papers and computer backups should also be considered.
- **Create inventories.**
 Inventories should be prepared and maintained by organizations for everything from gift shop merchandise to office furniture. Arts organizations with significant inventories, such as art collections, historical artifacts, or

costume collections, may wish to have their inventories professionally appraised for insurance purposes.

- **Purchase appropriate insurance.**
 As just noted, extensive, valuable, or historic collections may need specialized insurance. But every organization must consider various other kinds of insurance. The laws of each state may require certain levels of liability and workers' compensation insurance. In addition, the board of directors should obtain directors and officers liability insurance to protect members from against personal lawsuits stemming from actions of the corporation.

- **Avoid conflicts of interest.**
 A **conflict of interest** occurs when an individual's personal interest differs from obligations to the organization he or she serves. Conflict of interest also includes situations in which an individual stands to gain personally from a corporate decision, as well as other actions that might reasonably be queried by independent observers. Organizations normally avoid such questionable activities as hiring relatives of staff or board members, using the businesses of board members as vendors, and having board members vote on matters that affect their private finances or businesses. It's a good practice for a board to clarify appropriate behavior by adopting conflict of interest policies.

SAMPLE BOARD POLICY ON CONFLICT OF INTEREST

The example that follows is typical of a very simple conflict-of-interest policy. Templates for conflict-of-interest policies can also be found online, but organizations seeking adopt policies would be wise to consider legal advice as well.

CONFLICT OF INTEREST POLICY:
CHILD'S PLAY THEATER COMPANY

As a member of the board of directors of the Child's Play Theater Company, I understand that I must refrain from any activity that presents a potential conflict of interest. Therefore, I agree to:

1. Refrain from voting on or participating in decisions in which I may have a personal or business interest;
2. Identify any affiliations or associations that may potentially cause a conflict of interest;
3. Refrain from obtaining any list of clients for personal or private solicitation purposes during the time of my board affiliation.

Signed and dated: _____

THE FINANCIAL MANAGEMENT CYCLE

"Yet no matter how highly we value them, art and culture are produced by individuals and institutions working within the general economy, and therefore cannot escape the constraints of the material world."

—James Heilbrun and Charles M. Gray,
The Economics of Art and Culture, 2nd ed., 2001

Financial management in an arts organization, as in any business, is an ongoing process that feeds and is affected by other processes, including strategic planning, program management and evaluation, and fundraising. Financial management includes planning the budget and adopting financial policies; accounting and reporting throughout the year; and compliance with regulations and rules governing not-for-profit financial practices.

Many entities are responsible for the financial management of an arts organization. Depending on its size, one or more staff persons could be responsible for various financial responsibilities, such as daily bookkeeping, accounts payable and receivable, payroll management, and preparing financial reports. The treasurer of the board oversees financial activity, and, in the case of an organization with little or no staff, may be directly involved in accounting and reporting. Most boards also contain a finance committee, whose job it is normally to provide oversight (with the treasurer) of financial reports and compliance issues, as well as making recommendations for budgets, fiscal policies, and procedures.

The ongoing financial management cycle begins with the preparation of the organization's annual budget. This is a process that begins several months before the start of the fiscal year. Ideally, the budget flows from the organization's strategic plan and reflects the overall priorities as well as goals and objectives for the upcoming year. Since the budget is adopted by the board, planning must start several months before the fiscal year begins, to allow the collection of accurate information from staff members, departments, and committees, to complete the necessary research on prices (will our rent increase next year?), and to compile all of this into a comprehensive budget in time for the last board meeting prior to the start of the fiscal year.

Throughout the fiscal year, the management cycle continues with regular monitoring of the financial reports, comparison of results to the budget, and adjustments when necessary. An organization should not be surprised at the end of the year to discover a significant shortfall in the budget. A responsible organization will set up financial management processes so that it can accomplish its mission while staying financially healthy.

Once the fiscal year has ended, many organizations request an **audit** from a reputable accounting firm. An audit provides an objective opinion as to whether the organization has complied with Generally Accepted Accounting Principles (GAAP) and appropriate regulations. In fact, many funders, including governmental agencies, now require an independent audit for organizations to help ensure that their contributions will be used appropriately. A full audit, however, can be an expensive proposition and is sometimes unaffordable by small not-for-profits. Accounting firms can also provide services that are similar to an audit but

not as extensive (or expensive). A **compilation** is a collection and presentation of financial data without any accompanying letter of assurance that the statements are in compliance with GAAP. In a review, the accounting firm simply reads critically statements supplied by the organization. All arts organizations should check with funders and the IRS to make sure that they are getting the type of accounting advice that is necessary for their particular situation.

BUDGETING

Budget building is always an interesting exercise for a not-for-profit organization. It involves estimating income that may or may not come in, stretching limited resources to seemingly impossible lengths, and juggling the demands of the mission against the realities of the marketplace. Building a budget is more than an exercise in futility, however; it is an essential task for every business. A budget is a financial document, but it is also a good tool for accomplishing the organization's mission, and a necessary part of organizational stewardship.

For a not-for-profit organization, a budget is a useful but also a necessary tool. As a part of good stewardship, the budget helps the organization set program priorities so that funds are being allocated in a responsible way and that the mission of the organization is being achieved. A budget reinforces the overall goals of the organization. If an organization wishes to insure the organization against future economic downturns by creating a savings account, for example, it can choose to budget for a surplus of income at the end of the year. Other organizational goals, such as establishment of new programs or expansion of the staff, can be written into the budget as a way to ensure that they will be realized.

Legally, a budget helps the board accomplish its fiduciary duty, ensure the financial stability of the organization, and protect the organization from mismanagement. Having a written plan helps staff decide how much to spend on particular items, and minimizes the likelihood that the board will question these decisions. Programs and events can be evaluated when they are completed based on financial performance, so that responsible decisions can be made for the future.

Finally, good financial management, which includes preparation of a budget, is an important step in helping present an image of financial responsibility to the public. Many government granting agencies and foundations require the submission of a budget along with a grant application. They do so because they want to a chance to determine whether their money will be used wisely and responsibly. Organizations that construct realistic budgets, monitor financial activity against the budget on an ongoing basis, and are able to easily present understandable financial information are more likely to receive, and continue receiving, grants and contributions.

Should an organization estimate income or expenses first? That's a matter of opinion. Some financial experts believe that an organization should realistically project income and set expenses so as not to exceed income. Others assert that listing expenses allows the organization to calculate how much income will be needed, and to plan activities accordingly. Either way, the process usually involves a great deal of give and take, as well as consultation with a variety of staff members, board, and volunteers who are involved in the organization's programs and

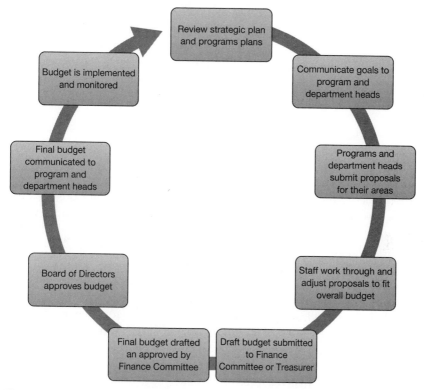

Figure 9.1 The Budget Planning Process.

departments. The chart above illustrates one way an organization can manage the budget planning process.

Developing a budget may be a very different process for large organizations and for smaller ones, but there are a number of commonalities. The principles listed in the subsections that follow can be used to achieve a smoothly running budget process.

Determine Financial Goals and Guidelines before Budgeting

Prior to beginning the budget process, the organization must determine the parameters under which the process will proceed. Will we budget for a **zero sum** or a surplus? What percentage of our budget will be artistic and what percentage administrative? Are individual programs expected to be self-supporting, or do we accept that some programs will run a **deficit** and be require to be support by surpluses in other programs? Some of these parameters will be embedded in ongoing policies; others may be dictated by the current financial situation. For example, if the organization had a deficit in the preceding year, it will be obliged to determine how to deal with that deficit in the current budget.

Determine the Organization's Fiscal Year

The organization must also determine the beginning and ending dates of its fiscal year. Unlike individual taxpayers, businesses do not have to begin their tax year on

January 1. Many arts businesses, like schools and universities, choose to begin their fiscal years on July 1. This is done so that expenses and revenue for one season are more likely to fall within one fiscal year and not cross over into two separate years. If a performing arts organization, for example, has a season that begins in September and ends in May, it will be more difficult to monitor expenses and income if the fiscal year begins on January 1.

Base Budgets on Historical Information

Budget construction is a more complicated process than simply taking last year's numbers and adding a percentage for inflation. However, historical information, particularly when studied as trends over a period of years, can add to the information that goes into preparing accurate and realistic figures. Young organizations can accomplish this by collecting information from similar organizations with a longer track record.

Estimate Income Low and Expenses High

It is far better to be conservative on a budget than to go without a budget, hope for high income, and be disappointed. If you have never gotten corporate sponsors before, for example, it is unwise to write into the budget a large amount of money for this item even in support of the goal of encouraging the organization to place a high priority on the activity. Budgets are different from goals: if income exceeds budget estimates or expenses come in lower than budgeted, that's good news, and far easier to deal with than the reverse.

Base Estimates on Research

It is far better to spend some time doing some research into potential expenses than to be surprised by an increase in your insurance rates or printing costs. It is easier to come to a realistic income figure for a program by calculating a conservative attendance and multiplying it by a reasonable ticket price than saying, "We need to make $10,000 on this program."

Likewise, income and expenses can be affected by factors outside the organization. Therefore, it may be important to investigate whether other arts organizations are raising prices, whether there will be new arts organizations in your community or organizations going out of business, or whether redevelopment or other factors will affect the community in which you operate.

Consider Hidden and Indirect Costs

Often, costs associated with increasing income, expanding programs, or hiring personnel are neglected during the budget process. An organization that strives to increase donations from individuals, for example, should remember that to achieve an increase in income, staff or volunteers are going to have to prepare mailings, process incoming checks, manage benefits, and send reminder and thank-you letters. When employee salaries are being determined, the organization should consider any changes that will become necessary in the areas of payroll taxes, benefits, professional development, and other employee-related expenses.

Likewise, it is important to bear in mind that all programmatic costs carry with them overhead expenses. **Overhead** is the term commonly used to refer to expenses like rent, utilities, salaries, and insurance, which are part of the cost of doing business but cannot be specifically assigned to any one program. Sometimes these expenses are also referred to as **indirect costs**, as opposed to **direct costs** such as the payment of musicians to perform in a specific concert, or the cost of art supplies for the pottery class. Since all projects benefit from the fact that the organization has an office and pays staff, it is common to charge each program with its share of the indirect costs. But doing this in budgeting is one thing; including it when fundraising is another. Many foundations and government entities will not finance indirect costs, preferring to concentrate their investment on direct programmatic expenses.[1] This means that the organization must have and maintain a healthy amount of unrestricted and earned income as a part of the budget to cover indirect expenses.

Budgeting doesn't have to be an unpleasant chore. The organization that uses the budget process as a way to translate strategic plans into fulfillment of the organizational mission will find the associated activities satisfying and exciting.

Consider Scenario Budgeting

Scenario budgeting is one way to prepare for different eventualities that may affect the organization during the fiscal year. In scenario budgeting, the organization prepares a budget and then examines what would happen if different realities came to pass. What if an expected grant does not come through? What if our fall festival is rained out? Scenario budgeting allows an organization to responsibly plan so that it can move quickly if necessary.

PLANNING AND ACCOUNTING FOR CONTRIBUTED INCOME

The presence of contributed income in the form of donations and grants sets not-for-profit accounting apart from for-profit accounting. Different principles guide accounting decisions for contributed and earned income, and different strategies also go into the planning and setup of contributed income accounts.

As noted in chapter 8, one of the indicators of financial health is the presence of a diversity of income sources. An organization, for example, that relies heavily on a large grant from the state arts agency every year would be in trouble if the legislature cut funding for the arts. Most organizations include a number of different types of contributed income in their budget mix.

What kinds of income can be identified as "contributed"? Generally, contributed income is classified as any type of gift or grant that is given in support of the mission with no expectation of any kind of specific return to the donor and does not need to be repaid. Some of the common categories of contributed income include:

- Individual contributions (also called gifts or donations)
- Corporate and business contributions
- Foundation grants
- Government grants

Sometimes, however, the distinction between earned and contributed income isn't easily made. The decision of whether to classify income as earned or unearned depends largely on what the donor/customer receives in return. To account for each kind of income properly, the organization must understand the rules for classification of contributed income.

Many kinds of income can be accounted for differently depending on circumstances or have special accounting needs. We shall discuss memberships, sponsorship, and special event fundraisers in some detail, finishing our listing by describing three other sources of income that must be accounted for: auctions; sales of pizza, candy, and other merchandise; and pledges.

Memberships

The word "membership" is used differently in different not-for-profit organizations. In some, **membership** is codified in the bylaws as a voting position with power to elect board directors and affect policy. In others, members receive benefits including free admission or ticket-purchasing priority. In some others, "membership" is more of a public relations term, essentially a donation for which the donor receives little of substance beyond the feeling of being "part of the family."

The factor that determines whether membership income are to be classified as earned or contributed income has to do with benefits the member receives that have cash value. Organizations which provide substantial and measurable benefits for members, such as free admission throughout the year, often classify memberships as earned income because that is simpler than trying to calculate how much of the membership fee is not tied to a benefit. An organization can classify membership income as contributed if the benefits given to the member are insubstantial or cannot be easily translated into a specific dollar value. For example, an electronic newsletter and the opportunity to purchase tickets ahead of the general public are considered to be items of insubstantial value. Even an invitation to a members-only social event can be classed as insubstantial, since not every member will take advantage of the offer.

The organization's classification of membership income and the value of member benefits should be communicated to members, so that they can also classify the donation properly on their own tax forms. Legally, a donor cannot declare as a tax deduction the portion of a donation that representing the value of member benefits.

Sponsorship

Businesses, corporations, and individuals often give gifts to not-for-profit organizations in return for the right to have their name or logo associated with the event or program. As with membership, the classification of **sponsorship** as earned or contributed depends on the benefits received by the sponsor. Corporate sponsorships are also common in the for-profit world, where they are considered to be advertising expenses because they are purchased with very specific expectations of the kinds of advertising exposures the sponsoring business will receive. Businesses often sponsor not-for-profits they wish to support without expectation that the organization will be able to offer as much advertising exposure as they would receive elsewhere or that the advertising impact will be as carefully calculated. However, an organization soliciting sponsorships should make it as clear as

possible what benefits, advertising exposure or naming rights they are promising, and what (if any) value those benefits have.

Many smaller not-for-profits treat sponsorship casually, or (wrongly) use the term interchangeably with "contributions." Remember, if you ask a business to sponsor your event, you cannot be offended if the firm expects advertising exposure in return. However, it is irresponsible to go to a business and suggest that management donate cash, goods, or services "in exchange for free advertising." Obviously, if the donation has any value at all, the publicity the business receives in exchange is not free. In any event, the tax-reporting requirements of some businesses will prevent them from participating in any such exchange. Still, many businesses understand that being connected with community organizations, especially respected and prestigious organizations, can be beneficial to their own public relations efforts, so they agree to become involved. The most successful arts organizations, however, will respect the needs of the corporation when soliciting sponsorships. See chapter 11 for more information on solicitating sponsors.

Special Fundraising Events

Special fundraising events, from marathon runs to gala dinners, are common forms of income generation for not-for-profit organizations. In events of these types, the classification of income depends on how the income is received. Often, a single event can contain multiple income streams, which are classified differently: ticket sales, sponsorships, and donations, for example, are income streams of different kinds and so must be treated differently.

If a person purchases a ticket to a special event, that income normally is considered to be earned. However, for special fundraising events (which we can loosely define for arts organizations as events or programs that are not part of the organization's primary mission-based activity) the cost is often calculated to include a donation as well as the ticket price. In these cases, the organization specifies on the invitation or event program that "$20 of your ticket price is a donation for tax purposes."

Pledges comprise a popular way of collecting donations through special event fundraising. In a marathon event, for example, participants collect pledges from friends or relatives for every mile they walk, every book they read, or every hour they perform. These activities can be classed as donations because friends who pledge are not purchasing anything, nor do they receive benefits. Activities like food or T-shirt sales are normally considered to generate earned income, even when they take place as part of a fundraising event.

Auctions

Fundraising auctions are an interesting classification category. In many cases, the items to be auctioned are donated to the organization, so the value of the items themselves should be considered as a part of the organization's contributed income. However, the IRS generally does not allow donors to deduct the full cost of their auction purchase—only the amount by which their purchase exceeds the fair market value of the item. Thus, if a weekend getaway package donated by a local hotel is valued at $200, and the winning bid is $250, the purchaser then can claim a deduction on $50.

Pizza, Candy, and Other Merchandise Sales

Schools, churches and civic groups frequently rely on product sales to raise funds. Even though many of the products sold in this way are coordinated through "fundraising companies" so that the organizations can avoid paying taxes on their earnings, for purposes of classification, this is earned income. People are purchasing items for a specific price and the organization is keeping the profits.

Not-for-profit organizations often sell products via gift shops, online storefronts, or other outlets. The IRS sometimes calls this earned income sometimes taxable income. We will discuss this shortly in the section entitled "Auxiliary Business Ventures."

Pledges

Many times, donors pledge to give a lump sum of money at a future date or to spread out payments for a given amount over a period of time. Legally, most pledges to give aren't considered to be receivables unless the organization signs a contract with each donor, as in the case of some government and foundation grants. This is because the donor has received nothing in return and so is not legally obligated to pay for something purchased. Sometimes, pledges are considered conditional; for example, a funder may promise to give a matching gift if a certain amount is raised from other sources. Although an organization's bookkeeper cannot enter pledges as receivables until the amounts have actually been received, most not-for-profits treat pledges as seriously as any other form of future income and develop policies for communicating with donors when pledges come due.

FUND ACCOUNTING

The need to segregate contributed income according to donor wishes guides the setup of contributed income accounts. As noted in the previous chapter, **fund accounting** is the practice of segregating contributed income according to donor wishes. Fund accounting is expected as a part of GAAP, and the Financial Accounting Standards Board has clarified these principles in Statements 116 and 117, as explained in chapter 8.

In fund accounting, contributions are segregated according to whether they are restricted or unrestricted. The restrictions are based on the conditions imposed by the donor, not the organization's accounting system. For example, a grant from the National Endowment for the Arts to fund an upcoming educational program is a restricted donation, since it can be used only for the declared purpose. A money market account created by the organization's board of directors to save for building improvements is not a restricted fund according to GAAP, even though the organization's internal policies prohibit the monies from being used for anything else.

As we have seen, unrestricted funds are funds that have no restrictions placed on them by any donor. All earned income, for example, is unrestricted. In addition, most small donations and memberships given to an organization's ongoing fundraising campaigns are considered to be unrestricted, since it would be difficult to manage individual restrictions on many small donations. This is

Case 9-1

Case Study: Donor Intent

Following the events of 9/11, the American Red Cross came under fire for having used some of the money it collected in ways some people thought were not consistent with donor intent. Many donors gave to charities in the wake of 9/11 and other disasters like Hurricane Katrina without fully understanding that the mission of the Red Cross and many other well-known humanitarian organizations is immediate disaster relief, not long-term recovery.

Information about these complaints can be found easily by searching for "American Red Cross controversies." The position of the Red Cross is posted on its website, www.redcross.org.

Discussion Questions
1. What can organizations do to help ensure that donors understand where their money is going?
2. Should organizations that will treat donations as unrestricted state this specifically?

why organizations generally do not promise that donations given to general fundraising campaigns will be used for a purpose other than to support the overall mission of the organization. An exception to this rule is a specific campaign such as a **capital** or building campaign. If an organization promises the funds will be used for a specific purpose, it has a legal obligation to make sure they will be.

Restricted funds, on the other hand, are donations that carry legal stipulations from the donor for the use of the money. Restricted funds, which can be temporarily or permanently restricted, are usually in the form of larger gifts, government and foundation grants, and funds received in special campaigns, as noted earlier.

A **temporarily restricted** fund is a donation that is specified for a specific purpose; but when that purpose or time period has ended, the funds are free for other uses (or, in some cases, must be returned to the donor). An example of a temporarily restricted fund is a grant given for an educational program. Once the class or workshop has taken place, the restriction is lifted.

A **permanently restricted** fund must be forever used for the intended purpose. Permanently restricted funds are usually limited to ongoing projects or endowment funds. An example of a permanently restricted donation would be a donation to a university's scholarship fund. The university invests that money, uses the interest to give an annual scholarship, and may never use the original funds for any other purpose unless the restriction is lifted by the donor.

The GAAP rules for accounting restricted funds are specific, and organizations that have restricted funds should consult an accountant to make sure they are being handled correctly. It also should go without saying (but we'll say it anyway) that organizations with restricted funds should keep detailed files on these funds, including any contracts, correspondence, and communication from donors stipulating or changing restrictions, as well as responses from the organization.

PLANNING AND ACCOUNTING FOR EARNED INCOME

Most not-for-profit organizations by necessity spend much of their time planning for and soliciting contributed income. Arts organizations, by virtue of the fact that their mission-based activities often involve programs for which they charge admission, can spend as much time planning for earned income as for contributed income. Nationally, arts organizations average about half their income from earned sources and half from contributions—although, of course, that ratio changes depending on the specific activities of each organization.

Although planning for ticket sales, gift shop income, tuition, and other earned income seems to follow many of the practices we associate with for-profit financial management, it still must take place within a mission-driven environment. Financial goals for earned income should be just as carefully supportive of the mission as the solicitation of donations. This means that when calculating ticket prices or gift shop discount policies, the organization's mission and goals will play as much a part of the pricing decisions as covering the program's cost.

That being said, many not-for-profit arts organizations use intuition and guesswork to calculate ticket prices instead of thoughtfully accounting for earned income goals. Saying you want to sell out the house is one thing, but when the board sits down and calculates exactly how many audience members it will take to achieve that goal, the ultimate decisions may be to set a less challenging goal.

The initial process of calculating the cost to the consumer of a manufactured product is simple mathematics. The cost of raw materials to make the product, the cost of the employees and equipment needed to produce it, and the cost of marketing and distributing the product are totaled, and a profit markup is added. This amount can be divided by the number of units to come up with a suggested retail price, as in the example below.

CALCULATING RETAIL PRICE

Calculating a retail price involves totaling costs, dividing by number of units, and adding a profit markup. The example given here is obviously very simplistic; there are many variations on this formula depending on how the product is sold.

Let's say you are making 1,000 units of an unnamed product, and your total cost is $7,000. That means your price per unit to manufacture is $7.

The cost to market the product is $1,000, adding $1 to each unit.

The cost of distribution and shipping adds another $1 to each unit.

The cost of indirect expenses (rent, utilities, salaries) adds yet another $1 to each unit.

This means that your total unit cost is $10 per unit. Adding a 50% profit markup would bring the unit cost to $15.

After the unit cost has been determined, the final retail price is adjusted depending on other factors, such as cost of competing goods, supply and demand, and marketing needs.

However, there are other economic principles at work that affect the price that is ultimately decided upon. Some of these principles include the following.

- **The laws of supply and demand**
 The price of individual products can be affected by how many products exist. A high number of products with low consumer demand may drive down the price of each product. On the other hand, a scarcity (or perceived scarcity) of the product at a time that consumers are demanding it may increase the price.

- **Price of other goods**
 The price of goods is affected by the price others are charging for the same or similar products. Thus, if a competing manufacturer pays a lower wage and therefore can afford to charge a lower price, other prices will go down, or some products will be removed from the market.

- **Number of suppliers**
 If a consumer has many possible suppliers for the same product, other factors such as convenience, location, and customer service come into play and the price may go down. Similarly, if there is only one outlet for a particular product, the price may go up.

- **Consumer expectations**
 Consumer expectations about the product can affect the cost, and expectations are often dictated by previous experiences. If, for example, a customer used to fast-food hamburgers feels that he should not have to pay more than $5 for lunch, other lunch providers will need to figure out a way to meet this price expectation, or to enhance the product or the experience enough to allow the customer to adjust to paying the higher price.

The wise not-for-profit business will bear in mind the foregoing economic considerations when establishing prices; because the ultimate goal is to achieve the mission, not create profit, however, there are other factors at work. The arts not-for-profit must also weigh additional items, including the following.

- **Amount of profit margin**
 Before considering other factors, a not-for-profit must ascertain the relationship of the profit margin to consumer cost. Because in principle the organization is not in business to make a profit, it is not essential to include a profit margin in the cost of every product sold by an arts organization. As noted earlier, the organization may wish to eliminate the profit margin entirely in order to make its programs accessible to its intended audiences— or even price the product below cost and make up the difference with contributed income. Some products may be priced to break even, some to create a surplus that can support other programs, and some to lose money (assuming the loss can be covered elsewhere).

- **Cost of unsold seats**
 In a performing arts organization, calculating price is not as simple as dividing costs by the number of seats. The musicians must be paid, and the

sets need to fill the stage, whether there are 20 people or 2,000 in the audience. Many performing arts organizations calculate costs and prices based on a minimum number of tickets sold, to avoid losses due to smaller than expected audiences.

- **Fixed and variable costs**

 In an arts organization, some costs are fixed—that is, they remain the same no matter how many performances are scheduled or tickets sold. The cost of sets and costumes or payment to a guest curator might fall into this category. Other costs are variable—that is, the total cost depends on how long the show runs. An example of a variable cost might be musicians' fees (if they are paid per performance) or hall rental (if the organization is paying per use). The balance of fixed and variable costs is a factor in determining how long a show or exhibit will be open to the public.

- **Intangible costs to the organization**

 In a not-for-profit organization that relies on the services of volunteers, "costs" such as burnout and efficient use of available resources (human and otherwise) are factors that need to be considered. A large benefit gala, for example, often brings in a great deal of money but leaves volunteers and staff exhausted and less willing to chip in cheerfully when the education program comes along. The wise organization "budgets" for time, resources, and morale when calculating prices and financial goals.

Case 9-2

Case Study: Estimating Ticket Sales Income

A performing arts organization wants to make a new budget reflecting more income from ticket sales. Rather than just specifying a larger amount in the ticket sales budget, the organization has chosen to investigate two obvious options for funding this increase: raising ticket prices and trying to persuade more people to attend at last year's price.

Last year, individual tickets were $10. The hall the organization uses seats 800 people, and the average over the season was about 75% of capacity, or 600 people. Since there were four concerts, total ticket sales for last year were about $24,000. It works out like this:

$$\text{Total seats} \times \text{number of concerts: } 600 \times 4 = 2,400$$
$$\text{Total seats} \times \text{cost of ticket: } 2,400 \times \$10 = \$24,000$$

If the cost of each ticket were increased to $12, the total would rise to $28,800—if, that is, no current patrons are lost. In addition, research has revealed that a similar organization across town, which attracts a similar audience, will keep its prices at $10.

The organization understands that if they try to increase the audience size, they will incur some marketing costs, and of course there is no guarantee that the marketing will result in more patrons.

If you were part of this organization, what would you suggest? Are there other factors that should be considered, as well? If you were advising this organization, what other information would you request? How might scenario budgeting help?

AUXILIARY BUSINESS VENTURES

Many of today's arts organizations acknowledge the need to diversify and protect income and are thinking of creative ways to generate earned income that is not dependent either on the generosity of donors or the whims of audiences. One increasingly popular option is the creation of auxiliary business ventures that may or may not have any relationship to the organization's primary artistic product. A theater or museum, for example, may rent parts of its building to the public or to other arts organizations. Museums and public broadcasting companies have had great success with catalog sales and gift shops, as well as online sales via the organization's own website; having a separate distributor or even auction sites are additional choices that are gaining in popularity.

Auxiliary business ventures may seem attractive but must be carefully weighed with the organization's total financial and programmatic plans. The cost in staffing (paid or volunteer) and other internal resources may outweigh the additional income, especially since the activity may require skills from those the organization asks from current staff, board, and volunteers. For some organizations, the auxiliary venture has become more time consuming than mission-based programs; others are finding that they don't have enough financial skill on the board to function as both a not-for-profit and a for-profit enterprise.

There is also a tax consideration. If the business venture is regularly carried on (as opposed to coming to life periodically for a fundraising activity) and substantially unrelated to the organization's charitable mission, the organization may be liable for tax on the income it receives from the business. Such operations bring into play the **Unrelated Business Income Tax (UBIT***)*, which must be paid by any organization grossing more than $1,000 from business ventures unrelated to its primary mission.[2]

There are exceptions to UBIT. Income is not taxable if the business venture is run by volunteers (which fortunately is the case for many not-for-profit activities), if the venture is carried on for the convenience of members (such as an employee cafeteria) or if the merchandise being sold has been donated (thus letting thrift stores and library book sales off the hook, as well as not-for-profits that run auctions).

An organization considering an auxiliary business venture should get a professional opinion as to whether contemplated activities would qualify under UBIT laws. It may well be that the cost of the tax and trouble to compute it would be worth incurring because of the additional income to the organization. But it is also true that ignoring UBIT laws would be even more costly.

ASSET MANAGEMENT

Protecting the organization's assets is a part of good stewardship in the arts business. Many arts organizations have assets that are an essential part of their mission, like a permanent collection in a museum, a performing arts center building, or a costume collection at a theater. We've pointed out that some of these assets may be

accounted for differently than assets in a for profit business, as they may gain value over time. In addition, assets that were donated may be under restrictions.

A wise organization will include management of physical assets as a part of the annual financial management plan. Including costs in the budget for maintenance and upkeep of physical facilities and collections is a part of asset management. Some performing arts centers, for example, charge a per-ticket "facilities fee," added to the price of the ticket, which can be set aside to pay for building upkeep, so the organization is not threatened with bankruptcy if the roof needs to be replaced or the sound system needs to be upgraded. Other organizations include asset management in their ongoing operating expenses.

Another aspect of asset management is care of cash reserves, savings accounts, endowments, and investments. It has become increasingly common for not-for-profits to strategically invest proceeds in order to create income that can be used for ongoing expenses, and even to deliberately build up endowment or investment include through planned surpluses and special fundraising drives.

An endowment fund is a permanent savings account where the principal (sometimes called the corpus, from the Latin for "body") cannot be touched, but the interest received can be returned to the organization at regular intervals. Often, donors give contributions directly to the endowment fund with instructions that the gift be permanently restricted to the corpus of the endowment. Giving to endowment funds is popular with some donors, as it allows their money to support the organization in perpetuity. The organization, however, has a responsibility to invest the funds wisely and to monitor them carefully in order to help ensure that the organization will not be in trouble when the economy is poor and the organization is receiving less return from investments.

IN CONCLUSION

Good financial management in the arts organization starts with setting up systems properly and continues with planning carefully for earned and contributed income. Asset management and attention to IRS regulations are also important pieces of the puzzle. These activities help an organization properly support the mission and thrive.

DISCUSSION QUESTIONS

1. Can you think of an instance in which the decision to budget for a deficit might be a good one?
2. Would interest from a permanently restricted fund also be treated as restricted? Why or why not?
3. Calculating a per-person cost is easier in the performing arts when there are a fixed number of seats, and more difficult in a museum or gallery, which may have varying numbers of attendees on any given day. Are there ways that museums can estimate per-person costs?

CHAPTER 10

⟶

Fundraising Basics

"The Arts and Sciences, essential to the prosperity of the State
and to the ornament of human life, have a primary claim to the
encouragement of every lover of his country and mankind."
—GEORGE WASHINGTON, 1788

Fundraising is an art, a science, and an essential part of the activities of the arts
organization. For arts managers, volunteers, and board members, fundraising
is a daily activity, as much a part of the organization as planning programs or mar-
keting. Fundraising is not something that "someone else" does; everyone in the
organization has a crucial role to play in this important process.

For many, the thought of fundraising raises uncomfortable memories of going
from door to door as a child with a cardboard box full of candy bars. We hear
about arts organizations and other not-for-profits getting large gifts from wealthy
donors or **grants** from government agencies and **foundations**, and we have no
idea how those organizations figure out how to tap in to these sources. We want
our organizations to succeed, but we're not so sure we want to hit up our friends
and family for money.

As we will see in this chapter, from our discussion of the must-know basics, a
positive attitude toward fundraising and knowledge about fundraising techniques
and trends will enable the people of any arts organization to look forward to rais-
ing funds.

When you finish this chapter, you should:

- Understand the role of fundraising in the arts organization and begin to
 develop the proper mindset for fundraising
- Understand the different types of contributed income
- Be able to explain how different sources contribute to the arts
- Know how to set up a fundraising plan

WHAT IS FUNDRAISING?

The word "fundraising" is used in different ways for different types of organiza-
tions. Many board members and volunteers will come into the process thinking of
fundraising in the same context as it is used for school music programs, scouting

and Little League baseball: the creation of a sales activity (like candy or popcorn sales) or an event (like a raffle or festival) to earn money to supplement the organizational budget. These kinds of activities, while providing needed funds, are really earned income activities, with customers purchasing a product or service and the organization (or individual members) receiving the profit that remains when expenses have been paid. Even schools and organizations that are not 501(c)(3) not-for-profit corporations can conduct this kind of fundraising, since people who purchase the candy or come to the spaghetti supper are receiving a product or service in return. They understand that they are supporting an organization (and may be more likely to participate because of this), but they are not making a pure donation and cannot deduct the cost of the purchased products as a charitable contribution.

Fundraising, as it is defined in the context of a typical not-for-profit, means the solicitation of contributed income. Although a wide variety of activities, from appealing to the general public for donations to applying for foundation grants, are included in not-for-profit fundraising, the common factor is that the sums of money or **in-kind gifts** are given as donations; they aren't purchased items or services. Although a donor may receive as thank-you gifts benefits such as a premium (e.g., mug or T-shirt), recognition in a program or annual report, or even tickets to an upcoming event, these benefits won't be considered to be contributed income unless they are substantially lower in value than the donation.

Fundraising as the term is defined here requires a different mentality and a different process than selling candy or promoting a teen dance. The first and most important piece of this process is for all participants to recognize that soliciting **contributions** is an important part of the work of the not-for-profit; it is not a desperate measure, undertaken only when other methods have failed.

A typical arts not-for-profit uses a dynamic mix of earned and contributed income activities to meet its financial goals. Sales of tickets to performances and art from the gift shop are supplemented with grants, donations, and other kinds of contributed income. In this regard, arts organizations are different than some other kinds of charitable institutions, which may have a higher percentage of contributed income and little or no earned income. And, of course, arts organizations aren't prohibited from engaging in the same kind of special fundraising events as those mentioned earlier. A gala dinner dance with a silent auction, or sales of items that are not classified as pertaining to the organization's primary mission-based activity, fall into this category. However, a not-for-profit that raises revenue by conducting activities that are substantially unrelated to the mission may be liable for Unrelated Business Income Tax (UBIT) on those activities.

Some people use **development** or **advancement** to describe the fundraising effort in a not-for-profit organization. Both terms imply that the effort to support the organization with contributed income is a larger process than just asking for money. Typically, a director of development is in charge of all activities associated with the nurturing and maintenance of relationships that result in support for the

TYPICAL "FUNDRAISING" ACTIVITIES IN THE ARTS ORGANIZATION

Earned Income Activities	Contributed Income Activities
Scheduling a gala dinner or reception	Soliciting donations from individuals
Selling T-shirts or other organization "gear"	Writing grants to foundations
Selling raffle tickets	Applying for government funds
Operating a gift shop	Asking a business to donate used equipment

organization, including (depending on the organization) raising funds, developing new major donors, providing members and donors with updated information about the organization, applying for grants, coordinating special events, and even facilitating promotional and advocacy efforts.

THE FUNDRAISING MENTALITY

The first important step in the fundraising effort is to adopt a mentality that enables the organization to engage in the process with strength and a positive attitude.

It's hard for some people to think of fundraising as anything but an organizational failure—for an organization to be successful, however, everyone involved must understand that fundraising is an important and necessary part of the activities of a not-for-profit business. A board member who says, "We'd better make a lot of money on ticket sales or we'll be forced to fundraise to make up the difference," is showing a basic misunderstanding of fundraising. Arts organizations don't seek contributed income because they can't sell enough tickets to survive, they do so because securing donations from those who support the mission is essential to enabling that mission to happen. Including contributed income in the revenue mix is also a way to protect the mission by diversifying the income. As we have already discussed, an arts organization that relies on a high percentage of ticket sales may find itself in financial danger if ticket sales drop in one year or there is bad weather on opening night.

Some activities and programs within the organization can be supported with a high percentage of earned income, and some will call for more donated funds than ticket sales. Each organization learns what is the norm for its art form, its community, and its unique circumstances, and each one crafts budgets that balance the various types of income. For many organizations, fundraising also enables the organization to offer programs to the community at more reasonable prices than would be possible if they were funded by earned income alone, thus ensuring that more people have access to the art.

Another important piece of the healthy fundraising mindset is that fundraising is just as much about relationships as money. Fundraising experts are fond of

saying that you should never ask a stranger for money. This statement reflects a truism about fundraising: more people give to people they know and trust than to abstract causes. Just as a person is more likely to attend an arts event if invited by a friend, that same person is much more likely to financially support an organization if she knows someone involved in the organization. Just think of the candy bars and pizza you've purchased from nephews and neighbors, and you'll know why this is true.

During the fundraising process, the successful arts organization spends more time cultivating friends than it does asking for money. People are much more likely to give if they are knowledgeable about the organization, have attended events, know someone involved with the organization, or know others who have given. Cultivating donors is the foundation of a successful fundraising program. It's a learned skill.

Fundraising is not about begging. The prospect of asking someone for money should not evoke images of Oliver Twist holding out a tin cup and saying, "Please, sir, may I have some more?" Remember, we're not raising funds because we failed to accumulate revenue in other ways; we're raising funds because that's what not-for-profits do. We're raising funds because we believe in the mission of our organization, and we know that with the help of supporters, that mission will succeed. Fundraising is sharing your story about the wonderful things your organization will accomplish with the funds you raise. Fundraising presents opportunity after opportunity to share your passion about your organization with people who care.

It is valuable to understand national trends in fundraising, but the bulk of support for any organization comes from local sources: businesses, foundations, and individuals who know the organization well and trust it to do good things with their gifts. While it is tempting to think that hiring an expensive grant writer will help you find funds that "have got to be out there somewhere," in reality most organizations do better by cultivating local sources than by applying to national foundations.

The further away from the organization the funding source is, the less likely it is that the source will understand your organization, be aware of the good work you do in your community, or know your track record. The further away from the organization the funding source is, the more likely it is that you will be competing with hundreds of applications from all over the country. The closer your organization is to your funding source, the more likely it is that you will develop an ongoing relationship that, over time, will lead to more donations.

Ultimately, fundraising is about **stewardship**. The board, staff, and volunteers of an organization are entrusted with a mission and work together to make it happen. Donors give their money in support of the mission, and the organization takes care of that money by using it to present programs and create activities that further the mission. Raising funds is one of the most important ways that arts organizations can connect their mission with people who care about the arts. Put this way, we can see that fundraising is a privilege, not a burden!

TEN PRINCIPLES OF FUNDRAISING

The following fundraising maxims are a part of the chapter on fundraising and development of the Tools for Results toolkit developed by the Texas Arts Commission (www.arts.state.tx.us). They are common principles accepted by most professional fundraisers.

1. **Never ask a stranger for money.**
 - People give to people and because of people. People who don't know you or your arts group probably will not give.
2. **Cultivate before asking.**
 - Cultivate potential donors through special events, receptions, openings, opportunities to meet guest artists, ad hoc committees, advisory boards, memberships and membership benefits, support groups, etc. Only ask for a gift after you have had a chance to inform and educate a prospective donor.
3. **Think of the needs of the donor.**
 - Your need for money will not motivate a donor to give; your provision of service to meet clear community needs will. Find out what interests the donor has and think through how the donor will benefit by giving.
4. **Ask for support for what you need.**
 - Be sure you are sticking to your fundraising plan and are raising money for the things you need, not creating new things that sound more enticing to potential donors. You may need to practice and try different strategies for making the electric bill or the janitorial services sound enticing.
5. **Personalize your solicitation.**
 - People give more and are more likely to give when asked in person. People give more the more personalized the approach. Personal calls raise more than phone calls. Phone calls raise more than letters. Personalized letters and handwritten notes raise more than form letters.
6. **Raise money from the inside out.**
 - Start raising money by asking the board to give first. Ask any fundraising volunteers to give before they ask others to give.
7. **Raise money from the top down.**
 - Ask your best large-gift prospects first. Large gifts set the pace and build confidence, excitement, and momentum. Seventy-five to 95 percent of contributions come from 10 to 15 percent of donors (usually fifty to one hundred people).
8. **Make the case larger than the organization.**
 Show prospects how:
 - they will benefit (through involvement, becoming "part of the family," special privileges of membership);
 - their children will benefit (through educational opportunities, children's programs);

(continued)

○ their community will benefit (through economic development, community pride, enhanced quality of life); and

○ the gift is an "investment" in the future (for the reasons above).

9. **Develop a strategy you can accomplish.**

○ Aim for success. Don't overreach.

○ Fundraising success builds community, donor, and volunteer confidence so you can ask again. Everyone wants to be associated with a winner.

10. **Treasure your volunteer leadership.**

○ Good leaders are rare.

○ Substantial money cannot be raised without good volunteer leaders.

Source: Texas Commission on the Arts, *Tools for Results Toolkit.* ©2007. Used with permission.

PREPARATION FOR SUCCESSFUL FUNDRAISING

The arts organizations that are the most successful in fundraising understand the mentality of fundraising, but they also have elements in place to help ensure that they are able to easily and effectively persuade others to support them. Before any fundraising is attempted, the organization should establish a common vision of the goals. The process starts with basic organizational planning: the creation of long-range and strategic plans.

Obviously, the organization needs to be legally ready to accept contributions. This means that the organization must either be a tax-exempt, 501(c)(3) organization or have a fiscal receiver in place. A **fiscal receiver** is any not-for-profit arts organization or community organization that already holds a 501(c)(3) exemption and has agreed to accept contributed funds for nonexempt organizations. Often, arts service organizations such as arts councils are set up to act as fiscal receivers.

Mission and vision statements, which encapsulate the organization's purpose, are an important part of aligning the organization around the reason for the fundraising activities. A strategic plan prioritizes goals and programs; without it, an organization may find itself mired in internal competition as staff members and volunteers lobby for the success of "pet" programs. A budget identifies financial needs and potential income sources, and helps determine what percentage of revenue will depend on contributed sources.

Within an overall budget and strategic plan, each organization should identify specific financial and other goals for the fundraising effort. As we discussed in chapter 9, a budget is developed by using the most conservative figures possible, not the maximum amount you hope to receive. Monetary goals for the organization may be higher than budgeted amounts: what you would ideally hope to receive, not the minimum you must receive. These goals are set within the development department and are based on other factors, such as the relationship of

fundraising to earned income activities, organizational priorities, and current trends for programs and types of contributions. Some of the questions that organizations might take into consideration include the following.

1. Are we raising money for new programs, maintaining existing programs, or both?
2. If we need more money than last year, will those funds come from new donors or increases by existing donors? What is our renewal retention rate?
3. In addition to our monetary goals, what are our donor number goals in each category?
4. Do we need to design new opportunities for giving, such as corporate sponsorships, special events, or membership benefits?
5. Who will be designing and facilitating fundraising efforts?
6. How many staff and volunteers do we need to facilitate fundraising?

FUNDRAISING EXPENSES

Major-donor fundraising	Travel, dining, and other hospitality expenses related to donor visits Gifts, recognition, and premiums
Individual donor/ membership fundraising	Direct mailings (design, printing, mailing) Mailing list rental and purchase Gifts and premiums
Special events	Printing (invitations, programs) Venue and equipment rental Decorations Food and beverages
Grants	Copying (many grantors request multiple copies of all documents submitted) Visits to funders Overnight or certified mail for proposals
Overall	Staff time for facilitating fundraising Consultants, if necessary Professional development for staff Brochures, website, and other promotional materials Annual report
Technology and infrastructure	Database software Computers/copiers/scanners Cell phones and communications gear Internet provider/website host Secure donation mechanism for Web page

It is tempting to set the annual fundraising goal by simply increasing last year's goal by a certain "cost of living" percentage. But, as Ilona Bray points out in *Effective Fundraising for Nonprofits,* fundraising involves too many variables for this type of approach to lead to accurate results.[1] To arrive at an informed goal, it is necessary to look at every revenue source and make a reasonable projection based on monetary and other goals.

It's also important to consider expenses related to fundraising during creation of the fundraising plan. Not only will estimating expenses help prioritize goals—you may find, for example, that a special event would cost too much to be worthwhile—the IRS and many funders request expense information for purposes of evaluating your fundraising effort. No funder or regulatory agency likes to see a significant portion of contributed funds being used to solicit more funds. However, no not-for-profit should skimp on the necessary expenses, either.

Before beginning fundraising, the organization should have in place a list of policies and procedures for every step of the process. These may include record-keeping systems, policies for how money should be handled, bookkeeping procedures, and policies for acknowledgment and donor recognition. Sample policies can be found in Appendix 2.

The Case for Support

A **case for support** (sometimes called "the case") is an important part of fundraising planning and should be prepared prior to every fundraising campaign. The case tells potential donors what the campaign is about, how the funds are to be used, and why the program or organization should be supported. A **case statement** forms the basis for preparation of fundraising materials such as brochures and grant applications, but it also is used as an internal tool to help board, staff, and volunteers align with the fundraising process. The case statement helps the members of the organization coalesce their thoughts about the worth of the project and allows them to develop arguments that will be most persuasive to potential funders.

The case can be as simple as a paragraph or as complex as a multipage document. Developed from fundraising plans, the case at its simplest states an organization's mission and the goals for the present fundraising effort and explains why donors should give, using persuasive and compelling terms that all of the participants in the fundraising process can understand. A longer case statement also answers questions donors are likely to raise; lists information about giving methods, benefits, and recognition; and creates a sense of urgency for giving now. If the case is prepared well enough, its language can be used throughout the campaign for creating fundraising materials and in grant applications and personal visits.

Who Does the Fundraising?

One of the important steps in the fundraising process is understanding who does the work. The exact roles will vary from organization to organization, but in all cases, it is important to adopt the mindset that fundraising is everyone's job. Raising funds is a complex process, involving cultivation of donors and personal relationships as well as administrative tasks.

A SIMPLE CASE STATEMENT FOR AN ARTS ORGANIZATION'S ANNUAL FUND DRIVE

Consider this sample document for a hypothetical arts museum. Where in the statement can you find the elements for a successful short case statement listed in the text? Is there anything missing? What would you add?

The Case for the Lake City Art Museum

Since 1796, the Lake City Art Museum has been accomplishing its mission of showcasing the diverse artistic expression of the people of Lake City. Through visual art exhibits, juried shows of local artists, and art education programs, the Lake City Art Museum has maintained a high standard of quality while making art accessible to people of all ages.

The coming year promises to be crucial for the museum. Traditionally, the museum has received nearly 50% of its funding from the city council. The remainder comes from admission fees to events and programs, grants, donations, and corporate sponsorships. Admission to the museum is free to all Lake City residents, and we are committed to continuing that policy. However, Lake City is cutting our funding by 10%, increasing the proportion of funds we need to raise from community sources.

Next season, several exciting programs are planned to further enhance our mission. A new touring exhibit featuring historic quilts will be presented here as the first of several stops in locations throughout the state. The annual juried art show will have a high school component for the first time, and we are working with local high school teachers to encourage participation. New classes in printmaking, photography, and watercolor are being planned, and we will be presenting some classes in the new Senior Center.

Our goal for the upcoming year is to raise $64,000, an increase of $12,000 over last year's successful campaign. In order to raise these funds and continue our important service to the community without cutbacks, we need the support of individuals, businesses, corporations, and foundations. Interested donors should contact our development department at 555–1212.

One of the governing roles for a not-for-profit board of directors is ensuring the financial stability of the organization. Thus the board has a crucial role in fundraising. While a board member may not personally write a grant application or prepare a fundraising letter, all members can visit major donors, introduce colleagues to the organization, write thank-you notes, solicit in-kind gifts, and greet donors at social events. Board members should also be prepared to make personal gifts to the organization at the level of their ability.

Staff members are usually responsible for the day-to-day aspects of fundraising, such as coordinating mailings, writing and managing grant applications, and managing donor information and benefits. In many organizations, the board relies

on an executive director or development director for heavy assistance in the personal cultivation of gifts. Board members also count on staff to inform them of opportunities, do prospect research, and keep up on current trends in fundraising.

Volunteers can be useful to the fundraising effort in many ways. Often, a development committee includes volunteers other than board members and coordinates volunteer participation in fundraising. Volunteers can staff special events, work on mailings, and provide good connections to community members.

Because of the specialized and intensive nature of the activity, consultants are engaged to manage or assist in some fundraising tasks. Consultants are useful during the **feasibility study** process, as their objectivity can be important in eliciting from prospective donors candid answers about proposed programs and campaigns. Consultants or **contracted staff** can also be hired for isolated tasks such as grant writing or conducting a special campaign for which paid staff or volunteers lack the time or expertise. There is a caution when working with consultants, however. Some organizations make the mistake of thinking that they can turn the entire fundraising operation over to a consultant. Reputable consultants will never agree to this arrangement, since they follow the professional maxim that fundraising is as much about relationships as money. After the consultant leaves town, the organization will need to maintain the relationships with donors

ROLES IN THE FUNDRAISING PROCESS

Activity	Staff Role	Board Role	Volunteer Role
Grant proposals	Research guidelines, write proposal	Support with letter, phone call or visit	May be involved in any of these
Direct mail solicitation	Write and produce printed materials, receive gifts, record/acknowledge	Suggest names or lists, sign letters, write personal thank-yous	Help with design, envelope stuffing; provide names
Major donors	Research prospects, set appointments, recruit volunteers, accompany board members on calls	Help research prospects, suggest names, go on calls, write notes of support, invite major donors to events	Suggest names, help prepare materials, go on calls if trained
Special event fundraisers	Help with planning, coordinate support staff, monitor progress, facilitate activities	Assign committee chair and members; attend	Plan and staff the event, sell tickets, attend

in order to be successful with them in the future. A consultant can be useful in training the appropriate staff, setting up the fundraising campaign, and facilitating the process, but members of the organization must be involved every step of the way.

Many successful organizations do an annual audit of the fundraising process, and then plan for the future by making sure all board and staff members are clear about the organization's goals, plans, and responsibilities. Some organizations ask board members to sign documents indicating the level of their personal financial commitment and stating what they will do in the coming year to support the fundraising process.

WHO SUPPORTS THE ARTS?

In the United States, **philanthropy** is different than in many other countries. In their book *Successful Fundraising for Arts and Cultural Organizations*, Carolyn Stolper Friedman and Karen Brooks Hopkins state that no other nation in the world has a mix of health, educational, social, environmental, and religious not-for-profits similar to those supported by Americans. The proliferation of not-for-profits in America is a long-standing tradition that arises from the belief that individual participation in charitable causes is as important as government support. As Friedman and Hopkins put it, "The democratic idea that each person should do his or her fair share, combined with the more contemporary notion of income-tax incentives, has encouraged a wide range of U.S. citizens to become philanthropists." In fact, more than 80 million Americans contribute time and money to the not-for-profit sector. [2]

Americans are extremely generous people. In 2011 Americans gave nearly $300 billion to charitable organizations. Of that, $13.12 billion was given to arts and culture. According to the Giving USA Foundation, which has tracked philanthropy in America since 2001, gifts from individuals are the largest portion of contributions, about 73% in 2011.

The diversification of sources of revenue for the American arts organization can be complex. Each organization must not only promote earned income opportunities, such as ticket sales and admissions, it must solicit donations from many different sources at once. The typical arts organization manages hundreds of gifts and hundreds of donors, at all levels, and in many shapes and forms. Arts organizations approach local businesses for sponsorships, individuals for $25 and $50 memberships, wealthy patrons for larger gifts, and government or private sources for grants. The task of juggling so many different revenue sources can be daunting, especially for smaller, volunteer-driven organizations.

While it may be tempting to stick with earned income activities, it's important for each organization to investigate sources for contributed income as a way of both diversifying income and bringing more supporters into the organization. Each organization needs to balance the different kinds of fundraising and understand which sources will be most beneficial.

Individual Giving

As just noted, the largest percentage of donations to any organization will be from individuals. One reason individual giving is the largest single source of contributed income is that there are many different ways for individuals to contribute. Most arts organizations employ a combination of the methods geared toward support by individuals—for example, annual fund drives, membership programs, special events, major gift giving, and planned giving.

From an institutional point of view, individual givers are valuable to the organization in many ways. Individual supporters can act as ambassadors for your organization, spreading the word about your good work and bringing others into the fold. For the most part, smaller individual gifts do not come with strings attached and therefore can be used for a variety of purposes, including hard-to-fund items like rent and utility bills, whereas foundation or government grants must be used for specific programs. Grants, which run to the five figures and higher, are often larger than individual gifts, where $50, or even $5, is a typical donation. Individuals give because they believe in the organization and wish to support it. They may be attracted to the organization because of a personal connection or because they have benefited from the organization's programs. Understanding individual donors means understanding what motivates them to give and providing a variety of opportunities for involvement.

Most organizations count on a ever-growing number of donors to give every year, to form a base from which to budget and build programs. Annual giving can encompass a number of gift sizes, from very small gifts to larger ones. Annual gifts are **solicited** in a number of ways, from mailings to personal appeals to inserts in newsletters, programs, and other printed materials. Many organizations that conduct annual campaigns do so with the understanding that fundraising takes place year-round and that every communication with constituents is an opportunity for fundraising. Organizations also understand that a modest annual gift always has the possibility to grow into a major gift.

Many times, the opportunity to give brings with it the opportunity to become a member of the organization. Membership and annual giving may be indistinguishable: for some organizations, "becoming a member" simply means making an annual gift. For others, membership carries specific privileges, such as free admission to a museum, discounts in the gift shop, or a premium like a tote bag or coffee mug. Organizations offering membership programs need to be careful, however. In some states, the word "member" has a specific meaning in the not-for-profit setting, including the right to vote on important organizational decisions such as appointments to the board of directors. We'll discuss annual fund and membership programs in more detail in the next chapter.

Many donors find it convenient to give in-kind gifts instead of cash. Still others give with their volunteer time, make gifts through their businesses, or work to connect organizations with donors. These contributions can be as valuable as cash to an organization, which can apply the saved resources to other expenses.

How does an arts organization find individual donors? Many times, individual donors are those who have found value in the organization because they've

attended programs or participated in the organization's offerings. Individuals donate because they believe in the organization or cause and wish to support it. The best way to create true believers is to emphasize the need for contributed income in the course of promoting programs. Many organizations, for example, include a request for a tax-deductible donation on season ticket order forms or in patron newsletters.

Major Gifts

Although it is important for an organization to build up a large number of donors who are willing to contribute $25, $50, and $100 gifts, most organizations also find it worthwhile to seek larger gifts from wealthier donors. Major gifts must be handled differently than smaller gifts, both during solicitation and after the gift has been received. Major-gift fundraising is a highly personalized process that can yield great rewards for the organization.

What constitutes a major gift is different for every organization. For some organizations, $100 is a major gift; for larger organizations it might take $500 or $1,000 to reach the major-gift level. Major givers are usually highly invested in the organization and often are large donors to other organizations as well. Sometimes, major gifts are restricted to particular uses, such as a building project. Most major gifts require cultivation over many years, but many major donors, once they are on board, can be counted on to give year after year. Sometimes major donors give for specific projects and other times they give without restrictions. Most major donors are very invested in the organizations to which they give. They know the organizations well—perhaps they serve on the board or have served in the past. Perhaps they are friends of a board member, key volunteer, or artist.

Planned Giving

Planned giving is one of the fastest rising forms of charitable giving. The term is so named because a donor plans to make a future gift through a **trust**, will, or life insurance. Because of the large amount of income that is being willed to younger generations by wealthy individuals, a number of types of giving have recently been developed that allow both the donor and the organization to benefit. One popular type of planned giving, for example, transfers a lump sum from the donor to the organization but pays the interest to the donor until the donor passes away. The disadvantage of planned gifts is that you don't know when they will become available, so you can't count on them for immediate income. They are, however an excellent way to ensure financial stability for the future. Many not-for-profit organizations, especially larger ones, are beginning to establish permanent **endowments** in which gifts like these can be accumulated, providing the opportunity for steady income from interest earned.

Corporate and Business Giving

Like individuals, corporations and businesses can get involved with arts organizations in a number of ways. The impetus for giving, however, is usually different. Businesses and corporations may be less moved by emotional support and more concerned about how giving affects corporate goals.

Changes in corporate and business structure and the economy in the past twenty years have greatly affected the way corporations give to the arts. The twentieth-century model of a locally owned corporation that annually budgets for corporate contributions is in danger of disappearing. Mergers and buyouts have resulted in the consolidation of many smaller companies into fewer larger ones, meaning that decision makers with authority over giving are often in distant locations with little connection to local communities. Economic pressures have forced corporations to place more emphasis on spending activities that show a consistent return to stockholders. The result is not less corporate money in arts pockets, but money that arrives in different forms and may carry different kinds of obligations on the part of the arts organization.

Corporations and business can give in various ways. We'll discuss contributions, sponsorships, corporate in-kind gifts, and the work of volunteers.

Contributions

Even considering the conditions noted earlier, many corporations still make annual contributions. Some of these donations are administered through staff, and others are decided by an employee committee. Many corporations support the organizations their employees value by matching their donations (in cash or volunteer time).

Sponsorships

More often, corporations and businesses today are seeking forms of giving that offer them exposure in the community or provide other direct benefits. Usually, they choose to initiate a **sponsorship**, whereby the business provides a sum in exchange for being listed as an exclusive sponsor of an activity, sponsor of a particular facet of a program, or one of multiple sponsors. An arts organization that accepts sponsorships must be careful that the requirements for recognition of any business do not conflict with the organization's mission or obligations to other donors.

Corporate In-Kind Gifts

Giving gifts of goods or services benefits businesses in many ways. Giving away products, which is sometimes easier than identifying available cash, can be justified as a promotional tool. Some businesses that are frequently asked to donate have adopted policies that allow them to budget a certain amount of product or time to give to local not-for-profits annually. For example, an accounting firm might provide free accounting services, or a printer might donate special paper or reduce printing charges as an in-kind donation to lower a non-profit's costs.

Volunteers

Many corporations, in an effort to serve their communities without jeopardizing profits, have developed programs that encourage their employees to volunteer. Some companies pay for a certain amount of volunteer time; others organize groups of volunteers for short-term projects such as festivals or special events, either on or off company time.

The key to success with corporate giving is to approach each corporation individually to find out how it structures its community involvement programs. Because

Case 10-1

Case Study: Target Corporation

Target Corporation is one example of a corporation that dedicates 5% of its pretax profits to charitable giving. The giant retailer has traditionally concentrated its giving on education and the arts, with a focus on making decisions in individual communities. For more information, go to www.target.com, click Communities and then Arts.

of the different forms that corporate giving takes, you may have to approach a giving officer, a marketing department, a human resources department, or some other corporate entity. You are more likely to be successful if your approach is respectful of the goals of the corporation or business.

Foundation Giving

A foundation is a particular type of not-for-profit corporation specifically formed to give grants to causes in line with its declared purpose. Foundations can take many different forms. Foundations are required by the IRS to distribute a certain percentage of their assets each year, and many have formal application procedures for organizations seeking grants.

- **Family foundations** are formed with personal funds and controlled by donors as a means of supporting specific charities or communities. Family foundations not controlled by the original donors are often run by their heirs.
- **Corporate foundations** are formed with funds from corporate profits. Many corporate foundations support issues associated with the needs of their industries, and some support projects that will bring them visibility in communities they serve.
- **Professional foundations** are large foundations with paid staff, which often manage many millions of dollars in assets. Some professional foundations began as family or corporate foundations.

A newer form of foundation is the **community foundation**, which is a pooled fund of contributions from several donors. The combined funds allow for a greater return on investments, and the availability of professional staff relieves donors of the chore of accepting and evaluating applications for funds. Community foundations usually grant funds locally to improve the donors' community.

The method for approaching foundations varies according to the institutions size and purpose, and the intent of the donor. Larger foundations accept formal

applications according to a published schedule and give grants to selected applicants. Many smaller family foundations can be approached more informally, much as an organization might approach an individual major donor. We'll discuss more about this in the next chapter.

GOVERNMENT'S ROLE IN ARTS SUPPORT

"While no government can call a great artist or scholar into existence, it is necessary and appropriate for the Federal Government to help create and sustain not only a climate encouraging freedom of thought, imagination and inquiry, but also the material conditions facilitating the release of this creative talent."
—President Lyndon B. Johnson, 1965

The government has a varied and complex role to play in arts funding. Since the beginning of our country, Americans have struggled to create a role for the government in supporting the arts while maintaining enough distance to prevent official intrusion into artistic creation. Whereas many other countries provide a great deal more direct support for the arts than does the United States, our system does give both direct and indirect support; it also offers incentives for private donations and establishes other mechanisms that many believe allow art and arts organizations alike to flourish in an atmosphere free from government intervention or censorship.

Prior to 1965, direct support of the arts by the federal government included support of military bands, the Library of Congress, the Smithsonian Institution, and smaller cultural programs housed in other departments. In 1965 President Lyndon B. Johnson signed into law the National Foundation on Arts and Humanities Act. This law formed the National Endowment for the Arts (www.nea.gov) and National Endowment for the Humanities (www.neh.gov), creating mechanisms for direct funding of regional and local arts organizations around the country.

Within a few years of the formation of the National Endowment for the Arts and the National Endowment for the Humanities, most states had also formed government arts agencies. Much of the funding from the NEA and NEH goes directly to states, where it is matched with state funds to create a pool for granting to state and local organizations. Some states **regrant** this money, sending funds to local arts agencies to be matched with local funds and granted to local organizations.

Why does government support the arts? Why *should* government support the arts? The answers to those questions depend on what each individual believes the role of government to be. For those who believe in a limited role for government, support for the arts has to do primarily with ensuring the preservation of national or community treasures. For others, support for the arts has to do with improving quality of life, providing a rounded, high-quality education to all citizens, and supporting the economy by encouraging cultural and entertainment options for residents and visitors.

Most agree that the role of the government is to provide services that benefit all of society, especially services that cannot be adequately covered—by

individuals, private business, or charitable organizations. In many societies, therefore, government has been involved in the following activities:

- Preservation of national or community treasures, artwork, and historical artifacts
- Honoring persons, events, and achievements important to our history
- Creation of cultural democracy; ensuring that all citizens have access to the arts
- Enrichment of the nation's or a community's cultural life
- Examination of the role of culture in society

Government Giving

Today the U.S. government supports the arts in many ways, as do state and local governments at all levels. Some of the ways we shall note are direct grants from arts and other agencies, indirect funding, dedicated taxes, and support of arts venues and organizations.

Direct Grants from Arts Agencies

Arts and cultural organizations can apply for grants from the NEA and the NEH, as well as state arts agencies in all fifty states and many local arts agencies. Normally, government arts grants require the organization to match the funds received with additional funds raised in the community.

Direct Grants from Other Agencies

Many arts organizations are able to apply to other governmental agencies for funds if their projects impact other functions the government supports. For example, an arts council that wishes to paint a mural in a blighted area of town may be able to apply for funds from a state or federal urban development program. An arts program that provides opportunities to at-risk youth may qualify for jobs or human service funds.

Indirect Funding

One of the most significant ways in which the U.S. government supports the arts is by eliminating for charitable organizations the burden of paying income and certain other taxes. Such organizations receive **tax-exempt status**. While the U.S. government gives far less direct funding to the arts than most other big countries, its position has always been that the loss of tax revenue due to tax-exempt status equates to funding support, even though that support is indirect.

Many states honor the tax-exempt status of charitable organizations, although some require 501(c)(3) organizations to pay sales tax.

Dedicated Taxes

Many state and local governments have instituted specific taxes that are reserved for funding arts programs. Common forms are hotel room taxes, income from special license plate sales, and sales taxes. These programs are administered

differently, to accommodate local conditions. In some communities, funds are administered directly by the government, while in others, they are channeled through an arts council, which grants the funds to arts organizations. Some states have formed **cultural trusts** or endowments to help ensure the perpetuation of arts funding by removing this category of funding from the ongoing budget process.

Many cultural trusts are funded with an initial grant from the state, and many earn additional funds through tax incentives, license plate sales, or other means.

Support of Arts Venues and Organizations

Federal, state, and local governments all have traditionally recognized the importance of supporting arts venues, even though few venues in the United States are completely supported by government. Most require additional funding through admissions fees, memberships, or contributed support. The federal government supports:

- The Smithsonian Institution
- The National Gallery of Art
- The National Museum of the American Indian
- The Kennedy Center for the Performing Arts
- The Library of Congress
- A variety of nationally significant historical sites
- National monuments and memorials

In states and local communities, support is common for the following types of institutions (although not every institution like this receives public funds):

- Public museums of history, natural history, and art
- Memorials and monuments
- Performing arts centers
- Locally significant historical sites

As with other forms of giving, the key to success in government funding is understanding the specific programs and sources for funding available in your community, state, and region. With government funds, since taxpayer money is being used, proper preparation, justification of your request, and accountability are crucial. Most government grants not only require extensive information during the application process but must be managed throughout the life of the grant to ensure compliance with governmental regulations.

IN CONCLUSION

Fundraising for the arts can be an exciting opportunity to share your passion for your art and for your organization, and to persuade others to join you. There is a rich variety of sources available to the not-for-profit arts organization. It is up to each organization to understand its needs, discover the needs of potential funders, and craft a story that will motivate others to give.

DISCUSSION QUESTIONS

1. Have you ever been involved in a fundraising project for a not-for-profit organization or school? What is your perception of the organization's attitude toward the process? Did people look forward to fundraising or approach it with trepidation? How were the attitudes above reflected—or not reflected—in the fundraising process?

2. Some organizations think that it would be a good idea to hire a consultant on a commission basis to raise funds: that is, the consultant would receive a percentage of each new gift brought into the organization. Although superficially this arrangement would seem to be a win-win for both consultant and organization, it is frowned on by funders and professional fundraising organizations. Can you think of some reasons for their negativity?

3. One of the challenges of arts fundraising is that the people who are most likely to believe in the organization are those who have already spent money attending programs. These people might feel that they have given enough after purchasing tickets or buying a piece of art in the gift shop. What are some ways to persuade people to give a donation on top of the support already contributed? Can you think of some types of people that might be persuaded to donate even though they have not participated in the organization's programs?

4. If you read or hear about a foundation supporting an arts program in your community, look it up online. Can you identify the kind of foundation it is by the information on the website?

5. Do you believe that government should support the arts? Why or why not? What arguments have you heard for and against government's involvement in arts funding?

CHAPTER 11

✣

Fundraising Nuts and Bolts

"Fundraising . . . is the process of giving people opportunities
to act out their values."

—KAY SPRINKEL GRACE, BEYOND FUNDRAISING:
NEW STRATEGIES FOR NONPROFIT INNOVATION
AND INVESTMENT, 2ND ED., 2005

In the last chapter, we discussed the philosophy of fundraising. In this chapter, we will put some meat on those bones.

Although it is essential for every member of the arts organization to understand the nature of giving, the different kinds of giving, and why donors give, it is also essential to know the nuts and bolts of how to make fundraising happen. Part of this process consists of developing a personal and organizational philosophy that guides fundraising. As Kay Sprinkel Grace notes in the opening quotation, the best fundraising transactions happen between organizations that have a strong mission and values and donors who believe in what their favored organizations do. Viewed this way, Grace states, "fundraising becomes less formidable and frustrating. It is viewed with less apprehension by volunteers and staff, and its potential as a transforming act for the asker and donor/investor is clear."[1]

When you finish this chapter, you should be able to:

- Describe how donor relationships and fundraising ethics are important to the fundraising process
- Describe how to find appropriate prospects for solicitation
- Write a persuasive fundraising letter
- Understand the procedures for applying for grants and soliciting corporate sponsorships

DONOR RELATIONS AND FUNDRAISING ETHICS

We noted in the last chapter that "people give to people"—in other words, fundraising, when successful, is more about creating relationships than completing a financial transaction. A donor who is emotionally invested in an organization is more likely to be pleased with the donation, to give again, and to bring others into the circle.

We've also discussed that donations (also called contributions and gifts) are classified as contributed income, inasmuch as the donor has not purchased a product but, rather, has given with no expectation of return. This financial definition does not tell the entire story: of course the donor wishes to receive something in return. The desired return in the case of a donation, however, is not a product; it may be an improved community, a successful organization, or more art for children—whatever is at the intersection of the organization's mission and the donor's interests.

Sometimes, however, other donor interests may be just as important in the decision to give. Sometimes a person wishes to leave a legacy to the community, perhaps by having a family name on a building or program. Sometimes it's more about prestige, corporate public relations, or networking. Some donors want perks like free tickets and tote bags. Others can be enticed to give simply because they know they'll be invited to insider parties and meet-the-artist events. Whatever reasons donors have for giving, successful fundraising is about finding out those interests and appealing to them, assuming, of course, that the organization's mission and goals are not compromised in those efforts.

Another fundraising maxim is: It takes three years to get a gift. This also relates to the need to get to know donors, to expose them gradually to the organization and make them feel as though their donation will make a difference. Successful organizations make plans for getting to know their potential donors by, for example, contacting them without asking for donations or inviting them to special events. This relationship goes on even after the gift has been received. The most successful fundraising professionals and organizations create lifelong associations with their donors.

Creating and maintaining relationships with donors, however, also brings up the need for strict ethical procedures and policies during all phases of fundraising. The first guideline is that the organization must never compromise mission, artistic values, or goals in order to attract a donor. To paraphrase something your mother used to tell you, "A donor who would ask you to do *that* is no friend." While each organization must decide where to draw the line, some donor requests may be impossible to fulfill within the context of its mission. Examples include hiring or firing staff or artists based on donor wishes, promising the donor a position on the board, putting corporate logos on stage, changing the design of a building, and dropping programs. Most donors understand that while they are invested in the project or organization by virtue of their donation, legal rules and ethical guidelines require the governing board to be free of influence in making decisions.

It's also good practice for board and staff to be familiar with the ethical principles of the Association of Fundraising Professionals (AFP), regardless of whether the staff are members of AFP. These principles are based on fair treatment of donors, avoidance of conflicts of interest among fundraiser, organization, and donor, and adherence to applicable organizational policies and mission. A summary of these principles can be found on the AFP website.[2] It is also wise policy, when interviewing fundraisers, to ask if they adhere to the AFP Code of Ethical Principles and Standards.

The Donor Bill of Rights is another important tool for those who solicit contributions. Although it is not a legal document, an increasing number of not-for-profit organizations are adopting it as standard practice and using it as their policy in donor relations.

THE DONOR BILL OF RIGHTS

The Donor Bill of Rights was created by the Association of Fundraising Professionals (AFP), the Association for Healthcare Philanthropy (AHP), the Council for Advancement and Support of Education (CASE) and The Giving Institute: Leading Consultants to Nonprofits. It has been endorsed by numerous organizations.[i]

Philanthropy is based on voluntary action for the common good. It is a tradition of giving and sharing that is primary to quality of life. To ensure that philanthropy merits the respect and trust of the general public, and that donors and prospective donors can have full confidence in the nonprofit organizations and causes they are asked to support, we declare that all donors have these rights:

1. To be informed of the organization's mission, of the way the organization intends to use donated resources, and of its capacity to use donations effectively for their intended purposes.
2. To be informed of the identity of those serving on the organization's governing board, and to expect the board to exercise prudent judgment in its stewardship responsibilities.
3. To have access to the organization's most recent financial statements.
4. To be assured their gifts will be used for the purposes for which they were given.
5. To receive appropriate acknowledgment and recognition.
6. To be assured that information about their donation is handled with respect and with confidentiality to the extent provided by law.
7. To expect that all relationships with individuals representing organizations of interest to the donor will be professional in nature.
8. To be informed whether those seeking donations are volunteers, employees of the organization or hired solicitors.
9. To have the opportunity for their names to be deleted from mailing lists that an organization may intend to share.
10. To feel free to ask questions when making a donation and to receive prompt, truthful and forthright answers.

[i]See the AFP website for a complete list of endorsing organizations.

PROSPECT RESEARCH

Talking about donor relations is one thing, but where does an organization find donors who are interested in giving in the first place? Prospect research is a very important part of the fundraising process. Research allows the fundraiser not only to find potential donors whose priorities match the organization's, but also to collect details about how to apply to various sources, learn what other organizations the donor has supported, and get a rough idea of the donor's capacity to give.

As emphasized earlier, the most successful transactions come about when the donor's interest matches the organization's vision. The purpose of prospect research is not primarily finding people who have a lot of money, but finding individuals, corporations, foundations, and government agencies that are good matches for your organization. This may mean prospects who have given amounts in the ballpark of your needs, funders who give in your geographic area, and prospects who have interests in common with your organization. It may mean obtaining information that will help you make your case to an organization that has not funded programs like yours in the past.

Successful fundraising operations keep lists of potential donors, along with detailed information on the priorities and application procedures of each one, so that they are ready to proceed when the time is right. With individual donors, the discovery of a name may lay the groundwork for strategic development of a personal relationship. With foundation or government grantors, it's important to have enough information to be able to act when a program meeting a given funder's guidelines is proposed. This, in turn, means knowing upcoming due dates, since time must be allocated to assembling information and writing a grant application.

Prospect research does not need to be an expensive or tedious activity. The good news is that in addition to printed sources, there is a wealth of information easily available on the Internet. Most foundations and government agencies publish granting guidelines, contact information, and sometimes even applications online. Larger corporations often post giving information on their websites, most often in the "Community" or "Community Relations" sections.

For individual prospects, it's necessary to find appropriate information while also respecting the privacy of the potential donor. Important things to know for individuals might be:

- Employment history (to establish networking connections or estimate salary level)
- Professional and personal affiliations, including board memberships, professional organizations, and offices held
- Other gifts given in the community (to whom and how much)
- Accurate contact information (including seasonal residence, if applicable)
 With individuals, this information can help establish a connection with your organization. For example, you may find that your prospect serves on

another board that also seats a member of your board. If so, that board member can make the connection.

An organization's own records comprise one of the best sources of names of potential individual donors. People who have participated at some level in the organization's programs or events can be invited to increase their involvement—from a smaller donor to a higher level, for example, or from a ticket purchaser to a member. Another good clue to the potential of a donor to support your organization is support of similar organizations in the past. It's easy to find lists of donors of other not-for-profit organizations on websites, in program books, and in annual reports.

One of the best sources for potential foundation donors other than their websites is via their Forms 990, which as we learned in chapter 9 are public records. Toward the end of the 990-PF (the form used by private foundations), the foundation must list the grants given, their purpose, and the amounts. There, you can discover a great deal about what kinds and amounts of gifts have been given in the recent past.

WEBSITES FOR PROSPECT RESEARCH

Information on foundations other granting entities is readily available online. Several websites contain databases of publicly records such as 990 tax returns; others have additional information based on questionnaires filled out by foundations. Research websites normally provide some of this information for free and require subscriptions to access more detailed information. Listed below are three of the most commonly used sites.

– The Foundation Center: http://foundationcenter.org/

– Guidestar: http://www.guidestar.org

– NOZA: https://www.nozasearch.com

THE ANNUAL CAMPAIGN

Most organizations think of their fundraising effort in terms of an annual cycle, often known as an annual campaign. As a part of the planning process each year, goals are approved for each type of fundraising that goes into the organization's contributed income mix. In addition to monetary aims, this goal-setting process may include other necessary goals such as increased visibility for the fundraising effort, increased involvement by volunteers or alumni, or such participation goals as increasing the number of members or the percentage of renewals.

Goals for the annual campaign should be set based on past performance, knowledge of future trends, feasibility, and current economic conditions, not financial need. It is irresponsible for the board to approve a plan that, for example, increased corporate sponsorship by 500% "because we really need the money and we aren't getting enough corporate sponsors now." The "We'll just have to make it work" attitude is dangerous for the organization's budget—unless the organization is backing up this desire with additional staff or resources to help make it happen. Even so, it's important to remember that fundraising success is never directly tied to simple effort alone. Fundraising goals should be considered differently from budgetary needs. The budget line item is the minimum amount that will be needed; the corresponding goal may be higher than that, but failure to achieve it won't cripple the organization.

In thinking about goals, organizations should consider what they are asking donors to fund. Unrestricted contributed income is highly desirable because the organization will be able to spend that money in the area of highest need. As noted in previous chapters, the bulk of unrestricted contributed funds comes in smaller individual donations, special event fundraising, and memberships. These activities often form the largest percentage of income and effort in a not-for-profit organization.

Each organization also needs to plan for restricted funds by evaluating existing and new programs to determine what will fit within foundation, government, and corporate priorities. The next page shows a sample of a basic fundability analysis that can be used to discover links between programs and funders.

Organizations contemplating new programs or expansions of programs that must be supported by donations often conduct a **feasibility study**. Feasibility studies research whether a campaign might be successful, based on information collected about other proposed fundraising drives in the community, willingness of major donors to support the project, availability of volunteer leadership, and questions or concerns potential donors might have about the project. Often, a feasibility study points to the need to delay or revise a program until a successful fundraising program can be mounted. Other times, leaders or major gifts emerge during the study process. For an organization facing a major campaign or a significant program dependent on fundraising success, a feasibility study is well worth the effort and cost.

WRITING SUCCESSFUL FUNDRAISING LETTERS

The ability to write a good fundraising letter, sometimes called an **appeal letter**, is one of the most important skills a fundraiser can have. Most Americans, especially those who have a history of charitable giving, receive appeals each year from many different sources. Even an ongoing relationship with a donor does not guarantee that the donor will continue to give. It's important to carefully plan each appeal and each communication with donors.

An appeal letter should be only one facet of an ongoing relationship. Ideally, by the time a donor receives a request for a donation, he or she is already familiar with the organization and its programs, is comfortable that the donation will be used wisely, and feels the need to support the organization. Still, people may want

FUNDING OPPORTUNITY WORKSHEET

Program: Dates: Reports to:	Summer Art Camp Weekends in August Education director			
	PROGRAM	**FOUNDATION**	**GOVERNMENT**	**CORPORATE**
Mission	Part of our educational mission		Arts Council interested in high- quality artist teachers	
Community needs or social issues addressed	Serves at-risk youth, inner city neighborhoods	May qualify for Community Foundation basic needs grant		ABC Corp. sponsors programs that provide alternatives for at-risk youth
Innovative, unique aspects	Using new "Art to Life" curriculum		Arts Council may be interested in new curriculum	
Visibility and PR potential	Need to work on this			Can ABC sponsor package include advertising support?
Endorsements	Received Governor's Award last year		Conforms to Arts for All guidelines	
Collaborators	Satellite classes at YMCA	Check Y's grant list for joint grants		Art supply store may donate supplies
Measurable outputs	Surveys sent to parents afterward		Arts Council insists on evaluation plans	

time to weigh your request against many others they have received, since the urgency associated with a decision of whether to purchase a ticket isn't an issue.

Therefore, a good appeal letter must include the "Three Whys":

- Why the donor should give
- Why the donor should choose your organization
- Why the donor should give now rather than later

Should a fundraising letter always be sent by snail mail? It depends. There are obvious benefits to using a paper letter for fundraising: a professional appearance, the ability to include supplementary materials such as brochures and reply cards, and assurance that the letter won't be assigned automatically to a spam folder. There are also obvious disadvantages, including the expense, the number of letters that won't reach their destination, and the competition with other "junk" mail. Though less commonly accepted as a professional way to make a first or only contact, e-mail is becoming increasingly more successful in political campaigns and national appeals, and is used more and more frequently by all kinds of charitable organizations as a way to create ongoing communication with donors, to remind them of lapsed memberships or overdue pledges, and to thank them.

No matter the means of communication, all good appeal letters will use:

- **Clear, persuasive language**
 Now's the time to go back to your college English class and brush up on the rules for persuasive writing! There is an art to being persuasive—encouraging people to see your point of view and motivating them to take action. Part of that simply means using clean, clear language to make your point—no words that people might misunderstand, no passive voice or run-on sentences, and especially no artistic insider jargon that might make people feel that they are not part of the family.

- **A personalized approach**
 It's very easy with software programs to personalize your letter, so that it reads "Dear Mary and Tom" rather than "Dear Friend of the Symphony." Some mail-merge programs allow organizations to include in the letter the amount the donor gave last year or a request for a specific amount based on the donor's situation. At the same time, it's unwise to be too familiar. Many people prefer not to be spoken to as if they were your best buddy. A friendly, yet professional tone avoiding the use of slang is best.

- **A positive tone**
 It's a delicate balance—people want to give where they are needed but they are usually reluctant to go down with a sinking ship. Be careful before positioning the appeal as "Give to us or we won't be around next year." Not only may that be needlessly negative, it may be an empty threat: if you still are around next year, what will you say to entice the donor? Most fundraising experts agree that the days of "holding out the tin cup" are

over. Donors don't want to listen to whining. Encouraging the donor to help support an excellent organization that relies on the contributions from people who care is a more positive way to frame an appeal.

- **Enough information to allow the donor to make a decision**
 If a donor is deciding among a sea of fundraising appeals and other solicitations, the smallest detail may be enough to send your letter into the recycle bin. Every letter should contain information about when the donation is needed, what it will be used for (avoiding restrictive language, of course), what (if anything) the donor will receive in return, and how the donation should be sent. Often it is beneficial to include with the letter a brochure or flyer with more details about the organization and its programs.

- **An easy way to give**
 Which donor is more likely to give . . . the donor who can take care of her donation immediately by clicking on a link to the website or slipping a check into a preaddressed envelope, or a donor who needs to search for his own envelope and write a note saying "This is for your annual appeal"? A fundraising letter that arrives with no convenient means of reply will not receive many responses. The most successful appeals include reply cards, return envelopes, links to an online giving center, and complete contact information, including a number at which donors can speak with a real person.

- **P.S.**
 Scientists have conducted eye-motion research that shows that the first thing a reader will read on the page is not the lead paragraph or salutation. It is the postscript (P.S.) at the end of the letter.[3] Therefore, most experts agree that including a strong P.S. is a key factor in getting people to read the rest of the letter. So use this "valuable piece of real estate" wisely by disclosing some benefit or irresistible information—enough to entice the reader to want to know more.

A sample fundraising appeal letter can be found in Appendix 11.

WHAT'S WRONG WITH THESE MESSAGES?

How would you change these bad examples to reflect the principles given in this chapter?

"We really need your help because we don't have enough money to get through the year."

"A gift to the ballet will help us institute classes teaching our dancers the Artemesia method."

"Call our office to learn about opportunities to give."

"Your gift that was received by us last year was a momentous addition to the panoply of responses."

"P.S. Please send in your donation today!"

SUCCESSFUL GRANT WRITING

A grant is a monetary gift to a not-for-profit from a legal entity such as a foundation or government agency upon submission of a grant application or proposal. As a rule, grants are restricted to a particular project that meets the grantor's guidelines. Grants normally require some sort of report to the grantor upon project completion.

Because the process of applying for a grant varies from grantor to grantor, sometimes significantly, it's not at all the same as asking for gifts from individuals. Foundations and government agencies are limited in the types of grants they make by their charters, by legislative directives, and by organizational policies. The most important factor in successful grant writing is following the grantor's instructions, not simply making a persuasive case. No matter how wonderful your program is, you will not receive a grant if your program does not meet the grantor's guidelines, or if other applicants fulfill the stated requirements better.

Grant writing can seem like a mysterious process, since many times the organization has little or no personal contact with the grantor. Sometimes it seems that you've spent many hours on a grant application, only to send it off with no good feeling as to your chances for receiving the grant. Fundraising experts spend years learning how to write grants, and there are dozens of professional development programs across the country, as well as books and online resources that can provide advice. Successful grant writing is a skill that can be learned and can certainly be practiced, and there are many simple ways to help ensure that your grant proposals are the best they can be.

One of the most important steps in successful grant writing is understanding the process by which grants are evaluated. In small family foundations, decisions may be made by a single person or small group of family members, while larger professional foundations may begin with a staff review, which must be followed by board approval. Government grants to the arts are often judged by review panels consisting of artists and others who are knowledgeable about the art form being presented. You can find information about the grantor's approval process on the website of the foundation or agency, or by talking to a representative.

It is never a good idea to send in a cold proposal, hoping it will be persuasive on merit alone, like an appeal letter. As noted, most grantors have strict legal restrictions on the type of grants they can give. Your project may be of the highest quality; but it won't be funded if the grantor is prohibited from giving grants in your county or to your art form. The good news is, most grantors are not scary or mysterious—they want to give money to good projects. Indeed, the government requires them to give money annually, and so they are willing to work with organizations to make sure their requirements are understood.

A grant proposal also differs from an appeal letter in that it normally must contain more information about the specific project and your organization, including details on finances. Many grants are restricted gifts, given for specific uses within the grantor's giving parameters. Also, a grantor who doesn't know much about your organization (or even the arts) is nevertheless obligated to decide on your case according to certain criteria, designed to ensure that funds are going to worthy, respected organizations that will use the money well.

Even though the proposal process differs from grantor to grantor, many aspects are similar. Here are some of the sections of information typically found in a grant proposal:

- **Project summary**
 Many grantors request a summary of the project toward the beginning of the application, so that the multiple submissions inevitably received can be quickly screened for eligibility. It's a good idea to wait until the entire application has been written before constructing the project summary; this way the writer will have enough perspective to come up with wording that is carefully thought out and includes the most important aspects of the project.

- **Project detail**
 The funder will want to know what the proposed project is all about, when it will take place, who will be involved, who the intended audience is, and how the work will contribute to your mission or serve your constituents. Depending on the requirements of the grant, you may need to stress different aspects of the project: perhaps its innovation, its artistic quality, or its ability to meet community needs. Rarely is one project described in exactly the same way to different grantors.

- **Needs statement**
 Although there is variability from grantor to grantor, most are interested in seeing that your project addresses a need within your community, your industry, or the world. What need or problem does your project address? Are you serving your current audiences better, reaching new audiences, providing a program that deals with a social or economic issue? The emphasis by many grantors on problem-solving aspects reflects the fact that except for government arts agencies, people who work for funding organizations often serve other community groups, such as health, human services, or youth organizations. Many times, a key criterion for granting is selecting the project that effectively addresses the greatest need or makes the most difference to the individuals involved. This is not to say that all grant proposals must be related to a community or social issue; if, however, the proposal requires a needs statement, the wise arts organization will be prepared with a sound one. Arts proposals that give the impression that the organization expects a program to be funded just because it's "good art" often fare poorly against human needs organizations.

- **History and qualifications of the organization**
 A grantor will want to know that any funds awarded will be used wisely. Clues to this can be found in the organization's past history of conducting similar projects. Other information, too, may be important in the application: the presence of qualified personnel to carry out the project; the ability of the board of directors to oversee the project; the quality of the artists involved; or even the knowledge that the organization has received other grants from respected grantors.

- **Budget and financial considerations**
 The budget for the project will include specific income and expense projections for this particular project. Most grantors also require financial statements for the current and previous fiscal years, so they can look for evidence of good financial management; the financial statements also afford an understanding of how the proposed project fits into the overall budget of the organization.
- **Other funding for the project**
 Grantors are interested in knowing how their investment fits into the overall picture of the project's budget and whether the project is likely to take place with or without their support. Sometimes this is a delicate balance . . . you must convince the grantor that funds are needed, while at the same time showing a responsible budget with other funding in place. Grantors sometimes ask about your future plans for the project; they need to know whether, if they decide to offer you a grant now, you will be expecting them to continue that support. Some grantors state in their guidelines that they will support the project for a limited time only and request applicants to explain how funding will be obtained for the project once the grant has expired.
- **Measures of success and evaluation**
 How will you know the project is successful? For most grantors, this needs to be more substantial than "We will know it is successful if we receive a standing ovation." Many grantors ask that the proposal specify both goals and evaluation mechanisms. Some also require evidence of careful strategic planning, including the presence of artists and community members in the planning process, as appropriate.
- **Funder benefits and other requirements**
 Promising coffee mugs or invitations to social events is not part of the granting process, nor will it necessarily help your cause to promise naming rights or publicity if such benefits are not mentioned in the funder's guidelines. However, some grantors do have recognition requirements, such as the inclusion of their name and logo in the printed publicity, as well as the website and program for the event. Government agencies often require that there be a public performance or other event that's open to the public, since taxpayer dollars are funding the granting program. The grant application must address these requirements and assure the grantor that they can be accommodated.
- **Supplementary materials**
 Depending on the application, the proposal may include such supplementary materials as a list of board members, organizational brochures, résumés or bios of key personnel, and proof of tax exemption. Submit everything that is required, in the order listed, and nothing else.

In short, a grantor wants to know:

- Who you are: your uniqueness and your credibility
- What the project is all about and how it fits into your mission

- Why you are the best organization to do this project
- Why this is the best time to do this project
- That you'll have the infrastructure necessary to complete the project
- That you'll have the resources (staff, volunteers, other funding, artists, equipment) to do the project at the quality level described in your application
- That you'll use the funder's money responsibly and account for it completely upon completion of the project
- That the funder will be recognized appropriately

A grant application that follows the guidelines of the proposal and answers these questions satisfactorily has a much greater chance of success than one that ignores published guidelines or omits pertinent information.

A sample of a typical grant application form can be found in Appendix 10.

SOLICITING CORPORATE SPONSORSHIP

Corporations and businesses have multiple ways of contributing to not-for-profit arts organizations. Many give outright gifts and grants through corporate giving budgets or corporate foundations, but others have found creative ways to support community organizations through their advertising and community relations budgets. When a corporation's advertising budget is used, the investment can be classified as a sponsorship rather than a gift, and it usually comes with expectations of public exposure in return for the investment. Because of this, a corporate sponsorship is often considered to be earned income: the corporation is purchasing an advertising plan, using the same budget they would use to purchase a newspaper ad or create a public relations event.

In the solicitation of corporate sponsorships, then, it is important to understand the priorities of the business whose assistance is sought. Businesses most often respond positively to sponsorship proposals when the exposure anticipated would help them achieve their business goals and has the potential to gain them new customers, reward current customers, or generate positive public relations.

It is also important to understand that you are not competing here against other not-for-profits, you are competing against other advertising choices. The corporate marketing director must allocate the advertising or public relations budget to outlets that serve the corporation, and that sometimes means deciding whether to support a community event or put an ad on the radio. Therefore, the marketing director must be able to decide between apples and apples; your sponsorship proposal must be framed to be comparable to a solicitation from an advertising proposal from the local newspaper or radio station.

The corporate sponsorship proposal will supply different information than the grant proposal. The corporate sponsor will be less likely to require information on the organization's finances, artistic merit, or project budget, and more likely to want information on the type and amount of exposure that would be received. The sponsorship proposal, therefore, should have the following components.

- **Description of the organization**

 In this type of proposal, you will emphasize your organization's successes, visibility in the community, evidence of respect, and quality
- **Sponsorship opportunities menu**

 With an initial corporate visit, an organization seeking sponsorship will often present the sponsor with a menu of possibilities at different costs and types of exposure. Once the company has indicated how it would like to proceed, a more detailed proposal can be completed.
- **Details of advertising benefit**

 When account executives from newspapers and television stations approach potential advertisers, they make their case in terms of the number and quality of viewers or readers that will be exposed to the ad. A sponsor applicant should do the same. Included in the data you submit can be your audience demographics, number of audience members expected to attend, numbers of ads you'll place, and the amount of space the company will receive on ads, on the website, in program books, and in other printed materials. In addition, some corporations may be looking for creative exposure opportunities, such as the opportunity to pass out free samples at an event, have signage at a the gallery, or rent your mailing list.

 The discussion of advertising benefits often brings a not-for-profit into conflict with its mission—how far can the organization go in recognizing a sponsor without compromising the organization's artistic integrity or mission? The answer, which will be different for each organization and perhaps even each project, must not clash with existing policies and with known audience preferences. It does no good for an organization to receive a hefty sponsorship if the audience thinks it tacky and refuses to return. The relationship between income and mission often means that an organization will need to take a sponsorship proposal to the board for approval.
- **Other benefits**

 Many corporations are interested in more than the advertising exposure, and it may be difficult for smaller community organizations to compete with media outlets in terms of people reached. Arts organizations, however, can offer other benefits that may be equally important to the corporation: tickets to sold-out shows, access to artists, and invitations to social events. The corporation may even be interested in the public relations value of being associated with a worthy cause. Therefore, offering company officials the opportunity to say a few words at a gallery opening or have their pictures taken with kids at the pottery workshop often are attractive options.

Corporate sponsorships are increasingly popular because, simply put, they work. Take the Olympics, for example, or other highly visible events like college bowl games: these sponsorships have the potential of bringing millions of dollars to the sponsors, and not just because their ads are seen in between plays or during the half-time show. Equally important to the corporation is the association with particular events because of audience demographics. If audience members associate

the sponsor's product with an event they like, the sponsor increases its chances that popular opinion of the product will improve. This is where arts organizations can shine: we help businesses and corporations become associated with the arts—and that means being associated with quality, prestige, innovation, creativity, and fun.

IN CONCLUSION

Fundraising for the arts can be an exciting opportunity to share your passion for your art and your organization, and to induce others to join you. There is a rich variety of sources available to the not-for-profit organization. It is up to each organization to know its strengths, understand the needs of its potential funders, and craft a story that will motivate others to give.

DISCUSSION QUESTIONS

1. Try your hand at prospect research by doing a search on Guidestar or another research site. Can you find a foundation in your community that supports the arts?
2. Some people say that the arts have a harder "sell" in tough economic times because of such societal priorities as disaster relief, aiding the homeless, and reducing hunger. How do you make the case for funding for the arts in spite of the urgency of other needs?
3. Look around your community to find examples of corporate sponsorship. What kinds of events or programs tend to be funded by corporations in your community? Are there any corporations or businesses that are visibly supportive of arts and culture?

⤳

Education and the Arts

"There is no way to fast forward and know how the kids will look back on this, but I have seen the joy in their eyes and I have heard it in their voices and I have watched them take a bow and come up taller."

—Willie Reale, Artistic Director of the 52nd Street Project, Describing the Impact of a Theater Program on Youth Living the Hell's Kitchen Neighborhood of New York City, Quoted in *Coming Up Taller*, 1996[1]

As you think back through your life, what experiences led to your decision to become involved in the arts?

Most people involved in the arts can point to specific instances of meaningful encounters with the arts. For you as an individual, such instances may be recalled in terms of the thrill of appearing in a school play, taking a drawing class and realizing that you had the ability to create on paper an expression of what you felt; you may remember walking through a museum, marveling at the beautiful paintings, or attending a concert and being overwhelmed by the sounds and the skill of the performers.

The Internal Revenue Service criteria for obtaining tax-exempt status do not specifically include the arts.[2] Yet, arts organizations have traditionally been granted not-for-profit status because of the recognition of the role of the arts in childhood and adult education, in mitigating social problems, and in community improvement. And, not-for-profit arts organizations frequently include programs and activities that bring the arts to children, expose audiences to diverse artistic expressions, and preserve art, culture, and traditions for future generations. These activities not only allow people who are passionate about the arts to share this passion with others, they provide very real benefits to individuals and communities.

After finishing this chapter, you should be able to:

- Describe the benefits of the arts at various stages of human development
- Describe the various ways in which the arts can be delivered in educational settings and in arts organizations
- Analyze examples of education in arts organizations, schools, and other community venues

DEFINING BASIC TERMS

When proponents of arts organizations talk about education and the arts, most people think of arts education in schools. Since the focus of this book is arts in organizational settings, we need to expand our thinking to include the many ways of delivering arts education. Community arts organizations and artists are involved in all of these, so we will discuss all of them in this chapter.

Arts Education

The term most commonly used for music, dance, visual art, and drama training in schools is **arts education**. Arts education is normally delivered to students by artistic disciplines, and the majority of arts education programs in schools focus on participation and creation. Courses in the history and appreciation of art and music are also found in many schools, sometimes associated with arts departments, sometimes with the humanities.

Arts in Education

The term **arts in education** means the use of the arts to illuminate other subjects. Examples include viewing a play about a historical subject, creating three-dimensional models of geometric shapes, and listening to a musical setting of a poem that is being studied in literature class.

Lifelong Education in the Arts

Of course, arts learning does not stop at graduation. Many opportunities, from dance classes to library book groups, exist in communities to help participants continue to master their art form of choice or to try something new. Arts organizations often schedule **arts enrichment** programs like lectures, study guides, or meet-the-artist events to help their audiences get more out of programs.

THE ARTS AND HUMAN DEVELOPMENT

Those who promote the increase of support for arts education in schools and community settings point to a number of studies showing that the arts are crucial to the development of a whole, healthy human being.[3] The arts provide benefits to human development and learning that go beyond the mastery of a skill.

It's interesting to note that most of us start out life with the arts as a natural component of daily life. Early childhood education and home activity include a great deal of spontaneous creative play: drawing, building, role-playing, dancing, and singing. In fact, some studies have shown that young children score very high in creativity, but the ability decreases dramatically as we age.[4] Our current educational system, placing as it does a great deal of emphasis on logic and linguistic skills, sometimes ignores the role that arts and culture can play in human development.

Some of the benefits commonly cited include the following.

- **The arts and humanities draw upon a wide range of intelligences and learning styles.**

Experts now believe that people do not learn in just one way. The arts draw on a number of learning styles, "not just the linguistic and logical-mathematical intelligences upon which most schools are based."[5] Not only does the study of arts and humanities allow each individual to explore a variety of ways of learning and expression, it also offers an opportunity for students who don't excel in linguistic or logical forms of learning to shine. A student making music experiences the "simultaneous engagement of senses, muscles, and intellect. Brain scans taken during musical performances show that virtually the entire cerebral cortex is active while musicians are playing."[6]

- **The arts and humanities have the potential to enhance academic knowledge.**
 The arts give students a richer palette of information from which to draw when studying other subjects. By honing nonverbal and symbolic skills, children and youth can express themselves more accurately and increase their understanding of abstract concepts.

- **The arts and humanities spur and deepen the development of creativity.**
 These days, we hear a lot about the need for children to study math and science so they can be competitive in the global environment and conceive of new ways to solve the problems of the world. Of course, math and science skills must be paired with creative ability in order for those innovations to be imagined. Businesses are increasingly looking for workers who show evidence of the ability to think independently and creatively. As Clifford V. Smith Jr., president of the GE Fund, put it: "Developing business leaders starts in school. Not in assembly-line schooling, but rather through the dynamic processes that the arts-in-education experience provides."[7]

- **The arts and humanities teach the value of discipline and teamwork and the tangible rewards each can bring.**
 A wise person once said, "When you play Beethoven, nobody has to lose." Working together on a play, concert, or exhibition requires both intense efforts and cooperation, but it brings positive rewards. And, when students' efforts culminate in performance in a public setting, they can experience affirmation for their efforts.

- **The arts and humanities provide a different perspective on life.**
 The Greek playwright Aristotle talked about the concept of catharsis, or the purging of emotion when you see someone on stage acting out a story or experiencing trauma. Reading books about faraway places or performing a play about a social issue allows children to imagine outcomes different from the one presented, to experience situations vicariously, and to work through emotions in a healthy way. The arts also help us understand people who are different and expose us to a variety of cultures and lifestyles.

- **The arts provide healthy options for self-expression.**
 Jane Alexander, former chair of the National Endowment for the Arts, said: "If you put a paintbrush or a pen into the hands of a 7 year old, that same child, at the age of 13, will not pick up an Uzi."[8] A 2012 study from the National Endowment for the Arts showed that at-risk students who have

access to the arts in or out of school also tend to have better academic results, better workforce opportunities, and more **civic engagement** than their peers who lacked this advantage.[9] Indeed, some studies are showing that measurable cost savings could accrue to communities that invest in arts education because of a reduction in crime attributed partly to arts programs.[10]

- **The arts provide lifelong benefits.**
 The National Center for Creative Aging suggests that the arts have much to offer seniors.[11] Benefits range from enhanced opportunities for creating community and communication with others to keeping minds sharp and bodies nimble.

ARTS EDUCATION IN THE SCHOOL SETTING

Maintaining arts education in schools has been an uphill battle since the last part of the twentieth century. Tight budgets, the call for more math and science programs to increase America's competitiveness in the global marketplace, and a mischaracterization of the arts as **extracurricular** have placed many arts programs on the chopping block. In 2012 the Arts Education Partnership developed thirteen benchmark policies essential to quality arts education, including defining the arts as a **core subject**, mandatory arts education at all levels, making arts a requirement

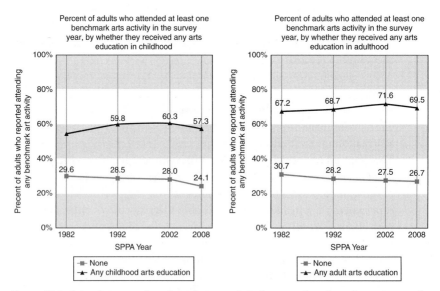

Figure 12.1 Attendance at a benchmark arts activity by arts education - Percentages of adults who attended at least one arts event by whether they received arts education in childhood (left) or in adulthood (right) in four SPPA years.

Source: 1982, 1992, 2002, and 2008 waves of the National Endowment for the Arts Survey of Public Participation in the Arts.

for graduation, and licensure requirements for teachers. Out of fifty states, no state had all thirteen policies in place in 2012.[12]

The National Endowment for the Arts Survey of Public Participation, which has been taken every five years since 1992, shows a sharp decline in numbers of adults reporting arts education experiences as children, particularly those who turned 18 after the late 1980s. Although numbers decline across the board, they are particularly significant for Hispanic and African American students, as well as students in at-risk schools.[13]

Case 12-1

Case Study: Art—Ask for More

Americans for the Arts, a national service organization, has been actively involved in promoting awareness of the need for more art education in schools. Its public awareness campaign, called "Art—Ask for More," consists of print advertising, television advertising, and a website with facts about the benefits of arts education and ways in which local communities can take action. The list that follows is from the Art—Ask for More website (www.artsusa.org/public_awareness).

Ten Simple Ways Parents Can Get More Art in Their Kids' Lives

1. Enjoy the arts together. Sing, play music, read a book, dance, or draw with your child at home.
2. Encourage your child to participate in the arts and celebrate their participation in or out of school.
3. Explore your community's library and read the classics together—from Mother Goose to Walt Whitman.
4. Read your local newspaper to find out about attending local arts events like museum exhibits, local plays, festivals, or outdoor concerts.
5. Tell your child's teacher, principal, and school leadership that the arts are vital to your child's success and an important part of a quality education. Find out if your school has sufficient resources for arts education, including qualified teachers and materials. If not, offer to help.
6. Contact your local arts organizations to inquire about the arts education programs they offer either during school hours or after school. Volunteer to donate time, supplies, or help with their advocacy efforts and connect these services to your child's school.
7. Attend a school board or PTA meeting and voice your support for the arts to show them you care and make sure the arts are adequately funded as part of the core curriculum in the school budget.
8. Explore your child's dream to sing, to dance, to draw, to act—and encourage them to become the best they can be through the arts.
9. Be an arts supporter! Contact your elected officials, lawmakers, and school board members to ask them for more arts education funding from the local, state, and federal levels.
10. Sign up to become an activist on the Americans for the Arts website, just a click away! Through our e-activist list, you will get news updates and alerts about arts education.

One of the most significant developments in school arts education occurred in January 2001 with the passage of the No Child Left Behind Act (NCLB). The law established standards for school performance that rewarded successful schools and withheld federal funds from schools that did not meet performance criteria in a number of areas, including math and reading. Although NCLB included arts education as a core academic area, many suspect that the net effect of NCLB has been to hurt arts education. Because schools are rewarded based on standardized testing, many schools have reported decreasing time and resources devoted to subjects that are not tested under NCLB. Many arts and education advocacy organizations are working with members of Congress to promote arts education.[14]

While arts education in school settings may not be the primary responsibility of not-for-profit arts organizations, arts organizations can be actively involved in the schools. Some schools that have experienced budget cuts in arts programs rely on community organizations to provide programs, coordinate volunteers, and offer field trip opportunities to students. Most arts organizations also acknowledge the importance of supporting arts education in schools and work side by side with schools to promote the value of the arts and arts education.

Goals of Arts Education and Arts in Education in School Settings

The impressive data showing the benefits of arts education notwithstanding, the presence of glee club or band does not automatically ensure the achievement of these benefits—so simply putting more money into existing programs is not sufficient. In many high schools, for example, arts are classified as an extracurricular activity, and the primary enrollees are those who are already have an artistic skill. Often, students must choose between arts and sports, and sometimes even between one form of art and another, in order to be able to accommodate other required subjects. The subsections that follow discuss some of the ways in which arts professionals can work with educators to help ensure that the benefits of arts education are accessible to all, as well as steps that can be taken by individual schools with minimal outside assistance.

Case 12-2

Case Study: Community School of Music and Arts (CSMA)

Today, as arts programs are being cut back or eliminated in public schools, some community arts organizations are coming in to fill the void. One example is the Community School of Music and Arts in Mountain View, California (http://www.arts4all.org/). CSMA claims to be the largest not-for-profit provider of arts education in the San Francisco Bay area, serving more than 40,000 students per year. CSMA provides in-school arts education to more than thirty schools in addition to providing lessons and classes for students of all ages at its own facility.

Discussion Questions
1. Is "outsourcing the arts" a good way to solve the problem of arts education budget cuts? What are the pros and cons?
2. Are you aware of any arts education collaborations in your community?

Educate for Appreciation

It's important to include courses in arts appreciation as well as participation and creation. Not everyone has the talent to participate in jazz band or take advanced painting classes, just as not everyone can play varsity football—but that doesn't mean those with more interest than ability should be excluded from the arts. Arts appreciation courses enable all students to choose to have the arts as a part of their lives even if they don't sing, dance, or act.

Emphasize Process

Although the final product (concert, play, or exhibit) is an important part of arts education, it is not the only part. Students should learn that time spent in practice and in the studio is equally important to the educational process. This is where teamwork and discipline become evident and where students learn that mistakes and frustrations are a part of achieving a goal.

Include the Artwork of Diverse Cultures, Peoples, and Historical Periods

The arts can help us learn about people who are different from us—but only if we are exposed to the art and cultures of others. Collaborations with other teachers and community organizations also become an important part of realizing this goal.

Experience the Art of Others

Attending a performance at a local theater, listening to a spoken-word poet explain her work, and asking an artist questions about how he does his work—all these are opportunities for students to understand how the sometimes mysterious process of artistic creation works. Such occasions may also open avenues for their own participation.

Promote the Inclusion of the Arts at All Levels of Teacher Training

In order for arts in education to be effective, teachers in all disciplines need to be aware of how to incorporate the arts into the classroom. Arts professionals can work with curriculum developers to advance this goal.

Creativity Education

"The necessity of human ingenuity is undisputed. A recent IBM poll of 1,500 CEOs identified creativity as the No. 1 "leadership competency" of the future. Yet it's not just about sustaining our nation's economic growth. All around us are matters of national and international importance that are crying out for creative solutions, from saving the Gulf of Mexico to bringing peace to war-torn areas to delivering health care. Such solutions emerge from a healthy marketplace of ideas, sustained by a populace constantly contributing original ideas and receptive to the ideas of others."

—Po Bronson, "The Creativity Crisis," 2010

One of the most exciting developments in arts education is the growing linkage between the arts and the need to teach creativity skills to students at all levels. Part of the growing rise in interest in creativity education comes from the realization that teaching creative problem-solving skills has suffered after years of standardized testing. The death of Steve Jobs in 2011 led some to wonder where the next generation of visionaries is coming from.[15]

What is creative thinking? Most define it as the act of thinking outside the box, developing new ideas, or thinking of things in different ways. Some scientists relate creative thinking to whole-brain theory, or the idea that the right and left hemispheres of the brain are responsible for different functions.

Although some people display dominance in one hemisphere or the other, it is also true that just as language can be learned, right-brain functions can be improved by training. Creative problem solving asks us to look at problems without assuming that there is one right answer, which we need to learn for a test. Creative thinking involves:

- Divergent thinking: the generation of many ideas that are eventually narrowed down or combined into the desired solution
- Interdisciplinary thinking: using various approaches to the same problem (How might a scientist look at this? How might a musician look at this?)
- Synthesis: gathering information from a variety of sources and bringing all the pieces to bear on a problem
- Imagination: the ability to imagine a situation in a different way
- Coping with ambiguity: being comfortable with a number of answers, or no answer at all

FLEX YOUR CREATIVITY MUSCLE

Here are a few exercises that will allow you to use your creative skills.

1. How many uses can you think of for a paper clip? Brainstorm as many answers as you can, without assuming that the little object needs to actually clip anything.
2. What is half of twelve? Use interdisciplinary thinking to imagine how a mathematician, a language expert, a baker, and a shoe salesman might answer.
3. Think of something in your life that is completely utilitarian—a stapler, perhaps, or a pad of paper. How might you make it beautiful?
4. Think of a new mode of transportation that is better than any of the devices you currently use. What features would it have?
5. Draw a number of dots at random on a piece of paper. Now connect them. What do you see?
6. Pull a book from the shelf at random. Use the title of a book in a five-sentence love story.

- Displaying a sense of aesthetics: understanding and incorporating beauty into whatever solution is found

Obviously, creativity and the arts are not the same thing. Creativity and imagination can occur in any field. But the arts have much to offer the study of creativity, especially if we define the arts as belonging to everyone, not just "talented" people.

EDUCATION IN THE ARTS ORGANIZATION

People encounter the arts throughout life in many ways. Here are just a few.

- The arts can be a vocation, a hobby, a pleasant diversion.
- The arts can be a doorway to new experiences and new ideas.
- The arts can provide opportunities for creative self-expression for people of all ages.
- The arts can be a part of social, religious, and civic activities.

Arts not-for-profits define arts education more broadly than than do most school boards. Because people can encounter the benefits of the arts in many ways and at many different stages of life and development, it's common for arts organizations to want to encourage interaction with the arts in many different ways, treating educational opportunities as an important part of their mission. Many organizations devote considerable resources to educational programs.

Educational activities presented by arts organizations vary considerably from organization to organization. Examples include participatory activities (Saturday morning pottery classes), field trips (bringing a school group to a performing arts center), and enrichment (post-performance discussions for adults).

For some, education programs offer a means of addressing social problems in the community. After-school programs and programs linked with youth agencies provide after-school care, positive reinforcement, and even jobs programs for at-risk youth.

Most arts organizations also acknowledge the role of education programs in developing future audiences. Many studies have shown strong links between education and arts participation, and this leads arts organizations to believe that providing opportunities to learn more about the arts will help children and adults alike enjoy the arts and get more out of arts experiences.[16] Arts organizations also advocate for increased support for arts education both in and out of school settings. By supporting education programs in not-for-profit arts organizations that expose children and youth to the joys of participating in the arts, they hope to set participants on the path to becoming lifelong arts supporters.

Education programs in arts organizations are also predicated on the notion that the more one learns, the deeper and richer the experience with the arts will be. A person who attends a post-performance discussion with the cast of a play turns from a passive spectator into an active participant. Similarly, someone who seeks out a lecture on art history before visiting a museum will enhance the viewing experience.

For all ages, educational experiences provide opportunities for interaction with other arts lovers, exposure to new experiences, and exploration of creative expression.

Education and Audience Development

Most arts organizations understand the worth of education programs to their missions; these programs are also an important factor in developing audiences for the future.

Case 12-3

Case Study: Save the Music

The cable television network VH-1 is a commercial enterprise that has created an organization to support music education. Its foundation, Save the Music, was formed to raise awareness of the importance of music education in schools. Its mission is spelled out on its website:

The VH1 Save The Music Foundation is a nonprofit organization dedicated to restoring instrumental music education in America's public schools, and raising awareness about the importance of music as a part of each child's complete education. Since 1997, the VH1 Save the Music Foundation has provided nearly $50 million worth of new musical instruments to more than 1,800 public schools in nearly 200 school districts around the country, impacting the lives of over 2 million schoolchildren.[i]

[i]VH1 Save the Music Foundation 2012 annual report: http://www.vh1savethemusic.org/flip/STM_AR_2012/html5forpc.html.

There are many possible reasons to think that strong arts education, in schools and in the community, has the potential of increasing adult arts participation. The subsections that follow discuss just a few.

Sharing the Joys of the Arts

Although student participation in visual or performing arts does not guarantee a lifelong passion for painting or singing in a choir, at the very least, it can lead to an understanding of the process for creating art or performing, and accustom students to attending performances or exhibits. Students who learn about the arts in classes, attend arts events on field trips, and contribute to the success of a school musical or art exhibit have begun to incorporate these activities into their lives, thus increasing the chances that they will choose similar activities as adults.

Exposure to New Experiences

Arts participation in childhood also exposes children to new experiences, which may make them more willing to try new things as they mature.

Social Opportunities and Lifestyle Choices

We all understand the importance of peer groups to lifestyle decisions. If the arts are a regular part of a student's life and the lifestyle of his or her peers, and if the choice to attend arts events is a part of the "menu" of options for activities, then it is highly likely that the student will continue to seek out friends and associates for whom the arts are also important.

In addition to providing arts education activities for audiences of all ages, community organizations can actively work to support and supplement school programs. Being active partners in the arts education process can help ease tight school budgets, in addition to encouraging positive student involvement in the community.

One of the most common ways of supporting local school programs that have had drastic budget cuts is by providing replacements for classes that are no longer part of the school curriculum. The Community School for Music and Arts in California (Case 12-2, p. 190) is an example of such support. Community offerings also enhance the education of home-schooled children by affording opportunities to participate in group activities such as choir and band.

Many community organizations that are regularly engaged in working with school groups also plan extensively ahead of time. Such forward thinking, which includes providing study guides for teachers to use in their own preparation, help ensure that field trips are consistent with school curriculum guidelines. Teachers can often better justify expenditures for field trips, guest artists, and master classes that are tied to subjects they were hired to teach.

Lifelong Education in the Arts

The opportunity to make life richer by experiencing the arts is not limited to children and youth. Arts organizations that create programs for adults find that the events and activities provide benefits for both the adults and the organization.

Case 12-4

Case Study: Curriculum Connections

Arts organizations can help schools by supplying connections between curriculum items and opportunities to expose students of all ages to the arts. The chart below lists a half-dozen possible programs, along with appropriate grade levels and relation to the curriculum.

PROGRAM	GRADE LEVEL	CURRICULUM CONNECTION
We the People	4–8	H, T, C
Funny Bunny	Pre-K–2	B, L, M, S
Romeo and Juliet	9–12	B, L, H, T
Orchestra Live!	3–5	M
Bullying Hurts	1–6	S, T, C
Monet's Garden	3–6	B, H, T, V

Key
B = Based on a book
C = Cultural diversity
L = Language arts
H = History and humanities
M = Music
S = Social skills
T = Theater
V = Visual arts

Adult education programs serve arts organizations in many ways. They help deepen and enrich the arts experience, enhancing the likelihood that participants, having had at least one positive experience, will attend more arts programs. They provide social opportunities, and opportunities for hands-on participation. They can even increase loyalty to the arts organization, by providing what marketing specialists might call "value-added" properties in the primary arts experience.

Education opportunities can be as simple and as limited as single events or as complex as long-term opportunities. One of the easiest and most common forms of education is informing patrons about a concert, exhibit, or event. Among the ways of getting the word out are the following:

- Pre- or post-event lectures and discussions
- Program notes inserted in the concert program or mailed prior to the performance
- Docent tours
- Audio listening devices at museums and historic sites
- Meet-the-artist events

Ongoing arts education programs can range from informal participatory activities like book clubs to knitting groups to structured classes or individual lessons. Community choruses and bands are also a form of arts education, allowing participants to be a part of the art instead of passive observers.

IN CONCLUSION

The passion that drives many people to become involved with the arts in the first place also motivates them to work with arts organizations to share the arts with other people. Whether this involves supporting school arts education programs, developing lifetime arts enrichment opportunities, nurturing audiences for the future, or becoming involved in the community, education and engagement programs provide benefits to arts organizations, their community partners, and the people who experience the art.

DISCUSSION QUESTIONS

1. Does your state have standards for artistic subjects? To find out, visit the Arts Education Partnership website at http://aep-arts.org/research-policy/state-policy-database/. On this site, you can select your state and find out what standards are in place. When you find the standards, think about your own arts education. Did your school consider these standards in its arts education programs? If not, which parts were missing? Why do you think this might be so?

2. What was your arts education like when you were a child? Did it incorporate the goals listed in this chapter?

3. Some arts organizations say they cannot justify the expense of arts education programs because the results can't be quantified immediately. What are some reasons this may or may not be so?

4. Can you think of examples of other organizations or celebrities raising money for arts education?

CHAPTER 13

Marketing and Audience Development

"If we do not change direction, we are liable to end up where we are headed."

—Lao-tzu

Many arts managers have a love-hate relationship with marketing. Part of this has to do with what they perceive to be the nature of marketing, which some associate with manipulative behavior and lowering standards in the interest of appealing to the largest possible audience. No one wants to compromise artistic quality; but at the same time, we want full houses, throngs of people talking about our gallery shows, and eager children taking our classes. We know that we need to market in order to stay in business, but we don't want to compromise our art to do so.

For those who have not studied or practiced marketing, it's an art that seems very mysterious. Why do some businesses seem to use marketing successfully while others do not? How can an arts organization do all of the "right" things—get press releases out on time, distribute posters all around town, have a nice article in the newspaper—and still have empty seats?

Is there a magic bullet that will work every time? No. Can arts organizations use contemporary marketing techniques and still respect high artistic standards? Of course. That is the subject of this chapter. In order to be successful in marketing, every organization and artist needs to understand both how to market and how to market the unique product that is the arts.

After finishing this chapter, you should be able to:

- Explain the unique distinctions of marketing for the arts organization and the need for audience development
- Discuss the personal, social, and economic reasons people have for participating in the arts
- Cite marketing trends that affect purchasing decisions

CHALLENGES OF MARKETING THE ARTS

Arts organizations use some of the same marketing philosophies that are employed by for-profit businesses. Yet, because not-for-profits are mission driven, marketing

decisions must be made with the mission, not just profit, in mind. No mission-based arts organization wants to put on programs just because someone thinks they will "sell," even though balancing mission and attractiveness to potential audiences is one of the goals of arts programming.

Competing with commercial entertainment offerings has always been one of the biggest challenges of marketing the not-for-profit arts. In addition to the much larger marketing budgets that come with marketing nationally and internationally, for-profit corporations leave a product on the market as long as it is creating profit, unlike local not-for-profit arts organizations, which program according to a pre-determined schedule. The not-for-profit arts are therefore competing not just against movies, television, and recorded music; they're also fighting for consumers who expect to see a movie at their convenience, having learned about it through slick, omnipresent advertising.

Arts organizations have been challenged in recent years by the internal growth of the industry. Since the mid-twentieth century, the number of arts organizations has increased dramatically, while the overall audience for the arts has remained relatively stable. This means that arts organizations, in addition to simply market-ing to capture existing audiences, must also be concerned about developing audi-ences for the future in order to increase the total number of arts participants, which in turn will give all existing arts organizations the opportunity to continue to survive and thrive.

Arts organizations that avoid marketing because they are reluctant to cheapen their artistic product, or because they assume that marketing the arts can be accomplished simply by "getting the word out." are missing an opportunity. To succeed in communicating their passion about their art with the appreciative, growing audiences, organizations must not only understand the unique needs to arts audiences, they must strategically target audiences, work hard to develop future audiences, and increase loyalty among existing patrons.

THE MARKETING MINDSET

Before we begin to learn about marketing, it is necessary to get into the right mindset for marketing the arts. The best way to do that is to bust a few myths.

Marketing myth #1: Marketing means lowering your standards.

As we described at the beginning of the chapter, some arts organizations believe that if you use standard marketing techniques, you are pandering: that is, appealing to a low common denominator. Let's see if we can break down that myth a bit.

Mythbuster #1: If you believe that marketing means lowering your standards, then you must also believe that nothing that is mass-marketed can be of high quality.

Of course, we know this is not true. Even commercial artistic products that gain wide distribution, like movies, books, recorded music, and Broadway shows, can be of extremely high quality. Certainly there are many products that seem to be created and distributed just because people think they will "sell." But this strategy is not an automatic key to success. There are many examples of

products, from albums produced by TV characters to movie sequels that were created with profit, not quality in mind. Some of them succeed and some do not, just as with programs of higher quality.

The marketing mindset says that if we approach marketing with the same standards we use in developing our artistic product, we will succeed in conveying an appropriate message to our audiences.

Marketing myth #2: Not-for-profit arts organizations are supposed to be shielded from the marketplace. Our bottom line is mission, not money.

Mythbuster #2: Every arts organization needs to make money—or at least enough money to stay in business for another year.

The fact that not-for-profit arts organizations can accept contributions, sponsorships, and grants shields a 501(c)(3) organization from having to rely on ticket sales alone for income. But it doesn't shield these businesses from needing to share their products with other people.

The marketing mindset for the arts says that we are indeed in the marketplace . . . it's just a marketplace with boundaries that are different from those assumed by commercial businesses. The mindset that the arts and artists are entitled to make art outside of the need to market or even please people may have its roots in the traditions of government subsidies of the arts in some European countries. Having organizations that are truly shielded from the marketplace because they are completely supported by taxpayers just isn't our reality in America. The idea is to find a way to market our mission—not to assume that because we have a mission, we can't market.

Marketing myth #3: Marketing is just about "getting the word out."

Many people use "getting the word out" to describe the marketing process. Unfortunately, that phrase limits our understanding of all that has to happen to properly market our events, programs, and organization. "Getting the word out" assumes that simply informing people of what's happening will be enough to induce them to decide to participate.

Mythbuster #3: When was the last time you purchased a product or bought a ticket to an arts event that you knew nothing about based solely on having learned of its existence? Think about what else is necessary for you to be able to make a purchasing decision—and you'll realize that much more than basic information is necessary.

The marketing mindset says that marketing is a comprehensive activity that leads your customer to the eventual decision to purchase. Certainly supplying information about time, date, location, and program is part of marketing, but so is the process of answering customers' questions, getting them excited about participating, and developing a relationship with them. This won't happen on its own . . . marketers help make it happen.

Marketing myth #4: We need younger audiences for the arts to survive.

Many in the arts look out over their audiences, see increasing amounts of gray hair, and assume that because the people in the seats or roaming the galleries are getting older, we should be trying to attract younger audiences to replace them.

This assumption is kind of like saying that when our jeans get a little tight, we need to get new jeans, whereas we probably should be thinking about losing some weight.

Mythbuster #4: The designator "young people" usually means students or young professionals. Think about the kinds of activities young people like. For the most part, those activities are very different from the traditional arts experience: more participatory, less formal, more social, and more spontaneous. Is a typical symphony orchestra, for example, willing or able to change the concert experience in ways that would make younger people more comfortable? And what would happen to the orchestra's current audiences if big changes were made? Is it even possible for decision makers who are the same age as the graying audience to attract young people?

The marketing mindset says that we need to think outside the box that assumes that current audiences fit into a stereotype (older, wealthier, more educated). We even need to think outside the box that assumes that everyone wants to participate in the arts in the same way. And, the marketing mindset asks us to look at marketing comprehensively, considering the product and the experience, not just how we promote what we do.

Marketing myth #5: Since most people say they don't like the arts before they will be able to enjoy what we do, we'll have to educate them.

For years, declining participation in the arts has been linked to the gradual decrease in arts education in schools. Students are receiving less information about the arts, some have reasoned, and that is why they are not coming to concerts or museums. Like the "getting younger audiences" assumption, this rationale is based on faulty logic. Certainly there is some truth to the observation that more students today are growing up with less formal arts education than was available only a few years ago. But that isn't necessarily why they are not participating in the arts in larger numbers.

Mythbuster #5: You had plenty of math in school as you were growing up. Does that mean you are good at math now, or seek out opportunities to do algebra equations in your spare time? Maybe yes, maybe no. The truth is, "exposure" by itself is not the key to a lifelong enjoyment of the arts. Like other activities, active or passive participation in the arts must be nurtured; it must strike a chord with each individual.

Education is certainly a factor in the decision to participate in the arts—as it is for most everything. This doesn't mean that teaching the public about classical music or Impressionist art will automatically result in increased ticket sales. For most people, the experience is as important as the product itself, and in many ways, the experience of the arts does not fit comfortably into today's impulsive and technology-centered lifestyles. For example, it's hard to blame lack of knowledge of classical music for poor attendance of a concert that was scheduled for only one performance, or was sponsored by an organization that doesn't have a social media presence.

The marketing mindset asks us to consider that marketing has to do with everything that touches the consumers, from the time they first visit a website or see a

poster until the time they go home and tell their friends about their experience. To achieve success in marketing, we must study every part of the experience, from information gathering to ticket buying to the art experience itself, to ascertain its effect on the audience.

Adopting the marketing mindset means thinking about marketing in a comprehensive way, not just about spreading information about upcoming events. It means understanding your audiences, and listening to them. It means understanding contemporary marketing techniques, and how people react to different methods. In short, the marketing mindset makes marketing itself a much more exciting process.

UNDERSTANDING ARTS AUDIENCES

Most arts experts agree that these are exciting but challenging times for the arts industry, as indeed they are for many industries. Experts cite several reasons that the arts may be facing a time of great change:

- Arts audiences have not kept up with the massive growth in arts organizations that occurred between 1965 and 2000.[1]

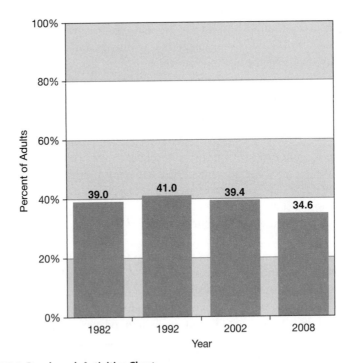

Figure 13.1 Benchmark Activities Chart
Graphical representation of the percentage of U.S. adults who attended a benchmark arts activity at least once in the past twelve months during 1982, 1992, 2002 and 2008.

Source: National Endowment for the Arts 1982, 1992, 2002, and 2008 Surveys of Public Participation in the Arts.

- An increasing number of activities are competing for our leisure time, many of them on demand and based at home.
- The seven art forms covered in the National Endowment for the Arts Survey of Public Participation (jazz, classical music, opera, musical theater, ballet, theater, and visual art exhibited in museums or art galleries) have declined in numbers of participants.[2]
- The median age of performing arts participants is rising faster than the overall population, which lends credibility to the claim that audiences are aging and younger people are not participating in the same way.[3]

What all of these studies seem to say is that it is not art that is the problem; it is the way the arts have traditionally been delivered. The current trends suggest that it may not be realistic for arts organizations to hope for massive numbers of new audiences for traditional arts experiences. However, there seems to be unlimited opportunity for arts organizations willing to embrace new methods of participation, incorporate technology, and understand the new ways people utilize the arts.

The Urban Institute, in its report entitled *The Diversity of Cultural Participation*, puts it this way:

> Those who wish to understand or expand cultural participation need to pay more attention to its diversity. Participation in arts and cultural events is not monolithic, although it is frequently discussed and acted upon as if it were. . . . The fact is, people participate in cultural events for different reasons, with different people, in different places, with different experiences. Thus, if people thinking to enlarge participation are to succeed, they need to clearly define and understand the type of "culture" in which they wish to expand participation and target their strategies accordingly.[4]

Case 13-1

Case Study: Old Milk in New Bottles

To illustrate the idea of adapting arts participation to current habits, Joanne Scheff Bernstein uses the example of the dairy industry, which in the United States brings in $23 billion a year.[i] Industry watchers noticed that the primary way of selling milk (in half-gallon and gallon containers), while convenient for refrigeration purposes, did not appeal to modern consumers, who often buy milk to drink outside the home. Dean Foods created the "chug," an 8-ounce milk serving in a convenient bottle that fits easily into lunch bags, cup holders, and coolers and can be purchased at convenience stores and fast-food restaurants. The company combined the packaging change with a new marketing strategy emphasizing how the product fits today's lifestyle; even the name "chug" suggests a quick snack on the go.

This story suggests that arts organizations may be successful if they can come up with new ways to package and deliver the arts to more closely mesh with modern lifestyles. Old art in new museums, perhaps? Can you think of any organizations that have successfully applied this philosophy?

[i]Bernstein, Joanne Scheff. *Arts Marketing Insights: The Dynamics of Building and Retaining Performing Arts Audiences* (San Francisco: Jossey Bass, 2007), 2.

HAS TECHNOLOGY HURT ARTS ATTENDANCE?

Some suspect that the ready availability of arts and entertainment via technology has hurt live attendance. Let's examine some reasons advanced to support both positive and negative answers to the question.

Has it hurt? Yes. . . .

- The high quality of home entertainment options means that it is no longer necessary to go to a concert hall to hear sound of excellent sound. Unlike the early days of radio, television, and recorded music, the live experience isn't necessarily better, and, because individuals at home now have the ability to carefully control and manipulate sound digitally, may be less satisfactory.
- Hectic and stressful lifestyles have led to a behavior that social scientists call cocooning . . . staying home after returning from a long day at work. Watching a movie on TV or listening to music on your iPod is easier than going out—and you don't have to dress up, park, or brave the weather.
- The diversity of technological options on the Internet, along with DVDs and music services, makes some of the best performances and art of all time readily available with a click of the mouse. Why go to a live opera when you can watch a complete opera featuring the world's best singers on public television or see legendary performances by Maria Callas or Luciano Pavarotti on YouTube?

Has it hurt? No. . . .

- If the studies are correct, and socializing trumps art when people are deciding on attendance, then it follows that technology can never entirely replace live events because the social aspect isn't there, or at least isn't there in the same way.
- The popularity of blockbuster concerts, Broadway shows, and museum exhibits of famous masterpieces indicates that when the content is right, people will still flock to see or hear the real thing. Technology in this case may even fan the flames of the desire to watch a live performer or see in person a well-known painting or sculpture.
- The new technologies that have emerged since the end of the twentieth century haven't supplanted the old technologies, they have just added options. Radio is still here despite its predicted demise following the introduction of television. Television is still here despite massive changes in structure, content, and delivery. Live performance is still here despite the availability to consumers of an array of technological options.

In short, it may be easy to blame technology for a drop in attendance at live events, but to do so may be oversimplifying the issue. Perhaps it is more useful to focus on how technology provides an opportunity for arts organizations to create excitement about attending live events. Consider the following case studies, featuring a film festival in Michigan and a dance company based in Brooklyn.

Case 13-2

Case Study: The Traverse City Film Festival

Michigan's Traverse City Film Festival was founded in 2005 by documentary film-maker Michael Moore (a native of the state) as a way to create interest in film and to support Traverse City with a tourist attraction. The festival was an immediate hit and has grown quickly; in 2011 there were showings of over a hundred films and attendance topping 128,000 during the six days of the festival.

One of the most popular events of the festival is a series of free films projected on a giant inflatable screen in a public park. Although the films in the outdoor series are favorites readily available for purchase or rental (titles have included classic films, musicals, and Disney movies), thousands attend every showing.

In an age when many believe that the availability of entertainment options on cable, via satellite, and through subscription services encourages people to stay home rather than going out, the example of the Traverse City Film Festival seems to contradict the popular wisdom. Why do you think the outdoor series has been so successful? What aspects of the live experience trump the comforts of home?

Figure 13.2 The Traverse City Film Festival takes place at the Legendary State Theater in Traverse City. Photo Courtesy of John Robert Williams.

Case 13-3

Case Study: The Misnomer Dance Theater

The Misnomer Dance Theater (www.misnomer.org), based in Brooklyn, New York, is one arts organization that is actively using technology, primarily social media, to create excitement for its live performances. On its website you will find links to its Facebook, Twitter, Pinterest, and YouTube presences, as well as videos of performances and rehearsals, links to blogs and articles about the company, and a TEDx talk by Misnomer founder Chris Elam.

 Misnomer's mission has an interesting twist, going beyond the artistic mission to one of audience development—and not just for the organization. The group is dedicated to "the creation, research and presentation of original dance and the development of boundary-crossing innovations in audience engagement to bring people closer to the arts." Part of the fulfillment of the second part of the mission is an innovative Web platform: GoSeeDo.org, a separate website which Misnomer created and maintains. GoSeeDo features artists and companies (including Misnomer) with booking options, media, and social media interaction, all intended to break down traditional barriers between artists and audiences.

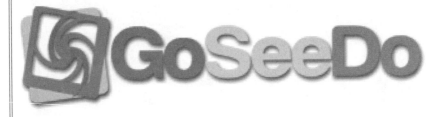

Figure 13.3 The logo of Misnomer's web platform, GoSeeDo.org (used by permission).

HOW CONSUMER BEHAVIOR AFFECTS MARKETING

When you stand in a grocery aisle confronted with dozens of cereal choices, you may not realize that your selection will be influenced by more than just the taste of the cereal or even the attractiveness of the packaging. Many factors contribute to your eventual choice—your habits (you like cereal as a midnight snack as well as for breakfast), your beliefs (you don't want anything with sugar listed as the first ingredient), your culture (you are committed to eating kosher) . . . even your behaviors in common with other consumers at any given moment (as evidenced by the inclusion of omega-3 fatty acids, soy protein, or higher proportions of fiber in cereals by manufacturers responding to a healthy eating trend).

Marketers understand that a final decision to purchase is influenced by a complex mix of societal and personal factors. Social factors, like peer pressure and opinions of those we respect, are very strong motivators, for example.

Some people are highly likely to be influenced by reference groups and opinion leaders, some less so. Social scientists say that some people are ready and willing to try new things, whereas others will wait until a new product has become commonplace.[5] It breaks down like this:

Case 13-4

Case Study: Consumers and Risk Willingness

According to sociologist Everett Rodgers,[i] a new product spreads through society according to how willing consumers are to risk purchasing a new product. The breakdown is as follows:

- Innovators are venturesome and willing to try new ideas with some risk: 2.5% of population
- Early adopters are opinion leaders in their community and will adopt new ideas early but only after careful consideration: 13.5% of population
- Early majority will adopt new ideas before the average person, but people in this category are rarely opinion leaders: 34% of population
- Late majority is skeptical and will adopt innovation only after a majority of others have done so: 34% of population
- Laggards are tradition bound; they adopt innovation only after it has become tradition: 16% of the population

What does knowing these characteristics about consumers tell you about marketing the arts? To which part(s) of the population do you think we are marketing?

[i]Rogers, Everett M. (1983). *Diffusion of Innovations*. New York: Free Press.

Consumers are also influenced by cultural factors: that is, the habits, beliefs, and lifestyles of their cultural group. Factors often included in discussions of culture are nationality, ethnic affiliations, race, religious groups, and social class.

When attempting to understand cultural factors, it goes without saying (but we'll say it anyway) that every attempt must be made to avoid stereotyping. It is one thing to suggest that people who live in the United States may not respond to a marketing technique that appeals to the French; to imply that all Americans are yee-haw patriots or that French people are effete snobs, however, is blatant stereotyping.

Psychological factors can also be powerful motivators to purchase or participate, but here again, it is possible to make false assumptions. People who say

that they believe in purchasing organic products may also believe in buying local products, or they may not. People who were raised in the suburbs may continue to live in homes with yards, barbeques, and gardens, or they may decide that their social habits would fit better in an urban environment.

The value of understanding psychological motivations is that creating an emotional response to a product is one of the strongest ways to encourage participation. Both thinking (understanding a product's features and desirability) and feeling (creating an emotional bond) are part of the customer's decision-making process—it depends on the product which part comes first or lasts longer. Certainly it is always true that no matter what the product or experience, every seller wants the buyer to feel good about the purchase he or she has made.

Each person's personal statistics (occupation, gender, income, age, etc.) also factor in to the individual's buying decisions. People who have more income are able to purchase more expensive items (and perhaps more of them). People in particular occupations need to purchase clothing of specialized types.

While it used to be more common to group people by age, most marketers acknowledge that the complexity of lifestyles today makes age less relevant than one's habits, activities, values and circumstances. A 21-year-old, for example, may be a college student or have a full-time job. He may be in a relationship, married, or single. Each of these factors may be more important than his age. A 30-year-old laborer who has young children and a single professional of the same age will be purchasing very different products.

Macroeconomic Trends

Large overarching social, political, economic, and technological trends are highly influential in our decision making. Marketers often tap into these so-called macroeconomic trends to position their products to serve current needs.

Here's an example of how macroeconomic trends affect marketing. Marketers who believe customers are affected by the economy and are being conservative in their spending may try to encourage people to buy by marketing their products as "good values," or they may offer special sales or promotions. Another macroeconomic trend, a strong consumer preference for safe, natural products, leads to companies developing organic products and emphasizing natural ingredients in their marketing.

MARKETING TRENDS AND PRACTICES

Along with understanding the arts industry, it's important to understand what trends and practices are driving marketing today for purchasing any kind of product. What drives marketing at any one time also depends on what is driving consumers, and tends to change. Although we discuss a number of current trends here, it's important for every good marketer to keep on top of the inevitable changes.

Here's an example: only a few years ago, few people were talking about social media as an important marketing tool. Today, it's generally acknowledged that this

phenomenon has effectively transformed marketing; we'll discuss this more in the next section. For now, consider it an example of what we're talking about: the rapid change in consumer habits and, therefore, marketing. The subsections that follow describe some important trends.

Lots and Lots and Lots of Messages

Experts estimate that every person is exposed to between 3,000 and 5,000 marketing messages every day. That's not so hard to imagine once you start thinking of the messages you see—not just television ads or billboards, but ads alongside your Facebook page (which change every time you refresh the page), posters and flyers posted to the wall in the hallway or workroom, even ads for credit cards and snacks on the gas pump while you fill your tank. Every single package at the grocery store is a marketing message (as are the signs jutting out from the shelves and pasted to the floor). Every T-shirt with a corporate logo is a marketing message.

Most of us process most commercial messages only peripherally. Some messages just go into our brain to be accessed when we need them ("Gee, I need to buy new athletic shoes, I think I'll look at some Nikes."). Others disappear in the clutter. Most people "file away" approximately 80% of the advertising they see. Much of the remaining 20% is noticed but not acted on. Again, think of your own experience and you realize how hard—and how necessary—it is for a marketer to try and get your attention.

Lots and Lots and Lots of Choices

The array of activities competing for your time often seems overwhelming. Even if you are home sitting in front of TV, the program you are watching may be on network television or on one of several hundred cable channels. You can watch something you've recorded or the DVD that just came from Netflix. You can rent a movie online from Amazon.com or iTunes. You can turn off the TV and fire up your iPad . . . and be presented with a new set of choices, which might include listening to music, playing games, or surfing the Web.

At the same time, there has been no decrease in the numbers of arts organizations and other community activities. Today's audience, on any given day, might have an array of choices among restaurants, clubs, outdoor activities and sports, festivals, exhibits, concerts, movies, and much more. None of this, of course, is unique to the arts. If you want to buy cereal, you have an entire grocery store aisle filled with choices. If you need some new shoes, you can go to a shoe store, a big shoe warehouse, a discount store, or any number of online retailers.

Marketers today understand that one of their challenges is helping customers to decide among many choices—and to give persuasive reasons for picking the product of their client.

Customer Involvement

Today's customer doesn't want to be a passive consumer of products and marketing messages. We shall devote a full section of this chapter to the impact of social media. For now, it suffices to note that the rise in use of Facebook, Twitter, and

other social media has led to a consumer culture in which customers routinely comment on, rate, and evaluate purchases. In fact, many consumers give as much credence to the ratings of products left by others as to the marketing messages of the businesses.

With twenty-first-century communications technology, customers expect to have their questions answered immediately, to find the information they need in the format they want, and to interact with other customers. Many websites have options to contact customer service by phone, e-mail, or live chat—and many operater 24 hours a day, 365 days a year, since there is no such thing as "end of the business day" on the World Wide Web. As a result, marketers must anticipate the kinds of interaction customers will expect and make customer service and involvement a high priority.

Niche Marketing

A "niche market" is a small, definable subset of a larger market population; it's a group whose members have specific characteristics in common and can be served with a particular product or strategy. One well-known niche market within a larger market consists of men between the ages of 18 and 25 who are interested in video games . . . or even more specifically, young men who participate in online gaming communities or favor a particular type of game.

Technology makes niche marketing more and more sophisticated. In fact, we've gotten to the point where one person can be a niche. Think about it—when you are selecting items on Amazon or Netflix, your past purchases or recommendations generate new suggestions for you. Each activity increases the reliability of the suggestions. Facebook ads appear at the side of your page based on your activities, your posts, and even your friends' activities—and you can "like" or remove any ad, further increasing the chance that the next ad that appears will be meaningful to you.

The prevalence of niche marketing, combined with the multiplicity of choices and marketing messages, means that consumers are increasingly insensitive to messages that are not geared specifically toward them. It also means that customers aren't waiting for marketing messages to come to them—there are many ways for customers to go out and find the information and products they want.

Experience Marketing

In the nineteenth century, say authors Joseph Pine and James Gilmore, America was a goods-producing society.[6] As goods became more plentiful and there was more competition among manufacturers, we shifted into a service-oriented society—the services offered to customers became at least as important as the products themselves.

Increasing competition in the latter part of the twentieth century led to the rise of what Pine and Gilmore call the "experience economy." The most successful companies, they say, are not just selling products or good customer service, they are selling experiences. One example of a successful experience economy business is Starbucks, which has transformed the coffee-drinking experience into a

multibillion-dollar love affair with half-caf double-foam caramel macchiatos (which are, of course, quadruple the cost of a plain cup of coffee). Another good example is Disney, which successfully cross-promotes movies, toys, television shows, and other products.

Today's marketers (or, as some companies say, "marketeers," paralleling Disney's "Mouseketeers") understand that successful products are a part of a fun and meaningful experience. This is good news for arts organizations—the experience is already a part of our product!

Relationship Marketing

Because of all of the trends that have developed from the increased emphasis on customer involvement, one of the most important strategies for successful marketing is to create and nurture relationships with customers. A customer who feels like part of a family, or at the least views the relationship as more than a one-way stream of marketing messages, will tend to be more loyal once she has discovered your offerings.

This is also good news for arts organizations. While some arts organizations, especially small community groups, will lack the people power, expertise, or marketing budget to take advantage of the strategies available to multinational corporations, we can continue to create relationships the old-fashioned way—by talking to people, finding out how they liked our performances, and inviting them to come back.

THE IMPACT OF SOCIAL MEDIA

"We no longer have a choice on whether we do social media, the question is how well we do it."

—Erik Qualman, *Socialnomics: How Social Media Transforms the Way We Live and Do Business*, 2nd ed., 2012

If you have a Facebook page or a Twitter account, or participate in any of the other social media, you will understand why marketers need to take these Internet-based applications seriously as marketing tools and as a consumer trend.

Social media is not merely an additional tool in the marketer's arsenal. The use of social media has fundamentally changed the way people buy things and acquire information— and therefore, it has also fundamentally changed the way marketers look at marketing. The most basic difference between social media and other forms of marketing is that social media is a dialogue (or perhaps even a multilogue), not a monologue. In the world of social media, companies and customers are equal in their ability to shape the conversation; in fact, the customer may have more power. Social media expert Erik Qualman claims that while 90% of consumers trust peer recommendations for products and services, only 14% trust advertising.[7] So, one bad customer experience now has the potential to affect ticket sales more than all of the organization's paid advertising. On the other hand, a positive

experience can quickly spread via social media and fuel the marketing fire. This is wonderful news for arts organizations that are energetic and creative in encouraging audience interaction.

We're introducing the idea of social media here instead of in the next chapter, when we discuss marketing techniques, to emphasize that this tool is and should

Case 13-5

Case Study: Stella Adler School of Acting

The Stella Adler School of Acting in New York City (and its Los Angeles counterpart, the Art of Acting Studio) has seen outstanding results from social media. After instituting a multifaceted program that included Facebook, Twitter, YouTube, and live blogging and tweeting from events, the organization not only saved nearly $70,000 previously budgeted for advertising, it doubled attendance.

One of the most successful ventures has been live tweeting from master classes. Below are some tweets from a panel discussion with playwright Edward Albee, which was part of the Harold Clurman Festival of the Arts, a program that benefits the school's Outreach Division.

StellaAdlerNY Oct 02, 9:09am via HootSuite
@theshelternyc Thanks for the RT! RT @theshelternyc Here's to writers! @StellaAdlerNY: Ellen Adler adds that having a writer like Clifford. . . .
Show Conversation

StellaAdlerNY Oct 01, 9:21pm via HootSuite
@TaylerVee She's the greatest! RT @TaylerVeeStill convinced I'll never love anyone as much as I love Betsy Parrish. @StellaAdlerNY
Show Conversation

StellaAdlerNY Oct 01, 5:30pm via Mobile Web
Edward Albee said that in his friendship with Sam Beckett they spent no time talking about theory/playwrighting - it was just what they DID
4 retweets

StellaAdlerNY Oct 01, 5:27pm via Mobile Web
Howard Shalwitz said there are many writers who engage in vital social inquiry & few who can "make it sing for an audience" #ClurmanFest
1 retweets

StellaAdlerNY Oct 01, 5:25pm via Mobile Web
Edward Albee says to approach your craft according to your own impulses & find out if it works or not & then forget about theory #ClurmanFest
3 retweets

StellaAdlerNY Oct 01, 5:23pm via Mobile Web
Howard Shalwitz says that in all the playwrights sited [sic] in the book Stella has an uplifting view of the working class characters #ClurmanFest

StellaAdlerNY Oct 01, 5:21pm via Mobile Web
Audience member & alum Rita Fredricks said Stella didn't have a narrow view of herself in the world; she was able to tap into the universal

Source: Twitter feed courtesy Stella Adler School, used with permission.

be an integral part of changing the marketing planning process. Organizations that think of Facebook and Twitter as just other ways of "getting the word out" are missing the point. Audiences want to interact, and in fact, they expect to be able to interact with your organization. The winners in the social media game are those who understand how people use these apps and take advantage of such insights.

AUDIENCE DEVELOPMENT

Earlier, we discussed challenges arts organizations face in developing new audiences for the future. Arts participation studies and overall market trends indicate the following broad trends.

- Although there are many more arts organizations than there were in the mid-twentieth century, the total number of participants in live, traditional art forms has experienced only slight decline. The numbers, however, are spread among more organizations.
- Unlike such commercial products as breakfast cereal and toilet paper, there is no built-in need for the arts. Our challenge is not enticing someone to choose our product over another, but convincing individuals to choose the arts at all.
- Participation in the arts via technology is growing rapidly and becoming integrated into the experience of the arts. This creates challenges for some traditional, in-person art forms, but opportunities as well.
- The baby boom generation is one of the largest single population groups in human history. Younger generations are not as large, meaning that if a similar percentage of the population participates in the arts, overall participation will be correspondingly reduced.
- If arts education in public schools continues to decrease, fewer people will have had the experience of arts participation by the time they become adults.

As the significance of this information sinks in, awareness is growing in the arts industry that we must do more than market each season's events: we must actively work to develop audiences for the future. In addition to advocating for the arts and for the continuing strength of arts education, arts organizations are beginning to incorporate activities that encourage existing audiences to participate more and potential members of new audiences to consider the arts.

The marketing mindset tends to divide the population into two groups: those who currently participate and those who have not yet participated. The audience development mindset presumes that people might choose to become involved in the arts for many reasons and that to convince new people to enter the pool, we need to understand these reasons.

In 2001 the RAND corporation, a not-for-profit think tank, released a major study on increasing arts participation. The study, entitled *A New Framework for Building Participation in the Arts*, acknowledged that the decision to participate is not a simple one, based on whether the consumer liked the particular art that was

being presented; rather, it's a complex decision based on past experiences as well as factors like those we've discussed.[8] The study attempts to capture the complex dynamics of the decision-making process by incorporating the factors that may predispose an individual to act in a certain way; it also tries to identify how and at which stage of the process these factors come into play.

The RAND study has given arts marketers a practical way to expand their understanding of arts audiences, and therefore to market to them more effectively. In other words, the information we provide to potential audiences is different for people in different stages of the decision-making process.

Kevin McCarthy and Kimberly Jinnett, the authors of the study, divided potential audiences into three groups: those who are currently participating, those who are inclined to participate, and those who are disinclined to participate. The needs of each of these three groups are different. Let's take them one at a time:

- The *"Yes"* group: those who are already participating
- The *"Maybe"* group: those who would participate if conditions were right
- The *"No"* group: those disinclined to participate

Audience development can involve all three groups, although the techniques are different for each one.

Yes

Increasing participation for the Yes group means encouraging its members to participate more and in different ways. If they come to one event, let's encourage them to come to two or three events. If they are ticket buyers, let's encourage them to donate. Key to success in developing Yeses is finding ways to deepen and enrich their experience, making it comfortable and affordable to participate more, and making them feel like an important part of the organization.

Maybe

The Maybes comprise the largest section of the population: the difference between those who identify themselves as arts lovers and those who participate in the arts but don't always recognize the arts as part of their lives. Maybes are defined as those who would participate if conditions were right. For an arts organization, then, it's crucial to understand why many people choose particular arts events, as well as what keeps them away.

Maybes often come to the arts for other reasons than the art itself. While they might not be lured by your event just because it's a concert of symphonic works, they might consider coming if invited by friends, if they know someone in the orchestra, or if the concert's theme is of interest to them. In other words, they have a variety of points of entry into the arts. The trick for an arts organization is to discover which points of entry are enticing to the maybes, and to market directly to those points of entry.

Here's an example. Suppose an organization wishes to promote an evening of Irish music. Using points of entry, the organization could simply promote the performers. It could be useful, however, to reach out to people who don't know much

about music but love Irish culture. This could be accomplished by, for example, working with travel agencies, Irish retail shops, and local pubs. Another example might be a play whose source is a book. The audience's point of entry may be the play itself, but it could also be the book or the subject matter of the book, hence the play.

Another way to figure out how to make the conditions right is to discover what keeps audiences away. **Barriers to entry** that are trivial to art lovers often are strong disincentives to maybes. Some common barriers to entry into the arts include the following:

- Auxiliary costs, like parking or transportation
- Inconvenient times
- Fear of behaving inappropriately in an unfamilar setting
- Nobody to go with
- Competition from family and work commitments
- Price

Each organization may have specific barriers (an unfriendly building, brusque ticket office staff, a reputation for being "too far away") and will need to adopt specific techniques for removing the obstacles or making sure the Maybes know that even though the venue might seem far away, parking is free and plentiful.

No

The No group includes people who, at least right now, are disinclined to attend. These individuals may have a deep-seated aversion to the arts or perhaps, for reason of race, social status, education, or income level, they are very different from the current patrons of the organization.

Diversifying the arts organization is a wonderful goal, but it is the most difficult aspect of audience development and requires the longest commitment. Successful diversification requires changing perceptions, both of new constituents and current audiences. Successful diversification also means incorporating in the decision-making process representatives of the population whose participation is desired. An organization won't attract many young people or people of color, for example, if the ones deciding how to do this are over 50 and white.

A successful audience development program will involve **deepening** the experiences of current patrons (Yeses), **broadening** the organization's effort to find points of entry and remove barriers for the Maybes, and **diversifying** the organization by working with members of the No group to understand their needs.

MARKETING PLANNING

Given the complex set of variables that go into a customer's decision to purchase, it should be obvious that marketing planning is the most important part of marketing. Marketing is a process, not a set of predetermined activities an organization simply executes. As with any other form of planning, marketing planning is a continual process of assessing the current situation, setting goals, planning and carrying out strategies, and monitoring the outcome. Each stage of the process helps inform future marketing decisions.

In any business, especially a not-for-profit business, an extensive planning process may seem like a luxury the organization cannot afford. Planning, however, is not only necessary, it might spell the difference between success and failure. Because planning helps the organization understand which tactics were effective and which were not, it helps the board deploy financial and other resources effectively. Without planning, an organization is more likely to rely on simply "getting the word out" to the general public without considering which methods are likely to work the best.

Planning does take time, but it doesn't need to steal that time from the actual creation or marketing of art. Many organizations use a strategic planning process to create a marketing plan: using a SWOT analysis to assess the current situation, setting goals, planning strategies to accomplish the goals, and building in methods to monitor progress. The goals developed during the process of developing the marketing plans are also used to determine the most likely potential audiences and possible messages to these audiences. These considerations are discussed further in the next chapter.

MARKETING RESEARCH

Many organizations avoid market research on the assumption that it's an expensive, time-consuming activity that requires extensive knowledge of sophisticated technology. In fact, technologies today have made marketing data much more accessible, and the research work itself easier and less time consuming. And, the more accurate the information collected, the more efficiently the organication can use time and resources in the marketing effort.

Marketing research can be used to:

- Describe (e.g., the geographic distribution of current audiences),
- Explain (e.g., why ticket sales dropped last season), or
- Predict (e.g., whether a new audience might respond to a promotion).

Market research can (and should) involve the following.

- **Primary data**, information created just for the project at hand, including:
 - ticket sales reports
 - audience surveys
 - focus groups
- **Secondary data**, information held by others, including:
 - census information
 - community trends
 - articles about trends in the arts industry

Marketing research can be used to address a variety of matters, from defining the current audience or estimating the potential of new audiences to testing the practicality of an artistic, price, or venue decision. Marketing research can discover barriers to attendance, as well as sources of satisfaction to build upon.

The most important contribution of marketing research is to reveal the real reasons for choosing specific marketing techniques. With this information, an organization can avoid spinning its wheels by discarding techniques that don't work and ceasing to rely on incorrect or obsolete assumptions. It's very easy for an organization to react to declining ticket sales with unproven assumptions: "For some reason, they didn't respond to our concert season this year," or "Nobody likes the new artistic director." Yet the real reason for the drop may have been a change in schedule that resulted in conflicts with another organization's offerings. It's often worth working with a skilled marketing professional to develop research mechanisms that ask the right questions, are easy for audiences to respond to, and provide usable information.

IN CONCLUSION

Marketing for today's arts organizations encompasses much more than simply "getting the word out" to prospective audiences. Understanding how to market successfully means understanding audiences, understanding marketing trends, and understanding the unique aspects of the arts industry. Going through the steps necessary to understand potential audiences and consumer behavior seems complicated. In many ways, it is—but it's also part of a process that can reward organizations that spend time on it.

DISCUSSION QUESTIONS

1. Can you think of quality movies, books, records, or shows that have been commercially successful? What artistic products can you think of that were not successful despite massive marketing campaigns? What conclusions can you draw about the relationship of product to marketing?
2. Check out a trend-watching website like www.faithpopcorn.com or www.trendwatching.com. What are some of the current trends these experts identify? How might those trends be used by or related to arts marketing?
3. A common marketing mistake is to think that new audiences must consist of people very different from those who currently attend. What changes might an organization currently patronized primarily by people over 50 have to make to attract "younger" audiences?
4. How have the arts organizations in your community used social media?

CHAPTER 14

&

Marketing Techniques

"You've got to be very careful if you don't know where you are going, otherwise you might not get there."

—YOGI BERRA

Some people believe that learning to market consists of learning the proper steps that must be followed every time you have an event or program to promote. But good marketing is a lot more than knowing how to write a press release or what goes into building a website—there is no set formula that will lead to a successful marketing campaign. If there were, every movie would be an international blockbuster, and every toy would be sold out before the holidays.

As we learned in the previous chapter, the consumer's decision to purchase any product is based on a complex set of personal, social, and economic factors, along with current trends and practices. Knowing how to market the arts also means understanding the reasons people choose to participate in the arts and the unique conditions in the arts.

After finishing this chapter you should be able to:

- Describe how an organization chooses the most likely potential audiences and determines the messages to share with them
- Identify the "Four Ps" of marketing and describe how they are used
- Explain the factors that go into marketing decisions

TARGET MARKETING

Audience development expert Sharon Rodning Bash describes a scene from a classic *Peanuts* cartoon:

> Charlie Brown is practicing archery. He shoots his arrow at a fence, then walks to the fence and draws a target around the arrow wherever it has landed. Lucy walks up and asks, "Charlie Brown, why are you doing this?" His matter-of-fact response: "This way I never miss."[1]

Rodning goes on to compare Charlie Brown's technique of creating the target after the arrow has flown to common marketing techniques practiced by arts

organizations. Many arts organizations spend more time shooting arrows—sending out press releases to local newspapers, putting up posters all over town, sending out brochures to names on generalized mailing lists—than trying to locate the bulls-eye and directing marketing toward it.

We all want to believe that every person is a potential participant, and we want to make sure that everyone knows about our programs. In reality, however, some people are more likely than others to participate, and it only makes sense to concentrate on finding out who those people are and direct our marketing efforts toward them.

In **target marketing**, an organization selects a set of buyers (the target audience) having common needs or characteristics and decides to serve these people on the basis of their potential to be attracted by the organization's offerings. An organization's current audiences also are important in helping the organization determine future targets. The current audience, in fact, can be treated as one of the organization's targets. No less important than finding new audiences is helping existing patrons deepen their experience, increase their participation, and build their loyalty.

One of the common mistakes in targeting, however, is focusing on audiences you think should be reaching rather than audiences that are already within reach. Here's an example: a museum notices that its community is becoming more ethnically diverse; in keeping with the organization's mission to serve the community, the board of directors decides to target "the diverse populations of our city." Not only is this target too broad, it perpetuates a division between long-time residents and newer residents, and lumps all newcomers of different backgrounds into a single category. Perhaps a better approach for this organization would be to study which of the emerging population groups have other characteristics in common with current museum audiences, hence might be likely to respond.

We've talked before about directors of today's arts organizations seeing more gray hair in the audience and assuming that they should target is "younger audiences," among other segments of the population. As the targeting process will show us, "younger" is too vague a target to be useful. Using the strategic marketing process, an organization would define the term more closely: Is the idea to attract the next generation younger than the current audience? Young families with children? Youth in high school and college? The answers to these questions will indicate a way to speak with specificity to a more realistically defined target group.

The targeting process involves breaking up the available audience into smaller groups, called market segments, and prioritizing those segments according to their attractiveness. The most attractive segments will become targets, and once targets have been determined, the organization can develop a position toward these groups and make plans for communicating with them. The process, which is detailed in the subsections that follow, goes like this:

THE TARGET MARKETING PROCESS

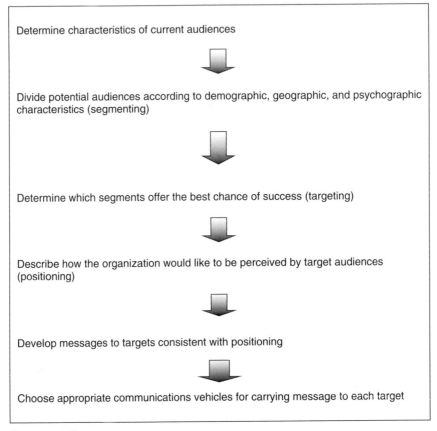

Determine characteristics of current audiences

Divide potential audiences according to demographic, geographic, and psychographic characteristics (segmenting)

Determine which segments offer the best chance of success (targeting)

Describe how the organization would like to be perceived by target audiences (positioning)

Develop messages to targets consistent with positioning

Choose appropriate communications vehicles for carrying message to each target

Segmentation

After the organization has determined the characteristics of its current audiences, its next step is segmenting the potential audience into groups. The purpose of segmenting is to identify groups that share certain characteristics that can affect their consumer behavior. Although, of course, every person is different, many groups share buying habits.

The three primary types of segmentation are geographic, demographic, and psychographic. We define these briefly as follows:

- **Geographic segmentation**
 Geographic segmentation is what you think: dividing people by geographic area. For example, a theater company may decide to group the potential audience according to how far people live from the theater, their suburb or neighborhood, or whether they are permanent or temporary residents.
- **Demographic segmentation**
 Demographics are statistics that describe audiences in terms of such variables as age, income, education, household size, gender, and ethnic heritage. Demographic studies of traditional arts audiences show that members of this group are more likely than the population at large to be over 45 years old, well educated, and at high income levels.

- **Psychographic segmentation**
 Psychographics are classifications of lifestyle, values, and beliefs. Some common psychographic characteristics are activities, interests, opinions, beliefs, and behavior.

Usually, a fully formed target audience will combine two or more characteristics. For example, it may not be enough to identify a target as "people living in the Whitney Park neighborhood." A better target might be "families with children living in the Whitney Park neighborhood" or "people living in the Whitney Park neighborhood who have participated in other community arts events."

Prioritizing Segments and Choosing Targets

Once the organization has chosen a number of segments that seem like possible sources of new audience members, it is time to prioritize the segments and choose targets.

It's important to remember that all possible targets do not need to be pursued immediately. Sometimes, a potentially attractive target can be put aside for a year and investigated in the future. Generally, it is best to narrow the world of possibilities down to two or three targets, plus current audiences, in order to use marketing resources most effectively, without diluting the message.

What makes a target attractive? How does an organization prioritize potential targets? Here are some guidelines.

- **A good target has characteristics in common with your current audiences.**
 Using the "birds of a feather flock together" metaphor, it is logical to think that potential audiences sharing at least one characteristic with current audiences are likely to respond to the same messages that attracted your current audiences. At the very least, new audiences are more likely to feel welcome and comfortable if others like them also are participating.

 Think about that organization we mentioned earlier that wanted to target "diverse" audiences. If they succeeded in bringing a few people of color into their mostly white local audience, how comfortable would the new recruits be? A better way to make targeted people feel welcome might be to approach potential patrons because they have something in common with current audiences—for example, employment at a particular company or membership in the senior center—than on grounds of a single demographic characteristic.

- **A good target is clearly defined.**
 As we've noted before, it may not be easy to market simply to "younger audiences" or "tourists." But if you are able to narrow down the target to include specific demographic, geographic, or psychographic information, the task becomes much easier. "College-aged music and theater majors" is much more specific than "younger audiences."

 Clearly defining targets also means avoiding the confusion that can result from including parts of two segments in a single target. For example, if the targets for your fundraising campaign include "former subscribers" and "donors," there are likely to be many people who belong to both groups.

- **A good target is substantial enough to warrant action.**
 Perhaps "people who have attended ballet in the past" is an excellent target in theory, but if your community has never had a ballet company, then that segment is going to be pretty small.
- **A good target is actionable.**
 A target is actionable if you would be able to reach it by using the resources you currently have. For example, "tourists from Chicago" may seem like an ideal target, but how can you reach a large group like this if you don't have enough money to advertise in Chicago-area newspapers and magazines? It might be more feasible to define the target as "tourists from Chicago who patronize North Shore theater groups" and then see about renting mailing lists from those groups.

 Another reason that a group might be hard to reach would be the absence of a dedicated medium through which to reach them. "Women over 70 who are not in a retirement home" might be a wonderful target, but not unless there is a media outlet, club, or group that caters to them.

POSITIONING

Once an organization has selected suitable targets, it will want to decide how best to show the selected people that the arts events being offered might appeal to them. To do this, the organization creates a positioning strategy.

Positioning is the act of describing the organization's image and offer in a way calculated to appeal to the target. Positioning involves selecting the aspects of the organization that are important to the target, showcasing them, and differentiating the organization from others that the target might choose.

Positioning forms the basis for the organization's ultimate decisions about message, branding, and marketing strategies. Lying to the customer, however, is never an acceptable strategy. You may determine that a target probably would be attracted by family-friendly activities, but this observation doesn't justify positioning yourself as a family-friendly choice unless you really are—and that means having family activities in place as well as amenities that families need (a place for snacks, accessible rest rooms, nearby parking, childproofing of all public areas).

A template for a positioning statement might look like this:

To [our target], who [has these needs], [our organization] provides [services addressing those needs], unlike [competing options].

Filling in the bracketed phrases might yield:

Families in Curd County with school-aged children who are looking for quality, affordable activities in which the whole family can participate will be pleased to find that the Curd County Historical Society provides safe, wholesome educational activities for all ages, unlike other entertainment options that may be inappropriate for young children.

COMMUNICATING THE MESSAGE

Once a position with respect to a selected target has been agreed on, you must figure out the best way to communicate it.

A **message** can be communicated in many different ways. Before deciding on the appropriate tool or tools—e-mail, postcard, website, social media, or all of the above—the organization must craft the message itself. What words, phrases, visual images, or graphics will tell the story you want to tell? How can you get your position across in a way that will be meaningful to your target?

The most important consideration in determining message is how the target is likely to interpret it. As we know, everyone receives many thousands of commercial messages every day. The best message will accurately describe the organization, communicate how it can meet one or more of the target's needs, appeal to the target emotionally or aesthetically, and encourage a purchase.

Effective communication calls for an understanding that people won't be capable of receiving a message until they are aware of listening it. Therefore, the steps in communication include creating awareness, arousing interest, and finally enticing the customer to make a purchase. Social media has changed the traditional communication formula somewhat, owing to the potential for customer involvement and interaction throughout the process. Good marketers realize that the message may be passed along by parties outside the organization, and that a carefully crafted message may be altered at over time as customers insert their own opinions. The communications game in social media is more about continuing interactions with customers, creating more awareness, and adapting to the evolving conversation than about hoping the message will remain the same as it passes through cyberspace.

Commercial businesses usually test potential messages on their targets before investing money in a marketing campaign. There are many ways to do this even without a large marketing budget. Testing a message can be as simple as asking a variety of volunteers, staff, board members, and representatives of the public to comment on your ideas—or as complex as convening focus groups or surveying potential audiences. The more an organization tests a message, the higher the likelihood of success.

The Philosophy of Branding

The word "brand" is used in several ways. Brand may be a synonym for a product line ("There are several different brands of toilet paper available"), the logo of a business, or the image of the product in the customer's mind ("The Starbucks brand is more about the experience than the coffee itself"). In fact, the concept of branding is all of these things and more.

Brand or "brand image" is the customer's mental image of the business, which supersedes any particular product. The goal of branding is to create an emotional attachment to the business that is so strong and clear that without thinking about it, people come to have a deep understanding of what the company is all about. They arrive at this understanding because of a variety of visual, written, and aural clues that are parts of the business's message.

Why should arts organizations consider adopting a brand image? Well, partly because everyone else is doing it. Customers use branding cues so routinely in formulating opinions about products they buy that they will tend to use whatever cues are available to form opinions about other products. In the absence of any information from the organization, they are likely to form opinions about the arts as well as stereotypes on the basis of what others have said, attitudes picked up in school, and their own early life experiences. Some customers have had positive experiences with the arts and have heard good things about your organization. Others might carry with them outdated attitudes according to which the arts are stuffy, elitist, expensive, or boring. Or, they may simply file the arts under "irrelevant."

Another reason for an arts organization to consider working on a brand image is that if emotional attachment can be built up, less work will be needed to "sell" each new play, concert, or exhibit. Customers who trust the organization might be more confident when they purchase tickets to see art or hear music they're not already familiar with, and they'll retain more positive feelings about the experience even if they have to endure a long line at the restroom or an uncomfortable seat.

A brand image also helps the organization work internally to create excitement among board, staff, and volunteers. It strengthens your organization's sense of self and helps your ambassadors convey that excitement to their circles of friends, acquaintances, and colleagues.

In a not-for-profit organization, branding has a different meaning than in a for-profit corporation. The brand of a not-for-profit arises from mission. Terence Riley, of the Museum of Modern Art in New York, puts it well: "Here at the Museum of Modern Art, we don't use the word 'brand.' We prefer the term 'spirit.'"[2] This usage implies that brand is also linked to mission—and the impetus that brings people together to support the organization. A good brand reinforces the mission, instructs patrons and others about what the organization does, and saves time and money that can be applied to program development.

What about branding in the age of social media? We have discussed how the prevalence of social media gives customers an unprecedented say in the content of the message, not the organization. Does this eliminate the need for businesses to brand? Not at all. In fact, social media makes branding more important than ever. With even less control over the message, it's important to take into consideration how and under what circumstances your audiences are sharing information about you. If you help the networking along by having good social media content available, what will be spread is what you want to see spread. If you reinforce your brand image by paying attention to all aspects of the audience experience, then the image they will carry with them when they mention your organization to others will match the brand you've created.

Elements of the Message

When we speak of "message," we don't mean just words. Every word, phrase, name, and visual image the customer encounters becomes a part of the message and the brand.

The first step in developing the message and brand is the creation of a concept around which every other choice will revolve. In order for a message and brand to

Case 14-1

Case Study: Los Angeles Philharmonic

In 2009 the Los Angeles Philharmonic (www.laphil.com) hired a new music director: Gustavo Dudamel, one of the world's most exciting young conductors. Dudamel had been conductor of the Simón Bolívar Orchestra, the top orchestra for El Sistema, a Venezuelan music program that has been enormously popular and successful in Venezuela and has recently been implemented in the United States. Dudamel, himself a product of El Sistema, had gained Internet fame when videos of the Bolívar orchestra became a hit on YouTube and when he featured the orchestra in a TED talk honoring El Sistema creator José Abreu.

Because of Dudamel's growing fame, the LA Phil decided to feature the conductor as a central focus of its new brand, with photos of him in action and the words "passion" and "excitement" splashed over the website. In fact, even using the name "LA Phil" is a part of this branding message—implying that hip people would refer to the organization with a snappy nickname rather than the more stuffy "Los Angeles Philharmonic."

Branding an organization on an artistic director or other personality is sometimes risky, especially if a community fails to develop a highly positive relationship with the artistic director. Other times, it has been the foundation for creating personal relationships with audiences that have lasted for years. Only time will tell whether the LA Phil made a wise decision—but what do you think? Is it a good idea to stake an organization's brand on one person? Why or why not?

be successful, all components mush mesh smoothly, without creating conflicting images in the mind of the target. All of this starts with our position and what we wish to convey to the target.

It essential to emphasize the obvious here: any message conveyed to any target needs to be authentic. In other words, if the message doesn't correspond to what the target is prepared to believe about the organization, or if the organization cannot deliver on its promise, that message may do more damage than good. For example, if an organization that wants to attract "young people" creates a young, hip message with appropriate graphics and words, and the first young people to buy tickets find a traditional arts experience, with mostly old people in the audience, their view of the organization will not be neutral, it will be negative.

The subsections that follow present the common elements of an organizational message.

Logo

The most familiar aspect of an organization's visual image is its **logo**. This is the graphic emblem or symbol associated with the organization or business. Logos can be abstract designs, visual treatments of the company name, or a combination.

How are logos developed? Like other marketing tools, the logo should represent the goals and message the company wishes to communicate. It can represent something familiar, as in the golden arches of McDonald's, which were an architectural feature of the original restaurants. A logo can include colors that underscore the message (bright and warm for excitement, calm or cool for

stability), or abstract symbols that visually represent (at least in the designer's mind) the company image.

Other Visual Elements

Of course, your logo is not the only visual image your potential patrons will see. Every color, every graphic, and every picture should be calculated to convey your intended message. Part of the process of adopting a logo entails deciding on how graphic and visual images will carry through the rest of the organization's communications. For example, if yellow and blue are the colors used in the logo, the same colors should appear in a variety of other ways: as background colors, perhaps, or in other graphic symbols.

All visual images should reinforce the brand. For example, if the Girl Scouts wanted to emphasize that they welcome all girls, they might choose to include on a brochure or website an image of girls of different ethnicities having fun together.

Tagline or Slogan

One of the centerpieces of traditional branding is the development of a catchy phrase that's associated with the business or product. A good tagline is able to create awareness and arouse interest in a few short words.

TAGLINES

Here are some examples of taglines from a variety of arts organizations. Which do you think are effective? Why? How would you change the others?

Historical society: Rooted in the past, growing to the future

Community theater: Spend some time in the dark with people you don't know

Library: Spread the words

Orchestra: Celebrating our 25th year

Art museum: Where the classics come alive

Words and Phrases

Although the tagline is perhaps the most commonly used written brand symbol, every word and phrase written or spoken about an organization contributes to its brand. If you consistently use certain words and phrases in your letters, in your other communications, and on your website, the practice will confirm your audience's existing perceptions about you. If your language is not consistent, then the image will be confusing. For example, if your tagline is energetic and hip, but your website reads like an academic textbook, nobody will take the tagline seriously.

Part of the branding process is developing a list of words and phrases that reinforce the image and message the organization is trying to communicate, and then using these words and phrases in letters, brochures, websites, and newsletters. Once again, in choosing language, it's important to consider the goals of the organization and the intended target organizations.

Case 14-2

Case Study: Political Messaging

Although it's sometimes a frustrating exercise, studying the language of politicians and candidates is one way to understand the power of words can be harnessed to create memorable images. Politicians are very good at using words for two purposes: to create both a positive image of themselves and their party and what they call a contrasting image of the other candidate or party. Phrases like "tax-and-spend liberal" or "right-wing conspiracy," repeated often enough, become embedded in the public's understanding of the dominant U.S. political parties, regardless of whether they are true. Such political messaging is very difficult to refute because of the emotional attachment it creates among partisans.

Although some organizations shy away from using power words because of the negative connotations often associated with political messaging, it's important to remember that there's nothing destructive about using words positively to brand a business. Only when someone uses negative words to brand a competitor does the process become undesirable—and not particularly fitting for a mission-based organization.

Some marketing experts say that the public will create a brand image of your business no matter what: that is, if you don't use words and images to help people get a feel for your brand, the public will revert to stereotypes of the arts that may be neither flattering nor accurate. To test this premise, spend some time looking at the websites of arts organizations in your community. Which ones use power words effectively, and which do not? A far too common practice among arts organizations is simply listing the facts about an upcoming event, with no descriptive language at all. Is this true of any of the sites you looked at? How would you improve them?

People Messages

Logos, taglines, and other cues can go only so far—ultimately, the message that is most effective is communicated through people.

The organization's board, staff, and volunteers are your ambassadors to the community, and therefore one of the most important aids at an organization's disposal for communicating its message. These committed individuals will be talking to friends, relatives, and associates about your organization, so it's important to let them know what message you would like them to communicate. Of course, your inner circle will also be receiving your brand and message cues; if you're doing your job right, they will get the message that way. But it doesn't hurt to take the extra time to communicate to your ambassadors what you would like them to share. They'll have a big leg up in shaping their personal messages if they've received an e-mail that says, "Be sure to share our upcoming program with your friends—it is an exciting, unique program and we know it will be a lot of fun for families!"

THE MARKETING MIX

"We're obviously going to spend a lot in marketing because we think the product sells itself."

—Jim Allchin, Microsoft

Once arts organizations have determined their needs and goals, chosen target markets, and developed their brand image, it's time to choose the strategies for delivering the message.

It's important at this point to take a moment to remember the process we've been using throughout this book. We've noted that marketing is part of our everyday life, something we're all familiar with. We are the targets of marketing by others, and we see thousands of marketing messages every day. We feel that we understand marketing. For this reason, it's easy to skip right to the strategies instead of going through the process of determining goals and targets before strategizing. Faced with a task of marketing an upcoming event, many will move directly to the tasks that need to be done: "We need to send out a press release, we need to create posters and put them around town, we need to send an e-mail blast to our patrons." But if we don't understand our purpose for sending marketing messages, then much of the time and money expended on that effort will have been wasted. The message won't be strong, and it may not reach the right people.

Promotion—that is, carrying the message to the targets—is only part of the story of marketing strategies. It's just as important to carefully consider the product being sold, the price for the product, and the way the product is accessed by the customer. Product, price, place, and promotion are known as the marketing mix, also called the **Four Ps** of marketing.

THE FIRST P: PRODUCT

In a for-profit business, each **product** is developed, designed, shaped, and eventually changed to conform to what research determines the market needs. This, of course, is the way to be successful in business: create a product that people need and distinguish it from other similar products in the marketplace. Doing so theoretically should assure success (although it doesn't always, as the makers of New Coke found out in a hurry).[3]

The only problem for not-for-profit arts businesses is that our business purpose is to achieve our mission. We often start with a product—or at least a type of product—that is dictated by our artistic mission. If our mission, for example, is to perform Baroque music, that's what we do . . . even if all of our market research shows that people in our community prefer Romantic music. When we choose our seasons, we choose them based on our own conceptions of artistic quality, not because we think a particular event will be more popular than something else.

This sounds counterintuitive. And in a way, it is. Why should any business deliberately choose products without knowing whether it will be possible to sell them? And, of course, not all arts businesses operate this way; commercial entertainment entities like film studios and record labels run on the philosophy that they must offer the public what will sell. *American Idol* is not about choosing the best singer, it's about finding the most sellable property. If you've ever seen an interview with someone booted off *American Idol* who says, "I understand, it's just business," then you know how sometimes artistic vision and profit can be at odds.

When it comes to product, there are many things arts organizations can do while staying true to a mission-based programming philosophy. Within our mission, for example, we can choose programs that are attractive to our customers. We can pay attention to the important parts of the product that don't affect artistic quality. And most important, we can show by our attitude that we acknowledge our patrons as intelligent and discerning people who'll let us know if we've ignored them. We need patrons, and so we cannot be patronizing.

Approaches to Product Definition and Delivery

Although the twenty-first-century not-for-profit arts organization still bases product decisions on mission, there are a variety of ways for the product to conform to the organizational mission while respecting customer needs and enhancing experience.

Redefining Product Delivery

One way to address customer needs without changing the artistic product is to consider how the product is delivered to its audiences. Changing the time or day of the performance can help accommodate customers without changing the actual product.

Here's an example: if you have a downtown arts organization, people who work downtown are likely to comprise a key target audience. However, if your programs run during regular business hours, many working people won't consider attending. Or, if you have performances beginning at 7:30 or 8:00 p.m., downtown workers will have to choose between staying downtown for two or three hours before the performance or going home and coming back. Scheduling musical or theatrical performances at 5:30 p.m. or talks by artists in brown-bag lunch settings helps accommodate working people without changing the artistic product.

Many organizations are thinking about how technology changes product delivery. Even if we assume that live participation is preferable (and some are even questioning that), there is no doubt that a lively interaction with technology can smash the boundaries of product delivery. Here are some of the ways organizations are now using technology to extend their audiences:

- Live streaming of events
- Live tweeting or blogging from events
- Video clips of rehearsals, artist talks, or program information
- Distance conferencing, interviews, and artist talks

Thematic Programming

While describing a program by listing the composers to be featured may be appealing to aficionados of those composers, it may be meaningless to others. Thematic programming, when used properly, can be a way to provide a **point of entry** to the "maybe" audiences we described in the last chapter.

Thematic programming simply means designing a program and marketing it around a particular theme that opens up the options for points of entry. It also

Case 14-3

Case Study: Crowdsourcing an Opera

In May 2010 the Savonlinna Opera Festival in Finland announced the creation of a crowdsourcing program called Opera By You. More than 400 people all over the world registered to take part in the first project, which ended up lasting two years. On July 21, 2012, the resulting opera, *Free Will*, was premiered online.

Using the crowdsourcing platform Wreckamovie, the steering committee of the project (composer Markus Fagerudd, librettist Iida Hämeen-Anttila, stage director Jere Erkkilä, stage and lighting designer Samuli Laine, costume designer Essi Palo, head of productions Jukka Pohjolainen, and project manager Päivi Salmi) gave the online community tasks and instructions, first for a libretto based on the story, then for the music. Next, the international community made suggestions on scene and costume design and marketing. Audience participation continued up to and including the final rehearsals in Savonlinna, where crowdsourcers all over the world could communicate with the process, give the director suggestions, and follow the final moments in the leadup to the premiere.

More information, including a video of the premiere, can be found at the Opera By You website, http://www.operafestival.fi/OperaByYou/English/Home.

opens up options for auxiliary events. A concert of Strauss waltzes could be paired with a dessert reception featuring Viennese pastries and tarts. A concert of music celebrating Mexican independence could be preceded by a dinner of Mexican specialties or an auction of Mexican art.

Thematic programming, however, is not just about slapping a clever title on a program to make it easier to market. The theme should be evocative, enticing to broad audiences and accurate. An orchestra that titles a concert "Rock Me Amadeus" may not only fail to attract the new audiences it seeks, but may also risk losing new audiences who come and are disappointed that there is only one Mozart concerto and no rock music.

Programming for Targets

Creating programs specifically to appeal to target markets doesn't mean compromising mission. It simply means choosing, from the array of available options, those that might be particularly appealing to the populations you've chosen to serve.

For example, if a museum devoted to showing the work of contemporary artists serves a target audience of adults over 60, then perhaps an exhibit of works by contemporary artists who began their work later in life would be appealing.

Education and Enrichment

One of the ways to increase fulfillment of the mission is to increase the amount of educational and enrichment activities associated with the program. Whereas some people may be attracted to the core product (exhibit, concert, play), others will be happy to enhance their experience by taking advantage of educational activities.

THE SECOND P: PLACE

In the marketing mix, **place** is defined as the locus at which the customer encounters your product. For many manufactured products, place is synonymous with distribution; in other words, the place or places at which customers purchase the product. Decisions about which stores will carry the product and where the product can be purchased online are part of the process of defining place for a manufactured product.

For an arts product, place has many meanings. Certainly physical products like paintings, ceramics, and CDs may use the term in the traditional marketing sense, since the items are going to be distributed and sold. Will an artist sell her handmade jewelry personally to customers at art fairs? Can the jewelry be purchased from a website or from an online storefront like Etsy? Will it be carried in galleries or museum gift shops— and if so, which venues are capable of showing the jewelry to customers who are most likely to purchase it?

For performing arts organizations, museums, festivals, and historic sites, place is more literal: it's the actual physical space in which the art is performed or viewed. The space in which the audience encounters the art is an important part— sometimes even the central part—of their experience. Think about the difference in the experiences of a person who attends a concert in a glittering performing arts center and one who hears the same works in a high school auditorium. Even if the performers are the same as well as the music, the experiences will be different. The person attending the concert in the performing arts center will experience the grandeur of the space—but may also run into added expense, parking problems, or difficulties finding the venue. The audience member at the high school may have the impression that the performance is quite ordinary, and the auditorium itself may be uncomfortable—but the high school may be easier to reach, easier to park at, and more friendly because of its familiarity.

A large part of the experience of place has to do with the people the customer encounters. Most of this aspect can fall under the category of customer service. A customer who has had a good or bad experience with a ticket sales representative will add the corresponding feelings about that encounter to his overall impression of the organization. In addition, customer service in the not-for-profit arts organization is often provided by volunteers, whom audience members may encounter socially, at the grocery store, or in the workplace. Since volunteers are ambassadors for the organization in the community, how they represent the organization, even when not at the venue, is an aspect of place.

Finally, place also includes any virtual spaces that are part of the arts organization's presence. The organizational website, Facebook page, or YouTube channel may be the first place the customer encounters the organization; for some, it may be the only place. It's important that the website and other virtual spaces reflect the experience of your organization as strongly as they convey the outstanding points about the physical space.

Put another way, in the not-for-profit arts organization, place has to do with accessibility: that is, how we make our product available to the largest possible

Case 14-4

Case Study: Museum Signage

For years, a community art museum had "NO PHOTOGRAPHY" and "NO FOOD" painted on its front doors. After learning from constituents that these words made the museum seem like a forbidding place, the board had the lettering removed. Then a sign appeared near the front entrance. "Welcome to your county museum," it began. "So that all may enjoy the museum, please observe the following...."

How might the customers' experience of place be affected by these changes in the display of messages the museum wished to be seen by all?

audience. For most arts organizations, accessibility is also a large part of mission. If our mission is, in some form, exposing audiences to art, then it is important for us to help ensure that all people can encounter our programs in some way, whether that be in a clean, beautiful facility, in alternative spaces, or online.

Virtual Place

In 2009 New York City's Metropolitan Museum of Art discovered that three-quarters of its visitors never came to the museum—they instead accessed the various collections via the institution's website.[4] This realization led to a major overhaul of the website to encourage even more online participation. In addition to accessing information about exhibitions and collections, website visitors now can become members, which allows them to access even more features, purchase items in the online gift shop, download teacher resources, and discuss the exhibits with other patrons.

An organization's facility is not the only place that helps define the organization. Increasingly, online "places" such as websites, Facebook pages, and YouTube channels are becoming front doors for arts organizations. In fact, many organizations are considering their online places to be as important as their physical space, if not more important.

Each organization's online presence should reflect the same personality as the physical location. Goals for customer service, ease of use, and convenience should be plotted as carefully for online visitors as for those who choose the live experience. The website is the most comprehensive opportunity and ideally offer a number of services to customers, including information about upcoming events, hours, locations, parking, shopping, and online artistic content such as artworks or clips from performances.

Interaction with other people is a central feature of the live experience, and arts organizations are increasingly able to find ways to extend this feature to the virtual space as well. Among the types of interaction arts organizations are using with great success are blogs by the executive director or the artistic director, audience reviews, live chats, and social media. In fact, social media offers the opportunity for even more interaction with patrons than the live event. At a live event, few in the audience will have the chance to talk with the curator of an exhibit, but if

that curator posts a blog or schedules a live chat about the exhibit, anyone can participate.

THE THIRD P: PRICE

While **price** is often seen as a budgeting issue, in reality it has a great deal to do with marketing. How much the product costs affects the public's perception of the worth of the product. A well-chosen price will encourage people to buy; a price that is too high or too low may discourage potential customers who perceive the product as either overly expensive or too cheap to be good. Discounts, sales, and coupons can offer marketing incentives.

The notion of price is changing in these technology-driven times. There are some products (e.g., a Google search, a YouTube video, a Facebook page) that people now expect to get without charge. This mindset has affected the prices people are willing to pay for other products.

If we look at price as a marketing issue, then what becomes important is our target audiences: what value they place on the art we are delivering to them, how much they are willing to pay, and how we can use pricing incentives to encourage them to purchase.

A major factor in price calculation is perceived value. While it is common for fans to pay several hundred dollars for tickets to see popular entertainers, it's also common to hear complaints about the cost of movies, which is near or in the low two figures. Part of using price in marketing is not simply calculating the right price, but increasing the perceived value. For-profit businesses do this by bundling extra items into the price ("But wait—there's more!") or by manipulating supply and demand to make the product harder or easier to obtain.

Pricing Strategies

Up until now, we've talked about setting the basic price of the product. Pricing can also be used as a marketing tool by employing discounts, group sales, and means of price cutting to provide an incentive to purchase. Here we introduce a few common pricing strategies.

Demand-based pricing assumes that there is more demand for some forms of the product than for others. Offering discounts for less-used times and charging premium prices for in-demand times is one way to encourage patrons to consider other options. For example, if Thursday nights are traditionally slow at the theater but Friday nights are often sold out, an organization could charge less for tickets on Thursday night and more for Friday night.

Customer segment pricing. Different types of customers may have different levels of demand for a product, and also different abilities to pay. It has become traditional in many arts organizations to offer discounts to, for example, students and seniors. One popular customer segment pricing scheme is the student rush ticket. Organizations offer discounts (sometimes very deep discounts) on tickets purchased the night of the performance with a student I.D. By taking advantage of the habit of many students to make entertainment choices at the last minute, this

arrangement allows the organizations to recover some costs on seats that would otherwise have remained unsold.

An increasingly popular customer segment pricing idea is the family ticket. This can be set up in several ways: by offering a flat rate (or price ceiling) for a family to attend together (no matter how many attend) or by offering discounts to children of different ages who attend with their parents. These ideas are based on awareness that the cost of bringing a family, especially a large family, to an event can be prohibitive. Since many arts organizations aspire to be family friendly, it doesn't make sense to price families out of the market.

Location pricing is related to demand-based pricing; for performing arts especially, certain seat locations are more desirable than others. It is common for performing arts organizations to charge more for ground-level center seats than for seats in the upper balcony.

Pricing incentives such as discounts must be used carefully. First, there must be a clear definition of who gets a discount and who does not. Pricing incentives are successful only if different segments of the audience have different intensities of demand. There is no benefit, for example, in offering a student rush if students are attending anyway.

It's also important to realize that incorporating multiple ticket prices into the system costs the organization money. Thus the cost associated with the time to program the software, plus the costs of printing more than one set of tickets and the cost of marketing the different options, must not exceed the benefit derived from the discounts.

THE FOURTH P: PROMOTION

"Are your messages fresh, wholesome, local organic cheese? Or are they just cheesy?"

—Trevor O'Donnell, in O'Donnell, with David Olsen,
*Marketing the Arts to Death: How Lazy
Language is Killing* Culture, 2011

When most people think of marketing, they are actually thinking of **promotion**: the act of disseminating information about an event or product in order to bring attention to it. We've saved promotion for last, however, to emphasize the point that promotion is only the tip of the marketing iceberg. If a business has used the strategic marketing process properly, promotion will be part of a comprehensive strategy, directed at specific people who are likely to respond, and supported by other marketing efforts.

Promotion is traditionally broken down into several broad categories:

- **Public relations**: the act of promoting, improving, or maintaining public interest
- **Direct marketing**: communicating directly with individuals by means of such promotional materials as brochures, newsletters, and e-mail messages

- **Advertising**: any paid form of nonpersonal presentation of the message
- **Sales promotions**: contests, discounts, and other incentives geared to encourage people to try a product
- **Personal selling**: using personal influence to encourage purchase

Here are some examples of each type of promotion.

EXAMPLES OF PROMOTIONAL TOOLS

Public Relations	Direct Marketing	Advertising	Sales Promotions	Personal Selling
Press releases	Brochures	Print ads	Coupons & rebates	Presentations
Media kits	Newsletters	Broadcast ads	Discounts	Telemarketing
Speeches	E-mail messages	Billboards	Premiums & gifts	Sales events
Staged events	Catalogs	Internet ads	Sampling	Box office
Advocacy	Letters	Signs	Booths/ exhibits	Volunteer sales
	Postcards	Program ads	Tie-ins	Social media

Each of these promotional methods has strengths and weaknesses, which must be taken into consideration in deciding which one to use.

ADVANTAGES AND DISADVANTAGES OF VARIOUS PROMOTION TOOLS

	Advantages	Disadvantages
Print pieces (direct mail, brochures, postcards, posters)	Very targeted Includes much information Can be posted or saved Can be passed on to others	Easy for customer to discard Long production time Good mailing list is critical Not interactive
Print ads (newspapers, magazines)	Broad reach Targets upscale, educated demographic Can attract attention Quick production turnaround	Harder to target Can be expensive Need series of ads to be effective Presents less information than brochure Competes with clutter of other ads Not interactive

(continued)

	Advantages	Disadvantages
Radio	Targeted to broad groups Can be less expensive than print ads Quick production turnaround Can feature music	Hard to describe visual images Need frequency to be effective Not interactive
Television	Very broad reach Very visual High impact	Hard to target Minimal information can be included in the ad Need frequency to be effective More expensive Long production time Not interactive
Website	Available 24/7/365 Highly targeted Can include lots of information Can be interactive Can change quickly	Initial expense plus maintenance time Need other vehicles to drive traffic to site
E-mail	Can send more frequently than print mail Fast turnaround time Can be interactive Low cost	Easy to ignore May trigger privacy concerns Hard to maintain accurate list
Social media	Highly interactive Low cost Many different outlets Customers can extend reach	Maintenance is time consuming Needs specialized knowledge to be effective

PUBLIC RELATIONS

Public relations can be broken down into two broad categories: community relations and media relations. Community relations encompasses a wide variety of activities that help organizations keep in touch with their constituents, involve the community in their activities, share information with new audiences, and encourage participation. Community relations activities may include public speeches and presentations, affinity groups such as singles clubs, or staged events such as enertainmen by flash mobs. Media relations consists of maintaining relationships with various media outlets, including newspapers, magazines, television and radio stations, and social media.

It's important to understand what public relations is and is not. Because most public relations does not involve purchasing ad space or printing brochures, many

businesses, especially not-for-profits, think they should concentrate their efforts on public relations and avoid higher cost promotional avenues.

Public relations, however, is not a "poor man's marketing tool." Public relations should be used strategically to take advantage of its unique properties, not because it costs less than other avenues. Since the primary cost for public relations is staff time, most organizations can use a variety of PR methods, technological and otherwise, to convey information. And, organizations can use public relations tools repeatedly to reinforce a message because no additional cost is incurred when a press release is sent to multiple media outlets or an e-mail newsletter goes out to many subscribers.

Public relations activities also have the potential to lend credibility to an organization's communication efforts. Customers are skeptical of advertising, knowing that the business has carefully crafted any message it sends out. Even though people say they don't trust the media, they do assume that a message about an upcoming community event received through the media has passed through some kind of editorial filter.

Public relations is also an important part of that priceless promotional tool, word of mouth. The more often potential audiences see or hear information about your organization, the more likely it is that they will talk about it with others. The use of social media amplifies this effect.

Using public relations also has some disadvantages. If you are counting on newspapers or broadcast media to carry your story, you are also taking a chance that facts will be misrepresented, the wrong ideas emphasized, or your organization portrayed in an unfavorable light. And of course you can't count on a media outlet to publish your story at all. Using social media to share a message also entails the risk that the message will be lost or portrayed incorrectly as it is shared.

Media Relations

Working with media to obtain coverage of arts events is an ever-changing process, much like the media itself. Media relations, in fact, is just that: creating and maintaining ongoing relationships with print, broadcast, and online media, with the goal of ensuring that the coverage you receive is positive, accurate, and fair. Part of media relations is simply keeping up with media trends. For example, the rise in twenty-four-hour cable news channels and the ability of the Internet to respond to breaking news has virtually eliminated what marketers used to call the "news cycle." Although, for example, most newspapers issue a print edition once a day, their websites are dynamic and subject to change at any time.

The good news is that with the competition presented to local media by online and cable sources, many local media are using the opportunity to highlight more local news that is difficult for the public to get elsewhere. The bad news is that budget cuts have forced many media outlets, especially in smaller communities, to eliminate critical reviews and reports byother arts specialists.

The bottom line is that no media outlet is in business to do favors for you; all are focused on attracting readers or viewers, and they are trying to do that in an environment of decreasing staff and increasing budget cuts. Media relations works

best when arts organizations consider carefully how to give media outlets what they need, in the format they request, with enough information to allow them to run a story without doing excessive backup work.

See Appendix 12 for an example of a media release.

Websites

An organization's Web presence is arguably its most significant promotional outlet. Available 365 days a year, 7 days a week, 24 hours a day, it can reflect an organization's message and image (as we've discussed), change quickly and frequently, and contain a variety of types of information for various customer needs. The most successful websites are not repositories for static information, they are dynamic entities, which offer frequently changing opportunities for interaction.

There are more platforms and formats available for website construction than can be discussed in detail here, but we list a few considerations should be a part of every design.

- **A good website should be a virtual organizational presence.**
 As we've discussed, a website is an organization's virtual place, one that has the potential for more visitors than the actual place. Therefore, it should reflect the same message and image as the organization's actual place, with the same attention to customer service.
- **A good website should be easily navigable.**
 Customers visiting the website should be able to easily find what they are looking for and to move throughout the site without having to constantly figure out where information might be located. This means that there should be multiple ways to get to the same place, and links throughout the site to other areas that are logically connected. For example, a customer who goes to the website to check on an upcoming exhibit should also see links to hours and directions. While navigating, the customer should not be taken to outside links that lead away from the organization's own site.
- **A good website should be interactive.**
 Websites are "pull" media, meaning that the user must be drawn in (as opposed to "push" media, which sends material to the user). Therefore, a successful organization will find ways to drive customers to the website and to encourage them to come back. A website is not only a form of promotion, it also needs to be promoted. To this end, mentions in other marketing can supply reasons for customers to visit the site. Web-only contests and sales promotions, polls, blogs, spaces for comment, and previews are some of the many ways that organizations create interactivity. Organizations with educational programs have also found success by using games and interactive children's content.
- **A good website should be dynamic and current.**
 Although some sections, like visitor information and history, will be static, sections on current programs must be be updated whenever necessary. There is nothing more offputting for a customer than taking the trouble to log on to a website and then seeing outdated information.

Social Media

As we discussed in chapter 13, social media isn't simply one more tool in the marketer's arsenal. The characteristics of social media are fundamentally different from those of broadcast media, and management must proceed with those characteristics in mind. The essence of social media is the consumer's ability to interact—to comment, review, ask questions, and pass information to others. Therefore, the most successful users of social media marketing are those who encourage that interaction by asking for customer input, facilitating sharing, posting fan content, and soliciting reviews.

The most successful social media marketers think of social media in the broadest sense and consider carefully how to involve patrons without violating privacy or copyright rules. Listed next are some of the ways social media marketing can move beyond a basic Facebook page:

- Posting videos of rehearsals, installations, and events on YouTube
- Asking patrons to post their own pictures of art on a museum's Flickr page
- Encouraging "collections" or previewing exhibits via Pinterest
- Tweeting limited-time promotions or discounts
- Maintaining blogs written by artistic directors, artists, board, volunteers. or staff
- Including an organization's social media in compilation sites like Stumble-Upon and Mashable

ADVERTISING

Advertising paying for space or time in a medium controlled by someone else. These days, advertisements appear not only in newspapers and magazines, on television and radio, but on Facebook, on websites, on signs . . . pretty much everywhere you look. Most people are aware that brand products used in television shows and movies are a form of advertisement, since the manufacturers have paid placement fees to secure this form of exposure.

As consumers, we have a love-hate relationship with advertising. It is ubiquitous, and we know we are being manipulated by it. We resent it for interrupting our favorite shows, yet we continue to purchase the products being advertised. Simply put, if advertising didn't work, we wouldn't see it anymore.

That being said, it's also true that advertising has changed a great deal since the advent of digital technology. Recently, marketing experts have been saying that mass market advertising, or the broadcasting of ads to many people at once, is losing effectiveness. Why? Because people have been inundated by so many ads that they either tune them out or turn them off. The response of the corporate world has been more and more aggressive advertising—ads that you can't click off before getting to the YouTube video, or ads repeated so many times that those who are actually paying attention become irritated.

For smaller organizations, one of the biggest turnoffs associated with advertising is its cost. Advertising works best when the message is repeated often—or at

least often enough for an adequate number of the target audience to see or hear it. Since many people automatically turn off advertising in their brains, it may take several exposures for them to notice the ad, much less to remember the message. This means that businesses must plan carefully in order to get the best bang for their buck.

If there are so many negatives associated with advertising, why should we consider it? The best reason is that with advertising, the organization controls the message completely and also controls the placement of the message. Because the message is controlled, it can be stronger than is possible with public relations, and repeated exposure can have a reinforcing effect.

Case 14-5

Case Study: Ad Composition

Common marketing wisdom holds that the eye of a person looking at print advertising tends to notice the picture first, then the headline, then (if the viewer is still interested), the copy. This means, however that the number of potential customers that make it to the copy is much smaller than the number of people who are exposed to the ad, and the number of people who are motivated to purchase is even smaller.

To test this principle, look at some ads for arts events on a newspaper page, in a magazine, or online. Can you find ads that successfully draw you in using a compelling picture or headline, and entice you to spend more time reading the copy? What are some of the characteristics of ads you feel are less successful? Even if not everyone is compelled to purchase the product after viewing the ad, are there ads that could be considered successful just because they drew attention to the product or organization?

SALES PROMOTION

Sales promotion refers to the act of temporarily manipulating the price or value of the product in order to encouraging a customer to purchase. Some common sales promotion techniques are discounts, coupons, rebates, free trials, contests, and giveaways.

Effective sales promotion assumes that customers need a reason to choose one brand over another and that when the promotion is over, they will continue to purchase the product. Sales promotions are an excellent way to get customers new to your brand to try a newly introduced product or to change behavior (e.g., upgrade a service or purchase quantities larger than they usually order).

Branded merchandise, including clothing, mugs, magnets, pens, and other items imprinted with a logo or message, are another popular sales promotion device. The advantage of branded merchandise is that it can also serve as a "walking advertisement" when the items are used in public.

Some arts organizations shy away from many kinds of sales promotions, believing that these commercial events lower the dignity of their artistic products and puts the promotion on the same level as a post-Thanksgiving sale at a discount

store. But there are several ways for not-for-profit organizations to use sales promotions effectively. The key to success is targeting carefully, providing promotions that appeal to your audiences, and following through to help ensure that those who participate will come again.

IN CONCLUSION

Marketing successfully involves careful planning and accurate communication to the most appropriate audiences. Organizations that think of marketing as "getting the word out" are definitely missing opportunities to connect with audiences; they also may be wasting time, money, and resources.

DISCUSSION QUESTIONS

1. Transferring a message from person to person in social media is not done solely by people outside the organization. How does an organization manage its message in the social media environment when several, perhaps many, people are updating Facebook or tweeting?
2. Often, performing arts centers, museums, and theaters use the building as a central part of their brand. What are the pros and cons of such an approach? How might it affect another organization using the same space?
3. Like public relations, advertising can be used both for image (branding) and for promotion of particular events. Many arts organizations prefer to concentrate their advertising budget on promotion of upcoming shows rather than running image ads over a longer period of time. Considering that repeated exposures are necessary to make an impression in the target's mind, it would seem to make sense for arts organizations to spend more time and money on image advertising. What are the pros and cons of this approach?
4. Some theaters are experimenting with setting aside sections where patrons can tweet or message during a performance—some in the back of the theater, some with special hoods over the seats in front to shield light—on the theory that this popular practice has the potential to increase excitement about what is happening on stage. What do you think?

CHAPTER 15

✧

Community Engagement

"It is from community that the arts developed, and it is serving
communities that the arts will thrive . . . communities do not
exist to serve the arts, the arts exist to serve communities."
—DOUG BORWICK, *BUILDING COMMUNITIES,
NOT AUDIENCES,* 2012

The idea that the arts can benefit individuals as well as groups of people
implies that mission-based not-for-profit arts organizations have more to
offer the communities they serve than mere entertainment. Many arts organiza-
tions have ongoing programs that connect to the civic, educational, social, and
political work of their communities. While these programs may contain educa-
tional components, the term "community engagement" is usually used in a
broader sense.

Another term, **community outreach**, was commonly used in the twentieth
century but is less popular today. "Outreach" implies that a magnanimous organi-
zation is reaching out to those less fortunate, and the community partner does not
have much to bring to the table. Today, more arts organizations are using the term
community engagement to paint a picture of dynamic partnerships between arts
organizations and community businesses, organizations, governmental agencies,
and individuals.

Examining community engagement means discussing the benefits that the
arts can bring to communities, as well as some of the challenges of looking at the
arts through the lens of community needs. Communities that understand the role
that the arts can play in the development of community identity, quality of life,
health, social needs, and the economy can use the arts and culture as a vital devel-
opmental tool. Arts organizations that understand the role that diversity and
community partnerships can play in the production and presentation of their pro-
gramming are able to create vital programming that provides great meaning to
individuals and communities.

After finishing this chapter, you should be able to:

- Understand what arts organizations mean by "community engagement"
- Describe the benefits of the arts to the civic and economic needs of the
 community
- Cite examples of community engagement in the arts

WHAT IS COMMUNITY ENGAGEMENT?

Community arts engagement is a broad field that encompasses several similar, but distinct, activities. At its core, the idea of community engagement breaks down the misconception that arts and culture are simply entertainment vehicles, to be patronized only by those who are specifically interested in them.

Arts organizations often say that the purpose of community engagement programs is to address specific community social or civic needs. These might include designing services and programs to underserved populations, like programs that allow community members to experience the arts free or at low cost and programs that make the resources of the organization accessible to community members.' Because engaging with the community is necessary to ensure that the organization is serving all of the community, not just those who can afford to pay, such engagement is often said to be at the very heart of an organization's charitable mission.

For many, community engagement is linked to social and political activism, arising from grassroots efforts to use the arts to bring attention to or encourage discussion around social issues. These efforts are predicated on the belief that artistic expressions reach people on a different emotional level than news stories and non-arts-related forms of civic activism.

Community engagement often involves artists and arts organizations partnering with community organizations, schools, business, governmental agencies, or all of the above. Engagement programs are different from community to community and from arts organization to arts organization. They are often developed with the community partners just listed, and they change over time according to the needs of the situation.

Engagement programs can certainly help an organization achieve its mission and serve the community. But engagement programs can be valuable to an arts organization for other reasons, as well. Engagement programs allow the organization and its partners to share resources and expertise, often enhancing what either group could do separately. They provide links to new audiences and help develop future audiences. They help the organization gain access to new volunteers, sponsors, and perhaps even future leaders.

Arts programs can also be valuable at bringing together diverse groups of people. In few other community settings do young and old, people of different ethnic backgrounds, and people of different socioeconomic groups come together as equals.

Most important, perhaps, engagement programs help integrate the arts into community life and go a long way toward erasing the misconception that arts are only for a select few. Working with community partners helps legitimize the organization in the eyes of potential supporters and underscores the value of the arts to the community.

CHALLENGES OF COMMUNITY ENGAGEMENT

True community engagement often involves thinking in unconventional ways about the nature of the art an organization makes, the marketing it does, and the way it interacts with its audiences. For some, the process can be uncomfortable,

as new partners and new audiences require changes to familiar ways of doing business.

Many in the arts industry have long thought that they were fulfilling charitable missions by merely providing new audiences with opportunities to be exposed to the fine arts. This viewpoint, unfortunately, reflects the assumption that the traditional fine arts such as symphonic music and ballet are, by their very nature, better than other forms of artistic expression and that no true artistic experience is possible unless it is selected and presented by people knowledgeable in the fine arts. This mindset also leads to fears that the organization will end up pandering to new audiences, seeking the lowest common denominator in the quest to appeal to audiences who are not "capable" of enjoying great art.

How do arts organizations open their doors to new audiences, new partners, and new ideas without losing artistic control or abandoning traditional audiences as they expand to embrace new ones? The answer may lie in the way we think about the nature of art. Doug Borwick, author of *Building Communities, Not Audiences: The Future of the Arts in the United States*, proposes that instead of thinking of art as high vs. low, or art vs. entertainment, we acknowledge that different kinds of art require different, but equally valid, responses.[1] Some art, Borwick says, is visceral, eliciting an immediate impact in a way that is entertaining and easy to absorb. Other art is reflective, requiring some education to understand and often eliciting a deeper response. The arts industry has divided these two kinds of art into different sectors; because the reflective art is considered culturally significant, it is almost exclusively in the not-for-profit realm, while visceral art is normally produced in the commercial sector. Of course, both sectors produce good art and bad art. Visceral art, if done well, can be of very high quality and can lure people to explore more reflective art. But if an organization goes into a community

Case 15-1

Case Study: Grand Rapids Art Prize

ArtPrize (www.artprize.org) is an open art show in Grand Rapids, Michigan. First conducted in 2009, the event is groundbreaking because anyone (not just "qualified" artists) can enter, any visitor over age 16 can vote, and any space in Grand Rapids can be a venue. As of 2012 there had been more than 4,500 artists in more than 500 venues; prize money awarded exceeded $1.5 million. The ability to vote online and by cellphone encourages people not only to vote but to track their favorite pieces in real time. As an experiment in the democratization of the arts, ArtPrize has accomplished its mission of decentralizing the top-down format of traditional art shows.

Some artists fear, however, that if the process for evaluating art is overly democratized, it will take the power out of the hands of people most qualified to pass judgment and that untrained eyes will inevitably choose work with less merit. Others, who believe that the line between "high" art and popular art is an artificial one, feel that involving more people in all aspects of artistic participation and creation is a good thing. What are your thoughts?

engagement partnership with the attitude of "We alone know what kinds of art will be suitable," then the partnership will miss an opportunity to be active, vital, and inclusive.

The idea of community engagement entails the acknowledgment that all partners contribute equally to the outcome. This mindset extends beyond the experience to the experience. Thus an organization working with tourism officials might find itself scheduling programs on days that are convenient to tourists, not just days that are convenient to artists or current audiences. Or, an organization working with diverse communities would come to the realization that programming must begin to represent more than white European art, and ticketing systems, signage, and customer service must be usable by those who don't speak English, as well as by those who rely on public transportation.

Some of the most exciting art being done today incorporates unusual partnerships, brings diverse communities together, uses technology in exciting ways, and allows a broad spectrum of the community to come to the art on their own terms.

COMMUNITY ARTS DEVELOPMENT

One of the distinct subfields of community engagement in the arts is community arts development. Community arts development in America arose in large part because of the work of Robert Gard, who received the first local arts development grant from the National Endowment for the Arts in 1966.[2] Gard promoted a philosophy that saw the arts developing from the grassroots up, according to the unique culture, population, location, and needs of each community. This fit with the mission of the National Endowment for the Arts, founded the preceding year, whose aim is to help ensure that all citizens, not just those in large cities, have access to the arts. As Mark Bauerlein puts it, "The Arts Endowment's mission was clear—to spread this artistic prosperity throughout the land, from the dense neighborhoods of our largest cities to the vast rural spaces, so that every citizen might enjoy America's great cultural legacy."[3]

ARTS IN THE SMALL COMMUNITY: A NATIONAL PLAN

Director's statement by Robert Gard

America is coming of age. Note the many changing aspects of America.

A maturing America means a nation conscious of its arts among all its people.

Communities east, west, north, and south are searching for ways to make community life more attractive. The arts are at the very center of community development in this time of change . . . change for the better.

The frontier and all that it once meant in economic development and in the sheer necessity of building a nation is being replaced by the frontier of the arts. In no other way can Americans so well express the core and blood of

(continued)

their democracy; for in the communities lies the final test of the acceptance of the arts as a necessity of everyday life.

In terms of American democracy, the arts are for everyone. They are not reserved for the wealthy, or for the well-endowed museum, the gallery, or the ever-subsidized regional professional theatre. As America emerges into a different understanding of her strength, it becomes clear that her strength is in the people and in the places where the people live. The people, if shown the way, can create art in and of themselves.

The springs of the American spirit are at the grass roots. Opportunities must exist in places where they never have existed before. A consciousness of the people, a knowledge of their power to generate and nourish art, and a provision of ways in which they may do so are essential for our time.

If we are seeking in America, let it be a seeking for the reality of democracy in art. Let art begin at home, and let it spread through the children and their parents, and through the schools, the institutions, and through government. And let us start by acceptance, not negation—acceptance that the arts are important everywhere, and that they can exist and flourish in small places as well as in large; with money, or without, according to the will of the people. Let us put firmly and permanently aside as a cliché of an expired moment in time that art is a frill. Let us accept the goodness of art where we are now, and expand its worth in the places where people live.

This statement was originally published in *Arts in the Small Community: A National Plan* in 1969. It is now a part of the revised version, *Arts in the Small Community 2006*, by Maryo Gard Ewell and Michael Warlum, © 2006 and available on the Gard Foundation website, http://www.gardfoundation.org/windmillprojects.html. Reprinted with permission.

Robert Gard's plan for arts in small communities involved the creation of arts councils, local arts organizations having as their mission and function supporting of the collection, creation, and presentation of art in each community. Because artistic needs and output were different in each community, each of these arts councils would function differently, responding to local needs. Thus, in one community, an arts council might give grants to arts organizations; in another, it might host round tables or forums where artists can connect with one another.

Because Gard's philosophy rested on the premise that the arts manifest themselves differently in each community, community arts development soon began to embody the idea that local arts represent not just the needs of the artists, but the needs of the communities themselves. And therefore, the opposite may be true as well: if the arts are uniquely poised to reflect the culture and heritage of the communities they serve, then perhaps communities will look to arts and culture to address some of their social and civic needs.

In recent years, other scholars have also cited the potential of arts and culture to be a tool for coping with community issues, bringing people together, and creating

pride and cultural identity. Robert Putnam, author of *Bowling Alone,* has documented the decline in civic engagement via other forms of activity that once were used to measure social capital: that is, the accumulation of connectedness and involvement exhibited by citizens. According to Putnam, more citizens today participate in the arts than participate in civic organizations like Jaycees and Optimists, attend religious services regularly, or vote.[4] If the arts engage such a large cross section of the community, argues Putnam, then perhaps arts and cultural activities can be employed more deliberately to create the social connections that formerly were developed via other means.

The importance of the arts to community development has been recognized not only by scholars, but also by governmental agencies and those directly involved in community and economic development. In 2012 the U.S. Conference of Mayors passed several resolutions affirming the role of arts and culture in vibrant cities and towns:

- To deliver high-quality arts instruction and to integrate the arts with other core subjects;
- To invest in nonprofit arts organizations through their local arts agencies as a catalyst to generate economic impact, stimulate business development, spur urban renewal, attract tourists and area residents to community activities, and to improve the overall quality of life in America's cities;
- To attract and serve additional visitors attracted by the "uniquely American" and "authentic" strength of the cultural arts;
- To urge local businesses and arts organizations to collaborate more together to demonstrate how arts partnerships help businesses enhance the critical thinking and creative skills of their workforce.[5]

The National Governors' Association also supports the role that the arts play in community development, saying that arts and culture can serve communities in a variety of direct and indirect ways, assisting state and local governments in:

- Leveraging human capital and cultural resources to generate economic vitality in under-performing regions through tourism, crafts, and cultural attractions;
- Restoring and revitalizing communities by serving as a centerpiece for downtown redevelopment and cultural renewal;
- Creating vibrant public spaces integrated with natural amenities, resulting in improved urban quality of life, expanded business and tax revenue base, and positive regional and community image; and
- Contributing to a region's 'innovation habitat' by simultaneously improving regional quality of life—making communities more attractive to highly desirable, knowledge-based employees—and permitting new forms of knowledge-intensive production to flourish.[6]

Acknowledging the value of the arts in communities means also acknowledging that delivering these benefits to communities is likely to involve partners

in the public, private, and philanthropic sectors. It may mean funding and support for the arts from new sources, the creation of vital partnerships, and the development of new audiences; but it also may mean that traditional arts organizations are no longer the only entities making cultural decisions or delivering the arts in their communities. Such changes, in turn, will oblige many arts organizations to examine their missions and programming goals in light of community needs.

SOCIAL AND CIVIC BENEFITS OF ARTS AND CULTURE

Revitalization

The small Massachusetts city of North Adams is often cited as an example of successful community arts development. In the film *Downside Up: How Art Can Change the Spirit of a Place*, filmmaker Nancy Kelly chronicles the transformation of her hometown from a case study in industrial decay to a growing and vital community, thanks to the repurposing of an empty capacitor factory into the Massachusetts Museum of Contemporary Art (MASS MoCA).[7]

MASS MoCA, which opened in 1999, sits on a 13-acre site that had housed manufacturing and industrial business since the eighteenth century. It was most recently home to the Sprague Electric Company (which closed in 1985) and uses much of the Sprague infrastructure. The closing of Sprague Electric caused the community to go into a decade-long decline that affected other downtown businesses, housing, and even tourism. The creation of a museum of contemporary art, which seemed counterintuitive for this small, blue-collar community, led to the influx of over 120,000 visitors per year, new businesses including high-tech companies and restaurants, and a new community identity.[8]

One of the buildings in the MASS MoCA complex currently houses the Center for Creative Community Development, a research offshoot of nearby Williams College. The center's mission is to "serve as a national focal point for research, education and training on the role of the arts in community development."[9] Research conducted by the Williams College economics faculty soon after the opening of MASS MoCA showed that the museum had a significant economic impact not just on the arts and cultural sector, but on housing, retail, and services businesses in the community. The data led the author of a 2004 report published by Williams to conclude that the arts are uniquely positioned to benefit not just those who participate in the industry, but other citizens as well.[10]

North Adams is certainly one of the most dramatic examples of community arts development in recent years, but it is far from the only one. Other communities have experimented with public art, murals, streetscaping, and adaptive reuse of buildings to revitalize communities.

Promoting Community Identity

Arts and culture are part of the image to the world of many communities. Some of the most well known include:

- New Orleans (Mardi Gras, Cajun and Creole food, the French Quarter, jazz)
- Hollywood (the film industry)
- Nashville (country music)
- Paris (painting, fashion, cooking)
- London (theater and literature; especially Shakespeare and the Globe)
- Chicago (architecture)

The development of a community's cultural identity is wrapped up in its history, its geography, and the people who make up its population. New Orleans, the port through which passed African slaves and Caribbean rum, developed a lively mix of African American, Creole, tribal, and European customs that led to the hybrid culture we see there today. Chicago's reputation for architecture has a lot to do with the rebuilding necessitated by the Great Fire of 1871. London owes its reputation for fine theater to a combination of happy circumstances: a few outstanding playwrights, a queen who loved plays, and the invention, during Shakespeare's time, of the modern box office.

But a community identity based on arts and culture is not confined to large cities. Smaller communities as diverse as Berea, Kentucky, and Door County, Wisconsin, have branded themselves on the cultural traditions that are unique to their areas. Communities that have experienced trauma and find the need to bring citizens together or to market a new image to the world have often turned to arts and culture to facilitate change.

Communities seeking to use the arts to enhance identity are most successful when that identity comes from the **authentic** expressions of its citizens. The discovery of what makes each community unique and authentic is sometimes called developing a **sense of place**. Authentic places contrast with places that are inauthentic, or lack a unique culture: for example, big-box chain stores, shopping malls with the same stores as malls in other locations, and fast-food restaurants. To develop authenticity, communities must ask themselves what unique history, customs, and traditions shape their culture, what geographical, physical features, or built environments stand out, and what values and beliefs the citizens hold.

Enhancing Quality of Life and Place

For communities wishing to attract and retain residents and businesses, enhancing the quality of life is paramount. The term **quality of life** refers to the well-being of individuals and society; it encompasses such factors as health, safety, and access to employment, housing and education, human rights, and recreation. Communities wishing to improve quality of life for their citizens must improve **quality of place**.

Creating that quality of place goes far beyond building roads and bridges. As Tom Borrup puts it, "What makes a community work, in every respect, is its culture and its governance—the shared understandings and expectations that people have of themselves, each other, and their collective endeavors."[11] In other words, the roads and bridges and hospitals need to be a part of a community, but arts and

Case 15-2

Case Study: Paducah, Kentucky

The city of Paducah, Kentucky, experienced a dramatic turnaround in quality of place as a result of a unique arts-focused effort in a declining area near downtown. Paducah, a community of 30,000, had seen inner-belt decay in the last two decades of the twentieth century and was dealing with the social effects of deteriorating buildings, absentee landlords, and a mobile population.

In 2000 Paducah developed the Artist Relocation Program, offering incentives to artists to purchase and renovate properties in the neighborhood known as Lowertown. The incentive package included such creative features as full financing, professional design services, marketing, moving expenses, and rehab assistance. As of 2012, more than a hundred artists lived and worked in Lowertown, investing in the community and transforming it into a thriving neighborhood of galleries, shops, and cafes.

More information can be found at http://www.paducahalliance.org/.

culture are what make people want to stay there, raise their children there, and contribute to the community's success.

The Arts in Healing and Trauma

The arts can be a significant factor in individual and community healing in times of trauma. For example, arts therapies can be effectively used for young children, abuse victims, and other patients who are unable to articulate their experiences. As we learned in chapter 12, when used for positive self-expression, the arts can be an important part of the personal development of people of all ages.

The arts can also be a powerful force for healing in communities. The arts provide a way for people to mourn together, to remember victims, and to help make sense of tragedy. Some of the ways arts and culture are used in the healing process include:

- **Documentation of events**
 Photographs, videos, and stories can be used to document events for historical purposes. Many people do not realize that historians and artists are often involved in the collection of artifacts from a tragedy, the documentation of human reaction, or even the curation of impromptu memorials and flower walls.
- **Expression of mourning**
 For millennia, humans have used song, dance, and story to express their grief. Today in times of mourning, we sing in religious and patriotic ceremonies, write and share stories and poems, and listen to the expressions of others.
- **Memorializing the dead**
 Visiting such memorials such as sculptures, parks, and public gardens is a concrete way for people to pay respects to victims of tragedy.

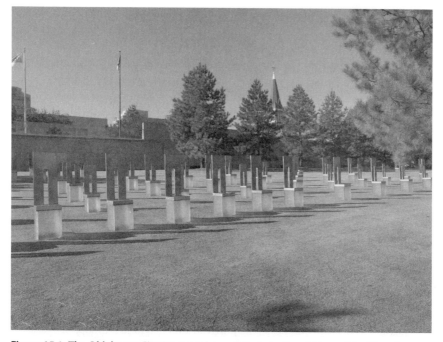

Figure 15.1 The Oklahoma City Memorial pays tribute to the victims of the Murrah Federal Building bombing.

ARTS IN THE ECONOMY

The Economic Impact of the Arts

If you ever tried to convince your parents that you wouldn't starve if you went into music or painting, you know that the arts are often not taken seriously as an industry. Many people think of the arts as an endeavor that primarily caters to hobbyists and doesn't affect the economy as a whole. Because this stereotype often leads to cuts in school arts programs and decreases in support for the arts by government, foundations, and other funders, the arts industry has in recent years collected a great deal of data to show the positive effects of the arts on economic development. Since 1996, Americans for the Arts has done four national economic impact studies, showing a growing and vital industry that contributes to economies, creates jobs, and returns revenues to local, state, and federal governments in the form of taxes and fees.

The 2012 Arts and Economic Prosperity study, like others before it, measured spending by not-for-profit organizations and audiences, full-time equivalent jobs, and tax revenue generated. Nationally, the industry generated $135.2 billion of economic activity—$61.1 billion by the nation's nonprofit arts and culture organizations in addition to $74.1 billion in event-related expenditures by their audiences. The arts industry also generates $22.3 billion in revenue to local, state, and federal governments every year—a yield well beyond the collective $4 billion in arts allocations from government to the arts.[12]

It's important to remember that the Arts and Economic Prosperity studies measured not-for-profit arts activity only—a small portion of the nation's total arts and cultural output, which also includes the commercial arts (film, recorded music, touring Broadway shows, publishing, private sales of art), public sector arts (school music, theater, and art programs; local, state, and federal governmental venues such as museums and performing arts centers) and of course hobbyists, who patronize businesses from music stores to craft stores to the tune of billions per year. As of the year 2000, the combined cultural industries were responsible for 5.68% of the U.S. gross domestic product, generating $443.9 billion in annual revenues, and were our country's largest export, with $60 billion annually in overseas sales.[13]

Although the numbers are impressive, and have been used nationally and within specific communities to underscore the importance of supporting arts and culture, many arts supporters argue that it is risky to rely too heavily on economic data alone to define the value of the arts. Without also emphasizing the intrinsic value of the arts and culture to transform individuals and communities, the industry runs the risk of being judged solely on the numbers, a narrow perspective that ignores what many argue are more important values of the arts. The arts industry, some say, was forced into making these arguments because decision makers disregarded proposals for supporting the arts unless the arts were linked to the broader social issues that sit further up on the public agenda.[14] These arts supporters advocate for using the economic impact studies as a tool to introduce the intrinsic values of the arts, such as personal transformation, appreciation of beauty, and intellectual stimulation.

The New Economy

Since the 1980s, economists have been describing changes to the economy that are a result of the transition from an emphasis on manufacturing toward an economy that takes advantage of technology, information, and global resources. Sometimes known as the **knowledge economy** or the information economy, the so-called **new economy** is defined differently by different economists, and in fact is still developing as technology changes. Some of the principles of the new economy include the following.

- **Reliance on a global economy and global resources**
 In a world of instant communication, companies can search for the most cost-effective ways to do business, which may include manufacturing some parts of a product in China and others in the United States, taking customer service calls in India, and making corporate decisions in Atlanta.
- **Higher value on ideas than products**
 The technology, software, and innovative effort that go into the creation of a project are now more valuable to investors than the product itself.
- **More intangible products**
 The economy is increasingly driven by the sales of items you can't hold in your hand—things like e-book and music downloads, Facebook ads, and iPhone apps.

- **Lower infrastructure costs = more free stuff**
 The move toward intangible products has also encouraged businesses to offer some products at no charge. Think, for example, of a Google search. The infrastructure that Google needs to support the search engine—essentially broadband capacity and software—is now so inexpensive to the company that it is virtually free. Google makes its money by selling ads and premium services.
- **Jobs are different.**
 Fewer people are involved in the direct creation, production, and distribution of goods, and more people are involved in managing information.

Why are we talking about the new economy in a book about arts management? Because arts and culture are poised to take a leading role in the new economy. **Creative industries**, including the arts, design, architecture, publishing, software development, and video production, are emerging as a dominant employment sector. People employed in the creative industries not only use the arts as a part of their jobs, they also consume the arts at high levels.

Richard Florida, in his book *The Rise of the Creative Class*, defines the creative class as people whose jobs involve independent or imaginative decision making.[15] In addition to the jobs listed earlier, which are normally classified with the creative industries, Florida puts professions such as education, law, medicine, science, and engineering into the creative class. These jobs all share certain characteristics: they require a high degree of education and specialization; they reward creativity and innovation; the workers often set their own hours and work conditions; and job satisfaction is a high priority.

Florida says that the number of creative-class jobs currently represents more than 30% of the adult workers in the United States, but nearly 50% of wages paid. The high earning potential of the creative class is attractive, but not everyone is eligible for those salaries. Jobs in manufacturing, which formerly allowed workers without a specialized education to support a family, are being replaced by jobs requiring very different skill sets and, often, advanced degrees. Creative-class workers also differ from production workers in that they often choose their community first and then find a job, and they base their location decisions on the presence of amenities such as restaurants, shopping, arts, and culture.

Florida's economic theories have been criticized by some for being too simplistic and by others for being elitist. For many communities, however, the emergence of the creative class as an economic factor has caused significant changes in the way businesses are attracted and supported and jobs are created. Some communities are rethinking the practice of offering tax incentives and infrastructure to corporations and instead are supporting the technological and cultural amenities that are needed to attract creative-class businesses.

The foregoing trends are important to arts and cultural organizations in a variety of ways. First, if creative-class workers require arts and culture where they live, then it is incumbent upon communities that want to attract creative

businesses to support the cultural attractions, which have strong appeal to the creative class. Second, if creative-class jobs are dependent on innovation, creativity, and specialized education, the arts should have an important part of delivering those skills.

Cultural Tourism

"We need to think about cultural tourism because really there is no other kind of tourism. It's what tourism is. . . . People don't come to America for our airports, people don't come to America for our hotels, or the recreation facilities. . . . They come for our culture: high culture, low culture, middle culture, right, left, real or imagined—they come here to see America."

—Garrison Keillor, to the 1995 White House
Conference on Travel and Tourism

Cultural tourism is defined as traveling to gain cultural experiences ranging from visiting museums and witnessing performing arts activities to absorbing the unique and authentic historical, geographical, and heritage features of a location. When the activities focus on history or ethnic culture, we often speak of **heritage tourism**. The National Trust for Historic Preservation uses the term "cultural heritage tourism," defining it as "traveling to experience the places and activities that authentically represent the stories and people of the past and present. It includes historic, cultural and natural resources."[16]

Cultural and heritage tourism offer opportunities for local tourism councils to attract visitors based on some of the unique and authentic features that have made their communities special. These forms of tourism take advantage of trends in the industry toward seeking authentic experiences (as opposed to mere "getaways"), active vacationing, and specialty vacationing. Online resources make it possible for even small communities to promote tourism. When properly managed, cultural tourism allows communities to diversify their economies while supporting that which makes their community special. Cultural tourists spend more than other tourists, are more likely to stay longer, and tend to spend more money in the community than residents who attend the same events and visit the same attractions.

However, cultural tourism also brings challenges to communities. While it is considered a "green" industry, creating jobs without pollution or consumption of natural resources, success in cultural tourism may result in degradation of the sites that are being visited, as well as strains on local infrastructure, police and fire systems, and such service businesses as hotels and restaurants. Because of the influx of visitors, cultural organizations themselves can be overwhelmed; especially vulnerable are those that are underfunded and those that rely on volunteers for staffing. A well-managed cultural tourism program involves collaboration among many community partners, ensuring that all who are contributing to the tourism effort have the help and support they need.

PUBLIC ART

Public art is art of any medium that is located or performed in a public space. The adjective, which implies that the artwork is accessible to the general public, also may indicate that it was paid for, in part or in full, by taxpayer dollars. The Americans for the Arts' Public Art Network site[17] indicates that in 2009 there were more than 350 public art programs in the United States today, 81% of them housed within gov-ernmental agencies. Other public art programs are managed by independent not-for-profit organizations (often in a public/private partnership), colleges and universities, and museums.

When most people think of public art, they think of sculptures and memorials that for centuries have formed the bulk of this form of art. In recent years, however, artists and communities have been stretching the definition of public art to include temporary exhibits, interactive works, live performances, and unusual materials and locations. For many, the idea of siting the work in the public domain increases the opportunity for the work to be democratic (i.e., chosen with public input) and interactive.

Public art creates meaning for a community by beautifying an area, creating character, reflecting community history and values, and helping define public spaces. Some public art becomes a landmark, symbolic of a community or even a nation; the Statue of Liberty is a notable example. Public art can also express the unique character of neighborhoods, increase pride, and decrease vandalism. It can bring artists and communities together, increasing appreciation of the arts. For

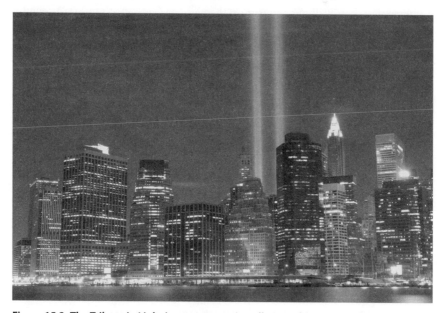

Figure 15.2 The Tribute in Light is a temporary installation of 88 searchlights produced annually at the site of the fallen World Trade Center.

Case 15-3

Case Study: Mural Arts Program

Philadelphia's Mural Arts Program was founded in 1984 in an effort to enhance the city aesthetically by replacing tasteless graffiti with other colorful, imaginative artwork. The city hired muralist Jane Golden, who reached out to graffiti artists in an attempt to persuade them to turn their energy and talents to constructive mural painting.

In 30 years, Mural Arts has grown into one of the largest public art programs in the world. Local artists have produced more than 3,000 murals, earning Philadelphia praise as the "City of Murals." The program serves more than 1,500 at-risk youth annually in arts education programs and is successfully using arts in prisons and rehabilitation centers to help in the task of breaking the cycle of crime and violence.

many communities, public art offers the economic benefit of attracting tourists and residents to the area in which it's displayed.

Because the art is in the public realm, it is often accompanied by controversy from those who object for some reason to an individual piece of art. Many famous public art works, including the Eiffel Tower, the Gateway Arch, and the Vietnam Veterans Memorial, were controversial when installed and only later became beloved landmarks. One famous controversy erupted in 1981 when *Tilted Arc*, a large steel sculpture by Richard Serra, was installed in New York City's Federal Plaza. People who worked in Lower Manhattan objected to the sculpture because it interrupted their walking patterns on the plaza and attracted graffiti. A lengthy struggle ensued, generating a great deal of conversation on the role of art in public spaces and whether the public should have input into placement works of art they must encounter in their everyday lives. The sculpture was destroyed in 1989.

Communities also find that the cost of a public art program includes not only the installation of works but their maintenance. The best public art programs include plans not only for artistic development, but for maintenance and replacement if necessary.

TEN CHARACTERISTICS OF A HEALTHY COMMUNITY

In July 2001, Americans for the Arts and the National Assembly of State Arts Agencies held a joint conference during which participants developed ten characteristics of livable communities in which the arts play a vital role:

- The arts bring together diverse people.
- Elected officials understand the importance of supporting the arts and do so.
- The arts are valued as a critical component of learning for all.
- Participation in culture creates individual and community meaning.
- Business/corporate citizens recognize that the arts are important to a healthy business environment, and support the arts in diverse ways.
- The arts are infused into the natural and built environments.

- The arts are integral to civic dialogue and community building.
- The arts are valued as an industry because of their contributions to the economy.
- The contributions of individual artists are valued and supported.
- The arts flourish with new and diverse leadership informed by those who paved the way for them.[i]

Think about how these characteristics might be manifested in communities, and how citizens can evaluate them. For example, a community might value the contributions of individual artists by providing access to group health care for self-employed artists, supporting arts incubators or low-cost studio space, or hiring local artists to perform for concerts in the park. How can community residents know if their elected officials or local businesses support the arts?

[i]Walker, Mara, and Boyer, Johanna Misey. Ten Characteristics of a Healthy Community: How the ArtsCan Be Integrated. Washington DC: Americans for the Arts, 2001. Used by permission. http://www .americansforthearts.org/NAPD/files/11611/Ten Characteristics of a Healthy Community (June '02).pdf

IN CONCLUSION

The arts can bring many benefits to communities besides entertainment. An organization that considers engagement to be a vital part of its program can play a major role in the cultural identity of its community while enhancing the lives of residents and visitors alike.

DISCUSSION QUESTIONS

1. Some arts organizations suspect that if they comply with requests to create arts programs for the benefit of communities, they will not be in control of their own missions and artistic decisions. What do you think?
2. MASS MoCA is often cited as an example of successful community arts development . . . yet a museum of contemporary art is anything but an intuitive fit for a small working-class community. Why has MASS MoCA been successful? Do you think it's authentic to the community? If so, how?
3. Have you seen examples of arts organizations partnering with other kinds of organizations in your community? What programs have been successful? Why do you think this is so?

CHAPTER 16

ᛉ

Advocating for the Arts

"While no government can call a great artist or scholar into
existence, it is necessary and appropriate for the Federal
Government to help create and sustain not only a climate
encouraging freedom of thought, imagination and inquiry;
but also the material conditions facilitating the release of this
creative talent."

—President Lyndon B. Johnson, Upon Signing
the National Foundation on Arts
and Humanities Act of 1965

Governments around the world have traditionally played a large role in the
creation, presenting, and conservation of the arts. Because governments
understand that the arts help define societies and civilizations, most governments
support the arts in some form.

In America, as elsewhere, there is ongoing debate about the role of govern-
ment in arts support. At issue is how much support there should be, which orga-
nizations or types of art government should support, and what mechanisms should
be used. Today, those guiding arts organizations understand that educating the
general public and elected officials about the needs of artists and arts organiza-
tions should be a part of our everyday activities.

After finishing this chapter, you should be able to:

- Understand the different ways that government is involved in arts support,
 and how federal, state, and local governments have supported the arts in
 America
- Describe the three types of advocacy and state how arts organizations can
 integrate them into ongoing activities
- Create a plan for making effective contact with elected officials

GOVERNMENT AND THE ARTS

As we learned in chapter 1, most established governments throughout history and
across cultures have supported the arts in some way. Governments from ancient
Rome to modern times have realized that art and culture are among the hallmarks

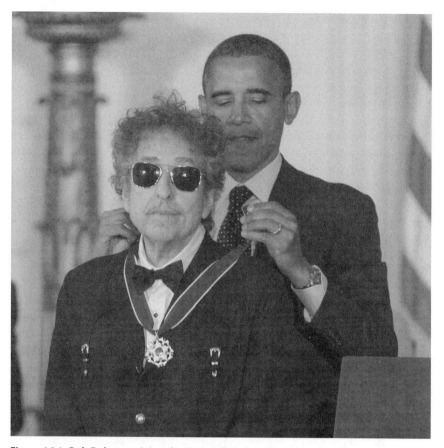

Figure 16.1 Bob Dylan receiving the National Medal of Arts from President Barack Obama, February 25, 2010. © Owen Sweeney/Rex Features.

of great civilizations, so they have created institutions to archive the artistic legacy of their society and have supported the creation of new art by their citizens.

For many governments, support of the arts is support of the polity's civilization and cultural traditions. Preserving national (or community) treasures, collecting outstanding works of art, saving cultural traditions and historical artifacts, and providing support for recognized artists is a good way to help develop or maintain a cultural identity. In the United States, government-owned and -operated museums, monuments, and historical sites are the most common forms of support for arts and culture at both the federal and local levels. Governments also may preserve treasures in other ways, such as conserving historical artifacts, collecting the work of a particular artist, or honoring achievements in the arts.

In a modern democracy, one of the purposes of government is to help ensure that all citizens have equal access to the benefits and privileges of society. Therefore, democratic government supports the arts by, among other things, helping provide access to the arts for children, those who cannot afford to pay, and other

underserved audiences. Some governments operate museums or performing organizations that can then offer free or low-cost admission; others give grants to organizations to enable them to serve more audiences.

In the previous chapter, we discussed some of the benefits the arts can bring to communities, including benefits to tourism, the economy, and the image of the community. Today, governments are beginning to understand that support of the arts can be an important factor in dealing with social and civic needs. Creating attractive parks with public art, designing community focal points and gathering spots, supporting community festivals and venues that attract tourists, providing positive activities for youth, and funding the kind of arts activities that attract knowledge workers are some of the ways that today's local governments are assisting the arts.

Governmental support for the arts can extend beyond supporting cultural heritage and providing access. Many believe that one of the things government can and should do is to provide ways for its citizens to achieve a satisfactory quality of life. Support of such things as libraries, senior and youth centers, parks, and hiking and riding trails falls into this category, and so do the arts.

In addition, one of the primary roles of any government is the formation of **cultural policy**, or the overall philosophies with which the nation, state, or region will operate with regard to the development and maintenance of culture. Cultural policy can incorporate such areas as **intellectual property** and copyright, exporting cultural products, protection and preservation of cultural treasures, preservation of languages and existing examples of lost art forms, and defining what activities will be supported by government funds.

ARTS IN THE UNITED STATES

From the founding of this country, the United States has had somewhat of a love-hate relationship with the arts. Many leaders in the new country believed that the prompt establishment of a cultural presence would legitimize the new country in the eyes of the world. Others thought that the fledgling country had more important things to tend to than establishing museums and erecting imposing architecture. This duality has translated over the years into a system for supporting the arts in America that is unlike those found in many other countries.

Many other countries around the world have maintained traditions of funding the arts at a much higher level than is seen in the United States. In Italy at the start of the twenty-first century, for example, the government **subsidy** for opera houses alone was ten times larger than the entire budget for the National Endowment for the Arts in America.[1] Funding at this level has given arts organizations a high degree of stability, and some countries are able to offer museums and other venues to the public at very low cost or at no charge at all. Critics of such heavy arts subsidies point out that government funding can be highly political and can vary with different people in power. Often governmental arts funding elicits the fear that those who control the funding may also ask for artistic input. Economic realities have in recent years caused cuts to the arts budgets of many countries,

however, and some countries have begun to rely more on private donations, corporate sponsorships, and other sources of funding that have been common in America for many years.

Support for arts and culture in America has grown slowly. Although a national cultural commission was proposed as early as 1826, federal support for the arts for many years was largely limited to support for national venues like the Smithsonian Institution and the Library of Congress.[2] In 1965 President Lyndon B. Johnson signed the National Foundation on Arts and Humanities Act, which created the National Endowment for the Arts and the National Endowment for the Humanities. Both agencies provide direct grants to arts organizations across the country; in addition, both conduct research, offer awards, and establish special initiatives to encourage public participation in the arts. Other agencies, including the Corporation for Public Broadcasting, the Institute of Museum and Library Services, and the Department of the Interior, provide funding for arts and cultural organizations and programs, as well.

Even though the percentage of arts organization funding that comes from government sources is small, most arts organizations have access to funding not only at the federal level, but at state and local levels as well. The National Endowment for the Arts was designed as a decentralized system. This setup allows a number of decisions to be made at the local level where, it can be argued, it is easier to find the organizations that are of the most value to the communities they serve. A portion of the NEA's budget is given directly to state arts agencies and regional arts service organizations. From there, state and regional agencies match the federal dollars with state funds, creating a bigger pool of support. Many states also pass some of their funds to local arts agencies, where it will be matched with local funds. Although more complex than the European norm, the decentralized system allows local organizations to compete for funds more effectively than would be possible if they were in a large pool with organizations from around the country. Moreover, arts organizations get more support than might have been available from local governments alone.

In addition to direct funding, the American system provides for a number of **indirect subsidies**, which offer financial benefits to arts organizations and incentives for Americans to support the arts. One of these benefits is tax-exempt status for not-for-profit arts organizations, which has been discussed in other chapters. Another is the introduction of a means of encouraging people to donate to charitable organizations by offering the opportunity to claim tax deductions on declared gifts.

While there are many who believe that the government at all levels can and should be doing more to support the arts, it's also necessary to understand that even the current levels of government support for the arts, like other items in federal, state, and local budgets, are subject to change at any time. Faced with tough choices over the past twenty years, many budgeting authorities at all levels of government have put arts and arts education programs on the chopping block. Funding for the National Endowment for the Arts and the Corporation for Public Broadcasting, in particular, have been targeted for funding cuts and even elimination many times in

recent years because some federal lawmakers have objected to what they perceive as inappropriate programming by these agencies.[3]

More and more organizations are coming to believe that working to increase and stabilize governmental arts support is as important to the future of their organization as fundraising or marketing. They are beginning to talk with government officials, educate people, and create materials that support their position that government should support the arts This activity is called **advocacy**.

ADVOCACY

"To encourage literature and the arts is a duty which every good citizen owes his country."

—George Washington

Advocacy is the act of speaking, writing, or acting in support of something or someone. Many industries and interests, including the arts, realize the benefits of actively promoting their needs to elected officials as well as to the public at large. Advocacy is an important way for citizens to be a part of the political process and to ensure that their voices are heard in the court of public opinion.

Some of the activities commonly included under the umbrella of advocacy include promoting the benefits of a cause, getting information about the cause to constituents and the public, and working with elected officials and political candidates. Providing information to elected officials about the benefits and needs of an industry, for example, can help ensure that, when the time comes to establish policies, vote on bills in committee, or pass laws, elected officials will have enough information to act in a way that supports the industry.

Although it's common to think of advocacy as primarily a political activity, advocacy for the arts, like advocacy for the environment or for health care, is about much more than politics. Arts advocacy is necessary to ensure that the public understands the value of the arts in communities and in the lives of individuals. In a democracy, the people's concerns are ultimately what make the difference in public policy. Arts leaders are aware that the decreases in funding over the past twenty years have been about more than money; they are a referendum on the role of the arts in society. The fact is, nobody would have seriously considered proposals to cut school music budgets or eliminate federal arts funding if people hadn't been hearing for so many years that the arts were a luxury, that we should be devoting more effort on teaching "core" subjects like math and science, and that if individual artists and arts organizations were worthy, they would succeed in the marketplace "like any other business." Statements like these, which show a fundamental misunderstanding of the arts industry, led to the conditions that made marginalization possible and advocacy necessary.

Advocacy for arts, culture, and arts education has become more visible and sophisticated than it was twenty years ago. Numerous resources exist to provide up-to-date information, accurate research about the value of the arts, and assistance for local

organizations. It is possible now for even small organizations and individual supporters of the arts to be effective arts advocates.

BE AN ARTS ADVOCATE!

How would you answer someone who expressed these opinions?

- "It's more important for students to spend time on math and science than the arts."
- "The arts are only for those who choose to attend to them. Let those who want the arts support them."
- "If we provide government support for the arts, we are simply encouraging bad artists and unworthy art. If art is good, people will support it."
- "The arts are often about objectionable subjects and support lifestyles I don't believe in. I don't want my tax dollars supporting that."
- "We have more important things to worry about. When we are at war and the economy is bad, we can't waste money on the arts."

The three major types of advocacy are personal advocacy, public advocacy, and legislative advocacy. All are necessary in order to effect change and promote positive attitudes toward the arts.

Personal Advocacy

Personal advocacy consists of influencing individuals on a one-to-one basis. Personal advocacy can be as simple as talking with friends or as structured as scheduling a meeting with the president of the chamber of commerce to discuss the benefits of the arts.

Personal advocacy is the most powerful form of advocacy, as you know if you've ever purchased a product or become involved in an organization on the recommendation of a friend. Most advertisers take advantage of personal advocacy when they use word-of-mouth campaigns and actively encourage their customers to be missionaries for the product.[4] Advertisers push sales of T-shirts and other gear with the company logo and offer a discount to anyone who induces a friend to purchase. Personal advocacy is no different: it assumes that people will be more likely to support a cause when information about it comes from someone they trust.

When an arts organization engages in personal advocacy, it actively encourages its board members, staff, volunteers, and supporters to inform others about the benefits of the organization. This means that these people need to be thoroughly and adequately informed about current issues that face the organization and the solutions the organization has decided are appropriate. The advantages of personal advocacy are diminished when someone in the community asks a question that a volunteer can't answer, or a board member expresses an opinion that is at odds with the official position of the organization.

Personal advocacy can happen any time the organization's supporters are interacting with family, friends, business colleagues, or community leaders. However, it can also be structured. Here are some activities that arts organizations have used to practice personal advocacy:

- Speaking to civic groups, perhaps with the aid of a prepared slide or video presentation
- Nurturing relationships with civic leaders
- Volunteering for community committees and task forces to bring the arts viewpoint to the table
- Including civic leaders, educators, and other influential people on mailing lists
- Inviting the same influential people to opening nights and press conferences
- Preparing "talking points" that board, staff, and volunteers can use
- Encouraging board, staff, and volunteers to share good news about the arts and the organization with their friends, colleagues, and associates

Public Advocacy

Public advocacy is very much like personal advocacy, but on a broader scale. Public and personal advocacy share the same goal: to change the minds of individuals by giving them information and helping them form a positive opinion. However, public advocacy attempts to reach more people simultaneously than is possible with personal advocacy.

In many ways, public advocacy is very similar to **public relations**.[5] Public advocacy involves attempts to create a positive image for the industry, cause, or organization in the public eye. Techniques used are similar to public relations; public advocacy campaigns can include disseminating information via newsletters, websites, and **public service advertising**.

Television advertising is a popular way to conduct public advocacy because of its influence and the number of people who have the potential to see the information. If you've watched a celebrity talk about bullying or prejudice, or heard a voiceover announcer tell you to "call your congressman" about a particular issue, then you are familiar with public advocacy. Social media has also provided an increasingly popular forum for sharing advocacy materials. The use of social media gives organizations an opportunity to reach further than its own resources permit, by allowing supporters to share with their friends and networks, and encouraging discussion and interaction.

Public advocacy can be done by the individual arts organization; often, it is undertaken by state and national service organizations on behalf of the arts. Many organizations, including Americans for the Arts and the Arts Education Partnership conduct public advocacy campaigns themselves and also provide advocacy resources to individuals and organizations.

Some of the ways arts organizations can use public advocacy are:

- Including advocacy information in newsletters, programs, websites, and other information made available to constituents

- Writing letters to the editor and guest opinion columns in newspapers
- Including information about the value of the arts and the organization in news releases
- Working to get local exposure for public service announcements, print ads, and other resources prepared by national service organizations
- Collaborating with other local arts groups to raise awareness of arts and culture in the community

Case 16-1

Case Study: Arts—Ask for More

Americans for the Arts has developed a public advocacy campaign for arts education called Arts—Ask for More. The campaign's public service announcements playfully point out the benefits of being exposed to the arts in school—and what may happen to children who don't participate in the arts. The website also provides a number of resources, including research on the benefits of arts education, activities appropriate for children, sample letters to elected officials, and ways for parents to ensure that their children receive a good education in the arts.

Learn more at http://www.americansforthearts.org/Public_Awareness/.

Legislative Advocacy

Legislative advocacy is the type that most people think of when the word "advocacy" is used. Legislative advocacy is any attempt to change public policy through the legislative (lawmaking) process. Legislative advocacy may include speaking with elected officials about a cause in general or a specific piece of legislation, asking constituents to contact elected officials, or providing voter guides to patrons.

Advocacy is often confused with **lobbying**. Advocacy encompasses a wide range of activities, including lobbying, but advocacy does not always involve lobbying. Lobbying is defined as working directly with lawmakers or their staffs to affect the content of specific legislation or influence the vote of a specific lawmaker. Advocacy is the entire effort to raise public support for your organization or cause. Both advocacy and lobbying are part of the democratic process and comprise an important resource for elected officials. Despite some highly publicized abuses, these practices, when conducted ethically by lobbyists and used correctly by legislators, are the best way for legislators to understand how issues affect their constituents.

Advocacy or Lobbying?

Here are three illustrations of the difference between advocacy and lobbying.

- Talking with a legislator about the economic impact of the arts is **advocacy**. Asking a legislator to vote yes on a bill that would provide support for community arts development is **lobbying**.

(continued)

- Sending a school board member information about the benefits of arts education to at-risk youth is **advocacy**. Asking a school board member to increase arts funding in the upcoming budget is **lobbying**.
- Asking your constituents to contact their legislators and ask them to vote for a piece of legislation is **advocacy**. Asking your legislator directly to support the bill is **lobbying**.

Based on our definitions, as illustrated above, how would you classify the following activities?

- Meeting with a new congressional representative to share information about your organization.
- Sending out talking points to your members about the importance of funding for the arts.
- Writing a letter to the editor about funding for the arts.
- Telling a senator that you support certain legislation and hope she does, too.

Since legislative advocacy is such an important, if often misunderstood, activity, we will spend the rest of the chapter discussing it. We begin by listing some of the legislative activities commonly performed by arts organizations:

- Including elected officials on mailing lists
- Inviting elected officials to speak at events
- Creating voter guides
- Informing constituents about legislation pertaining to the arts
- Organizing a grassroots response to a particular situation

Is Advocacy Legal for Not-for-Profits?

Some not-for-profits avoid advocacy and lobbying altogether, under the mistaken belief that these activities are illegal for them. Others use terms like **public policy activities** or "education" to describe their advocacy so that their constituents won't view these activities negatively. Although it's important to understand that both advocacy and lobbying are legal and part of the democratic process, not-for-profits must be aware that there are restrictions on what organizations with tax-exempt status can and cannot do. Organizations that violate these restrictions may be faced with fines, loss of **tax-exempt status**, or both. Because there are fine lines between definitions of particular activities, it's always wise for a not-for-profit organization to consult a lawyer before embarking on advocacy and lobbying activities.

The Internal Revenue Service says that no "substantial part" of the revenue of a 501(c)(3) tax-exempt organization may be used to directly influence legislation.[6] Although this provision has been on the books since 1934, the limit of "substantial" is not clearly defined.[7] Some guidelines, however, are clear. Not-for-profit organizations can perform lobbying and advocacy activities if less than 20% of their expenditures goes for lobbying or advocacy and the groups do not endorse or oppose candidates for political office, collect or distribute funds for political campaigns, or give candidates their mailing lists.[8] A not-for-profit engaged in what may be

considered to be significant advocacy activity would be well advised to consult a lawyer about the specific applications to the particular situation or organization.

In 1976 Congress set limits on permissible advocacy activities for not-for-profit organizations, and this law was clarified by new regulations in 1990. The 1976 law more closely defined what lobbying activities are permissible, but not-for-profits that wish to be subject to the 1976 law must apply to the IRS to be eligible for such treatment.[9] Most organizations for which advocacy is a significant activity choose to put themselves under the law to more clearly define the scope of their activities and to protect the organization from litigation.

An organization that wishes to engage in more substantial political activity can seek a different IRS designation, 501(c)(4), which is reserved for charitable organizations whose primary purpose is social welfare and betterment. Under 501(c)(4), lobbying is an acceptable way to accomplish the social welfare purpose of the organization.[10]

Organizations like Americans for the Arts and Charity Lobbying in the Public Interest (http://www.clpi.org/) keep a sharp eye on current regulations on behalf of not-for-profits around the country. Staying involved with a statewide or national advocacy organization is one way to help ensure that your organization is following proper advocacy procedures and staying current with applicable laws.

Although it is important to understand the limitations on advocacy for organizations, it also should be recalled that there are no such restrictions on the activities of private citizens. Therefore, one of the services that arts organizations can perform is the education of patrons on how to effectively advocate for their cause as individuals.

MAKING THE CASE FOR THE ARTS

Effective advocacy means providing legislators and the public with good arguments for the existence of arts in our schools, in our communities, and as a priority for our nation. Advocacy experts have found that when they craft arguments in support of the arts, it's effective to have facts and figures that refute the misconception that the arts are important to only a small segment of society. And although it's always good to talk about individual meaningful experiences with the arts, it's also important to be able to share a broader view about how the arts benefit society as a whole and how the arts fit in with current legislative priorities. Sharing these facts with elected officials will help them begin to see the arts as an investment in the future rather than a handout to a "luxury" industry.

We discussed the many benefits of arts and culture to communities and individuals in chapter 15. There is a growing list of studies that add numbers to these arguments; the most current information is usually available via arts service organizations, state arts advocacy organizations, and Americans for the Arts. Don't neglect to back up your arguments with the most up-to-date data so that your legislator will understand the immediacy and relevance of the issues you bring to her.

Even though it is important to be able to cite statistics about the worth of the arts to the economy, the community, and the individual, it is also important to emphasize

that the arts are enjoyable and meaningful in and of themselves. A study by the RAND Corporation in 2004 noted that there are strong arguments to be made not only for the instrumental benefits of the arts, like **economic impact** and tourism growth, but also for intrinsic benefits like personal enjoyment and enrichment.[11]

GETTING STARTED IN LEGISLATIVE ADVOCACY

Contacting elected officials with opinions and ideas is the right and duty of every citizen. Many of us feel, however, that the opinion of just one ordinary person could not possibly make a difference in the life of a busy legislator or city council member, especially those to whom highly paid, well-trained lobbyists have ready access. Most elected officials will tell you that this attitude couldn't be further from the truth. Elected officials rely on input from citizens in order to make decisions, and the more accurate, intelligently presented information they receive, the better they are able to represent those who elected them. In fact, they say, if you don't contact them, the only voices they are certain to hear will be those of the highly paid lobbyists!

A little effort can go a long way. Most elected officials believe that if one citizen feels strongly enough about an issue to write or contact them, there must be many others who have the same opinion. Thus, even ten letters in support of a particular position may be enough to sway a vote one way or another.

The first step in legislative advocacy is to become informed.

- **Find your elected officials.**
 It's easy to find names and contact information for elected officials on the local, state, regional, and national level. Most elected officials have e-mail addresses along with other contact information on their websites, facilitating correspondence. Many organizations keep contact information for appropriate officials on their mailing lists. Arts advocacy organizations often use software that finds legislators and provides links so that citizens can e-mail legislators directly at the lawmakers' official websites. You can also find local information by looking on city, county, or state websites. If you know the name of an official, you can find contact information by entering his or her name in a search engine.
- **Learn how government works.**
 The legislative process is complex and cumbersome. The federal and state budgets, for example, usually go through several committees before they are brought to the full legislature, where different versions are often debated. In order for a bill to become law, both legislative chambers must agree on a version, pass it, and send it to the executive (governor or president) to be signed. Citizen opinion is important at many stages of this process.

 To be an effective advocate, it is important to understand the legislative process, but it is also important to understand how the workings of your local city or county government, school board, or other political entities affect the work you do. If your state or national advocacy service organization

cannot help you with local matters, check the official websites of your city, county, or region for more information.

- **Know the issues.**

 Remember, arts advocacy is about more than just funding. A wide range of legislative issues have the potential to affect the arts. Be on the lookout for bills that impact education, economic growth, tourism, and charitable giving, for example. Many advocacy organizations, including Americans for the Arts, have e-mail update subscriptions available to keep constituents informed.

- **Learn about candidates' views.**

 It's rare to hear a question about the arts in a presidential debate, but that doesn't mean that issues about the arts aren't important to many citizens. Encouraging candidates to publish arts position papers, asking arts-related questions at public forums, and informing your constituency about candidate viewpoints on arts issues are among the ways at your disposal to bring the arts into the public debate at election time.

- **Consider arts positions when you vote.**

 It's improper for an organization to tell people how to vote. But as citizens, it is our right and responsibility to affect the legislative process by informed voting.

DEVELOPING EFFECTIVE MESSAGES

With all of the information elected officials receive every day, how can you ensure that your message is heard?

We live in the information age, and elected officials hear from hundreds of constituents each week. The ease of e-mail communication, the rise of advocacy groups and lobbyists, and the constant barrage of news from the media means that elected officials are never free from communications about issues of every description.

The good news is that elected officials do want to hear from citizens, and one effective personal message is often more influential than hundreds of identical e-mails coordinated by a lobbying group. To be sure your communication has maximal impact, be sure and do the following:

- **Identify yourself.**

 State your name at the beginning of your communication, and explain who you are (e.g., a member of the board of directors of your arts organization, a parent of a child who's talented artistically). Not only is this an important way to personalize your message, it lets the official know right up front what your interest is in the issue at hand.

- **State whether you're a constituent (or not).**

 Identifying yourself as an official's constituent moves you to the top of the pile. Since elected officials are responsible to the people in their district, communications from those in other areas are less important to them. If you're not a constituent, make a special effort to let the official know why you think his or her opinion and actions are important to you and your organization.

- **Identify your issue.**
 Be as specific as possible about the issue you're writing about.
- **Give examples.**
 Personalize your letter by giving examples of how the issue affects people in your community.
- **Let officials know why they should care.**
 Statistics from how important the arts are in your community to how many people are involved in the arts help assure your elected officials that this matter is not the concern of only a small special interest group.
- **Tell them what you'd like them to do.**
 Be specific about what you're asking them to do. Do you want them to vote a particular way on an upcoming bill? Participate in an event? Cosponsor a bill? Let them know.
- **Thank them.**
 People have high expectations of elected officials, and officeholders are often criticized no matter what they do. It doesn't hurt to let them know you noticed when they did something you liked.

See Appendix 13 for an example of an advocacy letter.

With "snail mail," e-mail, social media, and personal visits, citizens have a variety of easy ways to express their opinions to legislators. Which are most effective? Obviously, nothing beats a personal meeting—taking the trouble to schedule a meeting with a legislator or attend a town meeting shows how much you care about your issue and offers you the opportunity to learn what the legislator thinks and respond to her questions. But elected officials pay attention to every communication they receive. Sometimes the urgency of an issue requires an e-mail or social media message; other times, a thoughtful letter sent through the mail might get more attention. No matter which format you use, it's important to be courteous and respectful, and to give personalized information. It's much easier for legislators to disregard messages that are rude, contain false information, or are obviously copied and pasted from other sources.

IN CONCLUSION

Advocacy is an essential part of life for arts organizations in the twenty-first century, as important as marketing, raising funds, and organizing programs. Personal, public, and legislative advocacy helps ensure that the arts will be supported by the public in the future. Integrating arts advocacy into everyday activities should be a priority for every arts organization.

DISCUSSION QUESTIONS

1. Many feel that government doesn't need to be involved in enriching the lives of citizens. Others assume that libraries and parks should be supported, but not a museum or performing arts center. What do you think? What is the difference between a library and a museum with regard to government support?

2. Dana Gioia, who chaired the National Endowment for the Arts under President George W. Bush, has described America's current system for funding the arts as "complex, decentralized, diverse and dynamic."[12] Supporters of the current system point out that since many different individuals, institutions, corporations, foundations, and government at all levels support the arts in various ways, the result is encouragement of a wide diversity of arts and artistic expression. Critics counter that the system forces arts organizations to constantly scramble for funds and to alter their plans to conform to foundation priorities and government granting requirements. What do you think?

3. How have you engaged in personal advocacy? Think of a time when you've been able to influence a friend, relative, or colleague to support something you cared about. Can you also think of a time when you became involved in a cause because someone you trusted asked for your participation?

4. The rise of social media has led to an increase in political messages being shared via Facebook, Twitter, and other platforms. Do you feel these are effective? Why or why not?

APPENDIX I

CONSTRUCTING AN ARTS BUSINESS PLAN: SAMPLE TEMPLATE

A well-constructed business plan is essential for individual artists and arts organizations to gain support from the community at the start-up of a business or at crucial stages of growth or transformation. Potential donors, banks, government authorities, and others from whom you need help are going to want enough information to decide whether providing such assistance would be a sound investment. In addition, start-up businesses with well-thought-out business plans stand a much better chance of succeeding than entrepreneurs who embark on a new business unprepared.

An arts business plan doesn't have to be a stuffy document, however. One of the best ways to convince others that you know what you are doing and will be innovative and creative is to think of your business plan as an artistic document. Make it pretty. Use your imagination to show people what you do, instead of just telling them.

There are many resources for business planning on the Internet, including both templates and sample plans. Although there are a lot of different ways to approach the business plan, a good one usually contains the following elements:

1. Title page

2. Table of contents

3. Executive summary
 An executive summary is a one- or two-page document that boils the plan down for the convenience of donors, bankers, government officials, and, of course community members.

4. Mission and vision statements
 Any organization will benefit from well constructed mission and vision statements, as described in Chapter 4.

5. Situational analysis
 This component of the plan analyzes the internal and external environments that will affect the organization, building a case for the need for the organization to exist.

6. Qualifications
 The qualifications of founding personnel are listed.

7. Organization overview
 This section explains how the organization will be structured (e.g. sole
 proprietorship, partnership, not-for-profit corporation) and supplies an
 organizational chart, copies of the articles of incorporation and/or bylaws if
 these are already prepared, and a list of people who have agreed to serve on
 the board of directors.

8. Marketing plan
 The marketing plan lists target audiences and also covers market research
 undertaken to date, the founders' concept of the brand image, and strategies
 for promotion.

9. Financial plan
 Revenue income and expense projections are given for the first 3–5 years;
 sources of revenue and of start-up funding are identified.

10. Appendices (as appropriate)
 Graphics such as logo or brochure, information about similar successful
 organizations, and letters of support are properly submitted as appendices.

APPENDIX II

Sample Donation Procedures

Although individual policies and procedures will vary with the needs of each organization, these are useable by most organizations.

Donor relations

1. The office will keep a master list of potential donors and scheduled calls.
2. Board members who schedule calls on donors should inform the office of the date, time and format of the call.
3. Board members who complete calls should inform the office immediately following the call about the results and need for any followup.
4. The office will coordinate all official correspondence to donors and potential donors, including followup letters, acknowledgements and requests for more information.
5. Every attempt should be made to answer donors within 48 hours of contact, whether it be an acknowledgement letter, followup or request for more information.
6. Select one board or staff member to be point person for donor inquiries.

Records management

1. A prospect contact sheet should be maintained for each donor (can be on computer or hand copy).
2. A hard copy file should be maintained for donors who have unique correspondence, have given gifts over $250 or request special applications or other information.
3. All donations will receive acknowledgement letters.
4. All donations over $250 will receive an acknowledgement letter with the "no goods or services" line included.
5. All donations $250 or over will require a copy of the check on file.

6. All transactions with every donor will be entered into the fund-raising software, with annotation as to type of gift.

7. Regular reports on progress will be prepared for Board and development committee.

Board member responsibilities

1. Before making official contact with a donor, each board member should check the office to make sure they are up to date on previous contacts.

2. All calls and contacts should be reported to the office when they are scheduled and after they are completed.

3. Board members should be thoroughly familiar with case statement, brochures, and donation procedures.

4. Board members should not promise anything to donors (such as naming rights, special acknowledgement or support of specific programming) without first clearing this with the office and development committee. If an opportunity presents itself for a particular type of gift, the caller should inform the donor that they would be happy to check with the board and get back to them.

5. Board members should consider adding personal notes to official correspondence and/or sending additional handwritten notes to donors following meetings, pledges or donations as appropriate to each donor.

APPENDIX III

Commitment to Serve: Board of Directors, Humboldt Arts Council

In recognizing the important responsibility I am undertaking in serving as a Member of the Board of Directors of the Humboldt Arts Council, I hereby personally pledge to carry out in a trustworthy and diligent manner all the duties and obligations inherent in my role as a trustee of the organization. I acknowledge that my role as a trustee is primarily:

- To contribute to defining the organization's mission and the fulfillment of that mission and
- To carry out the functions of the Board of Directors that are specified in the organization's bylaws and governance policies. I will exercise the duties of this role with integrity, collegiality, and due care.

I Pledge to:

- Establish as a high priority my attendance at all meetings of the board and committees on which I serve.
- Come prepared to contribute to the discussion of issues and business to be addressed at scheduled meetings, having read the agenda and all background support material.
- Represent the organization in a positive and supportive manner at all times and in all places.
- Refrain from intruding in administrative issues that are the responsibility of management, except to monitor the results and prohibit methods not in congruity with board policy.
- Make every effort to learn the job of being a Board member and seek methods to help me function better as part of the Board team.

If, for any reason, I find myself unable to serve in the capacity outlined above, I agree to communicate promptly to the appropriate officer to remedy this situation.

For the upcoming fiscal year, I make the following specific commitments:

Serve on committee:

Chair committee:

Donation:

Other:

Signed: _____ Date _____

APPENDIX IV

⚜

JOB DESCRIPTION FOR VOLUNTEER POSITION AT CHILD'S PLAY THEATER COMPANY

CHILD'S PLAY THEATER COMPANY
JOB DESCRIPTION: VOLUNTEER USHER

POSITION SUMMARY
The Child's Play Theater Company has openings for ushers for mainstage and studio productions for the upcoming season. Ushers assist patrons before, during, and following each production by giving directions, assisting with finding seats, and solving patron needs. Because ushers are often the first line of communication between the patron and the theater, we are seeking a selective number of passionate and professional people who will represent the theater positively. Ushers must attend a brief orientation session and commit to at least two productions per month during the regular season. Although this is a volunteer position, our ushers are invited to watch shows once their duties are completed.

PRIMARY RESPONSIBILITIES
- Reports to house manager
- Assist patrons as they are entering the theater or finding seats, during intermission, and following the performance
- Swiftly report problems to house staff
- Pick up and recycle used programs following the performance
- Other duties as assigned

WORK SCHEDULE
- Minimum commitment of two shows per month
- A typical service lasts from 90 minutes prior until 45 minutes following the performance or until excused by house manager
- Required to attend orientation session and scheduled information meetings
- Evening, weekend, and weekday hours required; schedule TBD based on volunteer's schedule and theater's needs

QUALIFICATIONS:
- A passion for theater
- Demonstrated ability to work well with people of diverse ages and backgrounds
- Outstanding interpersonal, organizational, and communications skills
- Reliability

COMPENSATION
- This is a volunteer position.
- Ushers may watch shows once duties are complete.
- Uniforms will be provided.
- Ushers qualify for special discounts on other shows and events.

TO APPLY
Download and complete the volunteer application form on our website, or contact us at (555) 555-5555 or housemanager@cptc.org.

APPENDIX V

Sample Chart of Accounts for an Arts Organization
(Performing Arts Producing Organization)

Income

1100 Earned Income
- 1110 Ticket sales
 - 1111 Subscriptions
 - 1112 Single tickets
 - 1113 Group sales
 - 1114 Discounts
- 1120 Rental income
 - 1121 Rent
 - 1122 Equipment
- 1130 Education programs
 - 1131 Tuition
 - 1132 Fees
- 1140 Food & Beverage
 - 1141 Food
 - 1142 Beverage
- 1150 Gift shop
- 1160 Special events
 - 1161 50th anniversary gala
 - 1162 Holiday party
 - 1163 Summer event
- 1170 Valet parking
- 1180 Advertising
 - 1181 Corporate sponsorship
 - 1182 Program ads
 - 1183 Website
- 1190 Investment
 - 1191 Endowment earnings
 - 1192 Money market
 - 1193 Other

1200 Contributed Income
- 1210 Donations
 - 1211 Individual
 - 1212 Corporate
 - 1213 Other
- 1220 Grants
 - 1221 Government
 - 1222 Foundation
 - 1223 Other
- 1230 Memberships
 - 1231 Individual
 - 1232 Corporate
 - 1233 Other

Expenses

2100 Artistic Expenses
- 2110 Music
- 2120 Guest artists
 - 2121 Fall concert
 - 2122 Holiday concert
 - 2123 Spring concert
- 2130 Hall rental
- 2140 Instrument/equipment rental
- 2150 Costumes

2200 Administrative Expenses
- 2210 Salaries
 - 2211 Artistic director
 - 2212 Executive director
 - 2213 Administrative assistant
- 2220 Benefits and taxes
 - 2221 Benefits—medical
 - 2222 Benefits—nonmedical
 - 2223 Payroll taxes
- 2230 Rent
 - 2231 Office rent
 - 2232 Utilities
 - 2233 Parking
- 2240 Office supplies
- 2250 Marketing
 - 2251 Design
 - 2252 Printing
 - 2253 Advertising
 - 2254 Postage

J/

CHILD'S PLAY THEATER COMPANY
STATEMENT OF ACTIVITIES FY 20X1-20X2
End of Year as of June 30, 20X2

	BUDGET	ACTUAL	VARIANCE
1000 INCOME			
1100 Earned Income			
1110 Ticket sales	200,000	185,420	(14,580)
1120 Touring	15,000	11,500	(3,500)
1130 Food & Beverage	40,000	38,932	(1,068)
1140 Interest	8,000	8,000	0
1150 Gift shop	23,000	24,700	1,700
1160 Advertising	75,000	79,500	4,500
1170 Holiday gala	50,000	23,200	(26,800)
1200 Unearned income			
1210 Donations	80,000	62,000	(18,000)
1220 Grants	50,000	40,817	(9,183)
1230 Memberships	75,000	76,475	1,475
TOTAL INCOME	**616,000**	**550,544**	**(65,456)**
2000 EXPENSES			
2100 Administration			
2110 Office rent	5,000	5,000	0
2120 Office supplies	4,500	4,850	(350)
2130 Telephone	3,500	3,975	(475)
2140 Utilities	2,000	2,100	(100)
2150 Insurance	3,500	3,210	290
2160 Legal/Professional	8,000	7,245	755
2170 Dues	2,200	2,000	200
2200 Artistic			
2210 Hall rental	34,000	35,650	(1,650)
2220 Licenses/Royalties	12,000	11,950	50
2230 Scenery	50,000	54,300	(4,300)
2240 Costumes	30,000	22,000	8,000
2250 Lighting	20,000	18,000	2,000
2260 Other	8,000	5,000	3,000
2300 Marketing			
2310 Printing	10,000	12,220	(2,220)
2320 Postage	8,000	10,500	(2,500)
2330 Advertising	40,000	22,000	18,000
2340 Promotions	10,000	2,300	7,700
2350 Other	5,000	0	5,000

2400 Personnel

2410 Artistic salaries	120,000	121,311	(1,311)
2420 Administrative salaries	134,000	135,700	(1,700)
2430 Contract personnel	79,000	55,300	23,700
2440 Guest artists	27,300	27,300	0
TOTAL EXPENSES	**616,000**	**561,911**	**54,089**
NET INCOME	**0**	**(11,367)**	**(11,367)**

ᴥ

CHILD'S PLAY THEATER COMPANY
STATEMENT OF FINANCIAL POSITION
6/30/20X2

3000 ASSETS

3100 Current Assets		
	3110 Cash	27,000
	3120 Accounts receivable	0
	3130 Prepaid expenses	8,325
	Total current assets	35,325
3200 Fixed assets		
	3210 Office furniture	18,000
	3220 Theatrical equipment	42,500
	Equipment depreciation	(17,800)
	Total fixed assets	42,700
TOTAL ASSETS		**78,025**

4000 LIABILITIES AND FUND BALANCE

4100 Liabilities		
	4110 Accounts payable	5,675
	4120 Notes payable	52,500
	Total liabilities	58,175
4200 Fund Balances		
	4210 Unrestricted	24,217
	4220 Temporarily restricted	0
	4230 Permanently restricted	7,000
	Net income/(loss) YTD	(11,367)
	Total fund balances	19,850
TOTAL LIABILITIES AND FUND BALANCE		**78,025**

APPENDIX VIII

CHILD'S PLAY THEATER COMPANY
PROPOSED BUDGET 20X2-20X3

	BUDG X1-X2	ACT X1-X2	PROP X2-X3	NOTES
1000 INCOME				
1100 Earned Income				
1110 Ticket sales	200,000	185,420	180,000	
1120 Touring	15,000	11,500	15,000	Library tour will be rescheduled
1130 Food & Beverage	40,000	38,932	38,000	
1140 Interest	8,000	8,000	7,000	Interest rates have gone down
1150 Gift shop	23,000	24,700	25,000	
1160 Advertising	75,000	79,500	80,000	
1170 Holiday gala	50,000	23,200	40,000	Let's hope it doesn't snow again!
1200 Unearned income				
1210 Donations	80,000	62,000	65,000	
1220 Grants	50,000	40,817	40,000	
1230 Memberships	75,000	76,475	80,000	
TOTAL INCOME	**616,000**	**550,544**	**570,000**	
2000 EXPENSES				
2100 Administration				
2110 Office rent	5,000	5,000	6,200	Increase $100/month
2120 Office supplies	4,500	4,850	4,000	
2130 Communications	3,500	3,975	3,000	New contract will cut costs
2140 Utilities	2,000	2,100	2,500	Will only continue to increase
2150 Insurance	3,500	3,210	3,300	
2160 Legal/Professional	8,000	7,245	6,500	Lawyer has promised inkind gift
2170 Dues	2,200	2,000	2,000	
2200 Artistic				
2210 Hall rental	34,000	35,650	34,000	
2220 Licenses/Royalties	12,000	11,950	9,000	No royalties for orig. play
2230 Scenery	50,000	54,300	45,000	Borrow sets for "Cinderella"
2240 Costumes	30,000	22,000	25,000	Can use much existing
2250 Lighting	20,000	18,000	18,000	
2260 Other	8,000	5,000	5,000	
2300 Marketing				
2310 Printing	10,000	12,220	12,000	
2320 Postage	8,000	10,500	11,000	Postage increase Jan 1
2330 Advertising	40,000	22,000	25,000	
2340 Website	10,000	2,300	5,000	
2350 Other	5,000	0	3,000	
2400 Personnel				
2410 Artistic salaries	120,000	121,311	120,000	
2420 Administrative salarie	134,000	135,700	138,000	2% cost of living increase
2430 Contract personnel	79,000	55,300	60,000	
2440 Guest artists	27,300	27,300	0	
TOTAL EXPENSES	**616,000**	**561,911**	**537,500**	
NET INCOME	**0**	**(11,367)**	**32,500**	

APPENDIX IX

CHILD'S PLAY THEATER COMPANY
PROGRAM REPORT: "MYERLY ADAMS"

		Actual	Budget	Variance	Notes
INCOME					
	Ticket sales	22,300	25,000	(2,700)	
	Gift shop	4,070	4,000	70	
	Food & Bev	8,325	9,000	(675)	slow weekday ticket sales affected food sales
	Contributions	25,000	25,000	0	grants from Arts Board & Cowell Foundation
	TOTAL	**59,695**	**63,000**	**(3,305)**	we underestimated difficulty of selling new production
EXPENSES					
	Personnel	15,300	15,300	0	
	Guest artists	12,000	12,000	0	
	Hall rental	13,650	11,500	(2,150)	additional rehearsals due to late arrival of Ms. Jackson
	Royalties	0	0	0	none needed; premiere
	Scenery	19,200	18,000	(1,200)	supplier raised prices
	Costumes	8,253	9,000	747	
	Lighting	6,000	6,000	0	
	Other	1,750	0	(1,750)	unexpected lodging costs for Ms. Jackson
	TOTAL	**76,153**	**71,800**	**(4,353)**	
NET		**(16,458)**	**(8,800)**	**(7,658)**	

APPENDIX X

Dairyland Arts Council Grant Application

For more Information Contact
Dairyland Arts Council
800-123-4567
info@dac.org

DAIRYLAND ARTS COUNCIL

Grant Application

Name of organization/group:	EIN:

Address:	City/State/Zip:

Phone:	Fax:	Website:

Primary contact for this grant application:

Email Address of Contact:	Phone:
Name of chief administrator:	Title:

Amount Requested: $	Total Project Budget: $

Name of Program:

Brief description of request (Do not attach a separate sheet):

General mission of organization/group with year of establishment (Do not attach a separate sheet):

Has your governing board approved a policy that states that your organization does not discriminate?
Yes:☐ No:☐ If no, explain:

Provide the information requested above ON the cover sheet, not on attached pages. Submit copies of the following with this completed and signed cover sheet.
1. Complete list of the organization's officers and directors.
2. The organization's most recent audited financial statement; if an audit is not conducted, contact the Dairyland Arts Council for additional instructions.
3. Copies of the IRS federal tax exemption determination letters, if applicable. *An organization that submitted its determination letter with previous applications need not resubmit the letter unless the status has changed.*
4. Narrative and Budget (respond to questions on the next page in a ***maximum of three pages***, including the budget).

I attest that the information submitted is correct and complete to the best of my knowledge:

Signature of Chief Administrator:	Title:
Printed Name:	Date:

284

NARRATIVE AND BUDGET

Please structure your application according to the sections below. Limit your response to a maximum of *three (3) typed pages, including the project budget,* unless you receive prior consent from the Dairyland Arts Council. The Arts Council may omit from consideration any responses longer than three pages that are submitted without prior consent.

1. **ORGANIZATIONAL OVERVIEW:** Provide a brief overview of your organization's mission and history.

2. **PROJECT DESCRIPTION:** Describe the project for which you are applying, including specific activities that will occur, the type of art involved, where it will take place, and the organization's goals for the project.

3. **PLANNING:** What was the planning process for the project? Describe input by community members and artists in particular. Who will be responsible for implementing it, and what are their qualifications?

4. **FUNDING:** How will this project be funded other than with Dairyland Arts Council funds? How will the DAC funds be used?

5. **OUTCOMES**: How will your organization measure success of the project?

6. **PROJECT BUDGET:** Provide a detailed budget for the entire program, indicating what segments the Community Foundation is being asked to support.

7. How will this grant support the creation and development of the arts in your community?

All applicants are encouraged to share their ideas with the Arts Council prior to the submission of a formal application. Please call (123) 456-7890 if you would like to make an appointment.

⚓

SAMPLE APPEAL LETTER

Expressions Gallery

Tom Jones
333 Cherry St.
Cheddarville, WI
54321

Dear Tom,

> Mail merge programs make it easy to personalize your appeal

As a long-time member of the Cheddarville community, you know the lively heritage and interesting history of the town. But what if, in the years to come, your grandchildren didn't know what a wonderful place Cheddarville was?

> Ending the first paragraph with a question brings the reader into the story

At Expressions Gallery, our mission is to promote and share the artwork of our community and provide opportunities for all to participate in the arts. One of our most successful projects is the "History Now and Forever" program, educating the people of Cheddarville about the city's past and providing a place to preserve its history. We've made progress in expanding our historical collection and carrying out our mission, but we can't do it alone. As a valued member of our community, we ask that you please consider donating to Expressions Gallery and supporting us as we bring the community together by sharing the community's art and history.

Promoting and sharing the artwork of our community and providing opportunities

> It seems obvious, but you have to actually make the ask. Don't assume the reader will be moved to give until you ask them to do so.

As many Cheddarville residents are aging, we are losing precious memories and stories about the city's past. Please – give now. History not captured is gone forever.

Best,

Biggie Bucks
Biggie Bucks
Board member
Expressions Gallery

PS: Please feel free to use the enclosed reply card or give via our secure website, www.expressionsgallery.org. Whichever way you choose, we appreciate your gift!

> Studies show that when scanning a document, most people read the bottom first. This makes a wonderful opportunity to include a special plea in a P.S.

APPENDIX XII

ᴥ

SAMPLE MEDIA RELEASE

CURD COUNTY HISTORICAL SOCIETY
"We're Looking Good For Our Age!"
7232 W. 9th St.
New Guernsey, WI 54321

FOR IMMEDIATE RELEASE

MAY 1, [year]

CONTACT: Gertrude Andersson, Marketing Committee Chair (920) 123-4567 or info@cchs.org

DAIRY DAYS TO FEATURE "ALICE IN DAIRYLAND"

Green Bay, May 1: The Curd County Historical Society announced today that the next Dairy Days will feature a visit from Wisconsin's own "Alice in Dairyland." Dairy Days, a summer tradition in Curd County, will take place this year August 8-10 from 10 am – 6 pm each day in Holstein Park, New Guernsey.

This year's "Alice in Dairyland" is Betsy Butterfield of DePere, Wisconsin. Ms. Butterfield was crowned at last year's Wisconsin State Fair and spends the year making appearances to promote the dairy industry in Wisconsin. Ms. Butterfield's was also the 5th runner up in the "Wisconsin Idol" competition last year.

As has been the practice every year, Dairy Days will include a variety of activities, including cow tipping, egg tossing and the famous chocolate milk dunk tank. Ms. Butterfield will perform on Saturday evening in the amphitheatre and act as a judge for the butter carving competition, which ends on Sunday afternoon at 4:00 pm.

"Dairy Days is the product of hundreds of hours of work and planning by more than two dozen dedicated volunteers," said Hermione Granger, President of the Board of the Curd County Historical Society, which organizes the event. "We are so pleased this year to be able to offer a special attraction that not only brings attention to the festival but fits with our mission to showcase the traditions and history that make Curd County special."

Additional music acts and food vendors will be announced by July 15. For more information, please visit the CCHS website at www.cchs.org or call 920-555-5555.

###

APPENDIX XIII

✦

SAMPLE LETTER TO ELECTED OFFICIAL

April 24, 20xx

The Honorable Rufus T. Blowhard
1234 Senate Office Building
Washington, D.C.

Dear Senator Blowhard:

My name is Veronica Voter and I'm a student at the Wisconsin College of the Arts. I've lived in your district my whole life and my parents voted for you. Now, I have an opportunity to contact you about an issue that I feel strongly about.

> Identifying the reason you're writing up front helps them put your comments in context

> Elected officials will treat comments from constituents differently than others – after all, they are paid to represent you!

I'm writing today to encourage you to vote for Senator Foolhardy's amendment to the federal budget which calls for an increase in federal support of public art.

> Being specific about what you would like them to do helps!

As an art student, I hope someday to make my living as a sculptor, and I hope to remain in Wisconsin. Without funding at the federal level, this dream may be difficult to achieve. Recently, my school received funding from the Foolhardy program to install a new piece of sculpture on our campus. Each of us students had the opportunity to contribute to this wonderful work which will grace our campus forever. I was proud to be a part of the program and I hope future students will be as lucky.

> Personal stories are always important – they help show the official how their work impacts your life, and helps them justify their decisions to others.

Please, vote yes for the Foolhardy amendment. Thank you for your vote.

Sincerely,

Veronica
Veronica Voter
Vvoter123@yipee.com
789 Anywhere Lane
Cream City, Wisconsin

> Representatives and Senators commonly send snail mail in response to e-mailed or other contacts, so be sure and give them your address. More officials these days are using e-mail to respond, so include this if you are willing.

288

APPENDIX XIV

Arts Service Organizations

Actors' Equity Association
http://www.actorsequity.org
165 West 46th Street
New York, NY 10036
(212) 869-8530

Alliance of Artists Communities
http://www.artistcommunities.org
255 South Main Street
Providence RI 02903
info@artistcommunities.org
(401) 351-4320

American Alliance for Theatre & Education
http://www.aate.com
4908 Auburn Avenue
Bethesda, MD 20814
info@aate.com
(301) 200-1944

American Alliance of Museums
http://www.aam-us.org
1575 Eye Street NW, Suite 400
Washington DC 20005
(202) 289-1818

American Association of Community Theatre
http://www.aact.org
1300 Gendy Street
Fort Worth, TX 76107
info@aact.org
(817) 732-3177

American Composers Forum
http://composersforum.org
332 Minnesota Street, Suite East 145
Saint Paul, MN 55101-1300
(651) 228-1407

American Craft Council
http://www.craftcouncil.org
1224 Marshall Street, NE
Suite 200 Minneapolis, MN 55413
council@craftcouncil.org
(612) 206-3100

American Federation of Arts
http://www.afaweb.org
305 East 47th Street, 10th Floor
New York, NY 10017
pubinfo@afaweb.org
(212) 988-7700

American Federation of Musicians
http://www.afm.org
1501 Broadway, Suite 600
New York, NY 10036
(212) 869-1330

American Folklife Center
http://www.loc.gov/folklife
Library of Congress
101 Independence Avenue, SE
Washington DC 20540-4610
folklife@loc.gov
(202) 707-5510

Americans for the Arts
http://www.artsusa.org
1000 Vermont Avenue, NW, 6th Floor
Washington, DC 20005
(202) 371-2830

American Guild of Musical Artists
http://www.musicalartists.org
1430 Broadway, 14th Floor
New York, NY 10018
agma@musicalartists.org
(212) 265-3687

American Society of Composers, Authors and Publishers
http://www.ascap.org
One Lincoln Plaza
New York, NY 10023
(212) 621-6000

Arts and Business Council/Business Volunteers for the Arts
(a division of Americans for the Arts, with chapters in several communities)
http://www.artsusa.org
1000 Vermont Avenue, NW, 6th Floor
Washington, DC 20005
(202) 371-2830

Association of Performing Arts Presenters
http://www.apap365.org
1211 Connecticut Avenue, NW, Suite 200
Washington, DC 20036
info@artspresenters.org
(202) 833-2787

Art and Business Council of New York
http://www.artsandbusiness-ny.org
One East 53rd Street
New York, NY 10022
info@artsandbusiness-ny.org
(212) 279-5910

Arts Education Partnership
http://www.aep-arts.org
One Massachusetts Avenue, NW, Suite 700
Washington, DC 20001-1431
aep@ccsso.org
(202) 326-8693

Arts Extension Service, University of Massachusetts–Amherst
http://www.artsextensionservice.org
University of Massachusetts–Amherst
223 Middlesex House, 111 Country Circle
Amherst, MA 01003
aes@acad.umass.edu
(413) 545-2360

ArtServe
http://www.artserve.org
1350 East Sunrise Boulevard
Fort Lauderdale, FL 33304
information@artserve.org
(954) 462-8190

Black Theatre Network
http://www.blacktheatrenetwork.org
2609 Douglass Rd., SE, Suite 102
Washington, DC 20020-6540
info@blacktheatrenetwork.org
(202) 274-5667

Broadcast Music, Inc.
http://www.bmi.com
10 Music Square East
Nashville, TN 37203-4399
nashville@bmi.com
(615) 401-2000

Chamber Music America
http://www.chamber-music.org
99 Madison Avenue, 5th Floor
New York, NY 10016
(212) 242-2022

Chinese Music Society of North America
http://www.chinesemusic.net
P.O. Box 5275
Woodridge, IL 60517
(630) 910-1551

Chorus America
http://www.chorusamerica.org
1156 15th Street, NW, Suite 310
Washington, DC 20005
webmaster@chorusamerica.org
(202) 331-7577

Corporation for Public Broadcasting
http://www.cpb.org
401 Ninth Street, NW
Washington, DC 20004-2129
(202) 879-9600

Council on Foundations
http://www.cof.org
2122 Crystal Drive, Suite 700
Arlington, VA 22202
info@cof.org
(800) 673-9036

DanceUSA
http://www.danceusa.org
1111 16th Street NW, Suite 300
Washington, DC 20036
(202) 833-1717

Donors Forum
http://www.donorsforum.org
208 S. LaSalle Street, Suite 1540
Chicago, IL 60604
info@donorsforum.org
888-578-0090

Early Music America
http://www.earlymusic.org
2366 Eastlake Avenue E, #429
Seattle, WA 98102
info@earlymusic.org
(206) 720-6270

Folk Alliance
http://www.folkalliance.org/
510 South Main, 1st Floor
Memphis, TN 38103
fa@folk.org
(901) 522-1170

Fractured Atlas
http://www.fracturedatlas.org
248 West 35th Street, 10th Floor
New York, NY 10001
helpdesk@fracturedatlas.org
(888) 692-7878

Grantmakers in the Arts
http://www.giarts.org
4055 21st Avenue West, Suite 100
Seattle, WA 98199-1247
gia@giarts.org
(206) 624-2312

Heritage Preservation, National Institute for Conservation
http://heritagepreservation.org
1012 14th Street, NW,
Suite 1200
Washington, DC 20005
info@heritagepreservation.org
(202) 233-0800

Institute of Museum and Library Services
http://www.imls.gov
1800 M Street NW, 9th Floor
Washington, DC 20036-5802
(202) 653-4657

International Alliance of Theatrical Stage Employees
http://www.iatse-intl.org
1430 Broadway, 20th Floor
New York, NY 10018
iatsepac@iatse-intl.org
(212) 730-1770

International Society for the Performing Arts
http://www.ispa.org
630 9th Avenue, Suite 213
New York, NY 10036-4752
info@ispa.org
(212) 206-8490

The Japan Foundation, New York
http://www.jfny.org
152 West 57th Street,Street 17th Floor
New York, NY 10019
info@jfny.org
(212) 489-0299

Kennedy Center Alliance for Arts Education Network,
The John F. Kennedy Center for the Performing Arts
http://www.kennedy-center.org/education/kcaaen/
P.O. Box 101510
Arlington, VA 22210
kcaaen@kennedy-center.org
(202) 416-8817

Lawyers for the Creative Arts
http://www.law-arts.org
213 West Institute Place, Suite 403
Chicago, IL 60610
(312) 649-4111

League of American Orchestras
http://www.americanorchestras.org
33 West 60th Street, 5th Floor
New York, NY 10023
(212) 262-5161

National Alliance for Media Arts and Culture
http://www.namac.org
145 9th Street, Suite 102
San Francisco, CA 94103
(415) 431-1391

National Assembly of State Arts Agencies
http://www.nasaa-arts.org
1029 Vermont Avenue, NW, 2nd Floor
Washington, DC 20005
nasaa@nasaa-arts.org
(202) 347-6352

National Association for Music Education
http://www.nafme.org
1806 Robert Fulton Drive
Reston, VA 20191
(703) 860-4000

National Endowment for the Arts
http://www.nea.gov
1100 Pennsylvania Avenue, NW
Washington, DC 20506-0001
webmgr@arts.gov
(202) 682-5400

National Endowment for the Humanities
http://www.neh.gov
1100 Pennsylvania Avenue, NW
Washington, DC 20506
info@neh.gov
(202) 606-8400

National Guild of Community Schools in the Arts
http://www.nationalguild.org
520 8th Avenue, Suite 302
New York, NY 10018
guildinfo@nationalguild.org
(212) 268-3337

National Music Council
http://www.musiccouncil.org/
425 Park Street
Montclair, NJ 07043
sandersd@mail.montclair.edu

National Performance Network
http://www.npnweb.org
900 Camp Street, 2nd Floor
New Orleans, LA 70130
info@npnweb.org
(504) 595-8008

National Public Radio
http://www.npr.org
635 Massachusetts Avenue, NW
Washington, DC 20001
(202) 513-3232

Native Art Network
http://www.nativeart.net
7966 West 17th Avenue
Lakewood, CO 80214
(303) 205-1776

New Music USA
https://www.newmusicusa.org
90 John Street, Suite 312
New York, NY 10038
info@newmusicusa.org
(212) 645-6949

North American Performing Arts Managers & Agents
http://www.napama.org
459 Columbus Avenue, #133
New York, NY 10024
(800) 867-3281

Music for All
http://www.musicforall.org
39 West Jackson Place, Suite 150
Indianapolis, IN 46225
info@musicforall.org
(317) 636-2263

Opera America
http://www.operaamerica.org
330 Seventh Avenue
New York, NY 10001
info@operaamerica.org
(212) 796-8620

Pentacle
http://www.pentacle.org
246 West 38th Street, 4th Floor
New York, NY 10018
(212) 278-8111

Performing Arts Alliance
http://paa.convio.net
1211 Connecticut Avenue, NW, Suite 200
Washington, DC 20036
info@theperformingartsalliance.org
(202) 207-3850

Poetry Society of America
https://www.poetrysociety.org
15 Gramercy Park
New York, New York 10003
(212) 254-9628

President's Committee on the Arts and the Humanities
http://www.pcah.gov/
1100 Pennsylvania Avenue, NW, Suite 526
Washington, DC 20506
pcah@pcah.gov
(202) 682-5409

Public Broadcasting Service
http://www.pbs.org
2100 Crystal Drive
Arlington, VA 22202

SESAC, Inc.
http://www.sesac.com
55 Music Square East
Nashville, TN 37203
(615) 320-0055

Society for the Arts in Healthcare
http://www.thesah.org
2647 Connecticut Avenue, NW, Suite 200
Washington DC 20008
mail@thesah.org
(202) 299-9770

Stage Directors & Choreographers Society
http://www.sdcweb.org
1501 Broadway, Suite 1701
New York, NY 10036
info@sdcweb.org
(212) 391-1070

Theatre Communications Group
http://www.tcg.org
520 Eighth Avenue, 24th Floor
New York, NY 10018-4156
tcg@tcg.org
212-609-5900

The Association of American Cultures
http://www.taac.com
1635 South 15th Street
Lincoln, NE 68502
taacultures@gmail.com
(402) 472-0208

The Broadway League
http://www.broadwayleague.com
729 Seventh Avenue, 5th Floor
New York, NY 10019
(212) 764-1122

The Creative Coalition
http://thecreativecoalition.org
105 Madison Avenue, 11th Floor
New York, NY 10016
(212) 512-8570

VSA Arts, International Organization on Arts and Disability at the John F. Kennedy
Center for the Performing Arts
http://www.kennedy-center.org/education/vsa/
2700 F Street, NW
Washington, DC 20566
vsainfo@kennedy-center.org
(202) 416-8727

Volunteer Lawyers for the Arts
http://www.vlany.org
1 East 53rd Street, 6th Floor
New York, NY 10022
(212) 319-2787 ext. 1

Glossary

501(c)(3) section of the Internal Revenue Service code that defines charitable organizations

accountability the principle that an organization is responsible for its actions and may have to report them to a government body, donor, or other entity

accounts line items or categories within an accounting system

accrual (basis) accounting an accounting system in which transactions are recorded at the time they are initiated

action steps (tasks) specific steps by which strategies are accomplished

ad hoc committees or other entities that come into existence for a particular purpose and disband when they have completed that purpose

administrative expenses expenses related to the management of the organization

administrative management a management system which holds that workers are most productive when supported in a hierarchy

administrative workers people whose job is to perform the management duties that support the artistic function of the arts organization

advancement another name for the fundraising function within a not-for-profit organization; often used in colleges and universities

advertising a controlled message disseminated through purchased space

advocacy the act of speaking, writing, or acting in support of something or someone

annual work plan assignment of priorities and tasks for the upcoming year, based on a strategic plan

appeal letter a letter asking for a charitable donation

articles of incorporation documentation filed with the state that sets forth general information about a corporation. More specific rules of the corporation are contained in the bylaws

artisan a skilled worker trained in a particular craft

artistic expenses expenses related to the artistic product

artistic workers people whose job is to produce the artistic product of the arts organization: actors, directors, curators, artists, designers

arts education the systematic instruction of the arts in school settings, usually involving participatory activities such as band, choir, drawing, or acting

arts enrichment the use of the arts to provide cultural, social, and emotional benefits and learning

arts in education the use of the arts to teach other subjects

arts management the administration of arts and cultural activities

asset something owned by the organization that has monetary value

audit a formal analysis of a business's finances by a certified public accountant; includes a letter stating whether or not the business is in compliance with Generally Accepted Accounting Practices (GAAP)

authentic true to the origins, customs, traditions or beliefs of a culture or community

barriers to entry reasons for the failure of consumers to purchase products or participate with organizations

best practices ideas or lessons learned about effective program activities that have been developed and implemented in the field and have been shown to produce positive outcomes

board of directors the governing body of a corporation

board operations the duties that ensure that the board keeps operating and serving the organization well, including nomination, training, orientation, evaluation, and board development

brand the image of an organization that supersedes any particular product it may be selling

broadening increasing the scope of the audience

budget annual financial plan including expected income and expenses

business plan a document that describes a business, its objectives, strategies, and market, and provides a financial forecast

bylaws written rules established at the founding of a not-for-profit corporation which provide the basic rules by which the corporation is operated

capital assets that can be put to productive use. In not-for-profit organizations, often refers to material assets (buildings, furniture, collections, and equipment) as opposed to cash

case for support the reasons that donors should give to the organization or project

case statement a document outlining reasons for donors to give to the organization or project

cash (basis) an accounting system in which transactions are recorded at the time they are completed

cash flow inflow and outflow of funds throughout a given period

censorship the removal or withholding of information, art, or expression from the public by a controlling group or body

chain of command an description of the relationships between workers, including to whom the worker reports and to whom the supervisor reports, up to the head of the organization

charitable promoting the public good

chart of accounts a list of the accounts that will be used by the business, normally classified in a numbered system so that like categories will be easily summarized

collaborative involving input from more than one person or entity

commission (v) to cause to come into being

community engagement involvement by citizens in the improvement of communities other common work that benefits everyone

community foundation a type of foundation in which funds from various donors are pooled and granted to causes that benefit the community

community outreach programs that connect the work of the organization with community needs

compilation an assembling of the business's financial statements by an accountant without a formal letter of GAAP compliance

concurrent planning planning that continues while a system is running

conflict of interest condition that exists when the personal interest of a member of the board or staff differs from his or her obligation to the organization

constituent a member of a group represented by an elected official or organization

contingency (systems) the philosophy that different organizations under different conditions may need to be managed in different ways

contracted staff paid workers who are hired for short-term or specific tasks

contributed income cash or inkind gifts given (not loaned) to an organization, and for which the donor does not receive a purchased product in return

contributions donations or gifts

controlling the function of monitoring work to check progress against goals; includes taking corrective action when required

cooperative working together on a common purpose

core subjects primary or required educational programs

corporate foundation foundation founded with corporate funds which is managed separately from corporate earnings

corporation a legal business entity separate from its owners

cost center a unit of the business that requires the separate tracking of expenses and income

creative economy an economy characterized by the worth of ideas rather than physical capital

creative industries a broad range of businesses concerned with generation of knowledge, information and ideas

cultural policy the values and principles that guide any government in cultural affairs

cultural tourism the act of traveling to experience the culture, art, or history of a people or region

cultural trust a trust whose purpose is to support arts and cultural organizations

curator person in charge of collecting, conserving, and interpreting objects for exhibit at a museum, zoo, or other place of exhibition

current assets assets that can be converted into cash or expended within the fiscal year

customer segment pricing a marketing practice of offering pricing incentives to different types of customers (e.g., senior discounts or student rush prices)

deduction an amount that reduces income tax due

deepening enriching or increasing the experience of current patrons

deficit excess of expenses over income

demand-based pricing a marketing practice of charging according to demand for a product (i.e., charging more for items that are in short supply)

demographics measures of a population

development another name for the fundraising function within a not-for-profit organization

direct costs expenses that can be directly applied to a particular program

direct marketing contacting the customer individually by means of postal or electronic mail

diversifying increasing variety of constituents

dividend distribution of profits to stockholders

double-entry bookkeeping bookkeeping method in which each transaction is recorded as affecting two opposite categories

duty of care the responsibility of the board member to provide the finest service to the board

duty of loyalty the responsibility of the board member to be loyal to the organization in word and deed

duty of obedience the responsibility of the board member to act in accordance with the adopted positions and policies of the board

earned income income derived from sales of goods or services, for which someone receives a benefit or product in exchange

earnings in for-profit business terminology, synonymous with profits; for not-for-profits, any funds remaining after expenses have been paid

economic impact the effect of an industry on the number of jobs, tax base and benefit to the total economy

emeritus an honorary title given to a person who has retired from regular service but retains the title of office

endowment a permanent savings account set up so that the original funds are never touched, but interest from the savings can be used for the intended purpose

Enlightenment an intellectual movement in eighteenth-century Europe characterized by an emphasis on reason and scientific endeavor

entrepreneurship personal initiative in creating and maintaining businesses and organizations

environmental analysis see situational analysis

ex officio "by virtue of office or position." An ex officio member of a governing board is a person who serves on the board because of a particular position he or she holds

exempt excluded from, as in "exempt from paying taxes"

expenses outflows of money

external assessment analysis of community or global conditions that affect the organizations

extracurricular outside the classroom

family foundation a foundation, founded with personal funds, which gives grants in the interest of the donor or donors

feasibility study research done to attempt to determine whether a proposed business or program will be successful

fiduciary duty the legal responsibility to act wisely on behalf of the organization

fiscal receiver an organization that will receive funds for an organization before it has been granted 501(c)(3) status

fiscal year financial year

fixed assets permanent assets that will never be converted into cash

flex time an arrangement whereby the employee sets flexible hours within an overall structure, rather than being required to work a standard business day

for-profit a business whose purpose is to create profit for its owner or owners

Form 990 annual report, entitled Return of Organization Exempt under 501(c)(3), required by the Internal Revenue Service for not-for-profit organizations

formative evaluation evaluation that takes place while a program is in process

foundation a charitable organization which manages funds and grants them according to the mission of the foundation

four functions of leadership vision, communication, motivation, and innovation

four functions of management planning, organizing, leading, and controlling

four Ps The four aspects of the marketing mix; product, price, place, and promotion

fringe benefits non-wage payments or incentives included in an employee compensation package

fund accounting the segregation of donations in the accounting process so that they can be used for the purposes intended by the donor

fund balances same as net assets; used in not-for-profit accounting because of the need to segregate restricted and unrestricted funds

fundraising the act of soliciting unearned income

geographics measures of physical location

goal desired result or condition, which is to be accomplished by the conclusion of the plan

governance the actions of the board of directors of an organization with respect to establishing and monitoring the long-term direction of that organization

grant financial award from a foundation or government source

grant writing the process of applying for grants from a foundation or government source

grievance a complaint against management or the organization by an employee or employees

heritage tourism the act of traveling to experience the history and traditions of a people or region

hierarchical the arrangement of people by order or rank

humanistic perspective a management philosophy emphasizing the understanding of human behavior, needs, and attitudes in the workplace

income inflows of money; revenue

incorporated organized as a corporation

indirect costs expenses like rent and utilities, which affect the cost of doing business but are not assigned specifically to a program (see also **overhead**)

indirect subsidy a form of government benefit that does not involve a cash payment (e.g., a tax advantage)

Industrial Revolution the change in social and economic organization resulting from the replacement of hand tools by machines beginning in the eighteenth century

infrastructure services and facilities that are needed for the functioning of society, including roads, power, telephone service, and public transportation

in-kind (donations) gifts of goods or services

intellectual property the legal rights associated with inventions, artistic expressions and other products of the imagination

internal assessment analysis of conditions within the organization

internal controls measures a business takes to protect assets, prevent fraud, and promote compliance with governmental regulations

inventories lists of assets

invisible hand of the marketplace a theoretical concept of eighteenth-century economist Adam Smith: a market free from government intervention will ultimately benefit society as a whole, since businesses that provide the highest quality or most beneficial products are most likely to succeed

knowledge economy an economy characterized by the worth of knowledge and ideas rather than physical capital

leading the act of directing the behavior of all personnel to accomplish the organization's mission and goals

legislative advocacy influencing public policy through the legislative process

Letter of Determination (Letter 1045) notification from the Internal Revenue Service that an organization has been approved for tax-exempt status

liability something that is owed by a person or business

liable having legal responsibility

limited liability company (LLC) a business structure that is a hybrid of a partnership and a corporation: owners are shielded from personal liability and all profits and losses pass directly to the owners

linear planning planning out to the future for a set number of years

liquid (current) assets assets that can easily be converted into cash

lobbying attempting to influence lawmakers with regard to a specific piece of legislation

location pricing the marketing practice of charging different prices for seats in different sections of the house according to their desirability

logo visual mark symbolizing an organization, business, or product

long-range plan projection into the future of an organization's goals

management the process of directing the administration of a business or organization

Maslow's hierarchy of needs psychological philosophy proposed by Abraham Maslow; posits that people's basic needs such as food, water, and shelter must be met before other human needs can be addressed

material participation regular, continual, and substantial participation in an organization

measurable outcomes results that can be quantified

memberships revenue opportunity in which an organization offers certain annual benefits in exchange for a contribution or membership dues

mentoring assigning an experienced board member to an inexperienced one for purposes of training

message the means of communicating a position to targets

mission statement statement of purpose of the organization

mission purpose for which a not-for-profit corporation is granted tax exempt status

National Endowment for the Arts the federal agency that provides grants, research of the field, and other services in support of arts and culture

needs statement the section of a grant application in which an organization explains how the proposed program meets a community need

net assets assets minus liabilities

net worth the total assets of the business once liabilities have been subtracted

new economy term used to describe the transition from a manufacturing (hard-goods) economy to an economy that values ideas, knowledge and innovation

niche unique specialty within the total arts environment

nonliquid (long-term) assets assets that cannot easily be converted into cash

not-for-profit an organization whose purpose is defined by its charitable mission rather than the goal of creating profit for owners

objective short-term result consistent with a goal

operating plan see **annual work plan**

organizational chart a graphic representation of the various job functions of a business, arranged in terms of rank and relationship

organizing the process of converting plans into action

orientation systematic introduction of an employee, volunteer, or board member to the organization

outsource to engage outside firms to be responsible for certain administrative or artistic functions within an organization

overhead (indirect costs) expenses that are part of the cost of doing business and not directly applied to any particular program

partnership collaboration between entities such as businesses, community organizations, and governmental agencies

payable an obligation to pay a sum at a future date; expense that has been initiated but not yet paid for

permanently restricted describing a donation on which the donor has placed restrictions that will not expire

personal advocacy influencing individuals on a one-to-one basis

personal selling one-to-one efforts to sell products

philanthropy the act of giving to charitable causes

place one of the "four Ps of marketing," the location or locations at which customers encounter the product. Can include physical facilities, websites, and points of distribution

planning the ongoing process of developing the business's mission and objectives and determining how they will be accomplished

points of entry reasons consumers are attracted to a particular product or organization

positioning designing an image or an offer in a way that is meaningful to targets and differentiates from other products

presenter arts organization which hosts (presents) performances by touring performers

pretax any amount deducted from an employee's pay before earnings are taxed

price one of the "four Ps of marketing," the manipulation of cost and value in order to entice customers

pricing incentives in marketing, the use of discounts and other special offers to encourage potential customers to purchase

primary data research information that is gathered specifically for the project being studied

private sector the portion of the economy not controlled by the government

pro bono from the Latin "for the [public] good"; the practice of providing services (usually legal or financial) at no charge

producer performing arts organization that produces (creates) original plays or concerts

product one of the "four Ps of marketing"; the effect of the product itself and its characteristics or features on the customer's desire to purchase

professional foundation a large grant-giving foundation with professional staff

profit net revenue; money that remains once expenses are paid

program (management) committee a committee that assists with a particular management issue

program (project) plan strategic plan for an individual program or project within the organization

program reports financial reports that detail income and expenditures for individual program activities

promotion one of the "four Ps of marketing," the use of communications, advertising and media relations to share information about a product

psychographics measures of lifestyle, attitudes, beliefs, and habits

public advocacy influencing the general public through such means as public relations and advertising

public funding funding having tax dollars as its source

public policy activities term sometimes used to describe a not-for-profit's overall advocacy campaign

public relations efforts to create awareness of business or product

public sector that part of economic and social life that deals with goods and services provided by the government

public service advertisement (PSA) an advertisement that is printed or broadcast by media without charge

public/private partnership an organization that is managed in whole or in part by at least two entities, one a governmental agency and the other a private business

qualitative evaluation evaluation using intangible measures (quality)

quality of life the measurement of wellbeing of humans and societies

quality of place characteristics of a geographic area that contribute to quality of life

quantitative evaluation evaluation using hard data

receivable income that has been promised but not yet received

Reformation the sixteenth-century political and religious movement that resulted in the formation of Protestant Christian denominations

regrant to receive money from one source and give it to another source, usually with additional funds added to the original total

reimbursement payment for out-of-pocket expenses

restricted (funds) donated funds that can be used only for the purpose specified by the donor

review an examination of existing financial statements by an accountant

sales promotions short-term incentives to purchase

scenario budgeting a budgeting method that takes into consideration a number of different results

scenario planning creation of contingency plans for different circumstances

scientific management the management system that holds that workers are an extension of machines and can therefore be made more efficient with time-saving techniques

secondary data data that was collected for one purpose and is used for another research study

segregation of duties dividing financial and legal responsibilities to diminish risk

self-actualization self-fulfillment through development of human potential

sense of place a perception of a location's unique attributes that foster a sense of belonging

shareholders persons who own shares of stock in a corporation

situational analysis assessment, for planning purposes, of an organization's internal and external conditions

sole proprietorship small business owned by one person

solicitation searching and asking for donations

solicited requested

sponsorship support of an event, organization or program, usually by businesses or corporations

stakeholders person or groups affected by the organization and its decisions

standing (permanent) committee a committee, often mandated in the organization's bylaws, which has a continuing existence and is not formed for one particular task

statement of activities financial statement listing current income and expenses

statement of position financial statement listing assets, liabilities, and fund balances

stewardship taking care of resources under one's care

strategic plan a long-range plan that lists and describes the strategies an organization is using or will use

strategy method by which an objective or goal is achieved

subsidy an economic benefit granted by a government

summative evaluation evaluation that takes place when a program is complete

surplus excess of income over expenses

SWOT analysis a form of situational analysis involving brainstorming of strengths, weaknesses, opportunities, and threats

systems thinking management philosophy that sees an organization as a complex organism to be viewed not only as a whole, but as an interaction of separate parts

tagline a slogan or motto that distinctly sums up the organization's image

target marketing the selecting of segments of the population to whom an organization's marketing campaign will be addressed, based on individuals' potential to be enticed by the organization's offering

tax-exempt status Internal Revenue Service determination that an organization is not subject to (i.e., is exempt from) federal income tax by virtue of its charitable mission

temporarily restricted a donation on which the donor has placed restrictions that will eventually expire

Theory X management theory that supposes that workers generally dislike work and must be threatened if the enterprise is to succeed

Theory Y management theory that supposes that workers are generally predisposed to want to perform well and so should be encouraged rather than threatened

Three Duties the three areas that generally describe a board member's fiduciary duty to the corporation: *duty of care, duty of loyalty, and duty of obedience*

Total Quality Management (TQM) management system that seeks continuous input and improvement in all aspects of the business

trust A legal structure in which money to be used for a particular purpose is protected

trustee member of a governing board

underserved describing segments of the population sometimes prevented from accessing services or programs because of social, language, accessibility, or financial barriers

unearned income income derived from contributions or donations

unincorporated not organized as a corporation

Unrelated Business Income Tax (UBIT) a tax that is assessed on not-for-profit organizations for activities conducted as for-profit businesses outside the primary mission of the organization

unrestricted (funds) funds that can be used for any purpose

values statements statements defining an organization's beliefs and operating principles

vision statement statement of ideal future as a result of the organization's work

volunteers people who give service to an organization without payment

zero sum a form of budgeting in which the organization (or any of its individual programs) expects to end with equal revenue and expenses

Notes

Chapter 1

1. Kushner, Roland J., and Randy Cohen, *National Arts Index 2010* (Washington, DC: Americans for the Arts, 2010), 8.
2. National Endowment for the Arts, http://www.nea.gov. A complete list of research reports can be found at http://www.nea.gov/research/index.html.
3. Novak-Leonard, Jennifer L., and Alan S. Brown, *Beyond Attendance: A Multi-modal Understanding of Arts Participation* (Washington, DC: National Endowment for the Arts, 2011), 14. *National Endowment for the Arts*, http://www.nea.gov/research/2008-SPPA-BeyondAttendance.pdf. Retrieved 26 Nov. 2012.
4. Cherbo, Joni M., and Margaret J. Wyszomirski, eds., *The Public Life of the Arts in America* (New Brunswick, NJ: Rutgers University Press, 2000). Other participation studies also indicate higher numbers than the NEA study. For example, the studies by the Urban Institute (see http://www.wallacefoundation.org) and the Performing Arts Research Coalition (see http://www.operaamerica.org/parc) indicate that some cities report between 78% and 84% participation in attendance at performing arts events alone.
5. Harper, Douglas, *Online Etymology Dictionary*, 2001. http://www.etymonline.com. Retrieved 26 Nov. 2012.
6. Byrnes, William J., *Management and the Arts*, 4th ed. (Oxford: Focal-Elsevier, 2008).
7. *New York Philharmonic History*, New York Philharmonic, 2012. http://www.nyphil.org/about-us/history/overview Retrieved 26 Nov. 2012.
8. Arnsberger, Paul, et al., "History of the Tax Exempt Sector: An SOI Perspective," *Statistics of Income Bulletin* (Washington, DC: IRS, 2008), 107. *Internal Revenue Service*, http://www.irs.gov/pub/irs-soi/tehistory.pdf. Retrieved 26 Nov. 2012.
9. *The National Endowment for the Arts, 1965–2000: A Brief Chronology of Federal Support for the Arts* (Washington, DC: National Endowment for the Arts, 2000). *National Endowment for the Arts*, http://www.nea.gov/pub/NEAChronWeb.pdf. Retrieved 26 Nov. 2012.
10. National Endowment for the Arts, *The NEA 1965–2000*, 8.

Chapter 2

1. Daft, Richard, *Management*, 10th ed. (Mason, OH: South-Western, 2012), 24.
2. Daft, *Management*, 35.

3. Joyce, Helen, "Adam Smith and the Invisible Hand," *Plus Magazine* (1 Mar. 2001). *Plus Magazine*, http://plus.maths.org/content/adam-smith-and-invisible-hand. Retrieved 26 Nov. 2012.

4. Gilbreth, Frank B., Jr., and Ernestine Gilbreth Carey, *Cheaper By the Dozen* (New York: HarperCollins, 1948).

5. Byrnes, William J., *Management and the Arts*, 53.

6. Byrnes, *Management and the Arts*, 71.

7. Maslow, Abraham, "A Theory of Human Motivation," *Psychological Review* 50:4 (1943), 370–96.

8. DiMaggio, Paul, *Managers and the Arts* (Washington, DC: Seven Locks, 1987).

9. Drucker, Peter F., *Managing the Non-Profit Organization* (New York: HarperBusiness-HarperCollins, 1990), xiv.

10. Kotter, John, *What Leaders Really Do* (Cambridge, MA: Harvard Business School, 1999), 10.

11. Kotter, *What Leaders Really Do*, 10.

12. Hessenius, Barry, *Involving Youth in Nonprofit Arts Organizations: A Call for Action* (Palo Alto, CA: William and Flora Hewlett Foundation, 2007). *Hewlett*, http://www.hewlett.org/uploads/files/InvolvingYouthNonprofitArtsOrgs.pdf. Retrieved 26 Nov. 2012.

Chapter 3

1. *The Sector's Economic Impact* (Washington, DC: Independent Sector, 2012). *Independent Sector*, http://www.independentsector.org/economic_role. Retrieved 26 Nov. 2012.

2. Both for-profit and not-for-profit corporations have Boards of Directors, although their function is somewhat different in the not-for-profit. This will be discussed further in chapter 5.

3. Wolf, Thomas, *Managing a Nonprofit Organization in the Twenty-First Century*, rev. and updated ed. (New York: Fireside–Simon & Schuster, 1999), 18.

4. *Applying for 501(c)(3) Tax-Exempt Status*, Internal Revenue Service, http://www.irs.gov/pub/irs-pdf/p4220.pdf. Retrieved 26 Nov. 2012.

5. More information can be found at http://www.irs.gov; search Current Form 990 or http://www.irs.gov/pub/irs-tege/ty2010_2011_990_list_w_links.pdf.

6. More information about the Unrelated Business Income Tax can be found at http://www.irs.gov/Charities-&-Non-Profits/Unrelated-Business-Income-Tax.

Chapter 4

1. Kaiser, Michael, *Strategic Planning in the Arts: A Practical Guide* (Washington, DC: John F. Kennedy Center for the Performing Arts, 2007), 16. *Lincoln Arts Council*, http://artscene.org/uploaded/Pages/ArtistResources/StrategicPlanningintheArts-APractical-Guide.pdf. Retrieved 26 Nov. 2012.

Chapter 5

1. Although there is no legal prohibition that keeps not-for-profits from compensating board members, most not-for-profit boards are voluntary, in keeping with the spirit of directing resources to the organization's mission and maintaining independence from any considerations by board members of financial self-interest. To encourage active

involvement on the part of board members, however, many boards will reimburse members for direct expenses, such as travel to board meetings.

2. *Roberts Rules of Order*, http://www.robertsrules.com. Retrieved 26 Nov. 2012.
3. Roche, Nancy, and Jaan Whitehead, eds., *The Art of Governance: Boards in the Performing Arts* (New York: Theatre Communications Group, 2005), 69.
4. Jenkins, David, *501(c)Blues: Staying Sane in the Nonprofit Game* (Pray, MT: Fandango, 2003), 53.
5. Ibid.

Chapter 6

1. Deutsch, Claudia H., "For Love and a Little Money," *New York Times*, 23 Oct. 2007.
2. More information on volunteer deductions can be found in the IRS Publication 526: Charitable Contributions at http://www.irs.gov/pub/irs-pdf/p526.pdf.
3. Byrnes, *Management and the Arts*, 109.
4. Wolf, *Managing a Nonprofit Organization*.

Chapter 7

1. Grams, Diane, and Betty Farrell, eds., *Entering Cultural Communities: Diversity and Change in the Nonprofit Arts* (New Brunswick, NJ: Rutgers University Press, 2008), 1.
2. McDaniel, Nello, and George Thorn, *The Quiet Crisis in the Arts* (New York: FEDAPT, 1991).

Chapter 8

1. Burdett, Christine, "Financial Management," in Craig Dreeszen, ed., *Fundamentals of Arts Management*, 4th ed. (Amherst, MA: Arts Extension Service, University of Massachusetts–Amherst, 2003), 369.
2. Financial Accounting Standards Board, http://www.fasb.org.
3. A Unified Chart of Accounts has been developed for not-for-profit organizations that conform to IRS regulations. It can be found online in several places, including: http://www.nccs.urban.org/projects/ucoa.cfm. Although most organizations will need to modify this chart to their specific needs, it's a good start and gives organizations an idea of what the IRS expects.
4. In 2009 the IRS changed requirements with respect to the forms organizations must file. A comprehensive discussion of these changes can be found at http://www.boardsource.org/dl.asp?document_id=681.

Chapter 9

1. Bryce, Herrington J., *Financial and Strategic Management for Nonprofit Organizations*, (San Francisco: Jossey Bass, 2000).
2. More information about the Unrelated Business Income Tax can be found at http://www.irs.gov/Charities-&-Non-Profits/Unrelated-Business-Income-Tax.

Chapter 10

1. Bray, Ilona, *Effective Fundraising for Nonprofits* (Berkeley, CA: Nolo, 2005).
2. Friedman, Carolyn Stolper, and Karen Brooks Hopkins, *Successful Fundraising for Arts and Cultural Organizations*, 2nd ed. (Phoenix, AZ: Oryx, 1997), xiii.

Chapter 11

1. Grace, Kay Sprinkel, *Beyond Fundraising: New Strategies for Nonprofit Innovation and Investment*, 2nd ed. (Hoboken, NJ: John Wiley & Sons, 2005), 13.
2. The Association of Fundraising Professionals Code of Ethical Principles and Standards can be found at http://www.afpnet.org/files/ContentDocuments/CodeOfEthicsLong.pdf.
3. Warwick, Mal, *How to Write Successful Fundraising Letters*, 2nd ed. (San Francisco: Jossey-Bass-Warwick, 2008), 25.

Chapter 12

1. President's Committee on the Arts and the Humanities, *Coming Up Taller* (United States, 1996).
2. Internal Revenue Service. Instructions for Form 1023 can be found at http://www.irs .gov/pub/irs-pdf/i1023.pdf.
3. The website of the Arts Education Partnership (http://www.aep-arts.org) lists a number of resources. Another excellent summary of a variety of studies can be found at Americans for the Arts, http://www.artsusa.org/get_involved/advocacy/funding_resources/ default_005.asp
4. Bronson, Po, "The Creativity Crisis," *Newsweek* 19 July 2010, 44–49.
5. Eisner, Elliot, "Ten Lessons the Arts Teach." in Amdur Spitz & Associates, ed., "Learning and the Arts: Crossing Boundaries," meeting, 12 Jan. 2000, Los Angeles (Morristown, NJ: Geraldine R. Dodge Foundation, 2000), 14. *Grantmakers in the Arts*, http:// www.giarts.org/. Retrieved 26 Nov. 2012.
6. President's Committee on the Arts and the Humanities, *Coming Up Taller*, 16.
7. Quoted in Marlene Farnum and Rebecca Schaffer, *YouthARTS Handbook: Arts Programs for Youth at Risk* (Washington, DC: Americans for the Arts, 1998).
8. Quoted in James S. Catterall, *The Arts and Achievement in At-Risk Youth: Findings from Four Longitudinal Studies* (Washington, DC: National Endowment for the Arts, 2012). *National Endowment for the Arts*, http://www.nea.gov/research/arts-at-risk-youth.pdf. Retrieved 26 Nov. 2012.
9. Ibid.
10. Greenwood, Peter W., et al., *Diverting Children from a Life of Crime: Measuring Costs and Benefits*, (Santa Monica, CA: RAND, 1996).
11. *Creativity Matters: The Arts and Aging Toolkit* can be found at http://www.artsandaging .org.
12. Arts Education Partnership, *State of the States 2012: Arts Education State Policy Summary*, 2012. http://www.aep-arts.org/wp-content/uploads/2012/07/State-of-the-states-2012-FINAL.pdf.
13. Rabkin, Nick, and E. C. Hedberg, *Arts Education in America: What Declines Mean for Arts Participation* (Washington, DC: National Endowment for the Arts, 2011). *National Endowment for the Arts*, http://www.nea.gov/research/2008-SPPA-ArtsLearning.pdf. Retrieved 26 Nov. 2012.
14. As of this writing, the future of the NCLB is unclear and new initiatives are emerging. Americans for the Arts keeps current materials here: http://www.americansforthearts .org/networks/arts_education/arts_education_015.asp
15. Neuman, Scott, "After Jobs, Who Will Be Next American Visionary?" *National Public Radio*, (PBS, 7 Oct. 2011). http://www.npr.org/2011/10/07/141154870/after-jobs-who-will-be-next-american-visionary. Retrieved 26 Nov. 2012.

16. More information can be found on the Arts Education Partnership website http://www
.aep-arts.org/.

Chapter 13

1. Zakaras, Laura, and Julia F. Lowell,s *Cultivating Demand for the Arts: Arts Learning, Arts Engagement and State Arts Policy* (Santa Monica, CA: RAND, 2008), 3.
2. *2008 Survey of Public Participation in the Arts* (Washington, DC: National Endowment for the Arts, 2009). *National Endowment for the Arts*, http://www.nea.gov/research/2008-sppa.pdf. Retrieved 26 Nov. 2012.
3. For example, Peterson and Rossman found that the median age of classical music attendees was 40 in 1982, and 49 in 2002; for museums, 36 and 45. Richard A. Peterson and Gabriel Rossman, "Changing Arts Audiences: Capitalizing on Omnivorouosness," in *Engaging Art: The Next Great Transformation of America's Cultural Life*, Steven J. Tepper and William Ivey, eds. (New York: Routledge, 2008), 308.
4. Ostrower, Francie, *The Diversity of Cultural Participation: Findings from a National Study* (Washington, DC: Urban Institute and Wallace Foundation, 2005), Introduction.
5. Rogers, Everett M., *Diffusion of Innovations*, 5th ed. (New York: Free Press, 2003).
6. Pine, B. Joseph, II, and James H. Gilmore,, *The Experience Economy: Work Is Theater & Every Business a Stage* (Cambridge, MA: Harvard Business School, 1999).
7. Qualman, Erik, *Social Media Video 2013. YouTube*, http://www.youtube.com/watch?v=TXD-Uqx6_Wk. Retrieved 26 Nov. 2012.
8. McCarthy, Kevin F., and Kimberly Jinnett, *A New Framework for Building Participation in the Arts* (Santa Monica, CA: RAND, 2001).

Chapter 14

1. Bash, Sharon Rodning, *From Mission to Motivation: A Focused Approach to Increased Arts Participation* (Saint Paul, MN: Metropolitan Regional Arts Council, 2003), iv.
2. Holland, D. K., *Branding for Nonprofits* (New York: Allworth, 2006), Foreword.
3. Coca-Cola website, http://www.coca-colacompany.com/stories/coke-lore-new-coke. Retrieved 26 Nov. 2012.
4. Vogel, Carol, "3 Out of 4 Visitors to the Met Never Make It to the Front Door." *New York Times,* 29 Mar. 2006, http://www.nytimes.com/2006/03/29/arts/artsspecial/29web .html. Retrieved 26 Nov. 2012.

Chapter 15

1. Borwick, Doug, *Building Communities, Not Audiences: The Future of the Arts in the United States* (Winston-Salem, NC: ArtsEngaged, 2012).
2. Gard, Robert, *The Arts in the Small Community: A National Plan* (Madison: University of Wisconsin Press, 1969). *Robert E. Gard Foundation*, http://www.gardfoundation.org/windmill/ArtsintheSmallCommunity.pdf. Retrieved 26 Nov. 2012.
3. Bauerlein, Mark, and Ellen Grantham, eds, *The National Endowment for the Arts: A History, 1965–2008* (Washington, DC: National Endowment for the Arts, 2008), *National Endowment for the Arts*, http://www.nea.gov/pub/nea-history-1965-2008.pdf. Retrieved 26 Nov. 2012.
4. Putnam, Robert, *Bowling Alone: The Collapse and Revival of American Community* (New York: Simon & Schuster, 2000).

5. *The United States Conference of Mayors 80th Annual Meeting*, Proceedings of the 80th Annual Meeting, 16 June 2012, Orlando, Florida. *The United States Conference of Mayors*, http://www.usmayors.org/resolutions/80th_Conference/. Retrieved 26 Nov. 2012.

6. Psilos, Phil, and Kathleen Rapp, *The Role of the Arts in Economic Development* (Washington, DC: NGA Center for Best Practices, 2001).

7. Kelly, Nancy, dir., *Downside Up: How Art Can Change the Spirit of a Place*. Center for Independent Documentary, 2001. http://www.downsideupthemovie.org/. Additional information available on http://www.pbs.org/independentlens/downsideup/

8. More information can be found at http://www.massmoca.org.

9. More information on the Center for Creative Community Development can be found at http://web.williams.edu/Economics/ArtsEcon/about.html.

10. Sheppard, Stephen, *A Brief Summary of the Economic Impact of MASS MoCA in Berkshire County, MA* (North Adams: Center for Creative Community Development, 2004). *Center for Creative Community Development*, http://web.williams.edu/Economics/ArtsEcon/library/pdfs/MassMocaSummary.pdf. Retrieved 26 Nov. 2012.

11. Borrup, Tom, *The Creative Community Builder's Handbook: How to Transform Communities Using Local Assets, Arts and Culture* (Saint Paul, MN: Fieldstone Alliance, 2006), 4.

12. Cohen, Randy, *Arts and Economic Prosperity IV* (Washington, DC: Americans for the Arts, 2012). *Arts and Economic Prosperity IV*, http://www.artsusa.org/information_services/research/services/economic_impact/. Retrieved 26 Nov. 2012.

13. Cherbo and Wyszomirski, *The Public Life of the Arts*.

14. Brooks, Arthur, et al., *Gifts of the Muse: Reframing the Debate about the Benefits of the Arts* (Santa Monica, CA: RAND, 2004).

15. Florida, Richard, *The Rise of the Creative Class* (New York: Basic-Perseus, 2002).

16. National Trust for Historic Preservation, http://www.preservationnation.org/information-center/economics-of-revitalization/heritage-tourism/. Retrieved 26 Nov. 2012.

17. http://www.artsusa.org/pdf/networks/pan/PANSurveyReport2009.pdf.

Chapter 16

1. *How the United States Funds the Arts*, 3rd ed. (Washington, DC: National Endowment for the Arts, 2012). *National Endowment for the Arts*, http://www.nea.gov/pub/how.pdf. Retrieved 26 Nov. 2012.

2. *The National Endowment for the Arts, 1965–2000: A Brief Chronology of Federal Support for the Arts* (Washington, DC: National Endowment for the Arts, 2000). *National Endowment for the Arts*, http://www.nea.gov/pub/NEAChronWeb.pdf. Retrieved 26 Nov. 2012.

3. Wallis, Brian, Marianne Weems, and Philip Yenawine, eds., *Art Matters: How the Culture Wars Changed America*, (New York: New York University Press, 1999).

4. Mayzlin, Dina, *The Influence of Social Networks on the Effectiveness of Promotional Strategies* (New Haven, CT: Yale, 2002). *Yale School of Management Dina Mayzlin*, http://faculty.som.yale.edu/dinamayzlin/soc_networks.pdf.

5. For more information and description of public relations, see the chapter 14.

6. For more information on Internal Revenue Service Code 501, see http://www.irs.gov/Charities-&-Non-Profits/Lobbying.

7. Smucker, Bob, *The Nonprofit Lobbying Guide*, 2nd ed. (Washington, DC: Independent Sector, 1999). *Center for Lobbying in the Public Interest*, http://www.clpi.org/images/stories/content_img/nonprofitlobbyingguide[1].pdf. Retrieved 26 Nov. 2012.

8. *Arts Advocacy Tool Kit* (Seattle: Washington State Arts Alliance, 2008). *Washington State Arts Alliance*, http://www.wsaa.qwestoffice.net/Toolkit.pdf. Retrieved 12/31/2012.

9. "Getting Involved in Arts Advocacy." Washington State Arts Alliance, http://www.wsaa .qwestoffice.net/Toolkit.pdf.

10. Braig Allen, Barbara A., Carter C. Hull, and John Francis Reilly, "IRC 501(c)(4) Organizations." *Internal Revenue Service*, http://www.irs.gov/pub/irs-tege/eotopici03.pdf. Retrieved 26 Nov. 2012.

11. Brooks et al., *Gifts of the Muse.*

12. Quoted in *How the United States Funds the Arts.*

References

Allen, Barbara A. Braig, Carter C. Hull, and John Francis Reilly. "IRC 501(c)(4) "Organiza-tions." *IRC 501(c)(4) Organizations.* IRS, n.d. Web. 31 Dec. 2012. <http://www.irs.gov/pub/irs-tege/eotopici03.pdf>."

Anderson, Chris. *Free: How Today's Smartest Businesses Profit by Giving Something for Nothing.* New York: Hyperion, 2010. Print.

Applying for 501(c)(3) Tax-Exempt Status. Internal Revenue Service, n.d. Web. 26 Nov. 2012. <http://www.irs.gov/pub/irs-pdf/p4220.pdf>.

Arnsberger, Paul, et al. "A History of the Tax Exempt Sector: An SOI Perspective." *Statistics of Income Bulletin* (2008): 107. *Internal Revenue Service.* Web. 26 Nov. 2012. <http://www.irs.gov/pub/irs-soi/tehistory.pdf>.

Arts Advocacy Tool Kit. Seattle: Washington State Arts Alliance, 2008. *Washington State Arts Alliance.* Web. 31 Dec. 2012. <http://www.wsaa.qwestoffice.net/Toolkit.pdf>.

Barry, Bryan W. *Strategic Planning Workbook for Nonprofit Organizations.* 3rd rev. & updated ed. Saint Paul, MN: Amherst H. Wilder Foundation, 2001. Print.

Bash, Sharon Rodning. *From Mission to Motivation: A Focused Approach to Increased Arts Participation.* St Paul, MN: Metropolitan Regional Arts Council, 2003. Print.

Bauerlein, Mark, and Ellen Grantham, eds. *The National Endowment for the Arts: A History, 1965–2008.* Washington, DC: National Endowment for the Arts, 2008. *National Endowment for the Arts.* Web. 31 Dec. 2012. <http://www.nea.gov/pub/nea-history-1965-2008.pdf>.

Bernstein, Joanne Scheff. *Arts Marketing Insights: The Dynamics of Building and Retaining Performing Arts Audiences.* San Francisco: JosseyBass-Wiley, 2006. Print.

Bodily, Susan J., Catherine H. Augustine, and Laura Zakaras. *Revitalizing Arts Education Through Community-wide Coordination.* Santa Monica, CA: RAND, 2008. Print.

Borrup, Tom. *The Creative Community Builder's Handbook: How to Transform Communities Using Local Assets, Arts, and Culture.* Saint Paul, MN: Fieldstone Alliance, 2006. Print.

Borwick, Doug. *Building Communities, Not Audiences: The Future of the Arts in the United States.* Winston-Salem, NC: ArtsEngaged, 2012. Print.

Bray, Ilona. *Effective Fundraising for Nonprofits.* Berkeley, CA: Nolo, 2005. Print.

Brindle, Meg, and Constance DeVereaux, eds. *The Arts Management Handbook: New Direc-tions for Students and Practitioners.* Armonk, NY: M.E. Sharpe, 2011. Print.

Bronson, Po. "The Creativity Crisis." *Newsweek* 19 July 2010: 44–49. Print.

Brooks, Arthur, et al. *Gifts of the Muse: Reframing the Debate about the Benefits of the Arts.* Santa Monica, CA: RAND, 2004. Print.

Brown, Alan S., and Jennifer L. Novak-Leonard. *Beyond Attendance: A Multi-modal Understanding of Arts Participation.* Pub. Washington, DC: National Endowment for the Arts, 2011. *National Endowment for the Arts.* Web. 26 Nov. 2012. <http://www.nea.gov/research/2008-SPPA-BeyondAttendance.pdf>.

Bryce, Herrington J. *Financial and Strategic Management for Nonprofit Organizations.* San Francisco: Jossey-Bass, 2000. Print.

Burdett, Christine. "Financial Management." *Fundamentals of Arts Manangement*, 4th ed., Craig Dreeszen, ed. Amherst: Arts Extension Service- U of Massachusetts Amherst, 2003. N. pag. Print.

Byrnes, William J. *Management and the Arts.* 4th ed. Oxford: Focal-Elsevier, 2008.

Carr, Eugene, and Michelle Paul. *Breaking the Fifth Wall: Rethinking Arts Marketing for the 21st Century.* New York: Patron, 2011. Print.

Catterall, James S. *The Arts and Achievement in At-Risk Youth: Findings from Four Longitudinal Studies.* Pub. Washington, DC: National Endowment for the Arts, 2012. *National Endowment for the Arts.* Web. 26 Nov. 2012. <http://www.nea.gov/research/arts-at-risk-youth.pdf>.

Center for Creative Community Development. N.p., n.d. Web. 31 Dec. 2012. <http://web.williams.edu/Economics/ArtsEcon/about.html>.

Cherbo, Joni M., and Margaret J. Wyszomirski, eds. *The Public Life of the Arts in America.* New Brunswick, NJ: Rutgers, 2000. Print. Rutgers Series on the Public Life of the Arts.

Coca-Cola. Coca-Cola, n.d. Web. 31 Dec. 2012. <http://www.coca-colacompany.com/stories/coke-lore-new-coke>.

Code of Ethical Principles and Standards. Arlington, VA: Association of Fundraising çProfessionals, 2008. *Association of Fundraising Professionals.* Web. 31 Dec. 2012. <http://www.afpnet.org/files/ContentDocuments/CodeOfEthicsLong.pdf>.

Cohen, Randy. *Arts and Economic Prosperity IV.* Washington, DC: Americans for the Arts, 2012. *Arts and Economic Prosperity IV.* Web. 31 Dec. 2012. <http://www.artsusa.org/information_services/research/services/economic_impact/>.

Cohen, Randy, and Roland J. Kushner. *National Arts Index 2010.* Washington, DC: Americans for the Arts, 2010. *Americans for the Arts.* Web. 21 Nov. 2012. <http://www.americansforthearts.org/information_services/arts_index/001.asp>.

Colbert, François. *Marketing Culture and the Arts.* 3rd ed. Montreal: Carmelle and Remi Marcoux Chair in Arts Management, 2007. Print.

———. *Marketing Planning for Culture and the Arts.* Montreal: Carmelle and Remi Marcoux Chair in Arts Management, 2008. Print.

Coopersmith, Jared. *Snapshot: Arts Education Access in Public Schools 2009-2010.* Washington, DC: National Center for Education Statistics, 2012. *Institute of Education Sciences.* Web. 8 Jan. 2013. <http://www.bmfenterprises.com/aep-arts/wp-content/uploads/2012/03/2page-summary-flyer.pdf>.

"Creativity Matters: The Arts and Aging Toolkit." *Creativity Matters: The Arts and Aging Toolkit.* National Guild of Community Schools of the Arts, n.d. Web. 31 Dec. 2012. <http://www.artsandaging.org>.

Daft, Richard. *Management.* 10th ed. Mason, OH: South-Western, 2012. Print.

Dalgleish, Julie Gordon, and Bradley G. Morison. *Waiting in the Wings: A Larger Audience for the Arts and How to Develop It.* 2nd ed. New York: American Council for the Arts, 1993. Print.

Deutsch, Claudia H. "For Love and a Little Money." *New York Times* 23 Oct. 2007: n. pag. Print.

DiMaggio, Paul. *Managers and the Arts.* Washington, DC: Seven Locks, 1987. Print.

Dreeszen, Craig, ed. *Fundamentals of Arts Management,* 4th ed. Amherst: Arts Extension Service-U of Massachusetts Amherst, 2003. Print.

Drucker, Peter F. Preface. *Managing the Non-Profit Organization.* New York: HarperBusiness-HarperCollins, 1990. xiv. Print.

"Education Reform." *Arts Education.* Americans for the Arts, n.d. Web. 31 Dec. 2012. <http://www.americansforthearts.org/networks/arts_education/arts_education_015.asp>.

Eisner, Elliot. "Ten Lessons the Arts Teach," in *Learning and the Arts: Crossing Boundaries.* Ed. Amdur Spitz & Associates. 12 Jan. 2000, Los Angeles. Morristown, NJ: Geraldine R. Dodge Foundation, 2000. 14. *Grantmakers in the Arts.* Web. 26 Nov. 2012. <http://www.giarts.org/>.

Farnum, Marlene, and Rebecca Schaffer. *YouthARTS Handbook: Arts Programs for Youth at Risk.* Washington, DC: Americans for the Arts, 1998. Print.

Farrell, Betty, and Diane Grams, eds. *Entering Cultural Communities: Diversity and Change in the Nonprofit Arts.* New Brunswick, NJ: Rutgers, 2008. Print. Rutgers Series on the Public Life of the Arts.

Financial Accounting Standards Board. N.p., n.d. Web. 18 Dec. 2012. <http://www.fasb.org>.

Florida, Richard. *The Rise of the Creative Class.* New York: Basic-Perseus, 2002. Print.

Freeman, Robert J., and Craig D. Shoulders. *Governmental and Nonprofit Accounting: Theory and Practice,* 6th ed. Upper Saddle River, NJ: Prentice Hall—Simon, 1999. Print.

Frey, Bruno S. *Arts & Economics: Analysis & Cultural Policy,* 2nd ed. Berlin: Springer-Verlag, 2003. Print.

Gallo, Robert P., and Frederick J. Turk. *Financial Management Strategies for Arts Organizations.* New York: American Council on the Arts, 1984. Print.

Gard, Robert. *The Arts in the Small Community: A National Plan.* Madison: University of Wisconsin, 1969. *Robert E. Gard Foundation.* Web. 31 Dec. 2012. <http://www.gardfoundation.org/windmill/ArtsintheSmallCommunity.pdf>.

"Get Involved: Policy and Advocacy." *Americans for the Arts.* Americans for the Arts, n.d. Web. 31 Dec. 2012. <http://www.artsusa.org/get_involved/advocacy/funding_resources/default_005.asp>.

Gilbreth, Frank B., Jr., and Ernestine Gilbreth Carey. *Cheaper By the Dozen.* New York: HarperCollins, 1948. Print.

Gilmore, James H., and B. Joseph Pine, II. *The Experience Economy: Work Is Theater & Every Business a Stage.* Boston: Harvard Business School, 1999. Print.

Governance in Form 990. N.p.: Board Source, 2009. *Board Source.* Web. 31 Dec. 2012. <http://www.boardsource.org/dl.asp?document_id=681>.

Grace, Kay Sprinkel. *Beyond Fundraising: New Strategies for Nonprofit Innovation and Investment,* 2nd ed. Hoboken, NJ: John Wiley & Sons, 2005. Print.

Gray, Charles M., and James Heilbrun. *The Economics of Art and Culture.* 2nd ed. Cambridge: Cambridge University Press, 2001. Print.

Greenwood, Peter W., et al. *Diverting Children from a Life of Crime: Measuring Costs and Benefits.* Santa Monica, CA: RAND, 1996. Print.

Gross, Malvern J., Jr., Richard F. Larkin, and John H. McCarthy. *Financial and Accounting Guide for Not-For-Profit Organizations,* 6th ed. New York: John Wiley & Sons, 2000. Print.

Guest, Christopher, dir. *Waiting for Guffman.* Screenplay by Christopher Guest and Eugene Levy. Castle Rock Entertainment, 1993. Film.

Hedberg, E. C., and Nick Rabkin. *Arts Education in America: What Declines Mean for Arts Participation.* Washington, DC: National Endowment for the Arts, 2012. *National Endowment for the Arts.* Web. 26 Nov. 2012. <http://www.nea.gov/research/2008-SPPA-ArtsLearning.pdf>.

Hessenius, Barry. *Involving Youth in Nonprofit Arts Organizations: A Call for Action.* Palo Alto: William and Flora Hewlett Foundation, 2007. *Hewlett.* Web. 26 Nov. 2012. <http://www.hewlett.org/uploads/files/InvolvingYouthNonprofitArtsOrgs.pdf>.

Holland, DK. *Branding for Nonprofits.* New York: Allworth, 2006. Print.

Hopkins, Karen Brooks, and Carolyn Stolper Friedman. *Successful Fundraising for Arts and Cultural Organizations,* 2nd ed. Phoenix, AZ: Oryx, 1997. Print.

How the United States Funds the Arts. Washington, DC: National Endowment for the Arts, 2012. *National Endowment for the Arts.* Web. 31 Dec. 2012. <http://www.nea.gov/pub/how.pdf>.

Ivey, Bill. *Arts, Inc.: How Greed and Neglect Have Destroyed Our Cultural Rights.* Berkeley: University of California Press, 2008. Print.

Ivey, Bill, and Steven J. Tepper, eds. *Engaging Art: The Next Great Transformation of America's Cultural Life.* New York: Routledge-Taylor & Francis Group, 2008. Print.

Jenkins, David. *501(c)Blues: Staying Sane in the Nonprofit Game.* Pray, MT: Fandango, 2003. Print.

Jinnett, Kimberly, and Kevin F. McCarthy. *A New Framework for Building Participation in the Arts.* Santa Monica, CA: RAND, 2001. Print.

Joyce, Helen. "Adam Smith and the Invisible Hand." *Plus Magazine* 1 Mar. 2001: n. pag. *Plus Magazine.* Web. 26 Nov. 2012. <http://plus.maths.org/content/adam-smith-and-invisible-hand>.

Kaiser, Michael. *Strategic Planning in the Arts: A Practical Guide.* Washington, DC: John F. Kennedy Center for the Performing Arts, 2007. *Lincoln Arts Council.* Web. 18 Dec. 2012. <http://artscene.org/uploaded/Pages/ArtistResources/StrategicPlanningintheArts-APracticalGuide.pdf>.

Kaiser, Michael M. *The Art of the Turnaround: Creating and Maintaining Healthy Arts Organizations.* Lebanon: Brandeis–University of New England, 2008. Print.

Kelly, Nancy, dir. *Downside Up: How Art Can Change the Spirit of a Place.* Center for Independent Documentary, 2001. Film.

Kerrigan, Finola, Peter Fraser, and Mustafa Ozbilgin, eds. *Arts Marketing.* Amsterdam: Elsevier, 2004. Print.

Kopczynski, Mary, and Mark Hager. *The Value of the Performing Arts in Five Communities: A Comparison of 2002 Household Data.* Rept. N.p.: Performing Arts Research Coalition, 2003. *The Performing Arts Research Coalition 2002.* Web. 13 Nov. 2012. <http://www.operaamerica.org/content/research/PARC.aspx>.

Kopczynski Winkler, Mary, and Mark A. Hager. "Washington, D.C. Performing Arts Research Coalition Community Report." *Urban Institute Research of Record.* Urban Institute, 2010. Web. 18 Oct. 2012. <http://www.urban.org/publications/410942.html>.

Kotler, Philip, and Joanne Scheff. *Standing Room Only: Strategies for Marketing the Performing Arts.* Boston: Harvard Business Review, 1997. Print.

Kotter, John. *What Leaders Really Do.* Boston: Harvard Business School, 1999. Print.

Leet, Rebecca K. *Message Matters: Succeeding at the Crossroads of Mission and Market.* Saint Paul, MN: Fieldstone Alliance, 2007. Print.

Lowell, Julia F., and Laura Zakaras. *Cultivating Demand for the Arts: Arts Learning, Arts Engagement, and State Arts Policy.* Santa Monica, CA: RAND, 2008. Print.

"Mapping the Public Life of the Arts in America," in *The Public Life of the Arts in America*, Joni M. Cherbo and Margaret J. Wyszomirski,eds. New Brunswick, NJ: Rutgers University Press, 2000. 67. Print.

Maslow, Abraham. "A Theory of Human Motivation." *Psychological Review* 50.4 (1943): 370–96. Print.

Mass MoCA. Mass MoCA, n.d. Web. 31 Dec. 2012. <http://www.massmoca.org>.

Mayzlin, Dina. *The Influence of Social Networks on the Effectiveness of Promotional Strategies*. Pub. New Haven, CT: Yale, 2002. *Yale School of Management Dina Mayzlin*. Web. 26 Nov. 2012. <http://faculty.som.yale.edu/dinamayzlin/soc_networks.pdf>.

McCarthy, Kevin F., et al. *The Performing Arts in a New Era*. Santa Monica, CA: RAND, 2001. Print.

McDaniel, Nello, and George Thorn. *The Quiet Crisis in the Arts*. New York: FEDAPT, 1991. Print.

McNamara, Carter. "What Is a Board?" *Free Management Library*. Authenticity Consulting, n.d. Web. 18 Dec. 2012. <http://managementhelp.org/boards/index.htm>.

National Center for Charitable Statistics. Urban Institute, n.d. Web. 31 Dec. 2012. <http://www.nccs.urban.org/projects/ucoa.cfm>.

National Endowment for the Arts. National Endowment for the Arts, n.d. Web. 18 Oct. 2012. <http://www.nea.gov>.

The National Endowment for the Arts, 1965–2000: A Brief Chronology of Federal Support for the Arts. Pub. Washington, DC: National Endowment for the Arts, 2000. *National Endowment for the Arts*. Web. 26 Nov. 2012. <http://www.nea.gov/pub/NEAChronWeb.pdf>.

National Trust for Historic Preservation. N.p., n.d. Web. 31 Dec. 2012. <http://www.preservationnation.org/information-center/economics-of-revitalization/heritage-tourism/>.

NEA Research Reports. National Endowment for the Arts, n.d. Web. 18 Oct. 2012. <http://www.nea.gov/research/ResearchReports.html>.

Neuman, Scott. "After Jobs, Who Will Be Next American Visionary?" *National Public Radio*.PBS,7Oct.2011.Web.26Nov.2012.<http://www.npr.org/2011/10/07/141154870/after-jobs-who-will-be-next-american-visionary>.

New York Philharmonic History. New York Philharmonic, 2012. Web. 18 Oct. 2012. <http://www.nyphil.org/about-us/history/overview>.

O'Donnell, Trevor, and David Olsen. *Marketing the Arts to Death: How Lazy Language is Killing Culture*. Los Angeles: Trevor O'Donnell, 2011. Print.

Online Etymology Dictionary. Douglas Harper, 2012. Web. 18 Oct. 2012.

Ostower, Francie. *The Diversity of Cultural Participation: Findings from a National Study*. Washington, DC: Urban Institute and The Wallace Foundation, 2005. Print. Building Arts Participation: New Findings from the Field.

Peters, Jeanne Bell, and Elizabeth Schaffer. *Financial Leadership for Nonprofit Executives: Guiding Your Organization to Long-term Success*. Saint Paul, MN: CompassPoint-Wilder, 2005. Print.

Psilos, Phil, and Kathleen Rapp. *The Role of the Arts in Economic Development*. Washington, DC: NGA Center for Best Practices, 2001. Print.

Putnam, Robert. *Bowling Alone: The Collapse and Revival of American Community*. New York: Simon & Schuster, 2000. Print.

Qualman, Erik. *Social Media Video 2013. Youtube*. Youtube, n.d. Web. 8 Jan. 2013. <http://www.youtube.com/watch?v=TXD-Uqx6_Wk>.

———. *Socialnomics: How Social Media Transforms the Way We Live and Do Business*, 2nd ed. Hoboken, NY: John Wiley & Sons, 2012. Print.

Roberts Rules of Order. N.p., n.d. Web. 26 Nov. 2012. <http://www.robertsrules.com/>.

Roche, Nancy, and Jaan Whitehead, eds. *The Art of Governance: Boards in the Performing Arts*. New York: Theatre Communications Group, 2005. Print.

The Sector's Economic Impact. Research rept. Washington, DC: Independent Sector, 2012. *Independent Sector*. Web. 26 Nov. 2012. <http://www.independentsector.org/economic_role>.

Scriven, Michael. *Evaluation Thesaurus,* 4th ed. Thousand Oaks, CA: Sage Publications, 1991.

Senge, Peter M. *The Fifth Discipline: The Art and Practice of the Learning Organization*. New York: Currency-Doubleday, 1990. Print.

Shagan, Rena. *Booking & Tour Management for the Performing Arts* rev. & expanded ed. New York: Allworth, 1996. Print.

Sheppard, Stephen. *A Brief Summary of the Economic Impact of MASS MoCA in Berkshire County, MA*. North Adams: Center for Creative Community Development, 2004. *Center for Creative Community Development*. Web. 31 Dec. 2012. <http://web.williams.edu/Economics/ArtsEcon/library/pdfs/MassMocaSummary.pdf>.

Smucker, Bob. *The Nonprofit Lobbying Guide. Independent Sector,* 2nd ed. N.p.: Independent Sector, 1999. *Center for Lobbying in the Public Interest*. Web. 26 Nov. 2012. <http://www.clpi.org/images/stories/content_img/nonprofitlobbyingguide[1].pdf>.

State of the States 2012: Arts Education State Policy Summary. N.p.: Arts Education Partnership, 2012. *Arts Education Partnership*. Web. 31 Dec. 2012. <http://www.aep-arts.org/wp-content/uploads/2012/07/State-of-the-states-2012-FINAL.pdf>.

State of Wisconsin. Wisconsin Department of Public Instruction and Wisconsin Arts Board. *Wisconsin Task Force on Arts and Creativity in Education: A Plan for Action*. Rept. N.p.: Wisconsin Task Force on Arts and Creativity in Education, 2009. Print.

Stern, Gary J. *Mobilize People for Marketing Success*. Saint Paul, MN: Amherst H. Wilder Foundation, 1997. Print. Vol. 2 of *Marketing Workbook for Nonprofit Organizations*.

Stern, Gary J., and Elana Centor. *Develop the Plan*, 2nd ed. Saint Paul, MN: Amherst H. Wilder Foundation, 2001. Print. Vol. 1 of *Marketing Workbook for Nonprofit Organizations*.

Succession: Arts Leadership for the 21st Century. Chicago: Illinois Arts Alliance Foundation, 2003. Print.

Taylor, Andrew, ed. *The Artful Manager*. Artsjournal, 2003. Web. 26 Nov. 2012. <http://www.artsjournal.com/artfulmanager/>.

Turk, Frederick J., and Robert P. Gallo. *Financial Management Strategies for Arts Organizations*. New York: American Council for the Arts, 1984. Print.

2008 Survey of Public Participation in the Arts. Washingto,n DC: National Endowment for the Arts, 2009. *National Endowment for the Arts*. Web. 31 Dec. 2012. <http://www.nea.gov/research/2008-sppa.pdf>.

United States. President's Committee on the Arts and the Humanities. *Coming Up Taller*. Print.

———. *Eloquent Evidence: Arts at the Core of Learning*. Print.

The United States Conference of Mayors 80th Annual Meeting. Proceedings of 80th Annual Meeting, 16 June 2012, Orlando, FL. N.p.: n.p., n.d. *The United States Conference. of Mayors*. Web. 31 Dec. 2012. <http://www.usmayors.org/resolutions/80th_Conference/>.

Vogel, Carol. "3 Out of 4 Visitors to the Met Never Make It to the Front Door." *New York Times* 29 Mar. 2006: n. pag. Web. 31 Dec. 2012. <http://www.nytimes.com/2006/03/29/arts/artsspecial/29web.html>.

Vonnegut, Kurt. *A Man Without a Country*. New York: Random House, 2007. Print.

The Wallace Foundation. Wallace Foundation, 2012. Web. 18 Oct. 2012. <http://www.wallacefoundation.org>.

Wallis, Brian, Marianne Weems, and Philip Yenamine, eds. *Art Matters: How the Culture Wars Changed America*. New York: NYU, 1999. Print.

Warwick, Mal. *How to Write Successful Fundraising Letters*, 2nd ed. San Francisco: Jossey-Bass-Warwick, 2008. Print.

Wolf, Thomas. *Managing a Nonprofit Organization in the Twenty-First Century*, rev and updated ed. New York: Fireside–Simon & Schuster, 1999. Print.

———. *Presenting Performances*. New York: American Council for the Arts, 1991. Print.

Author Bio

Ellen Rosewall is Professor of Arts Management at the University of Wisconsin–Green Bay, where she coordinates and teaches the Arts Management program. The UWGB Arts Management program offers both a major and minor in not-for-profit arts management.

Rosewall sits on the board of the Association of Arts Administration Educators (AAAE) and has served on several boards of directors, including the Wisconsin Public Radio Association (past president), Arts Wisconsin (past president), Northeastern Wisconsin Arts Council (past president), Cedar Center Arts (vice president), and Film Green Bay (founding board member). Rosewall served on the Wisconsin Legislative Council's Special Committee on Arts Funding, which created legislation that led to the adoption of the Wisconsin Local Arts Endowment in 2001. She continues to actively advocate for the arts at the local, state, regional, and national levels.

Known nationally for her work in arts management, Rosewall has given workshops and presentations around the United States to such arts groups as Americans for the Arts, the National Arts Marketing Conference, the International Conference on Social Theory, Politics, and the Arts, the Michigan Assembly of Community Arts Agencies, and the Association of Arts Administration Educators. Her article "Cultural Assessment and Response: Answering the Arts Building Boom," was published in the fall 2006 issue of the *Journal of Arts Management, Law, and Society* and "The Case for Mission-Focused Arts Management Education" appeared in the July 2013 issue of the *American Journal of Arts Management*.

As a consultant, Rosewall has worked with arts and cultural organizations throughout the Midwest, including the Milwaukee Ballet, the Birch Creek Music Association, and the Portage County Arts Alliance. In 2010 she was named a mentor for Arts in Crisis program of the John F. Kennedy Center for the

Performing Arts. For several years, in conjunction with the Wisconsin Arts Board, she advised new presenters in small towns on organizational assessment and audience development. During her 25-year career as an arts manager, Rosewall has served organizations with budgets ranging from $100,000 to over $14 million.

Ellen Rosewall is also the author of *Sparkle Island: Stories of Love, Life and Walloon Lake*, which was published by Raven Tree Press and nominated for the Great Lakes Book Award in 2000. "*Sparkle Island*" the story of Rosewall's family's hundred-year-old cottage in northern Michigan, is in its second printing.

Index